Robert Lepage's original stage productions

Manchester University Press

theatre
theory • practice
• performance •

series editors
MARIA M. DELGADO
MAGGIE B. GALE
PETER LICHTENFELS

advisory board

Michael Billington, Sandra Hebron, Mark Ravenhill, Janelle Reinelt, Peter Sellars, Joanne Tompkins

This series will offer a space for those people who practise theatre to have a dialogue with those who think and write about it.

The series has a flexible format that refocuses the analysis and documentation of performance. It provides, presents and represents material which is written by those who make or create performance history, and offers access to theatre documents, different methodologies and approaches to the art of making theatre.

The books in the series are aimed at students, scholars, practitioners and theatre-visiting readers. They encourage reassessments of periods, companies and figures in twentieth-century and twenty-first-century theatre history, and provoke and take up discussions of cultural strategies and legacies that recognise the heterogeneity of performance studies.

also available

Robert Lepage's original stage productions

Making theatre global

KAREN FRICKER

Manchester University Press

The right of Karen Fricker to be identified as the author of this work has been asserted by her in accordance with the Copyright, Designs and Patents Act 1988.

Published by Manchester University Press
Oxford Road, Manchester M13 9PL

www.manchesteruniversitypress.co.uk

British Library Cataloguing-in-Publication Data
A catalogue record for this book is available from the British Library

ISBN 978 0 7190 8006 7 hardback
ISBN 978 1 5261 7888 6 paperback

First published 2020

The publisher has no responsibility for the persistence or accuracy of URLs for any external or third-party internet websites referred to in this book, and does not guarantee that any content on such websites is, or will remain, accurate or appropriate.

Typeset by Servis Filmsetting Ltd, Stockport, Cheshire

In memory of my dear parents, John and Patricia

CONTENTS

FIGURES

ACKNOWLEDGEMENTS

This project has been long in the making and I have benefited from much support along the way. My first thanks go to Robert Lepage for the inspiration and provocation of his work, and to the teams at Ex Machina and Robert Lepage Incorporated for allowing me access to its processes and archives, especially Bruno Bazin, Lynda Beaulieu, Micheline Beaulieu, Édouard Garneau, Louise Roussel, and France Vermette. I extend gratitude especially to Michel Bernatchez for professional generosity and insights throughout the years.

With the late David Bradby, Maria M. Delgado was the first person to commission an academic publication from me – uncoincidentally about Lepage – and has never wavered in her support and encouragement. Thank you, Maria, for your mentorship, commitment to excellence, and belief in me as editor of the series in which this book appears, and thanks to Matthew Frost, Paul Clarke and Humairaa Dudhwala at Manchester University Press and copy-editor Judith Oppenheimer for your expert work in bringing the book to print.

Some material in the section of Chapter 1 titled 'Québec, nationalism, globalisation' was previous published in *Staging Nationalism: Essays on Theatre and National Identity* © 2005 Edited by Kiki Gounaridou and reprinted by permission of McFarland & Company, Inc.

Some material in the section of Chapter 5 about the production *Zulu Time* was previously published in *Globe. Revue internationale d'études québécoises*, 11.2 (2008), and is reprinted here with the editors' permission.

Gathering the photographs for this publication was a complex and inspirational process: merci/thank you/vielen dank to Jacques Collin, Gavin Evans, Ludovic Fouquet, Claudel Huot (with gracious intervention from André Huot), Érick Labbé, Louise Leblanc, Peter Mettler, Bernd Uhlig, and Nicola-Frank Vachon for your beau-

tiful images and the rights to publish them. Especial thanks to Jean-Sébastien Côté for the cover image and the shared delight in being able to put it to use here.

As the project came together, Elizabeth Amos, Witta Nicoyishakiye, and Kelly Richmond provided inspired research assistance, and the Office of Research Services and the Humanities Research Institute at Brock University helped me find ways to support them. In the final stages, colleagues from Canadian/Québec theatre and academia came through with vital information and expertise: thank you Sean Fitzpatrick, Amy Friend, Marion Gerbier, Paul Lefebvre, and Ann Swerdfager. I benefited from research leaves at Brock University and at Royal Holloway, University of London to work on this project, for which I am grateful. A British Academy small research grant supported my work on this project while at Royal Holloway.

Thank you to these amazing people for being sounding boards, supports, inspirations, and fellow-travellers along the way. You helped me get here, Michael Bacon, Charles R. Batson, Joël Beddows, Susan Bennett, Peter Berlin, David Binder, Sean Brennan, Emma Brodzinski, Angelique Chrisafis and Fiachra Gibbons, Jocelyn Clarke, Sylas Coletto, Susan Conley, Colette Conroy, Fabrizio De Donno, Loughlin Deegan and Denis Looby, Peter Dickinson, Kiara Downey, Roberta Doylend, Mark Elkin, David Fancy, Hilary Fannin, Nathalie Fillion, Giulia Forsythe, Marcy Gerstein, Milija Gluhovic, Robyn Grant-Moran, Randy Greenwald, David Gunderman and Andrew Raskopf, Paul Halferty, Jen Harvie, Karen Hines, Ravi Jain, Liam Jarvis, Alain Jean, Simon Jolivet, Yasmine Kandil, Dennis Kennedy, Ric Knowles, Stephen Low and Mikhail Sorine, Michelle MacArthur, Carolyn Mackenzie, Athena Madan, Carly Maga, Hayley Malouin, Helen Meany, Chris Megson, Aoife Monks, Sophie Nield, Maura O'Keeffe and Mel Mercier, Nicole Nolette, Stéphanie Nutting, Emer O'Toole, Nik Quaife and Emerson Bruns, Gyllian Raby, Alisa Regas, Peter Rehberg, Ani Sarkissian, Courtney Selan, Brian Singleton, Tabitha Sparks, Michael Stamm, Will Straw, Larry Switzky and Sameer Farooq, Bruce Thompson and Bill Ralph, and Ante Ursić. Most of all, thanks and love to my sister Elizabeth and brother-in-law Gary.

I finally salute my fellow Lepageans: Nadine Desrochers, Mark Fisher, Céline Gagnon, Erin Hurley, Jane Koustas, Melissa Poll, Jim Reynolds, and Lilie Zendel and Jean-Paul Picard. Over the decades my engagement with Lepage has brought these cherished people into my life, and the ideas in this book are most of all a continued conversation with them. I hope we will continue the debate for many years to come.

Introduction

Robert Lepage is one of the best-known and most productive figures in the contemporary international performing arts; the London *Daily Telegraph* has called him 'probably the planet's most venerated director' (Rees). He is active across performance genres, from original theatre productions to stagings of existing theatre and opera texts, to circus, ballet, film, and large-scale video installation. His creativity is at the centre of a small conglomeration of organisations in his native Québec City, which include Ex Machina, a not-for-profit production company; Robert Lepage Incorporated, a private organisation which manages Lepage's work for hire; and Le Diamant, a production complex opened in 2019 where Lepage will develop and present his work alongside visiting Québécois, Canadian, and international productions (Le Diamant replaces La Caserne Dalhousie, which was Ex Machina's headquarters from 1997 to 2019). Even before the mid-1990s, when Ex Machina was founded, Lepage productions were headline events in the locations where they have played, from London's Barbican Centre to the Théâtre National de Chaillot in Paris to the Brooklyn Academy of Music. In the media and critical discourses around his work, Lepage is celebrated as a star talent whose gifts reside in his capacity to bring together bodies, media, and objects on stage to tell stories in visually ravishing, complex ways that have a strong effect on viewers. His directorial signature is recognised as consistent across the variety of genres in which he works, and central to their value. His success is significant not just for him and the companies who produce his work, but for his stateless nation: his achievements are frequently held up in official discourses as evidence of the vitality of Québec itself. His has always been an autobiographically driven practice, in that his preoccupations and experiences serve as direct inspiration for his original shows and also tend to drive his choice of existing and canonical works. In particular, autobiography drives his solo productions, which treat the relationship

between his personal and creative identities and, taken together, present themselves as a narrative of his ongoing struggles to navigate the boundaries between the individual and the professional.

This series of opening statements is intended to establish some parameters of discussion about the subject of this book, but just as quickly I suggest another central premise: that Lepage is notable for his elusiveness and ambivalence about his work, about his own place in that work (personally and creatively), and about his role as a leading figure in global and Québécois arts. While discussing many other of his creative outputs, this book focuses on what I classify as his early- and mid-career original theatre productions – early being from the mid-1980s through the foundation of Ex Machina in 1994, and mid-career from 1994 to 2008. During this time he resisted taking full credit for this work, representing it both as the product of collaboration and, frequently, as the outcome of creative processes that have a life of their own. During this time the autobiographical nature of the work was also somewhat veiled, often through the use of characters that stood in for Lepage but did not exactly match him. As I will go on to explore, he skilfully uses such intimation of autobiography as a means of simultaneous self-revelation and self-concealment. On a corporate level, while Lepage is at the centre of all his enterprises, his signature is not consistently foregrounded as their defining and uniting quality: Ex Machina describes itself as a 'multidisciplinary company bringing together' a wide variety of creative and technical artists ('Ex Machina'), while Le Diamant is a 'venue for touring and multidisciplinary creation' (Le Diamant 'A Propos de notre mission').[i] In interviews Lepage resists the classification of genius that is often suggested to describe him, arguing for example to Stéphan Bureau that he lacks the quality of 'reflexivity' and the ability to 'create connections between everything and to find ideas' that he believes defines a genius, describing himself rather as someone who 'is listening' (125–6; see also Charest 69–73).[ii] Lepage describes Le Diamant and La Caserne as sites of refuge, where he can create work on his own terms and 'put down [his] suitcases' in the midst of relentless travelling (Le Diamant 'Mot de Robert Lepage'; see also Caux and Gilbert 18).[iii]

This resistance to being classified is such a consistent position on Lepage's part that it has become definitional. This is a paradoxical stance – defining oneself by avoiding definition – and it is thus not surprising that paradox is a key term in discussions of Lepage's work, as I will go on to explore. I believe that Lepage has cultivated such paradoxical identifications to allow himself to continue to work as a creative artist on his own terms. Resisting definition, eluding the capture of binary positions, and moving restlessly between home ground (Québec) and multiple international locations is a professional/personal strategy which has enabled the growth and perpetuation of his career. Such a position is also 'fundamental' to Ex Machina's approach to creativity, he underlines in *Creating for the Stage*, a book about the company's work:

i 'un lieu de diffusion et de création multidisciplinaire'. Translation here and throughout the book mine, unless otherwise noted.
ii 'Un génie, c'est quelqu'un qui, je pense, est capable de faire tous les liens entre toutes les choses et de trouver des idées, par sa seule force de réflexion … Je suis pas quelqu'un qui réfléchit; je suis quelqu'un qui est à l'écoute.'
iii 'poser mes valises'.

'It was by refusing frameworks that we established our approach' (Caux and Gilbert 27). The success of these strategies is evident in the striking lack of journalistic and scholarly consensus about Lepage's work, and the disconnected nature of Lepage scholarship. While some assert that Lepage is a unique talent – to the extent, for some commentators, that his work exists outside of classification and context – others call him an imitator and a populariser. He is described both as a banner example of a transnational artist, making work which draws from and mediates between cultures, and as someone whose work cannot be understood outside of the context of Québec. For some, his resistance to being pinned down is the laudable centre of his creativity, while for others it represents an abnegation of responsibility. Methodological approaches to his stage work vary widely. Some studies focus on his approach to creating work as a director and collaborator,[1] and a subset of this work focuses on the intermedial aspects of his creativity.[2] Other scholars explore the relationship of his work to the Québec context,[3] or liken his work to translation.[4] A further area of Lepage studies explores questions of authorship, representation, and responsibility.[5]

This book draws from many areas of this scattered terrain: the work of all these scholars has helped me to identify the themes and problematics that are the central vectors of my engagement. A central principle of my approach is to join together the exploration of the effects of Lepage's work with discussion of the methods by which that work is made. Another element shaping my approach has been Lepage's own assertions about his creativity and working methods, evidence which invites consideration as well as critical distance. While he is resistant to being defined or contained, Lepage has been clear and consistent in statements about a central objective for his work, which is to keep theatre relevant and available to audiences whose sensibilities are being shaped by recorded and digital media. As he writes in the Foreword to *Creating for the Stage*:

> The influence of film and television and the new dramaturgical possibilities offered by multimedia have turned narrative conventions upside down, opening the way to new forms of expression and new languages of staging that have only barely been explored. It is thus not simply the content and form of theatre that are being called into question by Ex Machina, but also the role that theatre will play in the new exchange of ideas in the twenty-first century. (7)

His project, as Lepage describes it, is an ongoing experiment in the creation of live performance that engages with new technologies, and with the ways in which these technologies are changing human perception and experience. Another key principle for Lepage is that he focuses more on the process of making theatre than on the signification that results. Terminology used by David Saltz in his phenomenological analysis of theatrical narrative is useful in articulating this approach. Saltz argues that, contrary to conventional understandings, theatre creates more than one fiction; theatre's meaning resides in more than the narrative spectators understand to have been enacted on stage, and in more than any message spectators might take away. What happens live on stage – the action, the real-life event – is the 'infiction' in Saltz's formulation; infictions are 'prescriptions to imagine'. The outfiction is the 'narrative content that we extract from the performance event' (214). For Lepage, the

infiction has always been more important than the outfiction. When he talks about how he makes his performances, the discussion focuses on playing, creativity, and lack of structure. He is very attuned to reception – to audiences' participatory role in the theatre event – but resists identifying any message that his work might convey: 'There's no moral', he said in an important 1994 interview. 'It's just putting people into a bath of sensations and ideas and emotions. And then they come out of it and do what they want with it' (Bunzli, 'Geography' 97). The interest for him is not the ideas or facts that an audience member might take away from his productions, but the creation of performances that crystallise and reflect back the particular way in which contemporary spectators experience the world. There are limitations to this approach: the danger of universalising statements about the place of technology in human experience, given inequities of access (the so-called Digital Divide); the totality of Lepage's abnegation of control over signification (surely what he puts into his baths of sensation, ideas, and emotions has an effect on what audiences take out of them?); and, following on from the previous point, the relationship of the subject matter and themes of his performances to their real-world contexts – that is, questions of cultural ownership and appropriation. But, by identifying a focus on infiction, on spectatorship, and on the emulation of a contemporary, mediatised experience of navigating the world we come closer to an articulation of Lepage's terms of engagement and of the goals of his ongoing creative project. A final, key element is affect. Lepage's is a practice that foregrounds phenomenological effects over semiotic meanings: people go to the theatre 'to feel', he has said (qtd in Winters).

The ambivalence of the scholarship on Lepage – the extent to which scholars have struggled to classify his approach – is evident in the level of debate about whether his work is modern or postmodern, original or derivative. Duška Radosavljević characterises Lepage as a populariser, in the vein of Max Reinhardt, and paints this in a positive light: 'a theatrical and cinematic visionary whose work was a continuation of the previously established traditions, but hugely inspirational in its spectacular effect and entirely refreshing as part of the theatrical mainstream' (*Theatre-Making* 9). Greg Giesekam argues, in a more critical vein, that Lepage's strategies to incorporate recorded media into his work 'have been anticipated in the work of other practitioners' and that 'there is little sense of the sustained exploration of the broader implications of using film or video on the stage found in their work' (244). For Steve Dixon, while Lepage's work is 'stylistically postmodern and eclectic', it is firmly linked to 'the avant-garde and the modernists of the past' through 'his pioneering technological aesthetics, his formalist experiments with time and space, and his existential and spiritual concerns', as well as by 'drawing upon myths and grand narratives' (514). Dixon thus proposes Lepage as a bridging figure creating works that, while they might reflect the surface-level heterogeneity of postmodern cultural expression, are underlain by a modernist quest to make sense of and ground himself within his immediate experience and broader life-world, and by a desire to 're-ignite theatre for a new generation of audiences' (ibid.).

This conception of Lepage as a figure hovering between modern and postmodern – between the attempt to 'expose the truth or reality underneath representation' and the employment of 'representation *about* representation ... quotation as montage'

(Schneider 293, emphasis in original) – is a productive one that at once recognises Lepage's indeterminacy but does not allow him to slip out of discursive sight. It's something that Andy Lavender is getting at in his description of Lepage's investment in 'a pervasive sense of the "truth" of change' (148), as is Izabella Pluta's identification of a 'Lepagean *aesthetic of movement*' that is 'based on *transformation*, a key process in his work' (192, emphases in original). Marvin Carlson and Janelle Reinelt identify the openness of Lepage's work to multiple interpretations and points of entry as one of its defining and positive traits, in that his productions present meaning as contingent and promote reflexive awareness among spectators of their own ability to change their lives and the world around them (189–90). In his discussion of Lepage's 1995 film *Le Confessional*, Bill Marshall describes Lothaire Bluteau's performance as the central character Pierre as 'combin[ing] passivity and transformation: he is not a political actor ... but one who sees and changes' (310) – a description that could as easily describe Lepage as Pierre. For the theatre critic Robert Lévesque, one of Lepage's earliest and most acute commentators, the incapacity to pin down Lepage's project registers as frustration:

> It's hard to talk about an artist whose shows are so famous and whose name is synonymous with success ... *Circulations, Vinci, The Dragon's Trilogy, Needles and Opium* are good shows, but I wonder as I follow him, seeing since *Tectonic Plates* these frescos that last for hours, this 'work in progress' approach that he abuses: What does he mean, what is he telling us, what is this world that he shakes up like an air traffic controller? (*Liberté* 59)[iv]

What is Lepage trying to say? Is the best response to this what Lavender, Pluta, Carlson and Reinelt, and Marshall suggest: that Lepage's subject matter is the pervasiveness of change and the potential of transformation, to which he is an observer and a participant, evoking these phenomena in his work while not necessarily offering a comment on them? I believe this is a productive place to start, and I add to these observations that what Lepage communicates through his stage productions functions as much on the level of affect as it does through semiotic signification. As his statement above to Winters suggests, his signature does not work entirely on the level of the intellectual and thematic, and it is for this reason that he has been periodically discredited as being more preoccupied with scenography and stage trickery than ideas and arguments (see Billington 'Megaton', 'Lipsynch', 'Blue Dragon'; Lévesque, 'Trucs pour jouer'; Nightingale, 'Threads'). His prioritisation of affect and his insistence on seeing theatrical production as a form of play also contributes to his being perennially infantilised by commentators, as with the characterisation of him as a wunderkind well into his forties and fifties (see CBC Arts; Waugh 453). Beyond asking, as Lévesque does, what the work is about, I believe we need to ask how it works – and what this

iv 'Il est difficile de parler d'un artiste dont les spectacles sont si renommés et dont le nom est synonyme de réussite ... *Circulations, Vinci, La Trilogie des dragons, Les Aiguilles et l'Opium* sont de bons spectacles, mais je me demande, à le suivre, à voir depuis *Les Plaques tectoniques* ses fresques qui durent des heures, ces *work in progress* dont il abuse: que veut-il dire, que raconte-t-il, quel est ce monde qu'il agite comme un contrôleur aérien?'

combination of method and subject matter communicates about Lepage's perspective, and about the way many of us live now.

It is the contention of this book that Lepage's central, ongoing contribution to contemporary performance practices is his creation of productions that reflect spectators' privileged experiences of navigating contemporary globalisation. A further contention is that these productions reflect Lepage's own experience and render him a paradigmatic figure in the contemporary, globalised performing arts. I go on to further explore the concept and processes of globalisation in the following chapter, and as a working definition offer that of Malcolm Waters: globalisation is 'a social process in which the constraints of geography on economic, political, social, and cultural arrangements recede, in which people become increasingly aware that they are receding and in which people act accordingly' (5). Globalisation is a complex and much-debated phenomenon that is far from ideologically neutral. It is all about the breaking of boundaries – the circulation of goods, capital (in all its forms), bodies, ideas, and feelings around the world both literally and virtually at speeds unprecedented in human history. It is celebrated as a set of processes that are rendering the world and its communities more interconnected, creating a greater awareness of this connectedness, and offering unprecedented opportunities for contact with cultures and experiences other than one's own. While bringing new experiences, wealth, and pleasures to some, however, the benefits of globalisation are not shared equally; globalisation has reified divisions of class, status, and power among the world's populations. The increased movement of resources, ideas, and bodies under the conditions of globalisation is raising complex questions about responsibilities, affiliations, and ownership. Globalisation is having a profound effect on many creative practices, including theatre: it enables travel, contact, and exchange that reshapes understandings of differences and similarities between cultures and individuals; allows artists access to new stimuli and source material; and broadens the expectations and experiences of audiences. Again, however, such benefits are not available to all; they are an élite cadre of artists whose work circulates in the international network of festivals and venues which globalisation has fostered. The processes of globalisation are raising new challenges for theatre artists as they attempt to navigate questions of representation, intellectual and creative property, responsibility to others, intermediality, and embodiment through their practices. The question of how to maintain creative autonomy and the capacity for social and political critique has become a pressing concern for artists working within the arguably totalising conditions of global neoliberal capital.

Born in 1957, Lepage came of age in an era in which the flows of globalisation were increasingly affecting human experience and perceptions. All aspects of his career and creative practice have been shaped by globalisation: it is a primary life-world for him. The conditions of globalisation determine his lived reality, and the circumstances of his creativity and productivity frequently appear in his productions as subject matter and theme, and shape his formal approach. We see this reflected in his work in its consistent representation of travel and the experience of being between places, and in the repeated image of him suspended in mid-air on book covers and in promotional images (figure 0.1). This emphasis on motion and the state of betweenness is also reflected in his foregrounding of the process of making work as

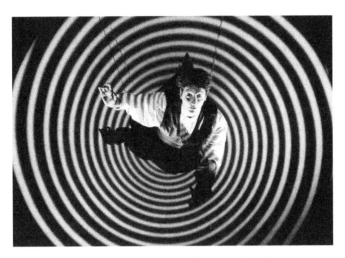

0.1 Robert Lepage in *Needles and Opium* (original version).

intrinsic to – perhaps even definitional of – its meanings. My goal here is to articulate globalisation not just as a complex and evolving set of processes but also as an affect, one that live performance has a particular capacity to produce. Lepage produces this affect by transposing cinematic techniques to live performance contexts, giving spectators the sensation of what John Tomlinson has named 'the paradigmatic experience of global modernity for most people ... staying in one place but experiencing the "dis-placement" that global modernity *brings to [us]*' (*Globalisation and Culture* 9, emphasis in original). Viewing Lepage's productions, at their most accomplished, offers this travelling-without-moving affect – the impression of space contracting and a familiar relationship between space and time being destabilised. He creates these effects by imbuing bodies and objects on stage with multiple significations which converge at key points: spectators experience a pleasing rush of sensations as they are challenged to hold onto and make sense of this profusion of signification. Making meaning of such moments feels *meaningful*, in the sense of being affectively rich (I go on in the chapters that follow to further parse this dual sense of 'meaning'). Again, Lepage's focus is the production of this affect by inviting engagement with the complexity of what is on stage, far more than with the significations that result from this engagement. I call this technique spatial montage, a terminology I explore in Chapters 3 and 4, which treat Lepage's transposition of cinematic techniques to the stage. Other scholars have drawn attention to this technique: James Reynolds, for example, calls it 'semiotic condensation' – moments on stage when an 'accumulation of meanings reaches saturation point' and 'becomes overwhelming and affective' (*Revolutions* 93). My argument, building on this, is that this sense of wonder stems from the chain of connections between what viewers see, the affect that comes from processing this, and their experiences of contemporary life, in which perceptions of the relationship between space and time are frequently destabilised and re-aligned.

These conceptualisations of semiotic condensation and spatial montage build on

and advance the key concept of *décalage* offered by James Bunzli in a 1999 article analysing Lepage's creative practice.[6] Drawing on Jeanne Bovet's earlier use of the term to explore Lepage's work, Bunzli defines *décalage* (French for 'gap' and part of the phrase '*décalage horaire*', or jet lag) as 'a concept that combines autobiography, coincidence, and paradox, and the performance moment' ('Geography' 84). The term resonates with Lepage's identity as a globetrotter: in order to maintain multiple international contracts, he travels very frequently and consistently navigates spatial and temporal displacement. Indeed, as Bunzli argues, part of the defining quality of Lepage's work is how it evokes such displacement in subject matter, form, and affect.

> For Robert Lepage, décalage is the main impulse, the principle [sic] mode of working, and a major result of his productions, both onstage and in the audience. It is an acknowledgment of gaps, indeterminacies; it is a way of working that trades on impulse, intuition, and broad creative freedom; it results in a theatre of simultaneity and juxtaposition in which actor, image, 'text', and audience are brought into a dialogue, a questioning, and an active co-constitutive role. (89)

Bunzli represents Lepage's career as an ongoing attempt to establish and maintain working conditions in which he can enjoy 'the freedom to work in whatever way he sees fit' (82). A central element of this way of working, which Lepage borrowed from formative years working with the Québec-based Théâtre Repère, is resistance to the concept of creative work ever being complete – the suggestion that 'process *is* product' (89, emphasis in original). The 'paradox and simultaneity' inherent in such an asserted equivalence 'are key engines in the practice of décalage', Bunzli argues (ibid.). Bunzli traces the first appearance of the concept of *décalage* to Lepage's early solo production *Vinci*, in which a character names things about Leonardo da Vinci that cause a 'strange feeling of décalage', including the fact that Leonardo 'could not bear … human suffering, and yet he invented war machines' (qtd in Bunzli 84). Other perceived paradoxes have been jumping-off points for Lepage's work: *The Seven Streams of the River Ota* grew out of his perception of contemporary Hiroshima as being full of sensuality, which was unexpected, given its associations with mass destruction (see MacAlpine 136); and *The Blue Dragon* is set in 'the effervescent paradox that is modern China' (Ex Machina 'The Blue Dragon'). The concept of paradox is clearly a key mode of thought for Lepage that allows him to keep multiple possibilities of meaning and relationship in play; it promotes complexity.

Such an account prompts questions, however, about representational, authorial, and corporate responsibility: pushed beyond its breaking point, a paradox becomes a contradiction. It is possible to argue that da Vinci's creation of war machines contradicted his otherwise pacifist ethics, and to use this as a basis to explore the question of whether the artist has an ethical responsibility towards the ways in which their creations are put to use. *River Ota*'s focus on paradox, in the view of critic Paul Taylor, resulted in a piece which offered 'a dream world that cannot be contradicted rather than an argument that can' and which raised 'alarming' questions about Lepage's apparent lack of misgiving about making art out of atrocity ('Paradox'). Among the aspects of contemporary Chinese society that feature in *The Blue Dragon* are women's reproductive rights, the rapid transformation of the country's urban centres

in preparation for global events such as the Beijing Olympics, marketisation, and art-forgery rings. While Melissa Poll finds the production's representation of China 'nuanced' (*Scenographic* 159), critic Peter Crawley argues that, by offering up various phenomena as evidence of the paradoxicality of today's China without exploring them in depth, *The Blue Dragon* 'reduce[s] China to reassuring preconceptions'.

And what of these gaps and indeterminacies that Lepage acknowledges through his way of working: does he skip over them, or examine what contents and meaning may already be located there? Gaps are not necessarily entirely empty; the indeterminate may not always remain so. Valorising incompletion, keeping things in motion, and committing to freedom above all else are also arguably strategies that allow Lepage to avoid acknowledging relationships to material, to collaborators, and to systems of identification and classification in which he is inevitably implicated. He frequently describes his productions as emerging independently and on their own terms: 'we often have the feeling,' he says in *Creating for the Stage*, 'that the play in its final form exists even before we begin to work' (Caux and Gilbert 31; see also 47, 51). Jen Harvie is critical of what she characterises as the ersatz postmodernism of Lepage's works which 'trivialise cultural specificity, both geographical and historical ... indulge the vague and nostalgic instead of documenting and interrogating the historically specific; and ... prioritise pleasure at the expense of achieving critique, deconstructive or otherwise' ('Robert Lepage' 229). In Ric Knowles's view, Lepage's foregrounding of process and audience response 'can tend simply to displace [Ex Machina]'s creative responsibilities for meaning production onto audiences with something resembling the familiar modernist shrug: my name is Robert Lepage, and I don't know what it's about' (*Reading* 44).

However seductive the assertion that process and product have the same value, this commitment to 'relentless indeterminacy' (Bunzli, 'Geography' 84) has also had significant material implications for producers, festival directors, and specta-tors, particularly in Lepage's mid-career period. Creating productions as they toured internationally over the span of many years sometimes resulted in early performances that were chaotic, messy, and incoherent. As I explore in Chapter 5, Lepage and Ex Machina's argument that this is a necessary part of the process and that audience feedback helps them understand and grow the work was hard to square with the pres-tige berths in international festivals in which these performances were presented, and the high ticket prices that came with this. Agreeing with Bunzli, then, that a defining aspect of Lepage's career has been the pursuit of conditions in which he can work on his own terms, the chapters that follow explore his ongoing efforts to do so, keeping in play the innovations in creative and production strategies that have resulted, as well as the ways in which Lepage's insistence on freedom affects those he works with and those who view his productions. While focused on Lepage, and specifically on his early- and mid-career original productions, this study treats themes and problematics that resonate with those of other artists and companies working today in the field of globalised performing arts: the relationship of globalisation to personal and national identities; the role of authorial signature in collaborative work; how artists reflect technological evolution and changes in human perception through their work; and the relationship between creativity and commodity under the conditions of neoliberal

capital. By exploring these themes I intend to open up understanding of the ways in which globalisation is affecting early twenty-first-century theatrical practices and industries more broadly, while identifying those aspects of his practice and experience that are particular to Lepage.

The next two chapters of the book are organised around key points of tension in the processes of globalisation and explore the two early-career original productions that established Lepage's reputation. These include, first, the relationship of the local to the global, which I explore in Chapter 1 through discussion of the breakthrough group-created piece, *The Dragon's Trilogy*, which toured from 1985 to 1992. Chapter 2 examines the place of individual subjectivity within global processes and flows, and focuses on Lepage's first major solo production, *Vinci* (1986–87). The following two chapters focus on Lepage's creative methodology, starting from the premise that modes of human perception and of creative production exist in dialectical relationship to each other, and, further, from Lev Manovich's assertion that 'cinematic modes of perception, of connecting time and space, of representing human memory, thinking, and emotion' underlie late twentieth- and early twenty-first-century ways of seeing the world (86). In Chapter 3 I introduce the cinematic paradigm through which I read Lepage's approach to dramaturgical construction and explore his increasingly adventurous use of techniques of spatial montage in works created in the late 1980s and 1990s: *Tectonic Plates*, *Polygraph*, and *Needles and Opium*. Chapter 4 explores the effects of these cinematic techniques, calling on affect theory and Jacques Rancière's theorisation of spectatorship, and delves into debates about rights of representation and cultural objectification in Lepage's work, with a particular focus on *River Ota*. In Chapter 5 I focus on Lepage and his collaborators' moves to adapt their producing structures in the context of the global performing arts festival network, drawing on Scott Lash and Celia Lury's analysis of the role of branding in the global culture industries (2007). Chapter 6 broaches questions of legacy and explores the ways in which Ex Machina both works within and attempts to withstand the neoliberal values of individualism, entrepreneurialism, and resistance to external regulation.

Throughout this study, Lepage himself appears and disappears as a central focus: he is the driver of all the creative practices discussed here; the source of much of the material treated in his productions, often their identified subject, and sometimes their performer; and the not-entirely-willing spokesperson for a particular approach to theatrical creation. Throughout, we see him resisting capture and classification in any number of discursive and organisational frameworks: national, gendered/sexual, professional/economic/neoliberal. In Chapter 7, as a coda, I offer four snapshots of Lepage in which, by design or by circumstance, he emerged from between layers of discourse and found himself exposed: three are moments of staging from his solo productions, while another is a period of controversy in the summer of 2018, when two of Lepage's productions, *Slàv* and *Kanata*, prompted interrelated and escalating debates about representation and cultural appropriation. All leave questions open about where Lepage and his work may head in the years to come.

In the remainder of this introduction I locate myself in this study and further introduce my methodological approach; place Lepage's original productions in the larger context of his creative work; offer an overview of existing research on Lepage;

and consider the contemporary reconceptualisation of the role of theatrical director and where Lepage fits within this, with specific attention to the evolution of the director-function in Québec.

My approach and methodology

My engagement with Lepage's work began in 1990, when I saw Théâtre Repère's production of *Tectonic Plates* at the Royal National Theatre in London, where I was living after graduating from university in California. I connected with the piece on the level of content – its story of young people drifting around Europe in search of inspiration and connection resonated with my own – but I was also struck by its form. So many of its elements were new to me and captivating, from its use of multiple languages (including semaphore signs) to convey meaning, to its multi-dimensional approach to scenography: chairs hanging from the flies of the Cottesloe Theatre formed part of the stage picture as I looked down from the balcony, and I'd never seen a show before in which actors walked through and performed whole scenes in a pool of water.[7] All of this created an atmosphere in which bodies and objects were constantly changing and transforming. A particular point of fascination was Lepage's cross-dressed performance as Jennifer McMann (figure 0.2): he played with subtlety and left the audience to fill in the emotional subtext, as I now know is his signature approach to acting. When I returned home to the United States, I wrote to Repère and asked them to send me anything that had been written about the company: a thin, letter-sized manilla envelope arrived, holding about twenty photocopied pages and a brief note from an administrator. I was surprised both that the company would respond to a random inquiry from a recent graduate and that so little had been written about work that seemed so important. In the summer of 1992, as I built a career as a theatre critic, I interviewed Lepage in advance of a run of his production *Needles and Opium* at the Brooklyn Academy of Music.

This began a productive artist–journalist relationship that resulted in me shadowing the creation of *The Seven Streams of the River Ota* from 1994 to 1996 and editing the production playscript for publication by Methuen. This editorial process involved working with assistant director Bruno Bazin and producer Michel Bernatchez to videotape and transcribe successive nights of performances at the 1996 Vienna Festival – at which the production was a headline event – because very little of the text was written down. I was also called on to update the production's English-language surtitles, because significant amounts of material changed in the days before and during the Vienna run. This was a disorienting and instructive experience, exposing a disconnect between the acclaim enjoyed by Lepage and Ex Machina and the playful, aleatory, and sometimes stressful behind-the-scenes realities. I wrote considerable thick description of staging and scenography in the playscript and was aware of the weight of this responsibility: these elements were central to the production's meaning-making but would not be captured in a script that included only spoken dialogue.

0.2 Robert Lepage as Jennifer McMann in *Tectonic Plates*.

Complex questions of authorship and authority circulated around this publishing process: Lepage is listed as one of thirteen authors in the playscript, and yet the production is widely referred to as the product of his singular vision and imagination. While the version we documented was intended to represent the culmination of the production's development, in fact *River Ota* entered another development phase in 1997, resulting in a revised staging that its creators came to consider the production's definitive version (I explore this process further in Chapter 5).

A proposed plan for me to publish a behind-the-scenes account of the making of *River Ota* never saw fruition, for a number of reasons, including the rightful scepticism of a number of the production's collaborators, who had reservations about a young Anglophone's capacity to capture their way of working (the rehearsal process was mostly conducted in Québécois French, which at that point I struggled to understand). Their concerns, as I understood them, went beyond language: the larger question was how anyone could perceive and describe all the elements, decisions, and

feelings in a creative process that spanned four years and grew to a production that was over seven hours long. I understand now that I was grappling for a methodology to document the making of theatre and performance which has since emerged as the field of rehearsal studies through the pioneering work of Gay McAuley (*Not Magic*, 'Emerging'), and which is also being explored through practices of embedded criticism, in which visitors (journalists, academics, artists, and/or students) observe rehearsal-room activities and write about them, usually in the serial form of a blog (see Costa 'The Critic as Insider'; Fricker 'Going Inside'; I further discuss the potentials of embedded criticism vis-à-vis Lepage's work in Chapter 5). The desire to make use of the knowledge, research, and questions I'd amassed about Lepage led me to the PhD programme in Drama and Theatre Studies at Trinity College, Dublin. My dissertation read a number of Lepage's early- and mid-career productions through post-colonial and psychoanalytic theory, exploring the relationship of his indeterminate personal identity to Québec's unresolved statehood. This volume draws on and is intended to contribute to the burgeoning application of theories of globalisation to theatre and performance practices, and also draws on theoretical and methodological approaches from cinema, affect, and queer studies.

An important methodological point – which connects to the larger theme of elusiveness I've established – is the process-based, iterative nature of Lepage's creativity. Calling on his training in collaborative creation (which I discuss in the following pages), Lepage built his early career and reputation through productions developed in successive iterations, in concert with audience feedback. This presents a challenge to researchers, particularly given that the scripts of early productions were not published. Visits to the Ex Machina archive (which has grown, since I first received that envelope with twenty pages in it, to a sophisticated multi-media resource with dedicated staff) allowed me to gather considerable documentation about these early- and mid-career productions, including reviews and other journalistic accounts; photographs and videos; and, in some instances, unpublished scripts.[8] I also call on live viewing of a number of the productions I write about here (*Tectonic Plates, Needles and Opium* [both versions], *Elsinore, The Seven Streams of the River Ota, Geometry of Miracles, Zulu Time, The Dragon's Trilogy* [revival version], *The Far Side of the Moon, The Andersen Project, Lipsynch, The Blue Dragon, Playing Cards: Spades and Hearts*, and *887*), and note my points of reference to each production which I discuss. My understanding of the productions is thus a result of reading and viewing all these materials with particular attention to the ways in which the productions developed and changed over time. Journalistic reviews of productions at various points on their trajectory formed an important part of this research process: while a review of a production of course reflects one person's perception, reading a number of reviews against each other offers insight into how significations may be differently understood in different contexts of presentation and reception. Journalistic sources such as interviews and preview articles are further useful in charting the ways in which Lepage frames his practices: he is skilful in suggesting ways of reading his work and shaping his public persona through engagement with the media, as I explore in particular in Chapter 5. My embrace of journalistic sources doubtless reflects my own professional affiliations: in the years during and since my doctoral studies I have continued to work as a

journalistic theatre critic as well as an academic, and occasionally engage with Lepage in that context (see Fricker 'Robert Lepage's show *88*').

My methodology thus takes on board the iteration-based nature of Lepage's method, in that I consider productions at various points in their development, as well as explore the implications of the work-in-progress model for the touring and reception of Lepage's shows. It is also important to underline at this point that while Lepage's creative signature is at the centre of his production and touring enterprise, he always works with others – performers, designers, dramaturgs, technicians, and producers – and resists ownership of his work, depicting it as collaborative, self-generating, and created largely via spectator interpretation. Part of my project here is to unpack Lepage's complex relationship to questions of authorship, while honouring the work of the many others who contributed to the productions discussed here.

Lepage's original stage productions in context

While making some reference to productions and professional developments since 2008, my discussion in this book focuses on Lepage's original works created before that time, because, in my view, an understanding of his contribution to theatre necessitates significant consideration of his early- and mid-career original stage productions, and because the scholarship as of yet lacks such an account bringing together formal, contextual, and reception-based approaches. It is important to underline that since the beginning of his career Lepage has directed existing works (plays and operas), as well as created original productions, and that his staging of canonical texts in particular helped to establish and extend his reputation. Since the founding of Ex Machina in 1994 the variety of his creative work has continued to expand to include dance, circus, and multimedia/technology-led forms (see Reynolds, *Revolutions* 3–4). I here provide a brief overview of his productions of existing texts and the way in which he and his collaborators have developed professional structures to allow him to work on in a variety of creative modes on self-determined terms.[9] Following the success of early original productions, including *The Dragon's Trilogy* and *Vinci*, Lepage accepted invitations to direct Shakespeare (*Le Songe d'une nuit d'été*, 1988) and Brecht (*La vie de Galilée*, 1989) at the Théâtre du Nouveau Monde, a leading Montréal theatre. These productions advanced Lepage's career by associating him with the cultural capital which those texts and that institution bring with them. Over the subsequent decade he moved back and forth between directing existing plays at mainstream theatres and creating and touring original productions. Between 1992 and 1995 he focused in particular – indeed, somewhat obsessively – on Shakespeare, directing twelve productions of Shakespeare's plays or works derived from them. These included *A Midsummer Night's Dream* at the National Theatre in London in 1992 (making him the first North American to direct Shakespeare at that institution); the Shakespeare Cycle, three plays (*Coriolan*, *Macbeth*, and *La Tempête*) translated and adapted by Michel Garneau (touring from 1992 to 1994); and *Elseneur/Elsinore*, a solo adaptation of *Hamlet* that was one of

Ex Machina's inaugural productions and toured internationally from 1995 to 1997. He gained 'notoriety as a radical director of Shakespeare' (Reynolds, *Revolutions* 14) for his approach, which always involved a significant intervention or hook – from the different levels of Québécois French in the Shakespeare Cycle; to the setting of *A Midsummer Night's Dream* in an on-stage mud pit; to the treatment of Shakespeare's text as but one element of *Elsinore*'s elaborate stagecraft. International opportunities to engage with Shakespeare included *Shakespeare's Rapid Eye Movement*, a collage of Shakespeare texts about dreams, at the Bayerisches Staatsschauspiel in Munich in 1993; and several productions at the Tokyo Globe Theatre (*Macbeth* and *The Tempest* in Japanese in 1993; the Michael Nyman-composed *Tempest* song cycle *Noises, Sounds, and Sweet Airs* in 1994). This intense concentration on Shakespeare was instructive for Lepage, Reynolds maintains, increasing his appreciation for complex texts that 'impose dynamic viewing' (*Revolutions* 15). In the 1992 programme for the Shakespeare Cycle, Lepage wrote that Shakespeare's plays are 'like sculptures, are multidimensional, and must be replayed … until every possible facet is discovered' (Théâtre Repère 'Lepage, Repère'). This focused engagement with Shakespeare ended abruptly in 1995, which is likely due to difficult experiences around *Elsinore*, including a devastatingly negative review by Robert Lévesque and the cancellation of an entire run of the show at the 1996 Edinburgh International Festival.[10] Save a 1998 French-language production of *La Tempête* (co-produced by Ex Machina, two Québec City theatres, and the National Arts Centre in Ottawa), Lepage would not engage with Shakespeare again until 2011, when he again directed *La Tempête* in French, this time in collaboration with the Huron-Wendat nation on the Wendake reserve outside of Québec City.

Lepage's other notable productions of classic texts include a 1994 staging of Strindberg's *Ett Drömspel* at the Royal Dramatic Theatre in Stockholm, and a 1998 Ex Machina–Royal Dramatic Theatre co-production of Fernando de Rojas's *La Celestina*, which Ex Machina subsequently revived in 2004 in a Spanish-language version co-produced with several theatres and festivals. Lepage's first foray into opera was a well-received 1992 double-bill of Bartók's *Bluebeard's Castle* and Schönberg's *Erwartung*, co-produced by the Canadian Opera Company and the Brooklyn Academy of Music. He has directed opera increasingly frequently in his mid- and mature-career periods, in Ex Machina co-productions with leading institutions including the Opéra National de Paris, London's Royal Opera House, the Théâtre Royal de la Monnaie in Brussels, and the Metropolitan Opera in New York. In the only volume-length study to date about Lepage's productions of extant texts, Melissa Poll argues that, despite Lepage's claims that there is no 'definitive process shaping his work' (*Scenographic* 23), he has a consistent approach, characterised by the use of 'scenography to reinvigorate and reconfigure existing works' (2).[11] This approach starts with the identification of a specific time and place as the 'interpretive axis' (24) around which he shapes the production; Poll calls this 'historical-spatial mapping' (3). Lepage's 1999 staging of *The Damnation of Faust*, for example, was inspired by 'the lush, romantic aesthetic' of the mid-1800s (25), when Berlioz wrote the piece, as well as by emergent nineteenth-century technologies, including photography and film (25–6). Building on such conceptual frameworks, Lepage then leads his design team in the creation of mobile scenography and encourages the cast to

develop embodied, physical scores for their performances (3): 'Lepage's strategy for adapting an extant text relies on the ways in which the set, sound, performers' bodies and text interrelate' (23). Through her research, which included rehearsal observation of Lepage's productions of *Siegfried* (2011) and *Götterdämmerung* (2012) at the Metropolitan Opera, Poll found that Lepage casts performers 'for their ability to author unique physical texts that are incorporated into the performance', and refers to these physical texts or scores as 'co-determined' by the performer and Lepage (33). She expresses concern that credit for the performers' contributions, which she classes as authorship, 'is often absent from Ex Machina's production materials' (ibid.) – a line of questioning that has arisen frequently around Lepage's work and which I address in Chapter 6 of this book.

 In the early phase of his career, it was largely the case that Lepage created original productions for his own company (understanding Théâtre Repère as such) and directed extant texts for other organisations. A key reason for forming Ex Machina, as Reynolds argues in *Robert Lepage/Ex Machina: Revolutions in Theatrical Space*, was to create a producing structure that could consolidate these activities. Institutional theatre systems, involving set rehearsal periods and timelines and with design processes happening alongside but separate from performer rehearsals, are not conducive to Lepage's preferred way of creating. At the same time, he is drawn to larger institutions: Reynolds recounts a formative encounter between Lepage and the revered Québécois playwright/director Jean-Pierre Ronfard while Lepage was still in theatre school. When the younger man asked Ronfard why he worked at major institutions when he was known as an experimentalist, Ronfard replied, as Lepage recalls, 'what is the use of [experiment] if you don't try and bring it into the mainstream?' (qtd in *Revolutions* 69). Lepage took Ronfard's words on board, making Ex Machina the conduit through which his particular way of working intersects with existing theatres and opera companies. Since its founding Ex Machina has co-produced all of Lepage's theatre and opera work: 'it has to happen in his house, with his conditions, with his crew, and costs and everything that goes with it', explains his frequent collaborator, dramaturg Peder Bjurman (qtd *Revolutions* 34). For the 2018 co-production of *Coriolanus*, for example, the Stratford Festival altered its repertory rehearsal system so that members of the acting company could travel to Québec City for two workshops and so that Lepage could rehearse the show in Stratford in concentrated blocks of time – a collaboration that took years of advance preparation and scheduling (*Revolutions* 70). As Reynolds argues and I further explore in Chapter 6, through such activity Lepage and Ex Machina destabilise and expand the conventions of mainstream theatrical production.

Lepage scholarship: an overview

As this account already suggests, scholarship about Lepage's work has been shaped by his particular approach to creativity. His own accounts of his life and creative

work are important primary sources: in these he resists articulating a methodology, gravitating rather towards an interview format mingling accounts of his personal/ professional experience and influences, commentary about Québec, and his observations of contemporary culture. Rémy Charest's book of interviews, *Quelques Zones de liberté* (1995, published in English in 1997 as *Connecting Flights*), covers Lepage's early career up to the advent of Ex Machina, while *Stéphan Bureau rencontre Robert Lepage* brings the narrative up to date at that point (2008) while delving deeper into Lepage's troubled childhood and adolescence.[12] Partly in response to the blossoming of scholarship about Lepage's work, Ex Machina published *Chantiers d'écriture scènique* (2007, published in English in 2009 as *Creating for the Stage*), an articulation from within the company of Lepage's approach to creativity.[13] He has also given a number of extended interviews published in scholarly anthologies (for example, McAlpine in Delgado and Heritage; Innes in Shetsova and Innes) in which he expounds on his inspirations and influences. Given his work-in-progress approach, rehearsal-room observation is a key tool for researchers, and Lepage welcomes such engagement to the extent that the position of observer has become an institutionalised part of Ex Machina's practice, informing work by many scholars, including myself.[14]

An early strain of scholarship that emerged in the 1990s focused on Lepage's creative methodology and adopted the position (following Lepage's lead) that it is so *sui generis* as to exist largely outside of other practices and cultural/social contexts; the work of Aleksandar Dundjerović falls into this category. While breaking ground as the first edited collection about Lepage's work, James I. Donohoe Jr. and Jane Koustas's *Theater sans frontiers: Essays on the Dramatic Universe of Robert Lepage* extended this tendency to represent Lepage's creativity as without precedent and context, as with the unproblematised assertion in their introduction that Lepage 'proposes theater beyond translation' that 'brings the audience to a space outside geography and cultural identity' (2). While a number of the essays in Donohoe and Koustas's book made a significant contribution to the emerging field, its mingling together of numerous theoretical and methodological approaches and discussions of various aspects of Lepage's creativity – original stage productions, opera, productions of Shakespeare, and film – with no internal organisation or meta-narration (the chapters appear in alphabetical order by their author's last name) contribute to the impression of Lepage studies being propelled by the chaos that Lepage so frequently remarks is central to his creative process.

Perhaps the most consistent seam of research on Lepage's work is that which focuses on his directorial approach, exploring the ways in which direction functions as a form of authorship. As I discuss further below, Irène Roy published the earliest substantive study of Lepage's theatre in 1993. Using an approach based in semiotics and linguistics, she argues that Lepage's work makes an important contribution to 'the evolution of contemporary theatricality' by privileging objects over words (12).[v] Lepage's stagings, Roy argues, open up a gap between what is presented and how to interpret it (which she likens to the Saussurean distance between *langue* and *parole*); the 'particular and dynamic agency of this variability [has the capacity] to engender

v 'l'évolution de la théâtralité contemporaine'.

something new' (61).[vi] Chantal Hébert and Irène Perelli-Contos have authored numerous publications (separately and together) exploring Lepage's contributions to a Québec tradition of *écriture scènique* (writing in space), while Dundjerović's several books and numerous articles focus on Lepage's creative approach. Doubtless because it is based on a well-known textual source, the *Hamlet* adaptation *Elsinore* has received more scholarly scrutiny than many other of Lepage's productions, including compelling accounts by M.J. Kidnie, Ric Knowles ('From Dream'), and Andy Lavender. A subset of the research on Lepage's direction-as-authorship focuses on intermediality. Ludovic Fouquet's book-length study, *The Visual Laboratory of Robert Lepage*, focuses on the adaptation and emulation of technological effects in Lepage's work, as do Dixon and Giesekam's studies already quoted. Dixon usefully suggests a historical continuum between Lepage's work and that of past stage innovators, including Svoboda and Piscator, while Gisekam places Lepage's work in dialogue with that of the Wooster Group, Forced Entertainment, and Station House Opera, among others. Piotr Woycicki persuasively argues for Lepage's place among stage directors and companies working in a post-cinematic mode, a line of thinking that dovetails with my own theorisation of spatial montage, while Pluta focuses on the relationship of the actor's body to technology in *The Andersen Project*, and Aristita I. Albacan's volume looks at the solo shows in particular.

Having made a significant contribution to studies exploring questions around responsibility, authorship, and body–object relationships in Lepage's stage work, Reynolds more recently turned to theorising Lepage's stagings of global mobility ('Hypermobility'), and with his volume *Robert Lepage/Ex Machina: Revolutions in Theatrical Space*, already mentioned above, provides an overview of Lepage's career from both creative and producing/business perspectives that was previously lacking in the scholarship. While the scope of my work here does not allow for a close consideration of Lepage's original stage works from 2008 onwards, Reynolds's volume covers this time period and includes a particularly detailed rehearsal-room observation of *Hearts* (2013), part of the four-part *Playing Cards* series of original productions that, at the time of writing, remains incomplete (see Chapter 6). Both Reynolds and Poll, in their volumes on Lepage's productions of existing plays and operas, draw attention to an important area of Lepage's practice that has emerged in the mature period of his career: revising and restaging his original works such as *The Dragon's Trilogy* and *Needles and Opium*. Poll calls these updated productions 'auto-adaptations' (151–80), while Reynolds adopts Lepage's own terminology and refers to them as 'upgrades' (*Revolutions*, 75–95).

Lepage and Québec

Another key area of Lepage studies focuses on the subject matter of his original productions, discussion of which brings us to the central place of his Québec back-

vi 'l'agencement particulier et dynamique de cette variabilité capable d'engendrer la nouveauté'.

ground and context in shaping his creativity and his outputs. From the mid-1990s to the early 2000s, a number of Anglophone scholars brought a critical focus onto Lepage's representations of cultures that are not his own. Christie Carson, Barbara Hodgdon, and Jen Harvie criticised what they argued was his appropriation and exotification of non-Western cultures and the identities and experience of non-Québécois collaborators. Their work was a key instigator of my PhD research, in which I explored the relationship of Lepage's treatment of difference and otherness in his stage work to cultural codes and precedents specific to Québec, working to understand the ways in which his background and environment shaped an approach to representation that struck (and continues to strike) many outside that context as problematic. Indeed, examining Lepage's relationship to his home culture has been a rich seam for researchers, including and beyond issues of representation. Harvie and Erin Hurley laid down a gauntlet in the award-winning article 'States of Play: Locating Québec in the Performances of Robert Lepage, Ex Machina, and the Cirque du Soleil' with their claim that 'in the guise of a vague cultural pluralism, [Ex Machina] is promoting a Western metropolitan elitism in pursuit of major and diverse commercial investment' (307). In response to Harvie and Hurley's argument that Lepage (and Cirque du Soleil) were exploiting Québec for 'start-up and infra-structure funding' and then disowning the nation in favour of 'corporate and aes-thetic identities that are homogeneous and unified' (314), I argued (see Fricker 'PRODUCT') that any current of exploitation between Québec and Lepage goes both ways. As part of its nation-building strategies from the 1980s into the 2000s, official Québec promoted its culture internationally through funding schemes and para-diplomacy, and a number of creative artists and companies including La La La Human Steps, Carbone 14, and Lepage benefited greatly from and contributed to these networks. In later writing Hurley characterises Lepage as one of a number of Québécois 'national stealth-figure[s]' (also including Cirque du Soleil and Céline Dion) 'whose work does not fit into the generally accepted criteria for inclusion in national theatre history' (*National* 14). Of these four criteria – ethnicity, geography, language, and aesthetic – Lepage meets only the first, being a 'francophone member of the dominant ethnic and linguistic group in Québec', but not the others, given that his productions travel extensively, are frequently multilingual, including 'languages not strongly associated with Québec', and are aesthetically resonant with practices of an international avant-garde, including the work of such high-profile figures as 'Robert Wilson, Ariane Mnouchkine, and Peter Brook' (14, 16).

It is tempting, given all this and in keeping with the argument I've established in this introduction, to classify Lepage's relationship to his home culture as ambiguous, and to explore the ways in which this might make him a representative Québécois subject. Jill MacDougall embraced such a conceptualisation in her 1997 volume *Performing Identities on the Stages of Québec*, which includes a study of Théâtre Repère's produc-tion *Tectonic Plates*. A key term for MacDougall is irony:

> Contemporary Québécois identity thrives on the ambivalent, slipping back and forth across imaginary borders between subjects, languages, and spaces. It is in this ironic gap, where the anxiety over collective identity meets its critical counterpart and where the

longing for wholeness clashes with the postmodern explosion of identity tropes that I wish to situate this [study]. (4)

MacDougall at times expresses frustration with Lepage and his collaborators' resistance to their work being tied down to any particular meaning or shape, but eventually identifies the 'maddening shifting of positions' in which they 'have both denied and confirmed the political nature of their work' as 'itself a political strategy' (193). Lepage's then-company Repère 'developed a subtle strategy of projecting Québécois difference by performing the problem of language itself' (ibid.), through a production which brings together multiple spoken and visual forms of expression to tell overlapping stories of characters in flux between national, gendered, and sexed identities. Lepage's aforementioned appearance in *Tectonic Plates* as Jennifer McMann, a transgendered Québécoise radio host working for Radio-Canada in New York, using standardised French which effaced her national identity, is central to MacDougall's analysis of the production as 'curiously representative of an imminently Québécois subject' (177). *Performing Identities on the Stages of Québec* holds an important place in studies of Lepage's stage work, thanks to MacDougall's exemplary use of rehearsal-room access and her location of *Tectonic Plates* in its cultural context; her work has contributed significantly to my understanding. I believe, however, that the paralleling of Lepage's shape-shifting identity with that of his nation can be only a partial approach: embracing it too fully might allow Lepage to disappear, again. Casting Lepage as representative (in his indeterminacy) of his indeterminate, stateless nation runs the risk inherent in all mimesis: that the subject disappears, consumed by the entity claiming equivalence with the subject – a position that is for Lepage a recognisable hiding place (I further explore questions of identity and mimesis in Chapter 4).

It is also important to hold up to scrutiny the close association of Québec, in the years in which Lepage emerged as an artist, with the qualities of 'uncertainty and doubt' (Schwartzwald, 'Chus' 51).[vii] The 1980s and 1990s were a period of ongoing and profound national self-questioning, as epitomised in the very close results of both referenda on Québec sovereignty – in 1980, 59.6 per cent of the voters voted no to the proposal that Québec pursue independence from the rest of Canada, while 50.6 per cent voted no in 1995. As debates raged in political, scholarly, and journalistic circles about the relationship of ethnic, linguistic, and cultural elements to the constitution of Québécois identity, some thinkers and artists argued that Québec should embrace such ambivalence as definitional and use it to shape a positive understanding of a diverse, hybrid society. In the argument of historian Jocelyn Létourneau, Québec culture is 'the product of a creative double tension between hybridities and lines of descent, on the one hand, and between centripetal forces (everything that tends towards a shared framework) and centrifugal forces (everything that tends towards diversification) on the other hand' (62). Similarly, the political philosopher Jocelyn Maclure argued that 'movement and *métissage* [cultural mixing] are integral to Québécois identity' (66) and characterised Québec as 'a plurivocal, dissensual community of conversation' (140–1).

vii 'l'incertitude et le doute'.

Such an understanding of Québec as inherently in motion and diverse grew out of its history – the complicated colonial situation of two settler cultures vying for rights and privileges on Indigenous land – and of successive waves of immigration and urbanisation. An influx of Italians in the 1940s and 1950s, Haitians in the 1960s and 1970s, Vietnamese in the late 1970s, and people of many other origins from the 1980s forward contributed to the creation of a 'multiethnic urban population' in Montréal (Ireland and Proulx 1), and to a lesser extent in the provincial capital (the presence of immigrant populations in Québec City was a central jumping-off point for Lepage's *The Dragon's Trilogy*, as I explore in Chapter 1). The question of how to interpret writing and other art forms emerging from this complex cultural landscape was a topic of considerable critical attention in the decades in which Lepage emerged as an artist. In the 1980s and 1990s Québec literature scholars widely adopted the term *écriture migrante* (writing in movement) to describe works that 'question[ed] paradigms of cultural identity' (Simon and Leahy 388) so as to avoid a binary distinction between work by 'Québécois *pur laine*' (people born in Québec, a terminology associated with ethnic nationalism) and by 'the other: migrant' (Phelps 85).[viii] This depiction of Québec as 'characterised by flux and hybridity' became so familiar as to be a 'critical reflex' (Hurley, *National* 112), as literary and cultural scholar Simon Harel argued in an important 2002 article, in which he insisted, contra Simon and Leahy, on a distinction between literature by members of 'cultural communities' – the distinctly Québécois descriptor of immigrant and/or minoritised groups – and 'migrant writing'. In Harel's view, writing by members of cultural communities anchors the author in relation to their 'social reality' whereas *écriture migrante* articulates 'a modification of the subject in the very movement of creation'. The overuse and imprecision of the terminology *écriture migrante* has 'become essentialist in its desire to eulogise, at all costs, a generalised deterritorialisation', argues Harel, evidence of a 'symptomatic malaise' in Québec around issues of identity (58 ff).[ix] The conceptualisation of Québec-as-ambivalence, then, is problematic, inasmuch as this classification can become a blind, eclipsing the complex realities of a population made up of various groups and individuals with multiple, often competing claims of belonging, difference, and minoritisation; and risks fetishising an abstracted claim of otherness as somehow definitional of being Québécois.

Theorising Lepage

Bringing other theoretical perspectives to bear on Lepage's work, while remaining attentive to the central and particular place of his socio-cultural and linguistic

viii 'l'autre: migrante'.
ix 'communautés culturelles … écriture migrante … réalité sociale … une modification du sujet dans le mouvement même de la création … me semble devenir essentialiste dans son désir de promouvoir à tout prix un éloge de la déterritorialisation généralisée … un malaise qui traduit l'état des lieux au Québec sur la question d'identité'.

background in shaping his creative practices, is useful in avoiding such a discursive collapse of artist into context. Bill Marshall's approach in his 2001 volume *Québec National Cinema*, for example, embraces this conception of Québec culture being never-fixed, always-emergent, and dialogic by reading its subject through a Deleuzo-Guattarian lens. The history of film in Québec, he argues, reflects '[t]he multiple, relational reality of Québec cultural identity', which 'means that to inhabit that cultural space is always to be becoming something else' (13). Marshall identifies the process of defining and re-defining the nation against changing contexts and realities – so central to Québec in this period – as a movement between terrorialisation ('the code of grounding') and deterritorialisation ('a process of decoding or unfixing'), and identifies Québec as a 'minor' culture vis-à-vis 'the vast North American and Canadian anglophone majority' and the language and culture of France (11, 12). This positioning, Marshall argues, affords Québec a 'capacity for proliferation and innovation (becoming)' and a resistance to 'the "major" culture's pretentions to the natural, normal, and universal' (13). Québécois artists are therefore particularly prepared to make work that resonates with audiences living under the conditions of globalisation – to 'carve out distinctive spaces' within the 'flows of postmodernity' (288). Significantly for this study, Robert Lepage emerges as Marshall's Deleuzian Québécois artist par excellence: an elegiac discussion of Lepage's 1995 film *Le Confessional* ends *Québec National Cinema*. While arguing that the difficulty of moving on from its troubled and indeterminate past is a familiar trope that has over-determined Québécois cultural representations, Marshall celebrates *Le Confessional* for presenting a 'potentially new conception of nation-time … that enables a revitalisation and problematisation of "our" perception of the present' (311). As already mentioned, Marshall argues that this is communicated through the film's central character, Pierre, and by productive ambiguities, including an open-ended ending in which Pierre carries his nephew on his shoulders as they cross the Pont de Québec on foot and 'the present opens on to a future that is contingent and open' (ibid.). Marshall's work helped to create a strong precedent of reading Lepage's films through Deleuze; indeed, Peter Dickinson calls a Deleuzian approach the 'dominant critical paradigm' ('Space' 133) in approaching Lepage's cinematic work. It is curious that this paradigm has barely been applied to Lepage's theatre, and in this book – particularly in Chapters 3 and 4 – I work to address that gap.

 Another notable absence in scholarship around Lepage's theatre is that of queer theory, which would seem a highly relevant tool, given his interest in all kinds of border crossings, transgression of norms, and resistances to categorisation (see Sedgwick 1993). The lack of queer readings of Lepage's stage productions can be attributed in part to his reticence around treating some aspects of his personal life and experience in his work. As I explore in Chapter 2, his childhood was marked by the onset of alopecia – total hair loss – which he discusses in interview with Bureau as a foundational trauma and one which made some people pity him, which he rejects: 'Pity, that's not a value, don't have pity, that's not good. People should have compassion' (2008, 65). He links this traumatic experience of embodiment to awakening awareness of his sexual identity:

When I understood also that I was homosexual, that too, that's a thing, you say: 'On top of all that, you find out that you're gay.' With that, you have the sense that you're in … So, you don't want that to become an important theme in your work, you don't want to identify with that, then pick up the gay flag. So you don't do that. And people say: 'Oh, OK, you're in the closet, you don't talk outright about your homosexuality, all of that.' But you do this because you don't want people, once again, to take you and categorise you. (65, ellipses in original)[x]

These statements provide an important vantage onto Lepage's resistance to definition, which he here equates with being reduced to identity markers which he understands as minoritised and inviting of condescending and dismissive responses. He offered a modified version of this position in an interview with the London *Times*'s Dominic Maxwell in 2008: asked whether he brought his difficult early experiences into his work, he replied, 'No, I never wanted to do that. I mean, there are so many gay shows. In Québec, all theatre was about coming out for a while, and I would just think: "Oh come on!" For me it was just something in my life, it wasn't a problem. I didn't feel I had to be a spokesperson.' Such a point of view is at some distance from the social movements advocating for acceptance, pride, and equality for LGBTQI+ peoples that emerged in the global North in the late twentieth and early twenty-first centuries, but Lepage underlines that, for him, being classified as a gay artist is limiting. He points to a visit to a video store where he found *Le Confessional* in the gay film section as a decisive moment in his thinking about these issues:

I didn't dare think that it's because I'm gay that they put my film in that section. I said to myself: 'Look, that doesn't make sense, it's not a film about that, that's not the theme of the film.' There's basically one character who's gay in it, but it's not a gay film … So, there are many things in my life, whether it's my childhood or it's this, that I don't share, that I don't talk about, not because I have shame, not because I want to hide them, not because it's bad, but people suddenly pity you, are politically correct with you. I avoid that. (66; see below for comment on the number of gay character/s in *Le Confessional*)[xi]

However distant he keeps himself from public association with his gay identity and gay causes, themes and expressions of gender and sexuality – including same-sex desire and eroticism – are frequently present in Lepage's productions and films. The fact that his work has rarely been treated in scholarship on gay and queer Québécois

x 'La pitié, c'est pas une valeur, faut pas avoir pitié, c'est pas bon. Faut avoir de la compassion… quand…' ai compris aussi que j'étais homosexuel, ça aussi, c'est une affaire, tu dis: "En plus de tout ça, tu découvres que t'es gai." Là, tu sens que tu es dans … Donc, là, tu veux pas que ça devienne un thème important dans ton travail, tu veux pas t'identifier, puis commencer à prendre le drapeau gai. Tu fais pas ça. Et les gens disaient: "Oh OK, tu es dans le placard, tu parles pas ouvertement da ton homosexualité, tout ça." Mais tu fais ça parce que tu veux pas que le monde, encore une fois, te prenne puis te catégorise.'

xi 'J'ai pas osé penser que c'est parce que je suis gai qu'ils avaient classé le film dans cette section. Je me dis: "Voyons, ça a pas rapport, c'est pas un film sur ça, c'est pas le thème du film." Il y a effectivement un personage qui est gai, là-dedans, mais c'est pas un film gai … Alors, ce sont toutes des choses dans ma vie, que ce soit mon enfance ou que ce soit ça, que je partage pas, dont je discoute pas, pas que j'en ai honte, pas que je veux le cacher, pas que ça fait mal, mais les gens, tout de suite, ont pitié de nous, sont *politically correct* avec nous. J'évite ça.'

and Canadian theatre is a measure of his success in avoiding such consideration, and is particularly notable given the strong tradition in Québec theatre of work by gay male writers including Michel Tremblay and Michel Marc Bouchard, for whom the intersection of sexual and national identities is frequent theme.[15] This connection has been much explored: as Charles Batson has noted, there is 'a veritable lineage of queer scholarship in Quebec' which connects 'the staged figure of the queer with a certain Québec, particularly one for which there are questions of *survivance* and of production of its differences' (Batson and Provencher 10).

Peter Dickinson's scholarship demonstrates the relevance of reading Lepage's films through the lens of queer theory and does important work in placing this analysis in the context of the particular conflation of the 'sexual symbolic and the national symbolic' in Québécois cinema. In *Le Confessional, Polygraph, Nô*, and *Possible Worlds* Dickinson identifies a consistent 'visual and narrative policing of the queer male body' in Lepage's films, which tend to adhere to the conventions of the 'thriller/mystery/detective story/whodunit/film noir' genres (*Screening* 131). Lepage, Dickinson argues, 'reproduces some of film noir's most entrenched clichés regarding gender and sexuality' and extends the homophobic trope, familiar from Québec film and other media representation, which equates 'that province's arrested development and English Canada's social dominance' with gay characters and same-sex desire (132). Dickinson identifies in *Le Confessional*, for example, an extended trope of overhead shots onto the body of Marc Lamontagne in states of emotional and physical distress. Such exposure occurs 'just before or after Marc receives crucial information about his family and about his own place within that sphere' and adds up to a 'policing of the queer male body as forever outside – *even when inside* – the bourgeois family' (137, emphasis in original).[16] While such imagery could perhaps be understood as a critique of heteronormativity, Dickinson finds it challenging to square the recurrence of such tropes across nearly all of Lepage's films, alongside plot and character points that link gay/queer lives with secrecy and guilt (*Polygraph*) and with frivolity and lack of socio-political agency (*Nô*). Dickinson's project is comparative, placing his analysis of Lepage's films against the stage works from which they are adapted or with which they are in intertextual dialogue.[17] Dickinson argues that these stage works are filled with 'all manner of queer characters and images of same-sex eroticism' (130) which is diluted and weighed down with 'overdetermined nationalist significations' when transposed to film (161). As my treatment of *Vinci* in Chapter 2 indicates, I locate more anxiety and ambiguity around queer themes and representations in Lepage's stage work than does Dickinson; in any event, it is hoped that this present discussion, alongside Dickinson's, might pave the way for more robust and sustained engagement with questions of queerness, nationality and other identity points in Lepage's stage work.

As will already be clear, questions of affect are central to my approach to Lepage's stage productions, and with this I address another gap in the scholarship. The focus of affect theory on all the ways in which '[t]he whole enterprise of theatre is geared to the perceiving body' (Hurley, *Theatre* 25) seems highly relevant to a corpus of work intended to generate feeling among audiences, and yet this approach has not yet been applied to Lepage's theatre (or, indeed, his films). Combining affect theory with the related work of Jacques Rancière on spectatorship allows me, in Chapter 4, to home

in on the effects of Lepage's signature moments of spatial montage – that is, to discuss the characteristic semiotic tropes in his work not only in terms of their formal composition but on how they work as 'feeling technologies', to borrow Hurley's terminology (*Theatre* 28). There is much more that can be done with these and other theoretical approaches to tease out the complexities of Lepage's work, and I hope that my use of them here may prompt further such explorations.

Lepage and the role of the theatre director

While Lepage has strategically worked to avoid classification and there is little scholarly consensus on how to approach his contribution as a theatre artist, it is nonetheless the case that he is frequently mentioned as one of the most important stage directors of his era. In many ways Lepage's professional identity corresponds to the role of the director as defined in the modern era – the 'single figure capable of harnessing and organising all the multiple crafts and codes that make up the theatrical experience' (Delgado and Rebellato 6) – but in others his practices resist such categorisation. This is a point of tension not just in Lepage's practice, but in fact draws attention to the changing understanding of Western theatre directing in the late twentieth and early twenty-first centuries – a function in which complex questions of creativity, authority, celebrity, and commodity converge. As Charlotte Canning argues, the standard history of stage direction features 'a focus on heroic figures' – nearly all male – 'whose towering genius had an enduring effect on theatre's practices even into the current moment' (50). Feminist and post-structuralist approaches such as Canning's set out to expose the 'discursive construction' (55) of the director as a 'disciplinary demonstration of power' (49). Lepage's approach to his work, and to the crafting of his public persona, can be read as an attempt to distance himself from this tradition of the star, *auteur* director and the power dynamics that come along with it. As previously noted, he resists being called a genius, and a repeated trope in interviews is the formulation 'I don't want to sound pretentious, but ...' – a verbal buffer through which he simultaneously disclaims and claims status and fame.[18] Lepage's resistance to the modern director function is further apparent in his working practices themselves, specifically in his use of collaborative creation techniques, his emphasis on process over product, and his claims of lack of authorial control over his work and its meanings – all of which follow larger tendencies in contemporary Western theatremaking, and which also reflect the specificity of his background and training in Québec.

The relationship of devising/collaborative creation techniques to director-led theatre has been explored in several recent studies which usefully problematise any 'binary opposition' between devised performance and text-based theatre (Radosavljević, *Theatre-Making* 62) and offer a usefully critical perspective on the assumed values and ideologies underlying devising practices.[19] In *Devising Performance: A Critical History*, Deirdre Heddon and Jane Milling offer an overview of devised theatre in the

United Kingdom, United States, and Australia from the 1960s to the early twenty-first century, while Duska Radosavljević, in two volumes published in 2013, explores devising as one of a number of interrelated contemporary theatremaking strategies. While Canada and Québec are not included in these accounts, many of the points made in them are applicable to Canadian and Québécois theatre traditions and contemporary practices (with some caveats and specifications which I note below). Devising had its heyday in the late 1960s and 1970s; working collaboratively rather than in traditional, hierarchical, director-led structures, and bypassing the system of authority that is the theatrical canon by creating original work from scratch, were ways in which some theatre workers participated in the counterculture movement. Among the 'early rhetoric' associated with devising practices was that they reflected the equal contribution of all members of a group to a creative process, and such work was regularly associated with 'freedom' (Heddon and Milling 4). Indeed the 'qualities frequently assumed to be implicit in devising ... give it an almost mythical status', argue Heddon and Milling; such qualities include:

> a social expression of non-hierarchal possibilities; a model of cooperative and non-hierarchal collaboration; an ensemble; a collective ... a de-commodification of art; a commitment to total community; a commitment to total art; the negating of the gap between art and life; the erasure of the gap between spectator and performer ... innovative; risky; inventive; spontaneous; experimental; non-literary. (4–5)

As they note, however, not all of these values were necessarily manifest in practice. For example, many companies using devising techniques were never non-hierarchal: among the prominent directors who worked 'within their ensembles or companies' include 'Judith Malina and Julian Beck, Joseph Chaikin, Richard Schechner, Liz LeCompte, Lin Hixon, Nancy Meckler, John Fox, Naftali Yavin, Hilary Westlake, Tim Etchells, and James Yarker' (5). In *The Contemporary Ensemble* Radosavljević similarly argues that 'there is ample historical evidence that a dominant leader has often been associated with ensemble, especially if training and group development formed part of the picture' (6). Her enumeration of such 'prominent leader[s] ... associated with an ensemble' includes Jerzy Grotowski, Ariane Mnouchkine, Eugenio Barba, Max Stafford-Clark, and Anne Bogart (5). Whatever associations that devising may have had with 'a particular political stance or creative methodology', it is now more accurate, Radosavljević argues, to consider devising as a term identifying 'an evolving performing arts sector in the United Kingdom not based on plays and playwriting' (*Theatre-Making* 60). Similarly, Alex Mermikides and Jackie Smart see devising practices as 'one of the major methodologies through which leading contemporary companies and practitioners create innovative work on an international scale' (4).

Lepage's approach to theatremaking, then, in which he serves as the leading figure and director of a collective practice, is not unusual, but in fact in sync with broader trends in twentieth- and twenty-first-century practices. The fact that he puts some distance between himself and the traditional profile of 'the director as visionary leader or author/auteur' is itself in keeping with a larger evolution in theatre practices which also includes, as Harvie enumerates,

scepticism about logocentrism, or the primacy of the word or text; in a related shift, a recognition that it is not only, or even principally, the playwright who creates a performance, but all those who contribute to theatre's multiple arts, including its performance, directing, and design; and a parallel recognition that the meanings of performance are produced not just by its 'backstage' and onstage makers, but also by its audience. ('Introduction' 3)

These characteristics and values are all present in Lepage's practice and his statements about it: the prioritisation of the visual and physical alongside if not above the textual; the distribution of theatrical authorship among multiple figures, including performers, directors, and designers; and the foregrounding of the spectator's role in theatrical meaning-making. All of this adds complexity to questions of authorship and authority in Lepage's practices, as I explore in Chapter 6.

Lepage's creative approach is also part of wider shifts in theatre and performance-making practices that reflect the influence of performance art and live art through a prioritisation of creative process over the creation of a polished final product. Such foregrounding of ongoing creativity over the end result can be understood both as a resistance to the commodification of art and as a critique of the idea that 'art can be posited (in Tracey Warr's words) as a fixed synopsis of the artist's intentions' (Mermikides 104). In so doing, such a way of working undercuts 'the principle underlying director's theatre': the 'Romantic notion' that the artwork represents the 'individual vision' of the creator (Mermikides 105). Inviting audiences to observe creativity in process underlines the extent to which each spectator brings her individual subjectivity and positionality to bear in making meaning out of the theatre event. In related innovations, postmodern practices such as those of the Wooster Group and the Builders Association critique the logocentrism of modern theatre by using existing plays as resources for creativity by cutting, reordering, and recontextualising material rather than presenting a play as a whole. Such irreverent treatment of theatre texts prompts awareness of the extent to which all theatre 'is involved in quotation or reiteration' (Schneider 293), be it of a canonical play, or of a set of activities established in a rehearsal process. In postmodern theatre practices a performance does not set out to mirror or imitate the world beyond the theatre, but, rather, questions the concept of reality itself, or, in more politicised practices, 'the "reality effects" of representational practices which ghost our habits of meaning-making' (ibid.). In such work, as Rebecca Schneider has argued, the work of the director can be understood as that of arranging a montage of cultural quotations and invented activities.

All of these currents – the relative mainstreaming of devising in contemporary theatre practices; the influence of live and performance art in centring process and spectatorship; and a postmodern awareness of theatrical creation as quotation and montage – contribute to shifting understandings of the work and authority of the director. In Maria Delgado and Dan Rebellato's estimation, contemporary theatre directors 'no longer aim to provide answers through their work but rather ask questions with which to provoke, surprise, and disarm an audience' (19), thus challenging the terms of evaluation which audiences and critics bring to all performances, be they experimental or traditional mise-en-scène. The notion of the 'death of the director' has been debated in continental Europe since the 1970s, but, in the view of

Patrice Pavis, the director (understood as the lone figure responsible for the mise-en-scène of an existing text) has not died, but in fact evolved into the 'neo-director', whose work tends to lack politics, avoid direct cultural and social reference, and offer no 'clear perspective, reflecting the world in which we live' ('Director's' 395, 397, 398). Such a description could usefully be applied to Lepage's stage work; while Pavis does not reference Lepage directly in this assessment, he had, seven years earlier, published an emotive reaction to the Ex Machina production *Zulu Time*, in which he decries the show for having 'crossed the limits' from a human spectacle into a technological one ('Afterword' 189), but allows that it nonetheless posed 'a challenge to aesthetics and to mise-en-scène' because it forced the audience to discern between what is 'foreseeable and mechanical' and what is 'unpredictable and human' (190). Such reconsiderations of the work of the director help to frame this study of a major theatre artist whose practices participate in – and have been questioned in terms of – the sharing of credit, responsibility, and authorship between star director and other collaborators; and who foregrounds creative process as something that gives his work value and liveness. A central tenet of my approach is to understand Lepage as a *montageur*, and the question of the extent to which his work engages critically with the postmodern realities it reflects is a central one, feeding into the 'what is he trying to say?' question that so troubles Robert Lévesque and, in a related way, troubles Pavis.

A related further set of questions has to do with the international artistic and cultural environment in which Lepage functions. The fact that star names such as Simon McBurney and Lepage rise out of avowedly collaborative practices is evidence not only of their approach to theatremaking but of a globalised network of production and circulation that requires – in fact, has produced – celebrity figures who function as brands in this particular niche of what Lash and Lury have identified as, following Adorno, the global culture industry. The star director's 'signature aesthetic' (Delgado and Rebellato 21) is that which gives him or her currency in this industry, even if this 'brand' may be 'cultivated by a team' (ibid.). Many of the moves in contemporary performance practices already outlined – the valorisation of process over product; the dispersal of authority via collective practices – can be read as attempts by theatre practitioners to resist or work around the overriding force of commodification bearing down on all aspects of contemporary life, including culture and the arts. Early twenty-first-century systems of neoliberal capital, however, have deftly adapted alongside creative practices in ways that now threaten to engulf or supersede them. As the focus of global systems of production shifted away from work that produces commodities and towards immaterial or affective labouring in which the outcomes, such as information and communication, are more conceptual than physically realised, it becomes increasingly difficult to consider creative practices as somehow different from or outside the marketplace (as if they ever were). In a related set of moves, governments and pundits celebrate the 'rise of human creativity as the defining feature of economic life' (Florida 15) and as 'the font of economic promise' (Ridout and Schneider 8) in the contemporary age. For Schneider and Nicholas Ridout, performance offers an ideal site for the contestation of this neoliberal appropriation of creativity inasmuch as the 'embodied balancing act of the live performer' (7) can be mobilised in resistant ways to critique the totalising logic of neoliberalism. It has also been argued,

however, that theatre and performance are perfectly suited to neoliberal conditions, given that they have always involved immaterial and affective labouring towards ephemeral outcomes. The challenge becomes, in Patricia Ybarra's words, to discover 'openings within neoliberal circuits of culture [that] can make critique possible – but from inside, rather than from outside its networks' (121). For Schneider and Ridout a means to this end could be a Brechtian deployment of affect 'in which a body producing affective engagement simultaneously critiques deployments of affective engagement in the neoliberal affect factory' – if indeed such a thing is possible: 'Can affect critique affect? Can complicity critique complicity?' (9). These, too, are apposite questions with which to frame a study of Lepage's work, given that questions have consistently been asked about whether a critical perspective is discernible in his work (prompting further questions about whether the presence or not of such a perspective should matter).

Alongside this broader framing of Lepage's work within shifting conceptions of contemporary theatre directing, it is also useful to place his practice specifically in the context of Québécois culture and theatrical practices. Understanding the relationship between Lepage and his particular milieu sheds light on the fundamentals of his approach, and also usefully complicates a tendency to describe him as exceptional when in fact he is part of an evolving tradition.

Lepage and Théâtre Repère

Through his training at the Conservatoire d'art dramatique de Québec and formative work with Théâtre Repère and Jacques Lessard, Lepage entered into a field of process-based, collective theatremaking that blossomed in Québec and Canada in the 1960s and 1970s, alongside similar practices throughout the West. As Alan Filewod has argued, part of the impetus behind the collective theatre movement was the 'desire' – in the spirit of the 1960s – to 'democratise' and render less hierarchical theatre processes 'which in the twentieth century placed increasing emphasis on the genius of the director as the interpreter of the text' ('Collective Creation'). Filewod notes a number of factors which converged in English Canada in the 1960s and contributed to what became known as the Canadian alternative theatre movement: an upsurge in nationalist feeling and a desire to articulate a Canadian theatrical voice distinct from the influences of Britain and the United States; newly available government funding; the maturing of a post-war generation eager to reject existing societal conventions; and a 'world-wide revival of experimental theatre' (*Collective Encounters* vii). A parallel yet distinct set of forces were at play in Québec, as a population 'alienated from every point of view' (Hébert, 'Sounding Board' 29) in terms of political, economic, social, and cultural autonomy experienced the period of rapid change, modernisation, and national self-realisation called the Quiet Revolution. As Chantal Hébert argues, 'committed political theatre, improvisation, and collective creation' were the main tenets of this new theatre movement in Québec, the means whereby artists and companies

questioned 'traditional values'; collective creation was a particularly powerful tool for an emergent women's theatre 'whose activity stood out as if in counterpoint to the political questions of the day' (31). The years 1968–78 are recognised as the 'golden age' of politically engaged collective creation in Québec (32), but the narrow failure of the 1980 referendum shifted the national mood and also prompted a shift in the focus of theatrical activity. While theatre continued to boom – in the five years after the referendum some forty-seven new companies were formed in Québec – and collective methods continued to be popular, energies moved away from work on national themes, to a questioning of theatrical norms and traditional theatre languages; the foregrounding of 'the figure of the artist' rather than the creation of 'family portraits'; and a focus outward, as young artists worked to insert themselves 'into the international scene' (37, 36). Lepage emerged as the representative figure of this period.

As argued, there is international precedent for a collective process to be led by a director, and the particular ways in which theatre culture developed in Québec provide further context for Lepage's such positioning. As Irène Roy has chronicled (76–7), the very rapid surge in development of theatre in Québec from the Quiet Revolution onwards, following many decades of relative stagnation, meant that the role of the director (as opposed to the textual author) as the central, determining factor in a work of theatre came into focus at the same time as the flourishing of collective methodologies. Thus, perhaps even more so than in the cultures treated in Heddon and Milling's *Devising Performance* and in Radosavljević's studies, collaborative theatre and so-called director's theatre were not distinct or oppositional movements in Québec but, rather, mingled ones. Accounts of the genesis and growth of Théâtre Repère further illuminate the specific circumstances in which Lepage emerged as a professional theatre artist and reveal that tensions around his status as an exceptional or star figure have existed since the earliest days of his career. These accounts include 'Dix ans de Repère' (Ten years of Repère), a dedicated issue of the Québec theatre journal *L'annuaire théâtrale*, in particular Hélène Beauchamp's chronological account of the company's first decade; Roy's analysis of Repère's working methods and culture; and Lepage's discussion of this period in *Connecting Flights* and *Creating for the Stage*. The basis of Théâtre Repère's work was the Repère cycles, a structured methodology for generating and shaping performance material which Jacques Lessard adapted from Laurence Halprin's RSVP Cycles.[20] Within Repère, as Roy describes, while all members of the ensembles 'were called upon' to use the Repère cycles, 'the director plays a primary role. It is he who leads the team, oversees the application of the process, sparks inspiration in everyone, and proceeds onto the organisation of the chosen material. Like a motor, he generates movement that he must then sustain through the stimulation of his presence' (32).[xii] In the spirit of collective creation, then, Repère was founded to facilitate group exploration of the Cycles and to use them to create theatre pieces, some wholly original, others drawing on classic texts. At the same time there was a structure of creative leadership within the organisation,

xii 'qui sont appelés … le metteur en scène joue un rôle primordial. C'est lui qui dirige l'équipe, voit
 à l'application du processus, suscite l'inspiration de chacun et procède à l'organisation du matériel
 choisi. À la façon d'un "moteur", il engendre un mouvement qu'il se doit de soutenir par sa présence
 stimulante.'

with Lessard as its founding artistic director; and its productions were spearheaded by directors, almost always Lessard or Lepage. As Beauchamp recounts, Repère's first ten years were varied and volatile, by the end of which the company had established a strong reputation in Québec for its structured approach to theatrical creativity, driven by Lessard's 'charisma' and 'generosity' and Lepage's 'immense creative energy' (53, 54).[xiii] Within the company there were growing tensions, however, about how to manage its productivity, and in particular what to do about the interest of domestic and international venues and festivals in productions directed by Lepage, including *Circulations, The Dragon's Trilogy*, and *Vinci*. While for Lepage the priority had 'shifted to touring our shows' (qtd in Charest 144), Lessard felt that '[t]he grants were too limited, the demand was too high, there were too many projects' (qtd in Beauchamp 51).[xiv] This led to a situation where, in essence, 'there were two Repères', one committed to international touring and the other 'involved in research and pedagogy' (Lepage qtd in Charest 144). Lepage left Repère in 1989 to take on the position of artistic director of French theatre at the National Arts Centre in Ottawa, clearly frustrated that Lessard's proposed establishment of 'two legitimate divisions' never took root institutionally (ibid.).

Many of Lessard's ideas became fundamental to Lepage's approach, for example the view that, in Lessard's words,

> The artist, in his creative act, should give precedence to emotions more than ideas ... Every human being has opinions. But these opinions are not the material of creation. Every opinion can be contested and every discussion based on the exchange of opinions will disappear when the moment to create arrives ... You can't contest emotions. ('Préface' 8)[xv]

Such a point of view is evident in Lepage's articulation, in a 1989 interview, why physical objects rather than ideas, themes, or concepts are preferable starting points (what in RSVP/Repère parlance are called resources) for creative projects:

> The survival of the artist ... that's a theme. If a group of actors get together and discuss it, we'll argue. The debate will become very intellectual. And in the end, the piece will be beige, because it depends only on the confrontation of ideas. A resource is something solid. A fried egg, for instance. If someone says that he sees in a fried egg something that has died so that someone else can live, I can't argue with that. It's a feeling. (qtd in Manguel 34)

Lepage is consistent in underlining the formative influence of Lessard's ideas and his time at Repère on his work, while acknowledging that in some ways he adapted the Repère principles, using them in a 'freer form' and more 'intuitively' than Lessard did (qtd in McAlpine 134). Given this relationship of influence, it is notable that the first sustained scholarly consideration of Repère's work – Roy's 1990 Master's thesis

xiii 'charisme ... générosité ... immense énergie créatrice'.
xiv 'Les subventions sont trop limitées, la demande trop forte, les projets trop nombreux.'
xv 'l'artiste, dans son acte de création, se devait de donner la préséance aux émotions plutôt qu'aux idées ... Tout être humain a des opinions. Mais ce ne sont pas les opinions qui sont les matériaux de la création. Toute opinion est contestable et toute discussion basée dur l'échange d'opinions est à fuir lorsque vient le moment de créer ... Les émotions, elles, ne peuvent se contester.'

at the Université Laval, published as a short volume in 1993 – side-lines Lessard's contribution as a director. Roy's study focuses exclusively on four of Lepage's productions, referring to Lessard as 'the creator of the Repère cycles' and Lepage as a 'director who uses this creative process' (31 ff).[xvi] This selective coverage of Repère's activity is particularly notable, given that Roy was a founding member of the company, along with Lessard, Michel Nadeau, Denis Bernard, Camil Bergeron, and Caroline Lepage (see Beauchamp). Through his application of Repère's principles, Roy argues, Lepage has 'overturned the mechanism by which theatre reproduces the world' and created a 'new language' of theatre in which objects rather than words are privileged as the 'primary discursive sign' (12, 13, 12).[xvii] By disrupting spectators' expectations and inviting them to process the relationship of different kinds of information (objects, bodies, sounds) in unexpected ways, Lepage's productions work on a connotative level that 'touches the emotional and sensory dimensions of the viewer while revealing to him a new vision of the world' (88).[xviii] By Roy's account, the magnitude of this contribution would seem to be such that it dwarfs or eclipses all other of Repère's activities and accomplishments (an account that Lessard himself endorses by contributing a preface to the published version of her research). As I discuss in Chapter 2, a similar claim that Lepage's work offers spectators new ways of looking at the world is made by Chantal Hébert and Irène Perelli-Contos in their 2001 volume La face cachée du théâtre de l'image. Hébert and Perelli-Contos wrote the book while they were professors in the faculty of literature at the Université Laval, where Roy too became a professor, forming something of a Laval school of Lepage studies. While drawing on and benefiting from this scholarship, I find it driven by a certain imperative to establish Lepage's singular contribution to contemporary artistic practice, in ways that, in Roy's case, lead to a limited account of application of the Repère principles across the company's work, and a foregrounding of Lepage's contribution to the extent that it occludes Lessard's. Such examples point to the complexity of the terrain of Lepage scholarship, and the importance of reading historical materials critically and against each other to clarify the influences on and trajectory of his career.

In this introduction I have established the key terms of reference for the chapters that follow, framing all of my comments in the context of Robert Lepage's resistance to categorisation, which I read as his professional, creative, and personal strategy to work and live on self-determined terms. I propose globalisation as an appropriate and usefully flexible framework within which to explore the development of his professional practice, and isolate one aspect of that practice – original productions created between 1984 and 2008 – as the focus of my discussion, while taking note of other creative activity in which he has been engaged then and since. My understanding of Lepage's work is informed by his own statements and by the writings of many other scholars and critics, which I introduce here both to provide readers with other potentially relevant references and to underline that I approach this book very much as an ongoing

xvi 'créateur des Cycles Repère ... metteur en scène qui utilise ce processus de création'.
xvii 'le genre théâtral est bouleversé dans ses mécanismes de reproduction du monde ... nouveau langage ... signe discursif premier'.
xviii 'toucher les dimensions émotives et sensorielles du spectateur tout en lui révélant une nouvelle vision du monde'.

dialogue – with Lepage's creativity, and with others who are fascinated and provoked by it. Lepage's successful strategies to avoid discursive capture have led to a dominant understanding of his work as defined by paradox, and, while acknowledging that this can be a productive approach, I also signal my intent to identify those points at which his work and the discourses around it present what I perceive to be contradictions. Underlining the subjective nature of such a perception is crucial: the 2018 controversies around *Slàv* and *Kanata* exposed the extent to which commentators' backgrounds and socio-cultural positioning shaped their response to those productions. This is, on the one hand, an obvious statement that could be made about any cultural interaction: where you're coming from determines what you perceive and how you respond. More specifically, the response to *Slàv* and *Kanata* revealed deep ideological divides around questions of cultural appropriation and creative freedom in Québec, the rest of Canada, and internationally that can be partially but not completely attributed to the differences between Anglophone and Francophone intellectual and cultural traditions. What some observers saw as contradictory and culturally tone-deaf actions and statements on Lepage's part, others saw as assertions of his artistic rights that were worth celebrating and championing. Understanding Lepage, then, needs to start with understanding his cultural milieu, and it is for that reason that I launch this study with the following chapter, which places his first group production to be a major international success, *The Dragon's Trilogy*, in the context of post-colonial Québec.

Notes

1 See Lavender; Fouquet *Visual*; Dundjerović; Knowles 'From Dream'; Hébert and Perelli-Contos *La face cachée*; Poll *Scenographic*; Reynolds *Revolutions*; Roy.
2 See Albacan, Dixon, Giesekam, Pluta, Woycicki.
3 See Bovet, MacDougall, Harvie and Hurley.
4 See Koustas *Robert Lepage*, 'Zulu Time'; Simon 'Robert Lepage', *Le trafic*.
5 See Carson; Harvie 'Transnationalism', 'Robert Lepage'; Hodgdon; Reynolds 'Acting', 'Authorial'.
6 In addition to *décalage* (a term also significant to Woycicki's analysis), the concepts and terms that scholars have used to analyse Lepage's stagecraft include *transformation* (Lavender; Hébert and Perelli-Contos *La face cachée*), *mediaphors* (Pluta), *technological echoes* (Fouquet *Visual*), *past-present effects* (Dundjerović), *scenographic dramaturgy* (Poll *Scenographic*), *simultaneity* and *the uncanny* (Reynolds 'Acting', 'Authorial', 'Hypermobility'), and *suspension* and *the extratemporal* (Dixon).
7 The Cottesloe was renamed the Dorfman in 2013.
8 Lepage's practices around documentation have shifted as his career has developed. Early resistance to capturing the work in the form of published scripts has eroded, and Ex Machina now sometimes authorises publication of its playscripts, working with the Québec City-based publisher L'instant scène. I explore these publishing practices further in Chapter 6.
9 A chronology of Lepage's productions (both original and of extant texts), along with his other creative work, appears as an Appendix to this volume and supplements this overview.
10 According to Reynolds, who interviewed Lepage on the subject, 'the negative experience of *Elsinore*' prompted him to stop acting and to step back 'somewhat from classical

drama' (*Revolutions* 3). The production's world premiere in November 1995 at Montréal's Monument National received profoundly mixed reviews: while *La Presse*'s Jean Beaunoyer raved about the production as a 'great moment of theatre' (un grand moment de théâtre) and complimented Lepage's acting in particular, *Le Devoir*'s Lévesque called the show superficial, narcissistic, and obsessed with technology and stage trickery at the expense of engagement with the text ('Trucs pour jouer'). Lévesque berated Lepage's performance in particular: 'What's really surprising about this heartbreaking failure is the weakness of Lepage's acting' (Ce qui étonne dans cet échec navrant c'est la faiblesse du comédien Lepage). Lepage and Ex Machina received another round of negative press when the show was cancelled in Edinburgh as a result of 'equipment failure' (Hannan and McNeil) – one of the motors that powered the moving stage 'malfuctioned' (Glaister). Writing in 2003, the *Guardian*'s Michael Billington called that 1996 non-event one of the 'great theatrical disasters' of our time, because audience expectations were very high and the cancellation happened at the last minute ('The show must float on').

11 I co-supervised, with Helen Gilbert, Poll's doctoral research about Lepage's productions of existing plays and operas at Royal Holloway, University of London between 2009–14.

12 As I neared completion of this manuscript, a new book of interviews by Ludovic Fouquet titled *Robert Lepage* was published by Actes Sud.

13 One of the book's authors, Patrick Caux, was a journalist who subsequently became Lepage's personal assistant; the other, Bernard Gilbert, was at the time the director of opera production for Ex Machina, and in 2017 became director general of Le Diamant.

14 Aleksandar Dundjerović, Benjamin Knapton, Andy Lavender, Jill MacDougall, Melissa Poll, and James Reynolds are among the other scholars who have been rehearsal-room observers of Ex Machina productions and co-productions. The dramaturg Lise Ann Johnson's account of the creation of *Shakespeare Rapid Eye Movement* is also a valuable part of this corpus, written by someone directly involved in a production.

15 The 2018 collection *Q2Q: Queer Canadian Theatre and Performance* does not include discussion of Lepage's work. Rosalind Kerr's 2007 collection *Queer Theatre in Canada* includes a reprint of Reid Gilbert's '"That's Why I Go to the Gym": Sexual Identity and the Body of the Male Performer', originally published in *Theatre Journal* 46 (4), in which Gilbert includes Lepage's *Polygraph* in a Lacanian exploration of the relationship between embodiment and sexual identity in three plays by gay men. André Loiselle, in *Stage Bound: Feature Film Adaptations of Canadian and Québécois Drama*, and Dickinson, in *Screening Gender, Framing Genre*, treat Lepage's adaptation of *Polygraph* from stage to screen. Both are critical of what they argue are homophobic elements of the theatre piece and the film. Sylvain Duguay briefly discusses queer aspects of the stage version of *The Far Side of the Moon* in a 2012 chapter about stage-to-film adaptations. These are, to my knowledge, the only significant published engagements with gay/queer themes and representations in Lepage's theatre.

16 In Dickinson's reading, *Le Confessional* has 'two queer characters' (135): Massicotte and Marc. The former (played as a young man by Normand Daneau and an older one by Jean-Louis Millette) is a priest who leaves the church and becomes a powerful diplomat, while the latter (Patrick Goyette) works as a male prostitute, with Massicotte as a regular client. The film charts the complexities of the Massicotte/Marc relationship: the older man knows the central secret of Marc's parentage, and Marc commits suicide after Massicotte tells him who his father was. By contrast, as noted above, Lepage asserts there is 'basically one' gay character in the film, presumably referring to Massicotte. Marc had previously been in a relationship with Manon, an exotic dancer played by Anne-Marie Cadieux, and they have a young son. If Lepage's comment implies that Marc is a straight man who turns tricks

with men to make a living, this offers a different, but still abjected, portrayal of sex between men than that which Dickinson sees in the film. It is a portrayal which also potentially supports Martin Lefebvre's reading of *Le Confessional* as a national allegory, in which Marc, representing Québec in a state of 'permanent identity crisis ... allows himself to fall back into a homosexual relationship' (Dickinson 132) with a figure representing English Canada (Massicotte is a federal diplomat). As do Schwartzwald ('"Symbolic" homosexuality') and Marshall, Dickinson critiques the 'homophobic presuppositions underpinning' such readings of Québec films, including *Le Confessional* (ibid.).

17 *Le Confessional* involves characters from *The Dragon's Trilogy* and *The Seven Streams of the River Ota*, while *Nô* extends one of the seven sections of *River Ota*. *Polygraph* and *La face cachée de la lune* are adaptations of plays of the same names. Dickinson's chapter also treats *Possible Worlds*, a film directed by Lepage with a screenplay by John Mighton based on Mighton's 1992 play.

18 In 1995, Lepage told Brian D. Johnson in *MacLean's* that 'I don't want to sound pretentious ... but I get offers from every opera house in the world' ('The Visionary' 60). In December 2001, referring to the seeming prescience of the show *Zulu Time* in its depiction of airborne terrorism, he said to the *Advocate*'s Matthew Hays: 'I don't want to sound pretentious or anything ... But you know, our company, when we immerse ourselves in new work, sometimes things like this happen.' Chapter 5 notes Lepage using this formulation at a 1998 press conference at the world premiere of *Geometry of Miracles* (see pp. 166–9). In 2017, discussing the legacy of his work, he told me in an interview for the *Toronto Star* that 'I don't want to sound pretentious, but I am way beyond the point where you want to be recognised' ('Robert Lepage's show *887*').

19 *Devising* is the favoured term in the United Kingdom for what is generally called *collaborative creation* and *création collective* in the North American context. While the terminology signals some differences in emphasis – devising 'does not insist on more than one participant' (2), while collective creation 'more clearly emphasises the origination or bringing into existence, of material *ex nihilo*' (3) – Heddon and Milling use both terms to describe 'a mode of work in which *no* script – neither written play-text nor performance score – exists prior to the work's creation by the company' (3, emphasis in original). I use the terms as synonyms here.

20 As Lessard explained to Philippe Soldevila in an interview published in 1989, he went to California in 1978 feeling 'fed up with collective creation' (ras-le-bol de la creation collective; 32) and looking for new ideas. Studying movement with Anna Halprin, he encountered her husband, Laurence, an architect, who was writing a book called *The R.S.V.P. Cycles*, which articulated 'a way to create architectural environments respecting their inhabitants and nature. It was a sort of creative cycle – a tool – which put all the elements of creation in perspective' (une façon de créer des environnements architecturaux respectueux des habitants et de la nature. Il s'agissait donc d'une espèce de cycle de création – d'un outil – qui mettait en perspective tous les éléments de la création; 32). Lessard adapted the RSVP Cycles' four-step approach – resources, scoring, valuation, and performance – to the context of theatrical creation.

1

Local, global, universal? *The Dragon's Trilogy*

Québec is multiple, it is in the global village, and not just in the francophonie. It has to be part of the world! My nationalist act is to make theatre here and abroad, with my roots and my languages, my history. (qtd in Lévesque 'Archange')[i]

Robert Lepage made this statement in 1992, less than a decade after his international reputation was launched with the touring success of the epic group production *La Trilogie des dragons/ The Dragon's Trilogy* and the solo show *Vinci*. While affirming the central place of his own culture to his artistic practice, he makes clear that his vision for his career involves working abroad as well as in Québec, and underlines that working internationally will have positive effects not just for him but for his nation. In affirming a dialectical relationship between the local and global in his creative practice, Lepage echoes one of the earliest and most influential social science definitions of globalisation, by Anthony Giddens: 'the intensification of world-wide social relations which link distinct localities in such a way that local happenings are shaped by events occurring many miles away and vice versa' (64).[1] Crucially, as David Held and Anthony McGrew argue, the pole of the local does not drop away under the conditions of globalisation; rather, 'the local becomes embedded within more expansive sets of interregional relations and networks of power' (3). As John Tomlinson points out, however, the general account of the effects of globalisation on local cultural identities has been highly 'pessimistic':

> Globalisation, so the story goes, has swept like a flood tide through the world's diverse cultures, destroying stable localities, displacing peoples, bringing a market-driven, 'branded' homogenisation of cultural experience, thus obliterating the differences between

i 'Le Québec est multiple, il est dans le village global et pas seulement dans la francophonie, il doit faire partie du monde! Mon acte nationaliste est de faire du théâtre ici et ailleurs, avec mes racines et mes langues, mon histoire.'

locality-defined cultures which had constituted our identities. ('Globalisation and Cultural Identity' 269)

Following Manuel Castells, Tomlinson proffers a counter-narrative: that, rather than being razed down by globalisation, localities have responded by asserting their cultural identities; thus local identities have been *produced* by globalisation, rather than destroyed by it, though this local resistance can often be 'multi-form, disorganised, and sometimes politically reactionary' (270). It is therefore useful to think of the relationship between local and globalised cultural identities as dialogic: 'a matter of the *interplay* of an institutional–technological impetus towards globality with counterpoised "localised" forces' (ibid., emphasis in original).

Québec stands as evidence of this understanding of the processes of globalisation being productive of cultural identity, and of cultural identity as an ongoing dialogue between local and globalising forces. A nationalist movement emerged in Québec in the 1960s, concurrent with the rise of nationalism in Anglo-Canada and some African and Caribbean countries, and with the early swell of economic, technological, and cultural aspects of late-capitalist globalisation that would coalesce in the 1980s and 1990s. While using the language of colonisation to refer to Québec is contentious, for reasons which I will go on to explore, it is my assertion that the interplay between nationalism, decolonisation, and globalisation shaped Québec's political, economic, and cultural life from the 1960s forward. Internationalism, always an important part of the Québec national project, became a particular focus of its cultural production and cultural affairs in the mid-1980s as the project for political sovereignty lulled, and other avenues for national promotion took the spotlight. As a gifted, restless artist with a particular interest in travel and cultures foreign to him, Lepage emerged at the perfect time to benefit from and feed this move towards internationalisation in Québec culture, and his career provides a revealing case study of the complexities of the negotiation of the relationship between the local and the global.

In this chapter I explore these complexities via a close examination of *The Dragon's Trilogy*, the show that helped to jump-start Lepage's international career. Patrick Lonergan has argued that a key characteristic of globalised theatre is its capacity to be received reflexively; that is, it allows its audience 'to relate the action to their own preoccupations and interests, as those preoccupations and interests are determined locally' (87). This discussion of *The Dragon's Trilogy* allows us to nuance Lonergan's formulation and begin to identify a characteristic aspect of Lepage's work – the juxtaposition of culturally specific material with material to which a broad spectrum of audience members can relate reflexively.[2] *The Dragon's Trilogy* and its reception are reflective not just of Québec's internationalism in the 1980s but of another concern then at the foreground of national discourses: the negotiation of cultural diversity, as Québec attempted to balance the ongoing quest for national self-articulation with the presence of migrants from various linguistic and ethnic backgrounds, and with its existing Anglophone and Indigenous populations. The production reflected this in its story of an extended Francophone Québécois family's encounters with immigrants to Canada and its movement across the country and eventually abroad, a tale that spanned most of the twentieth century.

The Dragon's Trilogy is a transitional piece in Lepage's career, in that it was made to be performed in Québec and Canada; its further international success was unexpected.[3] Thus it was Lepage's first piece of theatre to *become* globalised, in terms of circulation and reception; and differences in the ways the piece was understood in local, Canadian, and international markets are striking. Domestically, the piece was read and celebrated as an allegory of Québec's national self-realisation and opening up to difference, and as reflective of newly international understandings of national identity in the 1980s. In international markets, and even in Canadian ones, by contrast, the extent to which it was a self-portrait – and self-critique – of evolving Québécois national identity was hardly legible. Rather, what were praised consistently about the production were the innovative aspects of Lepage's stagecraft, which gave the impression of moments from the past overlapping with the present and of distant lives connecting. These effects had a powerful impact on privileged international audiences because they simulate and echo some of the experience of globalisation. This capacity to deliver feeling-global affects has become one of the keys to Lepage's international success, but it carries risks of sacrificing specific meanings for universal ones, and of potential misunderstanding when these powerful affects are delivered via culturally specific material. We see this in the differing responses to *The Dragon's Trilogy*'s depiction of early twentieth-century Québec as a racist place, 'stamped with xenophobia' (Camerlain 87):[ii] while understood locally as self-critical, commentators outside the province in some cases lacked the context in which to interpret this representation as critique. This chapter offers a reading of *The Dragon's Trilogy* as the articulation of a rapidly decolonising and globalising culture. I dwell at some length on the Québec context because, as his career has progressed, study of Lepage's work has focused on the meanings it makes in international locations. What has been less explored is the extent to which some of his work has been appreciated locally – indeed, in the case of *The Dragon's Trilogy*, revered – for its capacity to capture and reflect the national zeitgeist, and to offer grounded socio-cultural critique.

Québec, nationalism, globalisation[4]

France was the first settler nation of Canada, and a distinct French-Canadian culture developed in eastern Canada from the seventeenth century. In the Treaty of Paris in 1763, following the Seven Years' War, France relinquished any claim on Canadian lands and Britain became the official ruler of Canada, but tolerantly allowed French to remain the official language and Catholicism the official religion of the area Québec now occupies. The 1841 British Act of Union bringing together Upper Canada (Ontario) and Lower Canada (Québec) was opposed by many in the latter region, creating a growing solidarity among French Canadians. The Catholic Church took a leadership role in Lower Canada, facilitating the development of what is widely

ii 'empreinte de xénophobie'.

understood to have been a highly religious, conservative, rural, anti-statist, and some-what xenophobic culture.[5] In the mid-twentieth century Québec became increasingly modernised and secularised, in part due to the leadership of Premier Maurice Duplessis, who held office from 1936 to 1939 and from 1944 to 1959. While Duplessis was conservative and isolationist (his time in office is known as *la grande noirceur* – the great darkness), the strength of his leadership had the effect of loosening the hold of the Catholic Church over education, public services, and the worldview of the Québécois people. The introduction of television in Québec and Canada in 1952 also played its part.[6] University-based intellectuals began to question the 'clericalism, conservatism, and insularism of Québec society', while the urban working class started to exhibit scepticism about the limitations of traditional Québec values (Dickinson and Young 297). The death of Duplessis in 1959 and the subsequent election of Jean Lesage's Liberal Party to provincial leadership in 1960 galvanised these growing dissidences into the decade of nation-building activity called the Quiet Revolution. In order for the Québécois to become *maîtres chez nous* (masters in our own house), Lesage advocated the continuing empowerment of the Québec state so that it could take control of its economic, political, and cultural affairs.

These internal factors worked together with external ones in triggering Québec's national consolidation. An important early outside stimulus was the emergence of Anglo-Canadian nationalism in the face of the increasing economic and cultural domination of North America by the United States. Following on from the publication of the federal Massey Report in 1951, which recommended sweeping cultural reforms to assure Canada's continuing development as a country with a strong and independent identity, Québec set up its own Royal Commission of Inquiry into Constitutional Problems, known as the Tremblay Commission, in 1953. The report that resulted was a dense and somewhat contradictory document that at once re-endorsed traditional Catholic values and called for modernisation. Another element of the Tremblay Report was the definition of culture in a Québec context as national culture, which was 'taken as an absolute value' (Handler 91). As its most obvious distinguishing characteristic, the French language became, for nationalists, the primary signifier of Québec identity, and ensuring that French would continue to be the legal language of the province became a focus of the nationalist movement. Artists and writers played a key role in the creation of strong national feeling during the Quiet Revolution. Through their work, novelists (Herbert Aquin, Jacques Godbout), *chansonniers* (Felix Leclerc, Gilles Vigneault), essayists (Pierre Vallières), and playwrights (Michel Tremblay) – all working in French – described or argued for the vibrant existence of a unique and valuable culture where, it had long been asserted, none existed.

Another factor contributing to the Québec nationalist movement was 'an influx of "third language" migrants anxious, in a globalised world, to learn the *lingua anglia*' (Waters 194). Canada and Québec were the recipients of many immigrants in the immediate post-war years and, while immigration slowed in the 1960s and 1970s (Dickinson and Young 310–12), the presence of new populations became a central concern of official Québec, as new arrivals tended to assimilate into Anglophone culture. In response, Québec created a Ministry of Immigration in 1968, whose budget was to grow from \$2.8 million to \$20 million over the next ten years and which worked

to assimilate immigrants through programmes of 'language acquisition and cultural adaptation' (Gagnon and Iacovino 374). While the other Canadian provinces have since developed their own immigration policies, Québec remains the province with the most control over selecting and educating its immigrants. Assuring that French remains the only official language of the province and the language of common usage has been one of the most controversial aspects of Québec government policy. The Charter of the French Language or Bill 101, which the sovereigntist Parti Québécois enacted a year after it took power in 1976, requires immigrants to send their children to French-language schools, businesses with more than fifty employees to be run in French, and commercial signs to be in French. Many Anglophones saw the Bill as a hindrance to their liberties and left the province after it was passed, but it has remained policy ever since and is regarded by many to have played a central role in keeping French the majority language in Québec.[7]

Internationalism figured centrally in the development and promotion of a Québécois political, economic, social, and cultural sphere distinct from the rest of Canada. Québec's leaders initially built on its relationships with the United States, France, and the Francophonie, and developed a sophisticated para-diplomatic network to promote Québec's political interests, trading relationships, and cultural dissemination worldwide.[8] Interaction with established nations, it was believed, would enhance the legitimacy of Québec's own image (Keating 125). The success of this has been striking: Québec has become 'one of the most politically powerful subnational units of government in the world', according to political scientist Jody Neathery-Castro and sociologist Mark Rousseau (464). Québec played a primary role in promoting both the Canada–United States Free Trade Agreement (1989) and the North American Free Trade Agreement (NAFTA, 1994), and was the only Canadian province to vote in favour of NAFTA. This support of NAFTA revealed 'a very practical duality' in the cultural identity of a younger generation of Québécois at the time NAFTA was signed, according to James Csipak and Lise Héroux: '[O]n the one hand, economic liberalism is perceived in a very positive way, but on the other hand, strong cultural identity as expressed by Québec's nationalism manages economic liberalism, and not the other way round' (41). Indeed, another important aspect of economic globalisation is the extent to which it dovetailed with nationalist goals. Building up Québec as a powerful economic entity with strong international trading relationships was an observable strategy of the Parti Québécois. Political scientist Stéphane Paquin argues that Québec's global economic success was beneficial for the sovereigntist cause, by helping to convince Québécois and others that there was a 'decrease in risks associated with Québec independence' because Québec had become less dependent on the Canadian domestic market (190).[iii]

Closely aligned with Québec's policies on international relations, language, and the economy is its highly developed cultural policy. The newly elected Québec Liberal Party created the Ministère des Affaires Culturelles (MAC) in 1961, only ten years after the formation of its federal equivalent, the Canada Council for the Arts. In the Québec vision of cultural affairs, the state was to promote actively not only the crea-

iii 'les coûts du passage à l'indépendance diminuent sensiblement'.

tion of cultural products but their promotion outside the province. The Conseil des Arts (Arts Council), an arm of the MAC, was created, in then-Premier Jean Lesage's words, to 'try to stimulate artistic expressions which bear a seal, a sign, a trademark, which calls the world's attention to them as products of Québec' (qtd in Handler 106). Lesage's articulation underlines the interlinked ideals of nationalism and internationalism: the more that cultural emanation is capable of 'calling the world's attention' to itself, the more it is celebrated, at official levels, as representative of the nation. We see this thinking indicated in the eclectic group of artists whose names were included in a brochure co-created by the MAC in 2001, including Denys Arcand, Cirque du Soleil, Leonard Cohen, Céline Dion, Marc-André Hamelin, and Robert Lepage. Together these artists helped to send a potent message: 'Québec, a culture that travels the world' (Ministère de Culture et Communications 1).

Robert Lepage began his career at a particular turning point in the evolution of Québécois national identity. In 1980, René Lévesque's Parti Québécois government tabled a referendum asking Québécois to allow the government to negotiate a relationship of sovereignty-association with Canada (see Dickinson and Young 327–9). The referendum was lost by a very narrow margin, leading to a decline of momentum in the movement for a separate Québec state, and something of an exhaustion among Lepage's generation with the narrative of nation-building. In the theatre, which had been focused on the production of new plays with nationalist themes, this led to 'a sweeping diversification of aesthetics' among Québec's playwrights; an increased focus on forms of directing and theatremaking that moved away from being 'script-centric' (Schryburt 516); and 'the insertion of Québécois into the international scene' (Hébert, 'Sounding Board' 36). Lepage became a central figure in this new era of Québec theatremaking, hailed as 'one of the most original creators in Québec theatre' (Lefebvre, 'New Filters' 30). The playwright Michel Tremblay located Lepage's unique contribution in the expansion of the boundaries of what could be understood as theatrically representative of the nation:

> In the early eighties we were still using the Québec language as our primary weapon. Then Lepage arrived who, instead of language, used these incredibly powerful but simple images. We were all flabbergasted that the little boy from Québec City managed to overturn everything. (qtd in O'Mahony 5)

Lepage's productions did not leave language behind, but their combination of multilinguality, a strong visual sense, and international themes proved highly appealing to audiences in the rest of Canada and further afield; and this international success fed into the evolving narrative of Québec's identity as globalised and cosmopolitan. The restlessly outward-looking central characters of *Vinci* and *The Dragon's Trilogy* came to be seen as embodying the national spirit of the time, the 'passion for the elsewhere ... best represented by Robert Lepage' (Lévesque, 'Quebec Theatre' 56).

The Dragon's Trilogy: an epic, post-colonial melodrama

From its conception, *The Dragon's Trilogy* was a work about diversity and cultural mixing that placed Québec and Québécois creativity in settings beyond the province itself. That it was set in locations across Canada was not something that grew organically out of the process of creation; rather, in Lepage's words:

> It was imposed ... We toured with *Circulations* to Toronto and Vancouver. In Toronto, there were people who expressed interest in doing a co-production with us ... A Québec-Toronto co-production that didn't go through Montréal, that was unusual ... For the *Trilogy*, we gave ourselves the rule that the story would play out in Québec, Toronto, and Vancouver. (qtd in Lavoie 179)[iv]

The production was developed by Théâtre Repère over a span of three years, in three distinct versions. In its final realisation it was six hours long and divided into three sections called the Red, Green, and White Dragons, named after tiles in the game of mah-jongg. It followed the story of two cousins, Jeanne and Françoise, and their families: the first section is set during their childhood in Québec City circa 1910, presenting this as an insular society grappling with the presence of Chinese and English immigrants, in particular William S. Crawford, a Hong Kong-born Englishman who starts up a shoe store in the city; and Wong, the local Chinese laundryman. In the second section, set in Second World War-era Toronto, the lives of Québécois and immigrants become entwined, as Jeanne is married (against her will) to Lee Wong, the laundryman's son, and employed by Crawford, who has expanded his enterprise to Ontario. Meanwhile Françoise serves in the Canadian Women's Air Corps in Europe, and then settles back home in Québec City. The third section is set in Vancouver in the creators' real time – the mid-1980s – and focuses on the Lepage-identified character of Pierre Lamontagne, Françoise's son.

The fact that the production took as subject matter the presence of a Chinese population in Québec grew out of Lepage's interest in Chinatowns, and from a family anecdote about a childhood friend of Lepage's mother who was married off to a Chinese man by her father to settle a gambling debt; this story ended up directly in the production in Jeanne's marriage to Lee. Lepage also had a personal interest in East Asian cultures, shared with the five fellow artists with whom he created and performed the production and who are credited, with Lepage, as its co-authors – Marie Brassard, Jean Casault, Lorraine Côté, Marie Gignac, and Marie Michaud.[9] A related imaginative point of departure was a Québec City parking lot, which occupied the

iv 'il était forcé ... Nous avions fait une tournée avec *Circulations*, que nous avons joué à Toronto et à Vancouver. À Toronto, des gens s'étaient montrés intéressés à coproduire un spectacle avec nous ... Une coproduction Québec-Toronto, sans passer par Montréal, se serait curieux ... Pour *la Trilogie*, nous nous sommes donnés comme règle que l'histoire se déroulerait à Québec, à Toronto, et à Vancouver.'

place where the city's Chinatown used to be. Lepage and his colleagues were taken with the idea of the many stories and histories which they imagined lying underneath a simple plot of sand and gravel: 'we agreed to start with this space, to make it speak, to explore it on the surface and in depth' (Lepage qtd in Lavoie 178).[v] It was this source that inspired the collaborators to make the production's playing area a long, rectangular box of sand, which initially represented a parking lot but also came to stand in for many other locations (figure 1.1). The parking lot attendant's booth is the only non-mobile part of the scenography and is used in the production to represent a variety of locations.

It is my central contention that *The Dragon's Trilogy* was a narrative of Québec's decolonisation, a process that went hand in hand with its opening up to other cultures. As we have established, Québec was, until the mid-twentieth century, generally a conservative, rural, and sheltered society, legally and nominally part of Canada, but linguistically, culturally, and socially quite distinct. Describing this as a situation of colonisation begs the complex question of who exactly the coloniser was: most obviously, from a nationalist viewpoint, it was Canada that was holding Québec back from self-determination and sovereignty, but the restrictions of the Catholic Church, cultural domination by the former colonising powers of France and England, and the rising tide of Americanisation were all also factors holding back Québec society from full self-expression. All of these elements of existing or encroaching hegemony are in some ways present in the portrait of Québec offered by *The Dragon's Trilogy*; it is clear from their statements around the production that Lepage and his collaborators saw themselves as representatives of a subaltern cultural tradition performing their identity on a Canadian and international platform in order to, in Edward Said's words, 'assert their own identity and the existence of their own history' (*Culture* xii). That the production represented Québécois self-realisation via a story about immigration, and about the movement of Québécois across Canada and beyond, speaks to the particular cultural moment in which Lepage and his collaborators were working, when questions of diversity and cultural mixing in Québec were at the fore; more broadly, it is evidence of the extent to which the articulation of Québec nationalism and globalisation were simultaneous and intertwined.

The production's employment of the tropes of melodrama was a key means by which it offered its depiction of an oppressed society finding its own voice. The production's creators drew on the emotive power and 'allegoric turn' (Gittings 127) of melodrama to help create a powerful post-colonial critique. Melodrama is a popular mode, a site for the consideration of the status quo by ordinary people. It relies on strongly felt audience response: as cinema scholar Christine Gledhill argues, it 'feeds a demand for significances unavailable within the constraints of socially legitimate discourse but for which there is no other language' (37). Melodrama focuses on victims, on those who are subject to society but not in charge of it; thus, change can be imagined but rarely acted upon. The theatrical left has often turned to melodrama because its tendency to focus on polarities of good and evil from the perspective of the powerless makes it an

v 'nous nous sommes vraiment entendus pour partir de ce parking, pour le faire parler, pour l'explorer en surface et en profondeur'.

'effective means of conveying revolutionary sentiments to mass audiences' (Gerould 185). In melodramatic theatre, emotion is stirred up in the audience via 'the externalisation of intensity into music, colour, and extremity' (Bratton 385); all aspects of the mise-en-scène are mustered to give a sense of overall 'spiritual crisis' (Elsaesser 49). Flashbacks and circular storytelling – that is, a story looping back at the end to where it began, to bring home moral messages and point out continuity and/or change – are recurring characteristics of melodramatic forms. For Lepage, harnessing the affectual power of melodrama is a key tool in crafting a theatrical practice that communicates across cultures. With *The Dragon's Trilogy* we see him piloting many of the melodramatic techniques that he has continued to employ and innovate throughout his career, in this instance also to deliver a strong socio-political critique.

Melodrama's capacity to provide such a critique depends on its creation of a situation of dramatic irony wherein spectators are given a long view on societal problems, a view that the characters themselves lack. In the *Trilogy* Lepage used multiple means to give the audience the impression of having an over-arching perspective, first of all, in his use of a traverse staging configuration. The audience could see everything that was happening on stage and in the immediate off-stage areas; most staging techniques and effects were thus performed in the complicit view of the spectators (figure 1.2). The *Trilogy* also created dramatic irony through its epic scope, in that it treated a long period of time – some seventy-five years – and multiple generations of the same families, setting their individual stories against the backdrop of Québécois, Canadian, and world history. The audience were empowered to piece together the ways that the individual characters' stories worked together, and what messages they sent. While it was never stated directly in the production, it was clear that the source of the problems facing Québec was that it was colonised and unable to shape its own socio-political destiny. Characters in the early parts of the production were typically melodramatic,

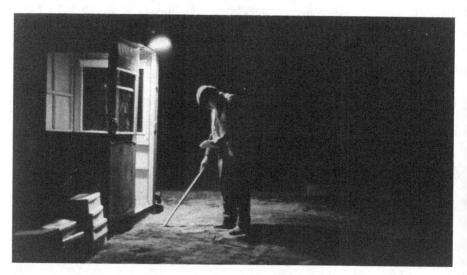

1.1 Jean Casault as the parking attendant in *The Dragon's Trilogy* (original version).

in that they were broadly drawn and legible as representative figures rather than fully fleshed-out and psychologically credible individuals. As time moved forward towards the present day, characterisations became more fully articulated and naturalistic and the acting, in the assessment of *Le Monde*'s Odile Quirot, more 'everyday',[vi] thus representing Québec society's emergence from colonisation and into self-realisation.

Colonised societies are often depicted in artistic representation as feminised, with local males disempowered and neutered by the presence of the masculinised coloniser. This plays out in *The Dragon's Trilogy*'s initial portrait of a society where traditional gender roles, parenting, and authority are all dangerously askew. In the first section, Jeanne and Françoise as pubescent girls talk about their dreams of having babies, but the only parents we meet are fathers – Jeanne's mother is dead, and we hear about Françoise's mother but never see her. The central relationship forged in the first section extends the community's dysfunctions: Wong and Crawford set up an illegal money-laundering scheme and smoke opium together. The troubling complexities of Jeanne's relationship to her father, Morin, are suggested in a dream sequence, in which Morin summons Jeanne to help bury his wife but discovers the girl's own body under the blood-stained sheet. As the sequence continues, Jeanne and her childhood love, Bédard, lie down under the sheet and their child, Stella, is conceived. As Pavlovic reads this sequence, the blood-stain constitutes a curse which elides marriage and death (the stain represents both the loss of virginity and the loss of life), which is then passed on to Jeanne in the form of her forced marriage to Lee ('Reconstitution' 52).

As was noted by many critics, the portrait of the Chinese and British characters in the first section of the *Trilogy* is highly clichéd. Wong is a stooped and shuffling laundryman who lures others to partake of opium with him in a mysterious underworld – the basement below his shop. Crawford is a fussy Brit who, as Jen Harvie points out, is 'made to bear the burden of a large portion of British colonial history – having lived in Hong Kong, the UK, and Canada' ('Transnationalism', 113). Martin Hoyle, reviewing the *Trilogy* in the *Financial Times*, recoiled at this characterisation: 'The Brit (one Crawford – a Scot?) is portrayed in the crude and uncomprehending colours one associates with nineteenth century Japanese depictions of western devils and is satisfyingly killed off, for being a success, in a plane crash' (qtd in Harvie, 'Transnationalism' 113). Certainly Crawford's arrival in Québec City sparks what can only be described as a renaissance of louche behaviour among its adult male population, but it is also made clear that the community's corruption preceded him. Wong started money-lending soon after he arrived in the city, and it is he who first offers opium to Crawford. In fact the production takes pains to contextualise Wong's and Crawford's activities as partially the fault of the xenophobic attitudes of the Québec people towards them: Crawford explains to Lee that he and Wong lend money because it's the only way to earn the respect of the locals, who are 'not very open to other cultures' (Pavlovic, 'Reconstitution' 49–50).[vii] Morin, the representative local, is a highly unsympathetic character who becomes a spokesman for

vi 'un jeu plus quotidien'.
vii 'peu ouverts aux autres cultures'.

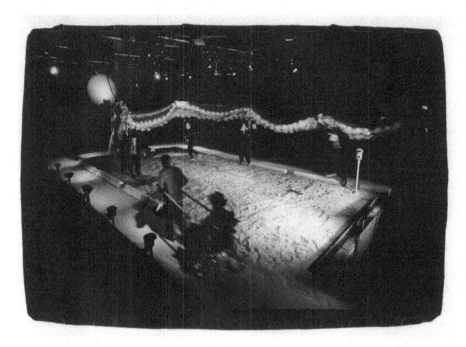

1.2 *The Dragon's Trilogy* (original version).

anti-immigrant racism in an early scene, in which he rattles off all the local prejudices against the Chinese.

While Wong's sisters cut themselves off from reality and survive by imagining that they are back in China, it is only they who continue to work – we see them washing sheets in barrels, keeping the family laundry going (figure 1.3). By contrast all the men, locals and immigrants alike, spend their days drinking, using drugs, and gambling. The production seems less interested in placing blame directly on one character's (or population group's) shoulders than in depicting colonisation as a reprehensible phenomenon that rains down misfortune on all who are implicated in it.

Jeanne and Lee are so tied into this diseased world that they cannot escape it, even by physically leaving. In the second section we see them enduring a cold but functional marriage in Toronto, raising Stella, the product of Jeanne's illicit coupling with Bédard. Stella contracts meningitis and is severely brain-damaged, and Jeanne is diagnosed with breast cancer. Lee loves Stella but does not stand in the way of Jeanne consigning her to a Catholic asylum, because he respects Jeanne's status as Stella's natural parent. Jeanne then takes her own life, and Lee disappears from the production. In the third section, Stella dies in the asylum, the victim of institutional abuse. Both Lee and Jeanne are presented sympathetically; it is clear that it is their different cultures as well as their fated pasts that are keeping them from being happy together. It is a portrait of multiculturalism gone wrong, because it is built on the too-shaky foundation of the corrupt and colonised Québec society.

As Lorraine Camerlain has noted (95), Jeanne is the production's most archetypi-

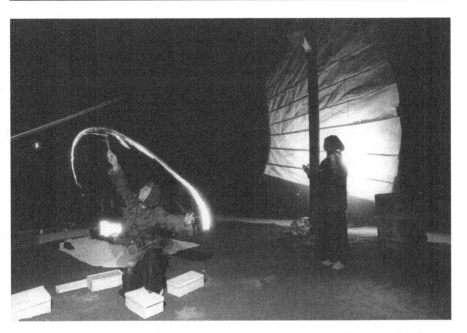

1.3 Marie Brassard (left) and Lorraine Côté as the Chinese sisters in *The Dragon's Trilogy* (original version).

cally melodramatic character, the victim of a series of terrible events that make her reject the present, as literalised on stage via her frequent flashbacks of Bédard riding his bicycle around their old neighbourhood. When Françoise visits Jeanne in Toronto and tells her about her happy life, the latter muses on the difference between them: 'You're in love and you have projects for the future. When I think of love, I think about the past. People never really live just in the present. We live in three times, like a waltz' (Pavlovic 'Reconstitution,' 61).[viii] Jeanne cannot escape from Québec's corrupt and colonised past, but Françoise is a positive thinker who lives in the present and the future. She is the character with the most agency and resilience in the production: she remains active after her husband's death, continuing to be a strong presence in her son's life even when he moves a continent away from her.

Language and difference in the *Trilogy*

In order to discuss the production's third section, which is closest to the creators' own experience, it is important first of all to introduce the ways that language functions in

viii 'T'es en amour pis t'as des projets d'avenir. Moi, quand je pense à l'amour, j'y pense au passé. On vit jamais juste au présent. On vit en trois temps, comme dans une valse.'

the *Trilogy* as part of its melodramatic structures and its creators' critique of colonisation. The production was performed in French and English, with some Japanese and Chinese, and did not provide translation between languages for audience members.[10] This was a remarkably bold gesture for a production that was always going to tour in Anglophone Canada. It began with a multilingual voice-over prologue, spoken alternately in French, English, and Chinese:

> I've never been to China
> When I was young, there used to be houses here
> It used to be Chinatown
> Today, it's a parking lot
> Maybe later, it will become a park, a train station, or a cemetery. (Brassard et al. 15–16)

The first staged scene in the production, between Jeanne and Françoise, called 'La Rue St-Joseph', was performed in rapid-fire, colloquial Québécois that is difficult for non-native speakers to understand. The girls play a game: they build a replica of the street where they live, with shoeboxes representing shops and houses, and enact imagined conversations between themselves and the shopkeepers (figure 1.4). To the Québec critic Lorraine Camerlain, this scene was crucial to her being 'conquered' by the imaginative world of the *Trilogy*: 'Why was I so moved by this scene? Above all because it was about pleasure and about language. About the pleasure that language can bring' (85).[ix] The sense of familiarity and intimacy that was so successfully evoked for a local audience member was not available to everyone. Viewers who did not understand French would grasp the basic rules of the theatrical game but would also perceive that they lacked the skills required to understand the substance of the dialogue and the details. As Barbara Godard comments, 'This minoritising of English carries particular political force in nationalist Québec, where English is as foreign as, but more imperialising than, Chinese' (348–9). And when we consider that the production was always intended to play in English-language markets across Canada, the political implications multiply: the production's creators offer non-French-speaking audience members a brief sense of what it is like to be a linguistic outsider – the defining status of the Francophone Canadian.

The girls' game is interrupted by Crawford's arrival in their community: he walks down the street, knocking on the tops of the shoeboxes, until he reaches Wong's laundry (represented by the parking lot booth). In a coup de théâtre that – as I will continue to explore – employs Lepage's signature practice of semiotic re-encoding, the shoeboxes and miniature street seem to transform into the real-life street and the shops along it, a transformation accomplished by the ways in which the performers interact with space and objects. Crawford asks Wong about the shoe store, called Petittgrew, that he is supposed to take over. Wong has some bad news:

> CHINOIS: The store is burn.
> CRAWFORD: Did you say a star is born?

ix 'conquise … Pourquoi suis-je aussi sensible à cette scène? Avant tout parce qu'il s'agit de plaisir et de langage. Du plaisir que peut procurer le langage.'

1.4 Véronika Makdissi-Warren (facing camera) as Jeanne and Simone Chartrand as Françoise in *The Dragon's Trilogy* (revival).

CHINOIS: The store is burn.
CRAWFORD: I'm terribly sorry but I didn't quite understand what you were saying ...
CHINOIS: Petittgrew ... (*With his candle, he sets on fire the paper that Crawford holds in his hand*). (Brassard et al. 24)[x]

Language is presented here as the cold face of cultural encounter and potential misunderstanding, and as one of the key conveyers of the production's message about the difficulties presented by colonial incursion into Québec. When Crawford interprets 'the store is burn' as 'a star is born' he is wildly off the mark: what he hears as some kind of mythic reference to new life is actually a factual account of real-life destruction. We have quickly moved from the harmonious and intimate shared language of the two girls to the possibility for misunderstanding because of a lack of a shared language (via, it must be said, a clichéd depiction of the particular pronunciation of English by some Chinese people). But the two men quickly find a way to get by, because Crawford understands but does not speak Chinese, and Wong seems to understand some English. Thus they enter into what is a familiar linguistic contract in Québec and other multilingual societies, in which each speaks his own language, and communication and understanding are eked out provisionally. But, however practical,

x Stage direction: 'Il prend le bout de papier que Crawford tient dans sa main et y met le feu à l'aide de sa bougie.' In the published playtext, Wong's character is listed as 'Wong, appelé le Chinois' (Wong, called the Chinaman), and then referred to as 'Chinois' in the running text.

this linguistic compromise is implicated in the production's damning portrait of the corruption and dysfunction of colonised Québec. Cultures and languages are placed next to each other, but real fusion and understanding is not being achieved.

Nor is it achieved in a more complex multilingual scene in the second section, in which the Catholic nun Soeur Marie comes to Lee and Jeanne's home to take Stella to the asylum. The Sister is trilingual: she was a missionary to China, and so can speak Chinese, and is also conversant in Canada's two official languages. But the scenes involving the nun are comic-tragic displays of people talking to each other but not really hearing: the nun monologues incessantly and passionately in French about her experiences in Mao's China, Jeanne is lost in her world of sorrow, and Lee tries to argue his position in a language (English) which his wife barely understands: 'Stella has a family. She must stay with her family. That's the Chinese way' (Brassard et al. 104). That Jeanne sends Stella away despite Lee's argument is evidence of just how little understanding ever existed between the couple. In a trope familiar from much modernist drama, their linguistic distance represents the spiritual and personal distance between them.

The production's third section features its melodramatic climax, the moment in which linguistic problems are overcome through compromise and cultural blending. On a visit to see her son, Françoise plays matchmaker between Pierre and Yukali, a Japanese artist who works in a souvenir shop in the Vancouver airport. Pierre is an artist and gallery owner; in one of the production's knowing prods at the idiosyncrasies of Québec culture, he is portrayed as an über-Francophile. He recognises Yukali's French perfume, 'Chagrin d'Amour', because he has a 'French nose' (qtd in Bovet 14); he has his mother bring him bottles of French wine when she visits from Québec; and, most of all, despite the fact that he lives in the far reaches of Anglophone Canada and runs a business there, he still speaks only the bare bones of English.

And yet he and Yukali, who does not speak French, find a way to communicate with each other by sharing their artworks and talking from the heart about them (figure 1.5). Their coming-together spiritually, artistically, and linguistically is represented by a ritual staged in a zen garden. The other actors bring on stage two ends of a thick rope, with a loop at one end; they bring the straight end through the loop as Pierre and Yukali explain, each in their own language, about a yin and yang ritual (apparently invented by the collaborators) executed every year in a Japanese village. The depiction of Pierre and Yukali's union participates in the production's melodramatic structures by thematically linking 'true' linguistic communication with an idealised merging of cultures, as well as with emotional and romantic/sexual union. It also does the moral work of the melodramatic form, demonstrating to audiences that resolution is possible, in that linguistic and cultural clashes can be overcome. In the context of decolonisation and globalisation, it is notable that this idealised union is between a Quebecer and an immigrant and does not take place on Québécois soil. The future for Québec, is it underlined, is in cultural openness, cultural mixing, and a deterritorialised understanding of identity.[11]

The production does not end here, however. A coda scene completes the melodrama by having the story return to where it began and affirm values of family and tradition, but innovates this convention by presenting a Québec that is progressively

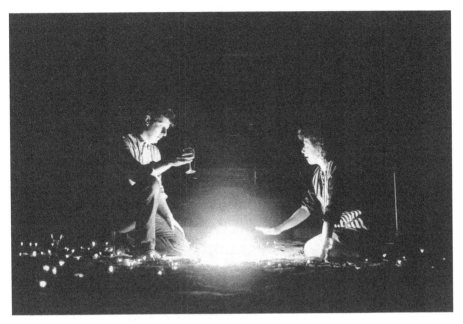

1.5 Robert Lepage as Pierre and Marie Brassard as Yukali in *The Dragon's Trilogy* (original version).

matriarchal and outward looking. Pierre and Françoise come back to the Québec City parking lot to watch the passing of Halley's Comet (which adds to the trope of circularity in the scene, as Jeanne and Françoise had talked about the comet in the first section), and so that Françoise can leave a memento for Stella. Naturally, they speak French to each other. Pierre has some news: he's received a travel grant and is going to China. On the one hand, this seems an odd choice of destination – given that he has just met and connected profoundly with a Japanese woman, it might have followed for Pierre to travel to her home culture. But his choice allows the creators to bring the production full circle, as immediately happens when Françoise repeats the first line of its prologue – 'I have never been to China …' – now in a grounded context of plot and character (Brassard et al, 169).[xi] Françoise and her generation did not have the means to travel outside the country for education or leisure; they represent the conservatism and limitations of closed-off, colonised early- and mid-twentieth-century Québec. But they laid the foundations for the mobility of Pierre's generation. Québec theatre scholar Jeanne Bovet reads this scene against another of the production's late plot twists: that the dying Crawford tries to revisit Hong Kong but perishes in the attempt when his plane crashes into the Pacific Ocean. In Bovet's view,

> It is as if the Québécois character, having strengthened his own identity and opened up to the world, is ready to take over and succeed where the Englishman has failed. The political

xi 'Je suis jamais allée en Chine.'

message is implicit: Québec's place in the world can only be ensured by a strong sense of identity coupled with open-mindedness toward other cultures. (18)

And, it seems, Québec's place in the world can be ensured only once the centrality of the mother-figure, and the French language, are affirmed. Pierre is prepared to head off to new horizons, but not without returning to the source, culturally and personally.

Reception of *The Dragon's Trilogy*

The Dragon's Trilogy communicated that Québec had suffered profoundly from colonisation, but that it was finding a way to move beyond this legacy and to integrate with other cultures, led by its young people and artists, while at the same time honouring its origins and the central place of the French language in Québécois identity. In 1990, reflecting on the production's success in the *Los Angeles Times*, Lepage called it a 'very Québec show' and 'one of the most nationalist pieces ever written in Québec theatre' (qtd in Kelly). As we have seen, however, its expression of an internationalised nationalism was particular to the cultural moment in which it was created, and it was read in significantly different ways among the many markets in which it played. Initially, the production was not entirely well received at home; there were criticisms that it was 'watering down Québec culture to succeed outside the province' (Kelly) and that it was a '"festival show", pan-Canadian, totally in the federalist spirit' (Fréchette 117).[xii] Lepage countered that, for him and his colleagues, 'offering up Québécois protagonists defending a nationalist idea is maybe not the best way to bear witness to nationalism any more' (qtd in Fréchette 117).[xiii] As we have seen, the production's strategic use of non-translation in its first section was clearly calibrated to highlight the realities of linguistic isolation for Francophone Canadians. That the production engaged with the English language nonetheless 'shocked' (Lepage qtd in Kelly) some local spectators. For Lepage, the production's multilingualism was mimetic: 'Québec is a French province, but it is surrounded by English and we use English a lot. We cannot pretend that we don't hear English on the street ... [the production is] about the Canadian mosaic, but it's French-Canadian impressions' (qtd in Kelly).

The *Trilogy*, as previously discussed, toured in three different versions over several years; by the time that the *intégrale* (full-length) version premiered at Montréal's Festival de Théâtre des Amériques in June 1987, the tenor of local commentary had become elegiac. 'Rapture, bewitchment, triumph!' cried Jean St-Hilaire in the Québec City daily *Le Soleil*. The production's 'seven hours of bliss' delivered, in St-Hilaire's account, 'an epic of Chinese settlement in Canada' in which 'races, ethnicities, destinies intersect in a dramatic melting pot where all of humanity simmers' ('L'intégrale').[xiv]

xii 'un "show-festival", pan-canadien, tout à fait dans l'esprit fédéraliste'.
xiii 'Montrer des protagonistes québécois qui défendent une idée nationaliste n'est peut-être plus la meilleure façon de témoigner du nationalisme.'
xiv 'Le ravissement, l'envoûtement, le triomphe! ... sept heures de félicité ... cette épopée du

Le Devoir's Robert Lévesque favourably compared the *Trilogy* to other experimental productions in the Festival (including pieces by Meredith Monk, Ping Chong, and the Wooster Group) and to international productions from Nicaragua, Haiti, and Brazil. Via its 'explosion of imagination and theatrical audacity', *The Dragon's Trilogy*, Lévesque argued, was 'an attempt to go to the source of one of the great human phenomena, migration, the mixing of cultures' ('Un grand prix').[xv] When the *intégrale* returned to Montréal a year later, having visited Stony Brook (New York), London, Galway, Limoges, Adelaide, and Toronto in the meantime, both Jean Barbe in *Voir* and Jean Beaunoyer in *La Presse* praised the production as 'monument' of Québec theatre. Beaunoyer's thoughtful review went on to describe the *Trilogy* as 'the history of Québec reviewed and corrected … a work that marks the end of a particular sort of nationalism and finally cuts off our stifling arrow sash *[ceinture fléchée]*',[xvi] referring to the colourful fabric belt associated with a traditional understanding of French-Canadian identity ('Le plus beau').[12] The production, continues Beaunoyer, features Chinese, English, and French, 'three languages that tear us up as they have always torn us up', and offers 'our truth, made of stupidities, intolerance, and fears, but also of consistency and startling generosity … It's our birth in multiple generations'.[xvii] As understood by Beaunoyer, the production marked a pivotal moment for Québec, in which a dominant paradigm of national identity tied to nostalgia and folklore was being replaced by the difficult but necessary embrace of diversity. Scholarly accounts have affirmed and expanded on Beaunoyer's reading of the *Trilogy* as capturing the changing nature of Québécois national identity. Sherry Simon describes the *Trilogy* as 'an exploration of what "Chinese" means in Québec cultural history' while 'questioning broadly and ambitiously the ever-changing morphology of relations to the other' (*Le Trafic* 156).[xviii]

Simon has also said that the *Trilogy*, '[p]erhaps more than Lepage's subsequent productions … gains from being understood within the specific context of Québec society' ('Robert Lepage' 218). Review response to the production outside Québec underlines the veracity of Simon's statement, in that the lack of knowledge of this context significantly hampered Canadian and international critics' capacity to apprehend its meanings. In twenty-nine reviews of performances in eleven locations in Canada, the United States, England, Ireland, France, and Belgium,[13] only two critics, Janelle Reinelt and Carole Woddis, mention that the production offers a particularly French-Canadian vantage on the material, and only one, the *Financial Times*'s Alastair Macaulay, clearly states that the production's 'underlying theme is the opposite poles

peuplement chinois au Canada … des races, des éthies, des destins se croisent dans un creuset dramatique où mijote la somme humaine'.

xv 'foisonnement d'imagination et d'audace théâtrale … une tentative d'aller à la source d'un des grands phénomènes humains, la migration, le mélange de cultures'.

xvi 'l'histoire du Québec revue et corrigée … l'oeuvre qui marque la fin d'un certain nationalisme et qui coupe pour de bon notre étouffante ceinture fléchée'.

xvii 'le Chinois, l'Anglais, et le Français: trois langues que nous écartelent comme nous avons toujours été écartelés … notre vérité faite de bêtises, d'intolérence, de peurs, d'ignorance mais aussi de consistance, de générosité qui éclate … c'est notre naissance en plusieurs générations'.

xviii 'une exploration de ce qu'est "le Chinois" pour l'histoire culturelle québécoise … questionne largement et ambitieusement la morphologie toujours changeante des rapports à l'autre'.

of cultural imperialism and multiculturalism'. A full fourteen understand the production's subject matter to be Canada (rather than Québec); the *Trilogy*'s initial champion in the United Kingdom market, the *Times*'s Irving Wardle, calls the show an 'exploration of Canadian time and space which triumphantly demolishes the idea of Canada's cultural dependence on Europe and the United States' ('Magic').[14] Such readings are incomplete and imprecise: as Lepage affirmed, the production underlined the Canadianness of Québec in ways that were new and contentious in the local context, but this was in service of a newly inclusive form of Québécois nationalism. When international critics, including Wardle, fail to make a distinction between Canada and Québec and understand the production as an expression of Canadian creativity, they fail to appreciate the work of cultural nationalism that the production undertook.

What earned critics' consistent interest and praise was Lepage's stagecraft. Each review considered here, even the few that contain negative critique, praises the production in formal terms. Many go to lengths to describe and analyse the staging, sometimes pointing out that this communicated to them in ways that the content did not, as when the *New York Times*'s D.J.R. Bruckner states that while he was 'at times … puzzled' by the work's meanings, 'Mr. Lepage turns unsettlingly naive devices into luminous theatrical metaphors'. As many of these critics note, at the heart of Lepage's technique are the 'transformations of commonplace objects' (Wardle 'Masterpiece') and bodies through the ways in which they are treated on stage, as when '[s]hoe-boxes in the hands of two teen-age girls become the shops of old Quebec Chinatown' (Bruckner) and when Yukali's comment to Pierre that 'her mother used to work in a nightclub in Japan' suddenly makes sense of a 'displaced scene from an earlier act, when an unidentified woman reclines on the roof of the parking lot shack and recites a dance list' (Conlogue). Such semiotic re-encoding of objects and bodies allows Lepage to make connections between characters, spaces, and time periods, and is a key element of his capacity to engage audiences and build work that carries a strong affective punch.

These moments of connection resonate with spectators, in my view, because they simulate one of the defining aspects of globalisation, 'the distanciation or separation of time from space' (Giddens qtd in Waters 62). In the pre-modern era, the experience of time and space was linked to an individual's immediate life-world, but through the processes of modernisation and post-modernisation, and the advent of mechanised travel, screen technologies, and digital media, time and space have become disembodied concepts not reliant on direct experience. We can imagine faraway places and times without having been there and can even feel as if we have experienced them by seeing them on film, television, and computer screens, or playing within them in virtual gaming environments. This in turn can lead to a destabilisation of identity positions, as individuals are increasingly put in contact with new experiences, ideas, and points of view. Effects in *The Dragon's Trilogy* (and many other of Lepage's productions), in which a body or object transforms on stage, emulate this phenomenon of time-space distanciation. The spectator recognises the body or object with both its previous and its present significations attached to it, and the sense is given of spatial and temporal collapse. The past signification overlaps with the present one; two distant locations seem to co-exist in the same space. In 'La Rue St.-Joseph', the

shoeboxes are still shoeboxes, toys in a children's game, but they also represent the shops on the street that Crawford walks down: ludic, imaginary space becomes the space of the characters' lived reality, and the spectator is invited to consider the relationship between them. When Yukali mentions her mother to Pierre in the final act, the spectator (ideally) recalls the previous appearance of the character of the Geisha and makes the connection between the two women – a connection invited by the fact that they are played by the same actress – and considers what the production is saying by suggesting links between them.

James Bunzli identifies such effects as part of Lepage's overall creative strategy of *décalage* which 'results in a theatre of simultaneity or juxtaposition in which actor, image, "text" and audience are brought into a dialogue, a questioning, and an active co-constitutive role' ('Geography' 89). Bunzli underlines that *décalage* effects tend not to alienate audiences but, rather, '[enjoin] them to take an active role in the creation of a piece's meaning' (95). James Reynolds agrees that such techniques of thematic and semiotic convergence have the capacity to engage audiences by accumulating meanings around bodies and objects towards moments of climax in which 'microcosm and macrocosm meet and become visible' – that is, when the relationship between the stories of individuals and a broader cultural or historical context overlap and become clear to the audience. At such points the spectator becomes aware of the subjectivity and provisionality of her perspective, 'producing deep intellectual and emotional appreciation of differences between ourselves and others' (*Revolutions* 94). The risk, however, is that spectators may not apprehend the intended meanings associated with the broader context; when this happens, spectators may be able to read moments of time-space distanciation only for their universality rather than their specificity. This is what happened with *The Dragon's Trilogy* when it was performed outside of Québec.

An example of this limited interpretation involved the scene of Stella's death in the third section, in which, as Wardle describes it, she claws in the sand, unearths 'the bloodstained conception sheet', and 'wrap[s] herself in it as a shroud' ('Magic'). This is a highly melodramatic and affectively powerful moment, drawing together and closing off the plot line of the entanglement of the Morin and Wong families across the production's time periods and geographical spaces. The double inscription of the sheet connects the difficult circumstances of Stella's conception and birth with the tragic event of her death, so that a relationship, perhaps even causality, is suggested between them. For viewers attuned to the local context, this moment underlines the effects of colonisation on Québec: what happens to Stella is a result of the oppressive, corrupt environment into which she was born and which proved inescapable for her parents and herself. There is a level of socio-cultural critique. For those lacking this context, the melodrama lacks a clear outside referent, and Stella becomes an archetypal victim of fate. While the reappearance and transformation of the sheet brings a strong charge of recognition, the work of decoding the connection likely leads to an affirmation of the powerlessness of individuals in the face of historical or cosmic destiny, as in Bruckner's assertion that the reappearance of the blood-stained sheet 'signals … the death of an innocent'. Few critics, in fact, discuss Stella's plot line at all in their reviews; Conlogue mentions it as one element of the production in

which 'random offshoots of people's lives … are seen, in mystical fashion, to resonate across time and space with each other' so that '[e]verything has meaning', but does not expand on what this meaning is. Several other critics[15] note the occurrence of Stella's violent death without commenting on its metaphoric resonances; and for Bradfer in *Le Soir* the subplot about Stella was the production's 'only false note'.[xix]

This incapacity to fully read the production opened up a line of negative criticism that has continued throughout Lepage's career, in particular from London-based reviewers: namely, that the work is 'intellectually not very challenging'. As the *Times*'s Benedict Nightingale argues,

> Lepage's overall point is hardly more than that there lies a lot of human history beneath modern car parks and building sites, that the Canadian Babel is a fascinating and troubling place, and that both Yins and Yangs are to be welcomed. Yet who can deny that he fulfils his major purpose, which is to tantalise the eyes and touch the zones of feeling behind them? ('Threads')

Nightingale and other critics could not be expected to fully understand what the production was saying about Québec, but it is also possible that the affect the production generated was so strong and pleasurable that it felt like a sufficient payoff and stopped them from looking for deeper socio-cultural meanings. We see a critical stance in formation here, which, as this book will argue, becomes part of the dominant understanding of Lepage's practice: that he is a formalist whose work 'appeals directly to the senses rather than the intellect' (Rea), and which is most generously understood as signifying on 'universal' terms (Bruckner). As I will continue to explore, Lepage does his part in abetting such readings, in his repeated assertions that he is not in control of his work and that meaning-making is the responsibility of the spectator. But, as I hope this reading of *The Dragon's Trilogy* has communicated, to praise it as 'universal' or to dismiss the sum of its representations as obvious and inconsequential is to discredit the pole of the local in the complex network that is the creation and circulation of significations.

Intercultural critiques of the *Trilogy*

These points further inform another important element in the complex story of the reception of *The Dragon's Trilogy*: its representation of non-Québécois cultures, in particular those of East Asia, which many commentators read as clichéd. Godard took the hardest line in her assertion that the *Trilogy* 'contributes to the perpetuation of Orientalism, to the longstanding Western identity-construction through … a process of othering' (349). James S. Moy argued that the Chinese characters in the production 'unwittingly reinscrib[e]' stereotypes: Wong is 'the untrustworthy gambler', while his

xix 'seule fausse note'.

sisters perpetuate '[t]he myth of the sojourner Chinese whose only desire is to return to China', and Lee recalls the 'impotent, and therefore non-threatening "Chink" of D.W. Griffiths' *Broken Blossoms*' (500–1).

In considering these claims, it is useful to turn to Brian Singleton's 1997 discussion of Orientalism:

> Interculturalism … does not attempt to set up an 'us and them' situation but embraces the pluralism and relativism of mass global culture. The post-colonial world has created new cultural arenas which go beyond those defined by the nation-state. It would be a huge task for European ex-colonisers, such as Britain and France, to erase the Orient from their post-colonial consciousness. The difference lies, however, in the treatment of the subject. Orientalism positions the Orient as subject whereas the interculturalism of, say, [Ariane] Mnouchkine treats the occident as subject. (96)

As I have argued, the subject matter of the *Trilogy* is clearly Québec itself and thus, if we accept Singleton's argument, it would be inaccurate to classify the production as Orientalist. Further, it is important to foreground that the creators of this production belonged to a culture which positioned itself as subaltern, both within the Canadian context and internationally; and the success of this production was truly unprecedented for a Québécois company at that time. This is in contrast to the work of other theatremakers associated with interculturalism, such as Mnouchkine and Peter Brook, who function in a socially empowered first-world context. As Marvin Carlson has argued, it is questionable whether it is accurate to call Brook's *Mahabharata* and Mnouchkine's *L'Indiade* intercultural at all, as those productions were performed in élite circuits of production and distribution which service an expert, educated, first-world audience (82). While such considerations become central in discussing Lepage's work from the 1990s onwards, these were not the conditions in which *The Dragon's Trilogy* was first presented. Then, Lepage and Théâtre Repère were starting to be recognised in theatre circles in Québec and were virtually unknown outside their home province. They saw themselves, and within Québec were understood, as speaking from the periphery.

It is also important to take a nuanced approach to the *Trilogy*'s treatment of plural Asian *subjects*; the production involves a multiplicity of cultural references by 'borrowing eclectically from sources as varied as cabaret, pantomime, Asian shadow theatre, Chinese festival, and theatrical expressionism' (Garner 227). This renders impossible any simple or overreaching statement about what 'other' cultures represent in the production. On the one hand, the representation of Chinese characters in the production, and its use of different languages, fits into Patrice Pavis's definition of multicultural theatre, which uses as its source '[t]he cross-influences between various ethnic and linguistic groups in multicultural societies' in the creation of a performance 'utilising several languages and performing for a bi- or multi-cultural public' ('Introduction' 8). Seen this way, the *Trilogy*'s representation of Chinese characters functions as mimesis (as does its inclusion of the English language): there were Chinese people living in Québec City during the time the production depicts, and the creators focused on their presence as a means to create a believable and pointed portrait of a society confronting difference – of the attempt to make a transition from mono- to multiculturalism in

the context of colonisation. When Godard criticises the production for its limited and clichéd palette of references to China, in particular 'the prominent position given to opium', which 'perpetuates the stereotypes of Chinese criminality that were part of the "yellow scare" mounted … to rationalise a keep-Canada-white immigration policy' (350), she fails to take into account that fact that the production's clichéd representation of the Chinese seems knowing and is surrounded by the strategic use of stereotypes and clichés of many cultures, including that of the Franco-Québécois themselves. As Jen Harvie argues, the 'thoroughgoing focus' of the play is its Québécois characters, not the non-Québécois, and '[t]he strongest response to these charges of clichéd, Orientalist representation is that, rather than betraying the racism of the production, they portray the racism of its main characters, problematising it by highlighting its naiveté, crudity, and extent, and emphasising its change over time' (114). Godard further critiques the production for the 'unidirectional' nature of its 'cross-cultural casting' (349; all the actors were white Québécois), which further misses the point that the production was consciously foregrounding itself as representative of, and about, a distinctly Québec point of view.

There are other representations of 'the Orient' in the production, however, than those which correspond to a relatively documentary reference, and which function as decoration, formal inspiration, and thematic shorthand. These depictions of certain elements of Asian cultures were decontextualised, idealised, and trivialised. That the production spoke from the (Western) periphery should not stop us from censuring the *Trilogy* for, at times, engaging in what Carlson calls 'the traditional Western appropriation of Oriental material for purposes of exoticism, spectacle, or making indirect political reference, without any attempt to discover the voice of that material itself' (88). For example, the production continually and indiscriminately slipped between Chinese and Japanese references, as when Wong's sisters appeared on stage to the sound of Japanese music.[16] The attachment of Yukali's family line to the rest of the production is tenuous, and the *Madame Butterfly* trope of the loved and deserted Japanese woman, which figures in the depictions of both the Geisha and Yukali, draws on and perpetuates over-familiar images. It is hard not to see the Japanese characters as shorthand for Japan as an idealised site of spiritual wholeness, gendered as female and penetrated by the Western male.

A final point on the production's treatment of otherness brings us to questions about the selective interpretation of Québec's cultural past. The prologue of the *Trilogy* turns digging in the sand into a metaphor for the cultural work that the production does in excavating the history of Québec:

> If you scratch the earth with your fingernails
> You'll find water and motor oil
> If you dig deeper
> You'll probably find pieces of porcelain
> Jade
> And foundations of the houses of the Chinese people who used to live here
> And if you dig even deeper
> You'll end up in China. (Brassard et al. 16–17)

Before they ended up in China, would not the *Trilogy*'s metaphoric diggers first have discovered remnants of Indigenous cultures? Omitted from this fictional narrative is the foundational act of colonisation by French and English settlers. Of course, Lepage and his collaborators had the right to choose their story and to style it as they wished; their choices are revealing. In an interview published in 1989, Lepage and Gignac talked about their goals for the *Trilogy* with Nigel Hunt:

> HUNT: What interests you more, traveling to other places or the cultures you find there?
> LEPAGE: It's all linked together – the language, the traveling, the tourist side of it. But the human side also: finding your roots in someone else's culture. Also because Québécois have strange roots. I don't know where I came from … we're looking for our roots.
> [...]
> GIGNAC: We are examining ourselves. … like in the *Trilogie*, we were talking about ourselves through our vision of China.
> LEPAGE: It was a pretext for us. We said, we're going to do a show about the Chinatowns. But we knew what really concerned us was the people we knew, our families, our intimates. (116)

By referring to the production as a search for Québécois roots Lepage engages a discourse of cultural enracination which, in this case, connects the Francophone population of Québec to a fellow immigrant culture – the Chinese – while not acknowledging that all immigrants to Canada were settling a land that was previously inhabited. When Gignac says that Repère was 'looking for ourselves through our vision of China', she implies that non-Québécois cultures function as the Lacanian other, as a mirror of otherness in which the creators can see themselves and their desires. Arguably it is the Indigenous population that served as the 'other' of Canada's so-called founding nations, but that history is so deeply buried in the country's psyche that it is not easily or comfortably unearthed.[17] This erasure becomes more problematic, given assertions such as Hunt's that '[t]he cultural collage of the *Trilogie*, and the struggle for a balance between cultural identity and assimilation, is, in fact, Lepage's version of the story of Canada' (114). As the claims about the *Trilogy*'s historical sweep become more extravagant, so do its omissions seem more glaring.

Conclusion

In discussing a number of Québec theatrical productions from the 1980s that involved multilinguality and translation, Sherry Simon singles out Lepage's work, including *The Dragon's Trilogy*, for highest praise: 'The dialogue proposed by Lepage between local and global idioms defines … the voices of our times' (*Le trafic* 165).[xx] I repeat her comment here in a more cautious and critical vein. Indeed, as we have seen, the

xx 'Le dialogue proposé par Lepage entre les idiomes du local et du global définit … les voix de notre temps.'

Trilogy marked a historic point in Québec theatre in its story of decolonisation and diversification told in ways that mingled local and globalised references and theatrical codes. But this did not lead to a dialogue in which communication was fully achieved. Rather, the case study of the *Trilogy* underlines the limitations of the circulation of locally specific material to global markets by pointing out the extent to which the *Trilogy* was not fully understood in the Canadian and international locations to which it toured. The production nonetheless did crucial work in advancing Lepage's career and reputation, and in furthering the international thrust of the Québec national project; in this brief conclusion I will explore the ways in which the success of the *Trilogy* was mediated and acted upon by Théâtre Repère and the Québec government alike.

A notable example is the first presentation of the *Trilogy's intégrale* in Québec City, in September and October 1991. It is notable that it took four years for the production's full-length version to reach the company's home city after its 1987 Montréal premiere, having visited twelve countries in the meantime. As we shall see, balancing presence in the home market with opportunities for international production and diffusion has been a central challenge for Ex Machina from the 1990s forward, a challenge clearly presaged by the unprecedented success of the *Trilogy*. Four of the production's six original collaborators – Marie Brassard, Lorraine Côté, Marie Gignac, and Marie Michaud – performed in this Québec City run.[18] The male roles originated by two performers, Lepage and Jean Casault, were now split between four actors, Robert Bellefeuille, Normand Bissonnette, Richard Fréchette, and Yves-Erick Marier (alternating at some performances with Gaston Hubert). Casault had died suddenly of a food allergy after the production's Stony Brook run in 1987; and Lepage stopped performing in the *Trilogy* before the premiere of the *intégrale* in 1987, in order to make way for other commitments, including the creation and touring of *Polygraph*, *Needles and Opium*, and *Tectonic Plates*, and his artistic directorship of French-language theatre at the National Arts Centre in Ottawa. Already, Lepage and his colleagues and employers were putting systems of work rationalisation in place in order for him to juggle his increasingly packed schedule.

Most interesting, for the purposes of this argument, are two articles that Repère reprinted in the programme for this run which clearly indicate how the company wished the production to be viewed in their home city: as an expression of a robust yet evolved Québec nationalism, at once politically committed and internationally viable. 'Into the Mouth of the Dragon' by Brendan Kelly is a preview feature, originally printed in the *Los Angeles Times* in 1990, which dwells on a controversy around the *Trilogy* when it had played in Winnipeg earlier that year. That run happened in the full heat of the Meech Lake crisis, in which the Canadian government attempted, eventually unsuccessfully, to involve Québec in the repatriation of the Canadian constitution.[19] Many audience members walked out of performances of the *Trilogy* at the Manitoba Theatre Centre, a response which a local reporter attributed to 'the amount of French and smoke' in the production (Prokosh; the first minutes of the show involved the use of a fog machine) but which Lepage saw as a protest against Québec's stance in the Meech crisis: 'I'm very shocked by English Canada's reaction to Québec, by the manifestation of hatred. Of course, it fuels the separatist in me' (qtd in

Kelly). Lepage goes on in the same interview to recuperate both the audience response in Winnipeg and the earlier negative response of Québécois to the production's use of English into a vision of himself and the *Trilogy* as edgy but positive forces of change:

> I think there's a lot of misunderstanding on both sides in the post-Meech period. We have to be careful … I think I am a [Québec] nationalist, but the nationalists think I'm fishy because I don't express my nationalism in an obvious way … [The production] clearly shows a very distinct society. It's very nationalist even if I'm very interested in English Canada. (ibid.)

It is further notable that Kelly's article including these quotations was reprinted in the programme in English, a further affirmation of the production's commitment to linguistic diversity and internationalism.

The other programme article, 'Des personnes qui s'imposent aussi bien à Londres qu'à Montréal' (Characters who fit as well in London as in Montréal) by Daniel Latouche, was originally printed in the Montréal daily newspaper *Le Devoir* in 1987. In it Latouche offers a vivid first-person account of having attended the *Trilogy* in London, reflecting on how seeing it outside the home context 'necessarily changes one's perspective'. Initially nervous about what other spectators thought of the production, and therefore about Québec, he eventually concludes that the production is 'indifferent to its origins' and that its 'Québec content is neither obstacle nor aid'. This is the key to its success and the answer, he argues, to Québec's 'insatiable search for "exportable" cultural products': 'By all evidence this piece was written for itself and not for any international spectatorship. It's not looking for shortcuts to a so-called universal. It is what it is and it's because we can recognise ourselves so easily in it that others can do the same'.[xxi] This formulation – that it is by being unapologetically local that artworks can best be understood across cultures – is a central tenet of Lepage's discourse about his creativity (see Perelli-Contos and Hébert, 'La tempête' 66). The success of the *Trilogy*, in London and other markets across the developed world, likely helped lead Lepage to this conclusion. But the level of understanding the production actually enjoyed, as we have seen, was limited and conditional, which problematises Latouche and Lepage's assertions that local articulations can be universally understood. In the chapters that follow I continue to probe assertions of universality made about his work by Lepage and others, so as to better understand the aspirations behind such assertions and the complicated realities underlying them.

From official perspectives, the success of the *Trilogy* dovetailed perfectly with Québec's policies on culture and internationalism and became part of the national narrative in a very material way. As Colin Hicks, a former director of cultural services at the Québec government office in London, argues, the popularity of productions

xxi 'modifie nécessairement votre perspective'; 'indifférente à ses origines'; 'contenu québécois n'est ni un obstacle ni une aide'; 'quête inlassable pour des produits culturels "exportables". De toute évidence, cette pièce a été écrite pour elle-même et non pour un quelconque public international. Elle ne cherche pas de raccourcis pour atteindre un prétendu universel. Elle est ce qu'elle est et c'est parce qu'on s'y retrouve si facilement que les autres font de même.'

including the *Trilogy* helped to prompt the expansion of Québec's international cultural mission to include new offices, such as the one Hicks was then running:

> The impetus to create this service came from the success of the late eighties, most notably *The Dragon's Trilogy* by Robert Lepage, *Jesus of Montréal* by Denis [sic] Arcand, the 'Montréal body hurtling' choreography of Edouard Lock at La La La Human Steps, the work of Gilles Maheu and Carbone 14, and the magical shows of Le Théâtre de la Marmaille. The objectives were straightforward: to develop Québec's market share and to promote its image as a contemporary society. (155)

Notes

1 Malcolm Waters acknowledges that his geographically focused definition of globalisation, cited in the previous chapter, takes inspiration from Giddens' definition cited here.

2 I also explore the openness of Lepage's work to self-reflexive interpretation, with a focus on *The Andersen Project*, in Fricker 'Cultural Relativism'.

3 *The Dragon's Trilogy* was first performed for an audience in November 1985 at the Implanthéâtre in Québec City. It toured in its various versions through 1992 (the touring archives section of the Ex Machina website includes a full listing of dates and locations). Ex Machina produced a revival of the production which toured from 2003 to 2007 and which included some changes to the original material. A playscript was published in 2005. I did not see the original production live; I saw the revival twice, in Montréal in June 2003 and in London in September 2005. I have viewed DVD versions of the original production and the revival. My description of the *Trilogy*'s plot and action relies primarily on the thick description (called a 'reconstitution') of the production by critic Diane Pavlovic, which was part of a 170-page dossier on the *Trilogy* published in the Québec theatre journal *Cahiers de théâtre Jeu* 45. I use the Pavlovic reconstitution (supplemented by review accounts) as the authoritative source on the original, and the playscript to verify direct textual quotes.

4 Some material in this section was originally published in Fricker 'PRODUCT'.

5 In the 1970s a strand of revisionism entered Québécois historiography, querying this traditional narrative of isolation and uniqueness. Historians and social scientists argued that Québec's experience before 1960 was not one of crippling conservatism, and that in fact its experience was in line with that of Canada and North America as a whole (the theorisation of Québec has having a unique quality of Americanness, or *americanité*, is one aspect of this line of thinking). See Turgeon.

6 In his film *Le Confessionnal*, Lepage depicts the opening up of Québec in the early 1950s, presenting the arrival of television as well as a real-life visit of Alfred Hitchcock to Québec City in 1952 as harbingers of this change.

7 As Dickinson and Young note, net emigration from Québec exceeded immigration by some 80,000 people in the years 1977–79, doubtless because of Bill 101 (311).

8 As of 2019, Québec maintained eight general delegations, five delegations, twelve bureaus, and five trade offices abroad (Ministère des relations internationales et de la francophonie).

9 As noted in the Introduction, the collective authorship of this and other of Lepage's productions is a complicated issue. This and other group productions discussed in this book – *Tectonic Plates*, *Polygraph*, *The Seven Streams of the River Ota*, *Geometry of Miracles*, *Lipsynch*, and *The Blue Dragon* – were all created using the collaborative technique Lepage adopted while working with Repère. Lepage was the director of all of these productions, with overall responsibility for shaping the material, and very quickly became the name

and persona associated with their originality and success. The productions all initially stem from his impulses and perceptions and are, for him, a very personal means of expression. Thus, while not wanting to dismiss the contribution of the co-authors of the productions, I feel it is fair to refer to the productions (with relevant caveats) as a product of Lepage's creativity. In the chapters that follow I continue to explore the cultural and individual forces that tend to consolidate authorship of the work around Lepage alone.

10 Michel Bernatchez, who produced the original and revival versions of the *Trilogy*, confirms that the only passage of the original *Trilogy* which was ever surtitled was in a second-act scene in which Françoise types a letter to Jeanne. The company provided English-language surtitles of the letter when the production was performed in some Anglophone environments, feeling that it provided necessary exposition that they did not want audiences to miss ('Phone interview').

11 In the version of the production documented in *Jeu* 45, Pierre had an Anglo-Canadian girlfriend named Maureen who breaks up with him before he meets Yukali, furthering the possible message that the future for French Canada lies beyond a rapprochement between Canada's two solitudes. See Camerlain 70–1.

12 The *ceinture fléchée* is recognisable today as the accessory of choice of the mascot of the Québec Winter Carnival, the snowman Bonhomme Carnaval. Also associated with the traditional dress of the Métis people and some First Nations, its origins are debated. See Simard and Rousseau.

13 Bradfer, Bruckner, Campbell ('Robert Lepage'), Christiansen ('Trilogy'), Conlogue ('Dragon's'), Coveney ('Masterpiece'), Crossley, Dassonville, Drake, Finlan, Gross, Hare, Jacobson, Léonardini, Levy, Macaulay, Moy, Nightingale ('Threads'), Quirot, Ratcliffe, Rea, Reinelt, Sheridan, Spencer ('Weird Soap'), Verdussen, Wardle ('Masterpiece', 'Magic'), Weiss, Woddis ('Dragon's').

14 Wardle saw the production at the du Maurier World Stage festival in Toronto in 1986 and wrote a rave review. It is widely understood that Wardle's enthusiasm helped to create the momentum that brought the production to the Institute of Contemporary Arts as part of the London International Festival of Theatre the following year and launched its international success.

15 Léonardini, Nightingale, and Ratcliffe.

16 In an interview in *Jeu* 106, Marie Gignac commented on this slippage as some of the 'clumsiness and incongruities' ([l]es maladresses et les incongruités) that the company were striving to address in a 2003 revival of the production. 'Today, we say to ourselves, laughing, "We mixed everything up back then"' ([a]ujourd'hui, on se dit en riant: 'On mélangeait tout à l'époque') (Hébert, 'O.K.' 127).

17 In the decades since the *Trilogy* was first created, Canada has made progress towards acknowledging historical wrongs against Indigenous peoples, including the work of the Truth and Reconciliation Commission (2008–15) in documenting the brutal treatment of Indigenous children in Indian Residential Schools and charting the legacies of the Residential Schools on subsequent generations (see *Honouring the Truth*; *Calls to Action*). In the mature period of his career, Lepage has taken a particular interest in First Nations cultures and staged *La Tempête* on the Wendake reserve near Québec City in 2011, with a cast including Indigenous and non-Indigenous performers (see Poll *Scenographic*, ch. 5). Lepage's 2018 production of *Kanata* for Ariane Mnouchkine's Paris-based Théâtre du Soleil became controversial, however, because it treated Indigenous–settler relations in Canada but did not involve Indigenous collaborators with direct experience of those relations.

18 For two performances Côté was replaced by Hélène Leclerc.

19 The background to this crisis was the repatriation from Great Britain of Canada's constitution in 1982 without the consent of Québec's parliament. In 1987 Québec Premier Robert Bourassa attempted to integrate Québec's specific claims as a special society into the constitution through the proposal of five conditions, the text of which was agreed on by Prime Minister Brian Mulroney and the provincial Premiers at Meech Lake in Ontario. The federal government and the provinces were then given three years to ratify the accord. In December 1988 the federal Supreme Court invalidated the French-language signage portion of Bill 101, but Bourassa overrode the decision, inflaming negative sentiments over the French-language issue throughout Canada and focusing opposition to the Meech Lake proposals. Meech Lake was scotched for good by a member of Manitoba's provincial parliament, Elijah Harper, who filibustered so long against the Accord that the deadline for ratification passed. Harper was the only Indigenous parliamentarian in Manitoba, and it was later acknowledged that his opposition had less to do with Québec's claims than with a lack of special status for Indigenous peoples in the Accord. The failure of the Meech Lake Accord reawakened Québécois nationalism and started a snowball effect that would lead to the creation of Lucien Bouchard's sovereigntist Bloc Québécois party, and eventually the barely failed 1995 referendum. See Dickinson and Young 354–61.

2

Vinci: Lepage in his own line of vision

The previous chapter discussed Lepage's first major success with an original multi-performer theatre work, *The Dragon's Trilogy*, and established Québec as a determining framework for the production. At the same time as he co-created the *Trilogy*, Lepage was at work on *Vinci*, which premiered at the Théâtre Quat'sous in Montréal in March 1986. In an interview published in 1988 Lepage says he views the *Trilogy* and *Vinci* as counterpoints to each other – one a group work, the other a solo; the *Trilogy* focused on 'organic' materials like earth and fire, while *Vinci* was 'technological; we worked with computers almost constantly' (qtd in Chamberland 63).[i] While the *Trilogy* is better known and was revived in 2003, it is my contention that *Vinci* deserves an equally central place in considerations of Lepage's creative project. It comes across as something of a mission statement, announcing his engagement in interrelated areas of inquiry that extend across his career: autobiography, visuality, and representation. *Vinci* is about Lepage himself, about his personal and artistic concerns; it served as an early self-articulation. It is also, more broadly, about how artistic representation works – about how artistic creations invite certain kinds of engagement from spectators. As such, it has an inherently metatheatrical quality: it's a piece of theatre that references its own making and an ideal mode of spectatorship that it aspires to foster among its audiences.[1]

Vinci is the first of six (at the time of writing) major solo pieces that Lepage has created throughout his career,[2] and establishes the basic storyline which all of them follow: a self-identified artist character who is suffering from a crisis brought on by loss and/or creative blockage goes on a journey in which he interacts with figures including great artists and artistic creations, and comes to a new level of understanding of his

i 'organique … technologique; on a travaillé avec des ordinateurs presque constamment'.

relationship to his work and his broader environment.[3] As with all of Lepage's original works, *Vinci* has its roots in autobiography, springing from a real-life crisis which sent him on a soul-searching trip to Europe. He has acknowledged in interview that his work helps him to understand his own life and that it functions to a certain extent as 'therapy' (qtd in Féral 140):[ii] 'that's why you do art – to know who you're about', he said in 1995 (qtd in Johnson 57). Creating these solo shows as well as his other stage works, films, and other projects, and living an increasingly high-profile life as an artist and cultural producer are all means by which Lepage has fashioned a public persona, a process that is highly reflexive: the artist narrates his own development as an artist and a public figure through the artworks which become a key foundation for his status and reputation as an artist. The solo works also provide an ongoing meta-narrative of Lepage's contention with various aspects of globalisation, including the integration of media and technology into the live performing arts; the relation of local narratives, preoccupations, and cultural codes to international contexts of production and reception; the growth of the international theatre festival circuit; and the culture of celebrity. As such, consideration of them, alongside his group works, forms an important part of this study.

The persona Lepage begins to construct in *Vinci* and *The Dragon's Trilogy*, and which he has extended since in other productions, media interviews, and public appearances, is one which foregrounds certain points of identification: those of being an artist, reflexively considering the relationship between himself and his work; and of being Québécois. As his career continues, these references compound and reinforce each other: Lepage's self-representations increasingly take on board his success and renown, exploring his evolving relationship to his artistic milieux and to his nation now that he is no longer an ambitious naïf but a senior cultural figure. While these aspects of Lepage's experience and self-presentation form an important part of my analysis here, I am also interested in exploring other points of identification that find their way into his work more obliquely: of being a gay man, and of being someone with a non-normative experience of physicality. Lepage has spoken in interviews since the mid-1990s about his painful experience of childhood: he developed alopecia when he was five, lost all his hair, and was mocked and bullied by his peers. Coming out was also a difficult and tentative process, and he has said publicly that it is his intention to keep his physical condition and his sexuality out of his work (see pp. 22–4). This stated desire to block these aspects of his personal experience from his work, and the ways in which they nonetheless find their way back into it, identify them as a site of defining trauma for Lepage, understanding trauma, after Cathy Caruth, as 'an overwhelming experience of sudden or catastrophic events' (*Unclaimed* 11) which is 'not assimilated or experienced fully at the time, but only belatedly, in its repeated *possession* of the one who experiences it' (*Trauma* 4, emphasis in original). Following his difficult childhood experiences, Lepage was a depressive, reclusive adolescent, and frequently notes that he is shy. Given all this, it is striking that he decided to work in theatre, and within that to focus on self-performance. He agrees that it is an 'enormous paradox

ii 'thérapie'.

that I turned towards a public profession ... a paradox I still can't figure out' (Bureau 66–7).[iii]

In this chapter I read in the self-performance of *Vinci* an attempt to figure out the relationship between his body, his sexuality, his creative output, and the environments he lives and works in – a pursuit rendered particularly complicated by the fraught and contradictory ways in which homosexuality, in particular male homosexuality, signifies in Québec and has figured in the history of Québécois theatrical production. As scholars including Robert Schwartzwald ('Fear', 'Symbolic'), Peter Dickinson (*Here, Screening*), and Jeffrey Vacanti ('Writing', 'Liberal') have argued, the Québec national project is tied to discourses of masculinity and power in that colonised Québec has been portrayed in political and creative writing as feminised and effeminate, and the process of decolonisation has been described in masculinist terms. This has led to a persistent homophobia in Québec intellectual discourse and some of its cultural production – paradoxically, given that Québec is a relatively liberal place when it comes to sexual rights and freedoms. Québec theatre has been a key locus for the exploration of gay themes and identities since the Quiet Revolution: some of its leading playwrights, including Michel Tremblay, Michel Marc Bouchard, René-Daniel Dubois, and Normand Chaurette, are gay men who frequently treat the complex relationship between national and sexual identities in their plays.

Lepage is widely perceived as outside this particular thematic and representational tradition – as Thomas Waugh observes, '[o]f all Québec's major gay artists, theatrical wunderkind Robert Lepage is perhaps the least *politically* gay' (453, emphasis in original). Certainly, he has avoided self-identifying as gay in his productions, presenting most of his self-identified characters as straight or asexual. Such resistance is potentially legible as his attempt to avoid these complicated political and representational waters, perhaps a response in Foucauldian terms to the fact that 'knowledge of bodies and the process of describing and categorising sexual practices are subtle ways of subjecting them to power and social control' (Conroy 32). But treatment of non-normative sexuality and embodiment does appear in his productions, in complex and coded ways. We see it in queer and queered characters, both self-identified personas and historical figures; in Lepage's playful exploration of the representational possibilities afforded by his unusual appearance and 'sinuous, ductile body' (Sidnell 46); and in representations of gender and sexual difference that come across as homophobic and self-punishing.

In this context, the theme of seeing and being seen, which is central not only to *Vinci* but to all of his solo pieces, takes on particular resonance. Laura Levin offers a Lacanian reading of Lepage's later solo *The Far Side of the Moon*, arguing that in it he 'presents us with a series of mirror stages' that are legible as some of the 'perpetual negotiations between self and environment' which we undertake 'throughout our adult lives' (*Performing* 179). This argument can be extended across all of Lepage's solos and back to *Vinci*: in them he places images of himself on stage in an attempt to better understand himself, his relationship to his work, and how he and that work fit

iii 'c'est un paradoxe énorme que je me sois orienté vers un métier public ... un paradox que j'arrive pas à saisir'.

in the world. This is an inherently relational foray: it is about Lepage's body being seen and recognised by others. This adds another level of complexity to *Vinci*'s engagement with ways of seeing: as Lepage deconstructs the conventions of perspective and draws the audience's attention to the triangulated relationship between artist, spectator, and artwork, he is also exploring where he fits in that relationship – what it means to be looked at and to return that look. As such, he is asking where he fits in the symbolic order – in the structures of society which, as Lacanian theorist Steven Z. Levine argues, we tend to understand as a 'generalised Other' (xiv) representing everyone who we want to believe knows the answer to the questions we have about the world and our place in it. The goal of psychoanalysis, in Levine's view, is to help the subject accept that 'the Other who is supposed to know … does not in fact exist as an all-knowing will that must always prevail over the subject's own desire' (xv). This conception of humans navigating the symbolic order chasing an Other defined by its elusiveness is expressed in the Freudian/Lacanian concept of the drive, 'this fundamental, permanently irreconcilable and forever drifting detour that the pleasure animal must make on its way towards its ultimate object' (de Kesel 169). The drive, in both Freud and Lacan's formulations, is at its base sexual; we manage it through strategies of sublimation by which 'sexual instincts are changed or redirected towards targets that are more socially appropriate' including 'in the direction of art' (Erwin 546). Sublimation is the place where psychoanalysis and art meet, and numerous aspects of *Vinci* offer it as a demonstration of sublimation – a mapping of the journey of the artist (Lepage) in the form of his fictional stand-in (the character Philippe) as he plunges into an art practice in search of the returned gaze of the elusive Other and as a redirection of sexual drives.

A particularly notable aspect of this production is the chimeric nature of Lepage's physical self-presentation. In consistently inventive ways, *Vinci* invites the spectator's gaze on Lepage's body as it refuses to maintain a singular or fixed identity. Bunzli argues that paradox is the key principle structuring and guiding *Vinci* in its 'narrative, structural, theatrical, and thematic layers' ('Autobiography' 25); by paradox he means 'differences – from changing time zones, to cultural and linguistic disparities, to personal, internal conflicts' (23) which sit together in *Vinci*, sometimes contradicting but nonetheless informing each other, and contributing to the 'fragmented autobiographical quest' (21) staged in the production. Paradox goes some way towards describing the production's qualities but is less useful as a hermeneutic, in that it leads to tautology: that there are elements of this production that are paradoxical affirms that it is a production about paradox (this demonstrates some of the concerns about conceptualising Lepage's work as paradox discussed in the Introduction; see pp. 7–10). Queer is a more useful term to describe the techniques of self-representation that Lepage uses in this production, understanding queer, after Eve Kosofsky Sedgwick, as 'the open mesh of possibilities, gaps, overlaps, dissonances and resonances, lapses and excesses of meaning when the constituent elements of anyone's gender, of anyone's sexuality aren't made (or *can't be* made) to signify monolithically' (8, emphasis in original). The production communicates queerness via, among other gestures, serving as the vehicle for a camp parody of perhaps the best-known image in art history, that of the Mona Lisa. A dream scene expressing Philippe's sublimated desire for his friend Marc, and

another representing Leonardo da Vinci cruising young men, are also expressions of the production's queer sensibility. The production ends with an image of artistic transcendence in which Philippe's queer identity is affirmed, but his desire for other men is left behind. It is particularly important to identify and analyse these queer significations in order to take full account of the critical and cultural work the production accomplishes, and the messages that it sends us about Lepage's relationship to his work and his national and international contexts. Failure to see the queer and camp in *Vinci* has limited the critical and scholarly account not just of this production but of Lepage's stage work overall.

Plunging into representation

The principal character of *Vinci* is a contemporary Québec photographer, Philippe, who undertakes a physical and metaphorical journey through time and space to meet Leonardo da Vinci, from whom he learns valuable lessons about art, vision, and life. In its treatment of Leonardo and the work of other Renaissance artists and architects, *Vinci* draws attention to the conventions of artistic perspective enshrined during the Early Modern period: that of the artist offering a lifelike, faithful representation of the chosen subject matter, while standing back from the frame with their body distanced from what is represented. The viewer then takes up the place held by the artist and views the artwork from this distanced and idealising perspective. This relationship of bodies, gazes, and representations reflects a Cartesian understanding of the separation of mind and body and the primacy of the former over the latter. As Amelia Jones has argued, this is more than just a set of aesthetic arrangements; it reflects a belief system which 'claims that the image and the body rendered within it can be comprehended, identified, and known if one stands in the "correct" place in relation to them' (42). Such a sense of 'sovereign viewpoint' as Chantal Hébert and Irène Perelli-Contos put it, is a way of 'restoring the order of the world, casting a gaze upon it that is supposedly objective and ordered' (*La face cachée* 107).[iv]

While challenged in subsequent centuries by avant-garde and non-representational artists and movements and by the advent of photography and cinema, perspectivalism as first established in the Renaissance remains the representational standard of Western culture. As Hébert and Perelli-Contos argue, Philippe 'goes back to the source of the *rules* that have exercised a hold over his vision – and ours – for some five hundred years' (*La face cachée* 77, emphasis in original).[v] The subject–object relationship dictated by Renaissance perspective provides the basis of the presumed relationship between stage and audience in modern Western theatre, which 'allow[s] spectators to project themselves into the onstage world … while creating a distance

iv 'point de vue souverain'; 'restituer l'ordre du monde, c'est-à-dire de poser sur lui un regard soi-disant objectif et ordonné'.
v 'remonter à la source des *règles* qui exercent leur emprise sur sa vision – et la nôtre – depuis quelque cinq cents ans'.

from their bodies as the loci of their looking' (Bleeker 15). Taking up this position provides the viewer with an image that appears to be governed by rules of 'nature, not the individual observer'. When perspective works, then, 'representation as representation' seems to disappear, 'rendering perspective and point of view invisible' (Bleeker 46, 48). This worldview understands making art as ennobling and places the artist in a position of knowledge and power vis-à-vis the spectator, who is privileged to be allowed to see the world through the artist's eyes.

In the late twentieth century some theatre artists began to challenge this perspectival, teleological model of theatre, creating works which offer spectators demonstrations of behaviour and action (or inaction) that break the rules of dramatic structure, character, and representation and do not necessarily contain a plot or add up to any moral or message. Central to this postdramatic turn, as Maaike Bleeker argues, is an unveiling of the systems behind perspective which seem to describe the 'real' world in a natural and unconstructed way. In a related line of thinking, Nicholas Ridout identifies as a key aspect of illusionist, modernist theatre its tendency to 'seek to eliminate the spectator from the set-up', thus masking not only the phenomenological reality of the 'co-presence' of spectators and production, but 'the economic and other power relations in the relationship between artist and audience' (10), as metaphorically represented by spectators sitting in the dark, consuming action performed for them. Theatricality is that quality which interrupts illusionism and reminds the spectator of what Ridout describes as the awkward but unavoidable truth of co-presence. While Lepage's work tends to be more dependent on narrative and other modernist theatrical conventions (his audiences still tend to be seated in the dark, for example) and is less directly participatory than some postmodern and postdramatic practices, it revels in theatricality and reveals a consistent fascination with the boundaries between performance and reality, stage and spectator – as signalled in *Vinci*'s playful engagement with perspective.

From its first moments *Vinci* announces its intention to de-naturalise the model of dramatic theatre and to expose representation as a series of conventions. The first figure to appear on stage is the character of a blind Italian narrator played (as are all the characters) by Lepage himself. The narrator addresses the audience directly and gives them a mini-lecture on the production they are about to see, explaining that it is about a visual artist and that he (the narrator) has been invited to hold forth on various aspects of the visual arts, despite the fact that

> I am not ... a visual artist myself. Nor am I an eminent highly-qualified specialist from a prestigious academy well-known for its innovative ideas on art and its many ramifications. In fact, I am a fictional character. (4)

Any given work of art invites a particular gaze; it tells us how it wants to be looked at. The character of the narrator is Lepage's self-referential means of announcing *Vinci*'s metatheatricality, and an example of the semiotic playfulness for which his theatre has become well known. By having the guide acknowledge that he is fictional, Lepage winkingly notes the interlocking sets of referential and illusional conventions in which audience and creators engage during a performance. The guide draws the

audience's attention to his status on stage as a sign, and to the distance between what he initially seems to communicate as a signifier (knowledge, authority) and what he then comes to signify (irony, self-referentiality, scepticism).

The overall narrative of *Vinci*, the dynamic that propels it forward, is Philippe's journey towards personal and artistic self-realisation. This is communicated by his physical journey across Europe, in which he encounters the artworks of Leonardo da Vinci and eventually encounters the artist himself.[4] The relationship with Leonardo is first distanced and idealised, but Philippe comes closer to understanding himself and his work via his increasing proximity to Leonardo and the Renaissance values he represents, leading to a climactic scene in which the performer embodies both characters at once. He does not keep his distance, quite the contrary: a mantra repeated throughout the production is the desire to breach the surface of a work of art, to 'plunge' in (20). As such, the piece expresses Lepage's desire to break the rules of Renaissance perspective so as to provide what many have argued is the holy grail of all artistic representation: a sense of 'direct access to something that seems "realistic"', in which there is 'seemingly, no boundary between the space I stand in and the space it presents' (Bleeker 15). *Vinci* signals Lepage's awareness that the conventions of perspective – in particular, dramatic perspective – have become too familiar to adequately provide this sense of direct access; he attempts to update these conventions, to offer spectators new ways of looking at the stage which might provide a renewed sense of contact with what is represented. Lepage's engagement with perspective is thus not in the service of exposing the desire for immediacy in order to critique that desire: rather, it is to fashion a contemporary mode of theatremaking that will provide spectators with the strong affectual charge that can come with the sense of immediate access to what is presented on stage. He does so by integrating the formal languages of cinema into his live theatrical practice; he delivers this affectual charge in particular by signature moments of spatial montage, as I will argue further in the next two chapters.

Thus we can understand the larger action of *Vinci*, and of Lepage's original stage work more broadly, as an attempt at the remediation of theatre, understanding remediation to mean 'translating, refashioning, and reforming other media, both on the level of content and form' (Manovich 89). Remediation is an ongoing cycle in which new media appear on the scene to '[appropriate] the techniques, forms, and social significance of other media [in an attempt] to rival or refashion them in the name of the real' (Bolter and Grusin 65). The goal of remediation is the delivery of a sense of immediacy, or what I have been calling direct access; that is, remediation ideally gives the viewer the sense of being 'in the same space as the objects viewed' (11). Immediacy works in tandem with hypermediacy, that is, a busy medial environment that draws attention to its status as mediated, which 'strives to make the viewer acknowledge the medium as a medium and to delight in that acknowledgement' (41–2). The cyclical quality of remediation is a result of new media forms becoming familiar, and therefore conventional: that which at one point used to deliver immediacy becomes legible as a media convention – part of the hypermedial landscape – and innovations are devised which find new ways to deliver the longed-for sense of direct contact between subject and object. Lepage appropriates the formal language of cinema, which Manovich calls the 'the key cultural form of the twentieth century' (9), to update the way in which

theatre communicates to audiences, and to thus maintain theatre's relevance and viability (again, I will expand on and support this argument in the next two chapters).

Though apparently produced on a modest budget, *Vinci* is formally and techno-logically ambitious. The gesture of the production is clearly to seek out new modes of on-stage theatrical communication that can be accomplished via the mingling of a live actor's performance with other media. It thus declares an interest in the relationship between the hypermedial, the immediate, and embodiment that will extend throughout Lepage's career. Several scenes are played out on or behind screens, using projections and live shadow-play; and at least one scene was apparently intended to be pre-recorded and played back on video.[5] In the course of the production Lepage appears in the guise of five distinct characters (sometimes playing two of them during the same scene). The action is accompanied by a live sound score including music, manipulation of Lepage's voice, and sound effects, designed and performed by Daniel Touissant. This flamboyant hypermediality is in service of delivering moments of immediacy, in which spectators are encouraged to look through (rather than at) the production's hypermedial surface to have the sensation of a direct contact with the material represented.

Unlike some other postdramatic and postmodern theatre practices, then, the formal innovations that Lepage inaugurates in *Vinci* do not constitute a deconstruc-tion of theatrical communication in order to expose and critique the ideological implications of theatre's capacity to present audiences with powerful impressions of real experience of the world as it is – that is, to query the age-old craving for immediacy. While it promotes active spectatorship, in that it presents complex images and layered narratives and invites audiences to interpret them, this is in the interest (as discussed in the Introduction) of simulating the experience of navigating contemporary existence under the conditions of globalisation. It presents audiences with something that is affectively and formally familiar, and then works within this affective and formal realm to provide audiences with a sense of direct experience. It is important to note in this context that Lepage does not leave representation and other conventions of dramatic theatre behind altogether. Though it plays with chronol-ogy, *Vinci* tells a story with a beginning, middle, and end; and rewards engagement with the psychology of its central character. The approach that he experiments with here – structuring a piece around conventional elements of dramatic theatre (plot, character), but including elements which challenge representation and invite direct audience engagement – becomes Lepage's template for original theatrical creation. Anne Ubersfeld has suggested that the pleasures offered by theatre are 'twofold', consisting of

> the pleasure of an absence being summoned up (the narrative, the fiction, elsewhere); and it is the pleasure of contemplating a stage reality experienced as concrete activity in which the spectator takes part ... it oscillates between the experience of an absence and the play with a presence. (128)

Lepage's theatre provides pleasure, James Reynolds has suggested, by creating complex images which the spectator is invited to decode: the spectator is stimulated into a 'creative, playful and pleasurable "reading into" of the gaps [the work] offers – and

into enacting the closure of that gap through imagination, association, and making significances' ('Evaluating' 117). While agreeing with this formulation, I would add that an overriding absence/presence in Lepage's work is that of dramatic theatre itself. Part of the knowing pleasure for Lepage's spectators (and the competence it assumes) is being able to relax into the familiar conventions of traditional dramatic representation, while also being challenged to interpret less familiar signs – or, in many cases, signs familiar from other genres and representational systems. This virtuosic layering of effects and pleasures is a central element of the Lepage signature.

Sexuality, camp, and queer in *Vinci*

Another set of signifying practices figure in and complicate *Vinci*'s cycles of remediation: images of gender, sexuality, and embodiment which invite a psychosexual approach to interpreting the production, starting with the painting that inspired it, da Vinci's *Virgin and Child with St Anne*.[6] In interview Lepage says he saw this painting on his first trip to Europe, and was attracted to it because

> It was moving, sensual, carnal, sweet, and there was something ambiguous about the relationship between the Virgin and Child … It's hard to describe the feeling I had when I saw it. When I decided to create *Vinci*, it was not to explain, but to revisit that feeling. (qtd in Fréchette 114)[vi]

Indeed the relationship between Virgin and Child in this painting is sufficiently intriguing to have attracted the attention of Sigmund Freud, who argues that we can learn much about Leonardo by analysing his account of a childhood fantasy in which a vulture put its tail in his mouth; Freud read the bird's tail as representative of both the mother's breast and the phallus, and uses this memory as a building block in theorising 'Leonardo's pre-oedipal relations with his mother and his eventual homosexuality' (Halpern 68). Freud finds evidence for Leonardo's preoccupation with vultures in the Virgin's skirt in the Virgin and Child painting, in which he argues can be discerned a sideways image of a vulture (figure 2.1).

The argument that the bird in da Vinci's fantasy was not a vulture at all but, rather, a kite – Freud had been reading a mistranslation – has been used to discredit Freud's approach and his tendency towards 'logical and evidentiary leaps' (Stannard 11). It is possible that, in identifying an 'ambiguous' relationship between mother and son as something that drew him to da Vinci's painting, Lepage is making a winkingly critical reference to Freud's writings on Leonardo, and more broadly to a psychoanalytic criticism in which we search in artworks for truths (often latent) about the artist's thoughts and desires. Such an approach would simultaneously

vi 'Il était émouvant, sensuel, charnel, doux, et la relation entre la Vierge et l'Enfant avait quelque chose d'ambigu … L'impression que j'en ai ressentie est très difficile à expliquer. D'ailleurs, si j'ai choisi de créer *Vinci*, c'est justement pour ne pas l'expliquer mais plutôt pour la faire ressentir.'

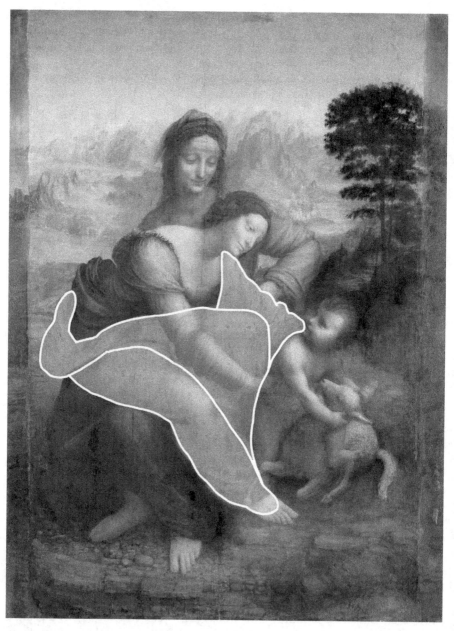

2.1 *The Virgin and Child with St Anne* by Leonardo da Vinci, with overlay.

encourage and destabilise a psychosexual reading of *Vinci*. It is equally possible that Lepage is being straightforward in his account of his attraction to the da Vinci painting and that, if he is aware of Freud's interpretation, he might be open to it: the notion of a Renaissance painting containing a hidden image communicating

2.2 Marc Labrèche in *Needles and Opium* (revival).

deep truths appears in his work in the humanist trope, repeated in *Needles and Opium* and *Lipsynch*, that the outline of the human brain is visible as a pattern within Michelangelo's *Creation of Adam* in the Sistine Chapel (figures 2.2 and 2.3).

In his book on Leonardo, Freud argues that the artist sublimated his troubled early experience of sexualisation, leading to a combination of 'frigidity, a cool repudiation of sexuality, and a stunted sexual life … with an insatiable and indefatigable thirst for knowledge' (Stannard 4). Such a description also applies to Philippe, to an almost parodic extent. The play's second scene establishes a key trope in Lepage's solo productions – the encounter between their self-identified central characters and an unseen therapist figure, which provides a formal means for exposition and character development in the context of the one-performer format. In this scene in *Vinci*, Philippe uses an anecdote of not being able to join colleagues in jumping off a cliff into a snowbank to explain to his therapist his inability to commit to anything: he is 'just afraid of letting myself go, of jumping off the edge into something I didn't really know and couldn't control' (11). He is an art photographer, and this sense of chilly self-control is reflected in his chosen photographic subject matter: 'bathrooms, toilet bowls, bathroom sinks, enamel and mirrors' (7). Critiques of his work as 'cold and soulless', Philippe says, miss his point, which is exactly to observe that 'we live in a very cold world' (7, 8); he finds further proof that he has been misunderstood in an approach from a bathtub company to use his photos in their advertising. Such self-deprecatory humour becomes a pattern in Lepage's work: he frequently places

2.3 Hans Piesbergen and Frédérike Bédard in *Lipsynch*.

his self-identified artist figures in situations where they are misunderstood or their weaknesses are challenged, and from which they lack the wherewithal to extract themselves (as in, for example, the lovesick Robert in *Needles and Opium*, stuck in a Paris hotel room next to that of a couple making seemingly endless, enthusiastic love; the artistically insecure Frédéric in *The Andersen Project*, forced to explain his opera project in broken English to an apparently humourless panel of arts bureaucrats; the lonely and professionally drifting Philippe in *Far Side of the Moon*, cold-calling his ex-girlfriend to sell her a newspaper subscription; and the arrogant Robert of *887*, watching his pre-recorded Radio-Canada obituary as the audience look on [figure 2.4]). The humour derives from the precise ways in which the situations pinpoint and exploit the characters' vulnerability in the service of the productions' principal thematics, the potential cruelty of such manoeuvres undercut by the audience's knowledge that the humour is self-directed: it is Lepage's defence mechanism against humiliation and suffering.

Hébert and Perelli-Contos argue (*La face cachée* 128) that pedagogy is an overt theme of *Vinci*: it begins, as we have seen, with a lecture on how to view it, and it features further sequences of direct address which can be read as instructions on how to view and interact with art. The trope of psychotherapy complicates this dynamic, inasmuch as it positions the audience as what Barbara Freedman classes as the 'mirroring other'

2.4 Robert Lepage in *887*.

who, in the processes of 'theatricality, psychoanalysis, and pedagogy alike provide a model for knowing ignorance through dialogue'. This mirroring other,

> whether teacher to student, analyst to analysand, or antagonist to protagonist … feeds back to the subject her own message from an asymmetrical standpoint … By functioning as a mirror to an unseen space within the subject, one can stage and displace that otherness so that, for a brief moment, she can know her blindness. (42–3)

Thus the student/teacher, ignorant/knowing, blinkered/seeing relationship in *Vinci* goes both ways: having drawn the audience in with his insouciantly confident first scene of audience instruction, Lepage here switches tack and places the audience in the powerful position of being the knowing party. This dynamic of being addressed in shifting ways is part of what makes spectating Lepage's productions an engaging experience, though, as we will see, the eventual role which the spectator plays in this exchange of looks requires interrogation.

The critique of Philippe's work as cold establishes the production's main thematic of his journey towards defiant artistic self-acceptance. The imagery of coldness in this scene also extends to Philippe's description of his relationship with his girlfriend: all we hear about her in this scene is that they eat frozen dinners together (9) and do not talk about his work problems; she drops out of the story completely once he heads off to Europe. His attachment to Marc, by contrast, is profound: he calls Marc a 'mirror' in which he sees his own lack of integrity and artistic conviction, and says that he feels 'guilty of' Marc's death (10). The quest for self-knowledge that Philippe undertakes on

his trip to Europe involves him challenging the rules of artistic perspective in order to get closer to and eventually merge with not only Leonardo but also Marc. The journey comes across as an exercise in eventually failed sublimation, in which Philippe displaces a passionate connection to Marc in a frenzy of creative activity which ends with the attempted consummation of self-identification with his contemporary artistic mirror and with the old master.

Another way in which *Vinci* engages with questions of gender and sexuality is via the cultural familiarity of many of the images and figures that Philippe encounters, which Lepage presents using strategies of camp, using his body as the site of these camp representations. Camp is famously difficult to pin down, and this elusiveness is essential to its subversive nature; I understand camp, following Moe Meyer, as being connected to a project of 'queer social visibility' (4). Meyer developed his understanding of camp in response to Susan Sontag's influential 1964 essay 'Notes on Camp', which decoupled camp from homosexuality, referring to it rather as a 'sensibility' (276) and thus, in Meyer's view, rendering it 'safe for public consumption' (Meyer 6) but draining it of its oppositional power. Meyer sutures camp to a queer politics by defining it as 'the total body of performative practices and strategies used to enact a queer identity', as opposed to 'some kind of unspecified cognitive identification of an ironic moment' (4). Reading *Vinci* through Meyer's definition of camp as 'a praxis formed at the intersection of social agency and [queer] postmodern parody'(8) helps us to identify the ways in which the production engages with gender and sexuality as well as with national and artistic identities – topics which are missing from existing scholarly commentary on the production, which classifies as ironic what are in fact slippery and more polyvalent references.

Camp relies on the familiarity of images, which it repeats in critically parodic ways. *Vinci*'s narrative involves many clichés of the North American's first trip to Europe – multilingual bus tours, Big Ben, the Mona Lisa, the Duomo in Florence. Some of these become vehicles for commentary on cultural difference and misinterpretation, as in the condescending reference 'little French Canadians' (14) by a London bus tour guide. Queer and camp enter the picture in a scene in which Lepage self-presents as da Vinci's most famous painting. He appears wearing a long wig, high heels, and a capelet, and delivers a monologue in the guise of a young woman who strikes up a conversation with Philippe in a Burger King near the Sorbonne (addressing the audience as if they were Philippe) (figure 2.5). She is an aspiring performance artist and museum tour guide whom Lepage uses as a further means to advance the theme of breaking the boundaries between spectator and artwork. Putting paintings under glass, she tells Philippe, is a way of 'trapping' them. 'A painting is not made so we can see our silly faces shining back, no, *merde*, we must penetrate, enter the painting' (19). Underlining the theme of coldness, she scoffs at Philippe's choice to photograph bathrooms as 'verry frrigid' (18): she prefers a warm medium, like painting. In fact she recently served as a live model for a painter friend (in the play's English version, translator Linda Gaboriau has Mona speak in an exaggerated French accent):

> I was at an angle, tree quarters, like zis. Wiz my hands on my stomach, glowing wiz an inner light, as if I was carrying ze embryo of a new generation of child genius. And so zat

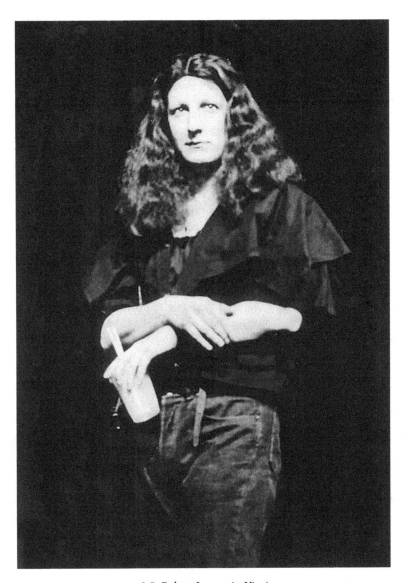

2.5 Robert Lepage in *Vinci*.

everyone would understand I was ze only one to know my secret, he painted me with a mysterious smile. (19)

As she speaks of her mysterious smile, the lights darken, a familiar landscape background appears on the screen behind her, and she appears unmistakably as the image of the Mona Lisa.

This is a consummate moment of remediation – of immediacy emerging out

of hypermediation. Into the production's diegesis, Lepage inserts a familiar image associated with another medial environment. When the Mona Lisa appears it is as if two different strands of time intersect, or, rather, that the dominant movement of time is briefly overridden or infused by an alternative temporal scheme. This is an example of the formal technique of spatial montage that, as I will further argue, becomes a signature of Lepage's cinematic stage storytelling. For the present, I am interested in the familiarity of this image and the fact that Lepage himself embodies it. Mona is multiply queered here: Lepage queers his own body by appearing *en travestie*, and he queers the famous painting by portraying its subject as a woman (played by a man) whose identity refuses to be framed and limited either as an artistic subject or as a soi-disant contemporary artistic radical, but, rather, hovers playfully between these two poles (this resistance to classification is further communicated in Mona's exchange with the unseen and unheard Philippe: 'I'm in ze Louvre. *Mais non, merde*, I am working zere') (20). We are clearly in the subcultural queer discourse of camp, inasmuch as this representation 'unfixes categories asserted as right, inevitable, and natural' (Morrill 98), such as gender and high/low culture, in that da Vinci's famously demure and mysterious subject is presented as foul-mouthed, brazen, and holding a fast-food milkshake. Scholars who describe Mona's presence as 'ambiguous' (Bunzli, 'Autobiography' 39) and Lepage's appropriation of the painting as 'ironic' (Hébert and Perelli-Contos, *La face cachée* 58)[vii] miss out on the elements of queer parody at play here.[7] Irony is too limiting a term to describe this representation: as Cynthia Morrill has argued, irony has a 'stabilising quality' (98) – even as an ironic statement posits the opposite of something in order to critique it, this 'can be seen to fix meaning in a binary system of difference' (97). The way in which Mona hovers between any number of cultural polarities – familiarity/difference, gender, high/low, live/visual art, language/physical expression – effects sufficient destabilisation to render her camp. This is a point of particular importance, as classifying this representation as ambiguous and ironic appropriates it into national discourses, given that ambivalence and irony are understood as definitional of Québécois culture in the years in which Lepage came of age as an artist and made *Vinci* (see pp. 18–21). Not noting the camp qualities in the figure of Mona establishes a critical precedent of reading Lepage's stage work as outside discourses of gender and sexuality, into which I am committed to writing it.

The scene immediately following Mona's appearance underlines the production's queer critique of the high/low culture binary: the blind Italian narrator returns and offers a 'Brief Anthology of Artistic Creations Which Have Defied the Rigid Rules of the Tape Measure', including prehistoric sculpture, the Statue of Liberty, the Great Wall of China, the invention of radio and photography, jazz, and Michael Jackson's moonwalk (22–3), while manipulating a metal tape measure into various configurations to illustrate the list. What unites these creations, it seems, is that when they were created they confounded existing definitions of what constituted art by occupying space and time in conceptually groundbreaking ways; to use the terminology introduced here, Lepage is presenting them as works of art that

vii 'ironique'.

effected remediation. This list extends the subversive critique of high/low culture binaries of the previous scene by removing revered artworks from their familiar contexts and grouping them in surprising ways with recent works of pop culture (Jackson first performed the moonwalk in the video for 'Billie Jean' in 1983, three years before this production was created). There is a knowing, campy subversiveness to the fact that, by offering this ingenious, bravura résumé of creative innovation, Lepage is implicitly including himself in the grouping of artistic greats he assembles.[8]

Consummation

In the final scenes of *Vinci* Philippe achieves what he has been seeking throughout the production – physical union with both Marc and Leonardo. In the scene 'Camping at Cannes', Philippe has a nightmare in which he begs Marc to help him finish editing the film Marc left unfinished when he died. The scene is played on a dark stage, with Lepage embodying both characters using shadow-play. Impervious to Philippe's pleas not to leave him and to help him express what is in his heart, Marc cuts Philippe's wrists, stabs him, and does not catch him as Philippe jumps off the cliff. 'My body's dragging itself along the ground, Marc. Am I dying or am I creating?', Philippe cries out, startling himself awake (34). These images of violent penetration and a failed leap into the unknown can be read as a fantasy of sexual congress gone wrong: Philippe dreams he finally has the courage to act on his carnal feelings towards Marc, but Marc is not there to meet him. This perhaps communicates Philippe's regret that he did not express his desire while Marc was alive. The confusion of creation and dying brings with it the entendre of the little death – orgasm: perhaps the fulfilment Philippe has been pursuing all along has been sexual as well as creative. He has been seeking the capacity to see himself clearly, to really know himself – which involves accepting that his drives lead him in the direction of same-sex union. His sublimation is pushed past its limit here and exposed for what it has been repressing, but the capacity to act on his desire for Marc appears to have come too late, leading Philippe to a nightmare of self-punishment.

In the following scene Philippe finally meets the artist whose work he has been pursuing throughout his European quest. In a Florence camping-ground shower room, the performer stands with his back to the audience in front of a row of mirrors, tilted so the audience can see his face in them. By putting shaving foam on one side of his face and head, and then turning his head from side to side as he speaks, he stages a conversation between Leonardo and Philippe (figure 2.6). The old man, like Mona, is not an untouchable icon; rather, he hangs out in the campsite bathroom to get an 'eyeful' of young men's bodies.

What is it, Philippe? Does this shock you? What were you waiting for? Sophocles or Pythagoras? Have you ever really looked at yourself like you need to, Philippe? Come on, look at yourself ... what do you see? On the one hand, there's a young Québécois intel-

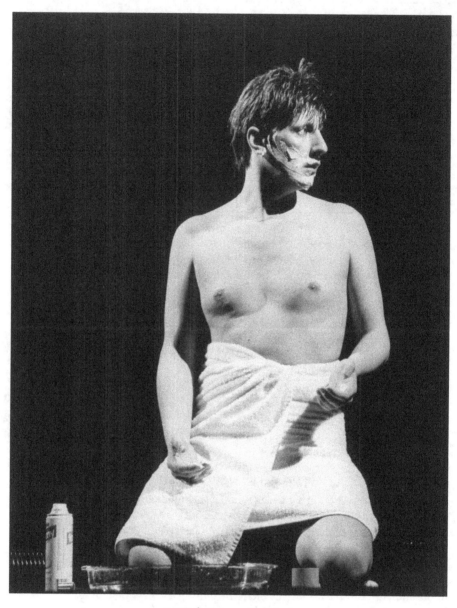

2.6 Robert Lepage in *Vinci*.

lectual who bores everyone with his speeches about art and integrity. On the other, there's the dirty old pig in you who likes to take advantage of a situation. (44–5)[viii]

viii 'me rincer l'oeil'; 'Qu'est-ce qu'il y a Philippe? Ça te choque? Tu t'attendais à quoi? À Sophocle, à Pittagor? Est-ce que tu t'es déjà regardé comme il faut dans un miroir Philippe? Allez, regarde toi! … Qu'est-ce que tu vois? D'un côté, il y a un jeune intellectuel québécois qui emmerde tout l'monde avec son discours sur l'art et l'intégrité, et qui a l'impression d'avoir une tache sur l'âme. Et de

What is presumably shocking here is not necessarily that Leonardo is homosexual but, rather, the subcultural queer practices with which he is associated. The scene associates the exalted historical artist with gay cruising – 'the active search for a potential sexual anonymous partner in different public settings' (Forsyth and Copes 558); or, more precisely, portrays him as engaging in possibly pedaristic voyeurism in a public bathroom, a location and activity evoking the culture of gay bathhouses, sites that were 'part of the emergence of a gay male community in the latter half of the twentieth century' (Tattelman 71). As Kooijman argues,

> Cruising as a cultural practice seems more 'queer' than 'gay male' in the sense that, in contrast to contemporary, relatively visible, and normative 'out and proud' gay culture, cruising remains in the shades of deviancy, harking back to pre-Stonewall times when homosexuality was forced into relative invisibility, at least in mainstream straight culture. (165)

This scene queers not only Leonardo, but also Philippe and Lepage, in that this dirty old pig is presented as part of the idealistic young artist's identity, a point driven home by the fact that Lepage's body is simultaneously the site for representing both of them, in a scene that brings together the thematics of mirrors and gazing running throughout the piece. Look at yourself, the old queer artist implores his young protégé: you cannot deny that I am a part of you – nor that many of the other figures you met on your trip ('A british guide with a cold critic eye in society [sic] … A cheap Mona Lisa longing for freedom at the back of a Burger King' (44)[ix] are also parts of you. These multiple identities are made possible, in terms of staging, by the device of the tilted mirror, which enables the illusion of a dialogue between two discrete individuals.[9] The notion of a clear and truthful view being possible only via a mirror evokes the Lacanian concept of anamorphosis – those elements of an artwork that are 'incompatible with our normal ways of seeing' (Adams xiv) and which make visual sense only when we view them from an unusual angle, by 'looking awry' at them (see Žižek *Looking*). Slavoj Žižek connects the concept of anamorphosis to his formulation of the Lacanian real, which Sean Homer describes as 'that which is beyond the symbolic and the imaginary and acts as a limit to both' and which 'above all … is associated with the concept of *trauma*' (83, emphasis in original). Žižek is fascinated by the idea of the real as something that 'does not exist (in the sense of "really existing", taking place in reality)' and yet 'has a series of properties' (*Sublime* 163). This chimerical quality of the real, that it does not exist but yet controls existence, connects it to the experience of a traumatic event, which is

> a point of failure of symbolisation, but at the same time never given in its positivity – it can be constructed only backwards, from its structural effects. All its effectivity lies in the distortions it produces in the symbolic universe of the subject … (169)

l'autre côté, il y a un vieux cochon en toi qui aime profiter de la facilité.' This translation is mine; the relevant pages of Gaboriau's translation are missing from the playtext.
ix 'Une Joconde de pacotille en mal de liberté au fond d'un Burger King.' The phrase about the British guide is spoken in English.

The sideways glance of anamorphosis is the way in which humans attempt to address trauma – to confront the real. They do so by, among other activities, creating cultural products which 'explore the precariousness' of the imbalance between reality and the real while 'sav[ing] us from its worst consequences' (Kay 58). Culture, in other words, does not reflect reality; it reflects back to us the reality we have constructed for ourselves: culture 'stages the complex relationship between reality and the real. At its most sophisticated, culture also reflects how this staging works' (68).

Considered through this formulation, Philippe/Leonardo gazing indirectly at the audience through the device of the tilted mirror comes across as Lepage's attempt to confront the traumatic fact that his identity is multiple, fluid, and cannot be contained or classified by a single gender and sexual positionality – in short, that he is queer. The traumatic event which holds his queerness in the position of the unassimilable Lacanian real is his childhood experience of loss – of his hair and of his access to normative sexuality. Through the activity of creative production Lepage is attempting to gain access to himself as a queer subject, to get a clear vantage on that which he has for so long repressed and sublimated. Accepting his desire for Marc, perhaps, is part of what has finally allowed him access to the real fact of his queerness. He is pushing his way through representation to gain immediate access to his own experience. The next scene presents the performer's body, unabashedly exposed: Leonardo tells Philippe that 'art is conflict ... Art is a paradox, a contradiction. Now, go wash yourself, Philippe' (44)[x] and the younger man takes a shower on stage, naked (figure 2.7).

In the final scene, Philippe appears in silhouette on the top of a cliff above the town of Vinci, wearing a large set of wings, and speaks again to his dead friend: '[b]etween the humility of the small village and the universal grandeur of Leonardo da Vinci, there is a cliff, Marc. I came to Vinci and I've seen but now I must conquer' (38). He runs towards the audience, and appears to jump over the footlights, seeming to fly as the production ends (figure 2.8). Philippe has been rebaptised and born again, Christ-like; he has discovered his métier, and found the courage to jump off the cliff and soar away into his artistic career. The queer synergy achieved with Leonardo helped him on his way; but the failed attempt at acting on his desire for Marc is left behind, unmentioned: Marc here appears to have been reinstalled in the position of muse. The sexual leap in darkness is side-lined in favour of an artistic leap towards the light. Thus the messages which the production sends around questions of gender and sexuality are complex. On the one hand, *Vinci* communicates queer meanings through Lepage's campily subversive presentation of classic works of art and artists, and more broadly via his playful, chimeric presentation of his body on stage. Given the autobiographical nature of the piece, this sends information about the artist himself: it invites us to consider Lepage's identity, including his gender identity, as fluid, chimeric, and ambiguous. Same-sex desire, however, comes across as fraught: the production in coded ways invites us to read into Philippe's journey a story of sublimated desire for Marc which is expressed too late and quickly again repressed.

x 'L'art c'est un conflit ... L'art c'est un paradoxe, une contradiction. Maintenant, va donc te laver Philippe'; 'disparait dans la vapeur et la lumière'. The latter phrase is a stage direction.

2.7 Robert Lepage in *Vinci*.

2.8 Robert Lepage in *Vinci*.

A new way of looking?

To draw the strands of this argument together, I return to the techniques of perspective that are part of the messages which the production sends about the relationship of art, artwork, and audience. As argued, the production updates the Renaissance tradition of perspective in which the artist creates a work of art and then considers it from a distanced position of control and mastery. Lepage's work here runs against this dynamic: he has plunged into the centre of his creative project, just as his alter ego Philippe has done too. The fiction of *Vinci* tells us that Philippe could not find a way to engage fully in his life, nor in his work; he was holding back. The creation of *Vinci* is evidence that Lepage has overcome this block: Philippe/Lepage's journey and eventual victory over his doubts and demons resulted in this artwork itself. Knowledge of Lepage's autobiographical relationship to the production turns it into a mise-en-abîme: Philippe's story stands in for Lepage's, and the very existence of the production stands as proof that Lepage is in full creative flight. *Vinci* and all of Lepage's solo projects, thus considered, are projects of public exposure, in which Lepage affirms his existence by enlisting us to see him in terms that he has determined. The adult who was a mocked and bullied child, exposed and defenceless, has now taken command of his self-presentation: he invites the world to gaze upon him and on all the virtuosity of which he is capable. What we see on stage is never exactly Lepage himself, of course,

and not just because he most often gives his self-identified characters a pseudonym: it is a scripted and rehearsed version of Lepage, through which he can please audiences with performances of self-revelation that may or may not actually be true. This offers insight into Lepage's statement, frequently repeated, that in theatre he discovered 'a hiding place much larger and infinitely more exciting than my parents' bedroom' (qtd in Manguel 34). Playing 'Robert Lepage' allows him to hide in plain sight, to simulate selfhood on his own terms. Part of the performance here, as I have been arguing, is the performance of a queer identity.

Considered in this way, the creation of a solo production such as *Vinci* seems like a positive experience of self-expression and self-assertion, in which the artist is able to address his traumatic past and, perhaps, move beyond it. Why, then, does Lepage continue to create solo productions, innovating but nonetheless repeating the story of the artist on a journey for inspiration and personal understanding? The answer lies, I believe, in the fact that Lepage performs his own story, and in the nature of his relationship with the audience, given that he is creator/subject/performer of the work. As performer, Lepage submits his own body and subjectivity to the audience's regard. While telling his own story on his own terms gives him a certain sort of power, he also relinquishes power and control by placing himself on stage. In so doing he submits to the audience's gaze – which involves, in Lacanian terms, 'the intimation or feeling one experiences of being seen by a look which is outside one's perceptions, of being watched without being able to determine from where one is watched' (Carney 40). The subject becomes aware of the gaze as the 'point of failure in the visible field' (Krips 93) – when there is something in the subject's field of vision, like a dazzling light, that cannot be brought into focus. This image evokes the actor's experience, unable to see the audience because the stage lights are shining in their eyes and blocking their vision. Being the subject of the gaze has a complex effect on the subject: 'the gaze is presented to us in the form of a strange contingency ... It surprises me and reduces me to shame' (Lacan 72, 84); but because it responds to the scopic drive – the need to see and be seen – it brings pleasure as well as anxiety. In submitting to the scopic drive, 'the subject poses as an object *in order to be a subject*' (Owens 215, emphasis in original). By putting himself on stage telling his own story, Lepage is trying to be seen on his own terms – he is posing as an object in order to become a fully realised subject in the symbolic order – but he cannot necessarily see who it is that is returning his look. The indeterminacy of this experience and the mixed effects it has on him – shame, surprise, pleasure, anxiety, incompletion – do not provide full satisfaction; self-presentation on stage therefore becomes part of Lepage's participation in the never-ending drive towards self-knowledge.

The next step of this exploration is the role and responsibility of the audience. As already argued, *Vinci* works to create a sense of direct affective contact with what is happening on stage through remediation. Another way in which Lepage draws the audience into the experience of spectating *Vinci* is by recruiting them to be his proxies, looking upon his self-presentation from a vantage that he can never have himself. Hence Lepage's consistent emphasis throughout his career on the audience's active role in providing feedback on his productions: he uses a work-in-progress

approach so that he can incorporate spectator response as the productions develop. By this Lepage seems to acknowledge that audiences will see his self-representations more clearly than he can, and might be able to provide him with the returned look that will affirm the secure place in the world (in Lacanian terms, in the symbolic order) that he is seeking. To be thus interpellated by a creative artist is potentially a flattering experience for an audience member, but also an overdetermined, even coercive one. We become complicit in Lepage's attempts at self-reproduction; we become the other to his grasping, incomplete subjectivity. This raises further questions about the extent to which Lepage's engagement with representation, spectatorship, and the spectator/ performance boundary can be understood as culturally critical. A critical, post-dramatic theatre, in Bleeker's argument, exposes the constructed nature of perspective (as dramatic structure) and 'draw[s] attention to the "blind spots" in these seemingly perspective-less visions' (49). The observation that perspective is constructed thus contains the potential of progressive politics, in that it might help viewers to see how situations are not inevitable, but the result of processes and dependent on the position from which one is viewing. On the one hand, as we have seen, Lepage invites participation by offering complex representations that require their audiences to do ludic analytical work in order to understand them. In *Vinci*, by questioning the Renaissance ideal of art as a faithful rendering of the world, and by drawing attention to the spectator's and artist's roles in producing the meaning of the artwork, Lepage could be seen as inviting a critical perspective on the extent to which what we understand as reality is itself constructed and produced – by ourselves and by others. The extent of the piece's engagement in such politics of perspective is limited, however, by Lepage's use of the piece as a site of negotiation of his personal concerns. The blind spot here is Lepage himself – his projection of his personal concerns and struggles into the production, and his recruitment of the audience as his proxy in the production's complex exchange of looks. What might it actually mean for Lepage to see and be seen, to use his productions as a means by which he 'surrenders to the look' of the other 'and embraces its vertiginous effects' (Levin 184)? This is a key question that the production leaves open.

Vinci in the critics' gaze

The final piece of this argument concerns the reception of *Vinci*. The production was embraced by journalistic and scholarly critics alike, who offered a strong consensus that it was a metatheatrical meditation on the work of the artist; those familiar with Québec and Canadian narratives understood it also as a metonym for Québec's ongoing negotiation of its national identity. Those aspects of the production that communicated a negotiation of Lepage's queer identity and an exploration of themes of same-sex desire were not understood as such by critics and scholars. In the *Globe and Mail*, Matthew Fraser called the show an 'interior odyssey on the nature of art and human transience', while Raymond Bernatchez in *La Presse* called it a 'reflection

on art' in which 'Lepage desacralises theatre and creativity'.[xi] When the production toured to London, England, several critics found its content lightweight but were nonetheless highly praising of its 'remarkable' structure and capacity to connect with audiences (Edwardes 'Vinci') and its 'stream of visually arresting and magical stage pictures' (Taylor 'Art, Youth'). Only Robert Lévesque, in a rave review in *Le Devoir*, notes briefly a theme of same-sex desire in the production – in his reading, Philippe's crisis is the result of his 'defeated love' for Marc – but does not comment further on the production's depiction of gender and sexual difference.[xii] The Québec theatre magazine *Cahiers de théâtre Jeu*, following on from its weighty dossier coverage of *The Dragon's Trilogy*, devoted two articles totalling twenty-two pages to thick descriptive and glowing accounts of *Vinci* by Diane Pavlovic and Solange Lévesque. Pavlovic argues that *Vinci*'s 'polyvalence and imagination crystallises the new values of (Lepage)'s era: sophistication and postmodern humour, post-referendum universality, multiculturalism, and renewed humanism' ('Du décollage' 87).[xiii] Solange Lévesque, too, read the production as an expression of the national spirit of the day: while praising the production's 'maximum internal coherence' she notes that 'we can read in it the misery of being Québécois, the conflict of the young artist who is not yet recognised by society and who doesn't feel at home anywhere' (108).[xiv]

Subsequent academic treatment of the production further enlists it in service of the national project. Canadian critic Nigel Hunt argues in *TDR* that

> Philippe's journey ... is very much the journey of today's Québécois. In the 1960s and '70s Québec was resolutely insular and introspective, in reaction against the cultural and economic domination by Canada's English-speaking majority. By the '80s this struggle had largely paid off. Having fought to secure its own French identity, Québec could now afford to look beyond its own borders with renewed interest. Lepage exemplifies this new attitude. (110)

Like Hunt, Jeanne Bovet sees Lepage/Philippe as standing in for his generation. She calls Philippe's journey 'a historical return to his cultural roots: Europe, the Old Continent, from which the first settlers left for the New World' (6). That he discovers humanist values that resonate with his sends the affirming message that 'the great Renaissance artist and the "little Québécois" photographer are akin, united in mankind' (12). The scene with Leonardo in the Florentine bathroom, which she acknowledges takes place in 'a very explicit context of homosexual desire', also affirms values of humanism and universality: 'The body is the final proof of the fundamental equality of men, socially and culturally undifferentiated in their nakedness' (10). By making himself understood through multilingualism and by affirming his kinship with his European forebears, Philippe comes 'to discover that a strong sense of identity is the only way to reach awareness of the unity of mankind ... this revelation may also

xi 'une réflexion sur l'art'; 'désacralise le théâtre et la création'.
xii 'un amour défait'.
xiii 'sa polyvalence et son imagination cristallisent les nouvelles valeurs de son époque: sophistication et humour postmodernes, universalité post-référendaire, multiculturalisme, humanisme renouvelé'.
xiv 'cohérence interne maximale'; 'la misère d'être québécois, le conflit du jeune artiste que la société n'a pas encore reconnu et qui ne se sent chez lui nulle part'.

seem to apply to the situation of Québec in today's world' (4). Such an affirmation of a sense of a robust Québécois identity in the context of globalisation, however, relies on a narrative which understands Québec identity as wholly based in Europe, perpetuating the racialised ideology of Québécois *pur laine*. Humanism is connected to colonial narratives that perpetuated violent differentiation between peoples, undermining the utopic claims which Bovet makes for the production.

While Bovet sees *Vinci* as affirming Québec's connection to the old world, Hébert and Perelli-Contos, by contrast, argue that the production marks a heroic break from colonial traditions. They see Lepage's cheeky treatment of the Mona Lisa in both 'major and minor modes' (*La face cachée* 55) as evidence of a new sense of cultural liberation from 'historic and cultural colonial sources':

> By making a mockery of the cultural frameworks which have long guided Québécois society, Lepage definitively distances himself from traditional representation and 'high' culture, and particularly European culture which was once the norm and the rule, to celebrate the margins of identity. (55–6)[xv]

Such a position, these scholars go on to argue in their volume-length study of the production, is part of the 'new vision of the world' which Lepage offers in *Vinci* in response to a postmodern 'crisis in representation' (61, 62).[xvi] There is much that is persuasive in Hébert and Perelli-Contos's engagement with themes of vision in *Vinci*; their reading of the production's disruption of Renaissance perspective informs my own. Their extraordinary claims on behalf of the production – that *Vinci* demonstrates a fundamental paradigm shift in contemporary thought, 'a new relationship between the subject and object of knowledge' (141)[xvii] overturning the way subjectivity has been understood since antiquity – would have been more convincing if supported by contextualising argument beyond the production itself. If Lepage indeed ushered in a new epoch of artistic representation with *Vinci*, one would have hoped for evidence of the effects of this contribution.

The larger point here is the numerous and in some ways contradictory uses to which *Vinci* has been put in service of narratives of Québécois identity. This provides some context for the lack of recognition of or commentary on the production's queer and camp aspects: entering gender and sexuality in discussions could arguably have been seen as disruptive to the national work to which the production was conscripted. Within the context of histories of representation in which colonised Québec has been linked to homosexuality, acknowledging Lepage's queer self-representation might have destabilised narratives of Lepage as the representative of a new, confident, decolonised Québécois presence on the international scene. He may also have outwitted himself in encoding his queer references so thoroughly as to render them invisible

xv 'des modes majeur et mineur'; 'des sources historiques et culturelles coloniales'; 'En tournant en dérision les cadres culturels qui ont longtemps guidé la société québécoise, Lepage prend définitivement ses distances tant par rapport à la représentation traditionelle que par rapport à la "grande" culture, et plus particulièrement la culture européenne qui jadis était la norme, la règle, pour exalter les marges de l'identité.'
xvi 'une nouvelle vision du monde ... crise de la répresentation'.
xvii 'une nouvelle alliance entre le sujet et l'objet de connaissance'.

to spectators attuned to interpret representations by young Québécois artists within national and personal identitary frameworks – particularly those of Lepage, who was by this point already 'in the process of becoming a myth in a Québec that is hungry for them' (Pavlovic, 'Du décollage' 86–7).[xviii] The result of this was that Lepage's invitation in the production to help him see himself through and beyond his trauma was not accepted. His response, as we shall see, was not to render representations of gender and sexuality in his productions more legible in order to better enable a returned exchange of looks. Rather, those representations remain encoded, and largely unremarked on as such in critical and scholarly commentary. In this book's coda I identify moments in Lepage's subsequent solo productions *The Far Side of the Moon*, *The Andersen Project*, and *887* in which Lepage starts to confront the realities of the returned gaze.

Notes

1 A Théâtre Quat'sous production, *Vinci* toured in Québec, Canada, France, Switzerland, England, and Ireland between 1986 and 1988. I did not see the production live on stage. My knowledge of it rests primarily on an unpublished playtext in the Ex Machina archive, which includes line drawings of key moments of staging. This playtext includes French and English versions of the script, the latter translated by Linda Gaboriau; my citations here are from Gaboriau's translation. I have also viewed a video of the production in the Ex Machina archive, which is of poor quality and missing several later scenes.

2 These are *Vinci, Needles and Opium* (1992), *Elsinore* (1995), *The Far Side of the Moon* (2000), *The Andersen Project* (2005), and *887* (2015). Lepage created a previous solo piece, *Point de fuite*, in 1985, while he was working with Théâtre Repère, documentation of which is limited (see Beauchamp). For the purposes of this study I identify *Vinci* as the starting point of Lepage's self-construction through solo works that gained considerable public attention. In calling these solos I refer to the facts that Lepage plays the central self-identified character and other figures in all these productions, in contrast to the works involving multiple performers playing a variety of characters. All the solo shows include the participation of other artistic collaborators, such as the composer Daniel Touissant, who performed live music and sound effects in *Vinci*; frequently also involve body doubles, as in *Needles and Opium*, *Elsinore*, and *The Andersen Project*; and, as they became more elaborate, came to require extensive backstage crew. With every solo show from *Needles and Opium* to *Andersen*, Lepage has handed the performing of it to another actor to extend the production's touring life – Marc Labrèche in *Needles and Opium*, Peter Darling in *Elsinore*, and Yves Jacques in *Far Side* and *Andersen*. Labrèche also performs in the updated version of *Needles and Opium* which began touring in 2013 and includes a second actor, Wellesley Robertson III; the updated *Needles* is thus no longer a solo.

3 In *Needles and Opium*, for example, the Québécois artist is the actor Robert travelling to Paris on a voice-over assignment; the crisis is a romantic breakup; and the artistic interaction, in this case rather an oblique one, is with Jean Cocteau and Miles Davis (I treat *Needles and Opium*'s particular structural and aesthetic qualities on pp. 115–19). *Elsinore* is the only one of the solo productions to be based on an existing work, Shakespeare's *Hamlet*, and while not every aspect of that production fully maps onto this schematic, the focus on the

xviii 'en passe de devenir un mythe dans un Québec qui en est avide'.

suffering central figure and the general narrative trajectory resonate strongly with it. In *The Far Side of the Moon*, Philippe struggles with the death of his mother and goes on a literal voyage to Moscow and a symbolic/imagined voyage to outer space as he gives up hopes of an academic career and perhaps embraces one as an artist (see pp. 208–10). The central character of *The Andersen Project* is a successful composer commissioned by a major Paris opera house (see pp. 210–13), while *887* contains an important reversal: in it, Lepage himself is the famous artist, struggling with his ego and legacy, and the significant encounter is with his working-class, self-effacing father (see pp. 213–16).

4 Enhancing the theme of travel, the production programme took the form of an itinerary, listing its nine named sections: '1. Takeoff; 2. Big Ben, London (jet lag: *décalage*); 3. Virgin and Child with St Anne, National Gallery, London; 4. Burger King, boulevard Saint-Germain, Paris, Ve; 5. Mona Lisa, Oil on canvas 77 x 53 cm, Louvre, Paris; 6. Camping in Cannes; 7. Duomo, Firenze; 8. Shower room, Firenze; 9. Vinci (A Hillside of Olive Trees)' (Théâtre Quat'sous).

5 The playtext indicates that the scene 'Virgin and Child with St Anne' was meant to be videotaped or filmed in advance and then screened during the performance, allowing for point-of-view shots that would have been very difficult to achieve on stage. The existing video, however, does not include this material and shows only the end of the scene, played live by Lepage on stage. It is unclear whether the early parts of the scene were ever filmed and screened as part of the performance.

6 Lepage told Carole Fréchette (114) that he saw a drawing in the National Gallery in London called 'La Vierge et l'infant avec St Anne' ('Virgin and Child with St Anne'). In fact the Leonardo drawing of that subject in the National Gallery includes the figure of St John as a child; it is a study for the 1510 painting *Virgin and Child with St Anne*, now in the Louvre, in which St John is excluded. This drawing in the National Gallery dates from approximately 1507 and is commonly known as the Burlington House cartoon. See Kemp.

7 Bunzli notes that 'sexual and gender ambiguity are … involved' in the depiction of Mona, given that 'the audience knows that the character is being played with a man' ('Autobiography' 39), but does not expand on the potentially subversive politics of this.

8 The inclusion of the Statue of Liberty in this list is possibly a lateral reference to another performance that significantly contributed to Lepage's fame in Québec, and which he gave in the same year as *Vinci*'s premiere. As a member of the Ligue National d'Improvisation, a televised competition structured like a hockey match, Lepage performed a nine-minute solo improvisation on the theme of 'New York: reality and illusion' which began with him impersonating the Statue of Liberty. See 'Les quarantes ans de la LNI'.

9 The device of the tilted mirror also figures in the climactic scene in *The Far Side of the Moon*, in which that production's Philippe surrenders to the audience's gaze.

3

Lepage's cinematic dramaturgy

This chapter and the one that follows explore the ways in which Lepage uses cinematic techniques in his original theatre work, and the effects of these techniques. Many have noted his productions' cinematic qualities, and the scholars Ludovic Fouquet and Piotr Woycicki have explored his engagement with film at some length. I build on these studies and extend them further by drawing on film and media theory, on affect theory, and on the work of Jacques Rancière to focus on questions of spectatorship. As I argue, Lepage borrows filmic techniques and reworks them for the stage to keep theatre in step with changes in human perception brought about by advances in media technologies. For Lepage, taking such advances on board is essential for the relevance and future of theatre practices; they are a key tool in his attempts to evoke in his work the complex lived reality of contemporary culture in the developed world:

> The only way that theatre can evolve, can stay alive, is to embrace the vocabulary of other ways of telling stories … People think fast today. They're trained by TV, by cinematographic language, by the web and the clip. We can tell stories all kinds of ways these days. So our narrative vocabulary is very sophisticated. People know without knowing the names – they know '*mise-en-abyme*', 'flashback', 'flash forward', 'jump cut'… And we arrive in the theatre with our very metonymic way of telling a story … If we want theatre to be at the very least moving at the same rate as the spectator we have to adopt these other narrative languages … I'm not saying I'm always successful, but I try to tell stories by borrowing these narrative forms. We have to create a theatrical space that is not just a theatrical scenography. We have to create a cinematic scenography too. (Lepage and Mroz)[i]

i '… la seule façon dont le théâtre peut évoluer et peut rester vivant, c'est s'il amène dans son giron le vocabulaire des autres façons de raconter des histoires … les gens pensent vite aujourd'hui. Ils sont entraînés par la télévision, ils sont entraînés par le langage cinématographique, ils sont entraînés par le Web, le clip. On se fait raconter des histoires par toutes sortes de façons aujourd'hui. Donc, notre

Underlying Lepage's statements here is an understanding of the role of media in shaping human perception that echoes that of many scholars, who have long argued that the way we see the world is not 'a trans-historical given' (Boenisch 105) but is, rather, shaped by conditions of history and culture. In the 1930s Walter Benjamin explored the implications of reproducing works of art through printing and photography (1968). Several decades later, Marshall McLuhan famously extended this line of thought by arguing that the medium in which an idea or expression is conveyed fundamentally shapes that communication. Mediation 'translates and transforms the sender, the receiver, and the message' (90). Media are thus 'by no means a neutral means to communicate or express something, but ... shape what can be thought, said, and stated at all times' (Boenisch 105). Lev Manovich furthered these arguments by naming cinema 'the key cultural form of the 20th century' (9), and arguing that the language of cinema provides the building blocks for the next epochal medial turn, to the digital:

> Rather than being merely one cultural language among others, cinema is now becoming *the* cultural interface, a toolbox for all cultural communication, overtaking the printed word ... Cinematic means of perception, of connecting time and space, of representing human memory, thinking, and emotion have become a way of work and a way of life for millions in the computer age. Cinema's aesthetic strategies have become basic organisational principles of computer software ... In short what was cinema is now the human–computer interface. (86, emphasis in original)

Manovich here builds on Jay David Bolter and Richard Grusin's understanding of the evolution of media forms not as a series of ruptures but as an ongoing evolution: film itself borrowed much of its representational language from (that is, *remediated*) theatre, and the language of human–computer interface – which, as Manovich argues, is the emerging dominant media form of the twenty-first century – borrows much of its formal language and logic, in turn, from cinema. This discussion of Lepage's remediation of cinema techniques extends the consideration in Chapter 2 of his early solo show *Vinci* as a remediation of depictions of perspective in Early Modern visual art (see pp. 65–91).

A key term which many scholars use in discussions of Lepage's theatre is *montage*, meaning 'the process or technique of selecting, editing, and piecing together separate sections of a film to form a continuous whole' (Oxford Dictionaries). As the Oxford definition indicates, montage is a term most often associated with cinema: the 'joining of one piece of film with another' (Bordwell 14) is a basic building block of the work of film directors, part of how they construct the overall piece and give it a particular signature. It is broadly agreed that Lepage's approach to theatrical creation is notable

vocabulaire narratif est extrêmement sophistiqué. Les gens savent – il ne les appelle pas comme ça mais ils savent 'mise en abyme', '*flashback*', '*flash forward*', '*jump cut*'... Et nous arrivons au théâtre avec notre méthode très métonymique de raconter une histoire ... Si on veut que le théâtre soit au moins à la même vitesse que le spectateur, il faut adopter ces langages narratifs ... Je n'ai pas la prétention de toujours réussir, mais j'essaie de raconter des histoires en empruntant ces formes narratives. Il faut créer un lieu théâtral qui n'est pas juste une scénographie de théâtre; il faut créer une scénographie de cinéma aussi.'

for its focus on the assembly of material on stage (bodies, scenography, other technical and technological elements), and for the ways in which his approach to this draws on cinematic techniques; many accounts of his work, including those of Steve Dixon, Fouquet, Izabella Pluta, James Reynolds, and Woycicki explicitly use the term montage to describe this. Here I take account of and add to those assessments, focusing in particular on Lepage's adaptation to the stage of spatial montage or 'montage within a shot', in which 'separate realities form contingent parts of a single image' (Manovich 148). Scholars including Bill Marshall and Peter Dickinson have identified Lepage's use of spatial montage as a signature aspect of his filmmaking, through which he creates 'space-time collapses' (Dickinson, 'Space' 133) that productively disrupt the relationship of past to present in a film's storytelling. Marshall argues that 'montage in Lepage's cinema [is] organised within the image or shot itself', and identifies this with Deleuze's concept of the crystal-image (309), in which a virtual image and an actual image '"run after each other", refer to each other, reflect each other, without it being possible to say which is first, and tend *ultimately* to become confused by slipping into the same point of indiscernibility' (Deleuze 46, emphasis in original). To these insights I add my own: that Lepage integrated spatial montage techniques into his theatre productions before re-remediating them into his films. These allow him to present multiple characters, activities, and/or scenic elements on stage simultaneously and suggest a relationship between them, exploiting theatre's unique qualities of liveness and three-dimensionality to make montage do representational, symbolic, and affective work not achievable in screened forms of representation.

In this chapter I look back to Lepage's early career to chart his development of spatial montage techniques in *Vinci* and *The Dragon's Trilogy*, and in so doing argue that his work engages with metaphor and metonymy in complex ways. I then explore how Lepage uses these techniques alongside film genre as building blocks of *Polygraph* and *Needles and Opium*. Discussion of *Tectonic Plates* reveals that, as his works grew in ambition, reference, and scale, Lepage struggled with overall narrative construction – that is, with montage in its basic definition, the arrangement of elements – and with the integration of material that represented a culture that was not his own or that of his earliest collaborators, who were all Québécois. The convergence of metaphoric and metonymic significations disrupted a structure in which meanings were clearly intended to remain iterative and suggestive, rather than definitive.

This consideration of the containment (or not) of signification in Lepage's work opens up larger questions about the cultural and political work that his productions accomplish. Chapter 4 foregrounds these central questions: to what extent do Lepage's theatremaking techniques draw attention to themselves as such, and therefore keep spectators at a certain remove from the work? Does his adoption of cinematic techniques invite spectators into a familiar mode of representation and promote immersion in his productions' plotting and characterisation; or does the fact that these techniques have been re-appropriated into another representational form – theatre – render them strange (in the Brechtian sense), so that the spectator is drawn out of the viewing experience and invited to reflect on the representation as representation? Addressing these issues requires, first of all, a consideration of the important role that affect plays in Lepage's work – an overlooked aspect of his

practice in the existing scholarship. I place this consideration in the context of Jacques Rancière's influential disruption of passive/active binaries around spectatorship. In my view Lepage's work invites spectatorship that 'moves back and forth between a Brechtian-style critical specular relation to the stage and a more Artaudian immersive, experiential connection' (Stevens 13) – a relationship that Lara Stevens understands to be definitional of Rancière's emancipated spectator. My argument builds from a consideration of signature moments of affectually powerful staging to consideration of Lepage's overall construction of his works in terms of dramaturgy, plot, and characterisation. Thinking through these terms allows a nuanced discussion of the effects of Lepage's productions and the ways in which they sometimes (but not always) invite what Hans-Thies Lehmann has influentially termed a 'politics of perception' (184).

Lepage's montage techniques

The cinematic qualities of Lepage's theatre productions are frequently noted by journalists and scholars. Andy Lavender, for example, underlines the extent to which Lepage engages the 'rhetorics of cinema, television, and video – flashback, flashforward, intercutting, cross-fade, image flow, [and] multiple imaging' in *Elsinore*. 'We experience [Lepage's] theatre with the eyes and ears of cinemagoers in a video age', Lavender argues, 'even as it trades in showmanship reminiscent of previous kinds of theatre' (143). Calling Lepage's a 'cinematic sensibility', Dixon identifies characteristic moments in Lepage's stagecraft in which 'leaps of creative thought' are communicated through multiple cinematic techniques adapted to the stage:

> he creates theatrical equivalents to film postproduction dissolve/mix effects; he echoes colours, shapes, and visual compositions in order to 'cut' seamlessly and elegantly from one scene to the next; or he may jump-cut between an event and its consequences for maximum dramatic impact. (503)

Of all the 'technological devices' and media that Lepage employs in his productions, Woycicki argues, 'his main interest and fascination seems to lie with film, and more specifically, with a cinematic way of telling stories' (40). Similarly, Fouquet identifies cinema as the audiovisual medium 'most referred to in Lepagean aesthetics' (*Visual* 108). More than an 'inspiration' or 'breeding ground', Fouquet argues, cinema is 'a foundation or a spectre' underlying any of Lepage's stage compositions (132). He likens Lepage's dramaturgical activity in his productions to 'a director in the editing room: he moves shots and rebuilds sequences in different orders. He has total control over the final cut' (109). In addition to these techniques of ordering and composing material, which Fouquet calls montage ('editing' in Rhonda Mullins' English translation of his book), he also identifies framing as one of Lepage's fundamental creative tools, through which he 'play[s] with depth of field, points of view, and the movement of the frame itself' (123). Fouquet hones in on the ways in which Lepage combines

montage and framing techniques to guide spectators' perception of their relationship to the stage action: framing, as he describes it, is Lepage working 'to vary the position of the camera' so that 'the audience's gaze no longer depends on its relation to the stage' (127). The camera doesn't literally exist here, of course: Fouquet's point is that Lepage puts the spectator in a similar position to a film's camera by giving her a sense of control over her vantage on the stage. He further notes that the cinematic gaze's mobility 'includes mobility within the sequence shot' (130).

Fouquet describes Lepage's engagement with cinematic techniques as a means of communicating with audiences on familiar terms by accessing 'shared references of a universal medium, references that are easily recognised by the audience' (120) – and thus as uncritical. In my assessment, and even in the terms that Fouquet has described it, however, critique is potential if not inherent in Lepage's approach: the destabilisation of the spectator's expected relationship to stage action is a way of highlighting the constructed nature of that relationship and the lack of inevitability of his productions' meanings. I will explore questions of the politics of perception generated by Lepage's montages in Chapter 4, making particular reference to the work of Woycicki and Reynolds (2019), who have made strong arguments for the critical and disruptive nature of Lepage's practices. I start here by introducing Lepage's use of montage techniques in his early productions: it comes across there as a series of experiments with their potential use-value and with the competencies he can reasonably expect a spectator to bring to the theatrical viewing experience.

A good place to start is Lepage's simulation of a spatial/temporal cut – the most basic of filmic editing moves, 'symbolic of the foundation of cinema itself' (Fouquet, *Visual* 113) – in the first section of *The Dragon's Trilogy*. As described in Chapter 1, the production was staged with audiences sitting on two sides of a rectangular playing area covered with sand, on which sat a small cabin initially representing a parking lot attendant's booth. The cabin figured in an early scene in which the characters Crawford and Wong moved from a ground-floor room in Wong's laundry shop downstairs to his basement. In film, the transition between the two locations might have been made via a simple cut from the ground-floor space to the basement. In Lepage's staging, Crawford and Wong enter the booth; the audience hear the sound of footsteps and the men's banter; there is a brief blackout as one of them says that the candle guiding their way has gone out; and the men then exit the cabin through the same door, indicating in their dialogue that they are now downstairs.[1] The effects of this sequence were several. It did the necessary work of changing location. It treated the cabin in a new way, identifying it now not as a parking attendant's booth but as a stairwell. It tweaked and defamiliarised the filmic technique of the cut by slowing it down and inviting the audience to imagine that the action was moving through space as well as time, even though stage objects remained stationary. Overall, it required the audience to read the staging on all these levels: to absorb and interpret the re-identification of the stage object, to follow the advancing plot, to apply their competence in reading film images in a new context, and to use their imaginations to conceptualise spatial as well as temporal shifts. In my observation, the effect on the audience was ludic and pleasurable: the sequence earned gentle audience laughter both times I saw the 2001 revival of *The Dragon's Trilogy*.

In a more complex instance of remediated filmic technique in *The Dragon's Trilogy*, Lepage fashioned a stage version of a Hollywood montage sequence, in which 'portions of a process are rendered through emblematic images linked by dissolves and other forms of punctuation' (Bordwell 82). Such a sequence functions as a temporal ellipse, that is, a stylistic gesture which compresses storytelling time (a familiar example from the romantic comedy genre is the falling-in-love montage, in which brief scenes of a couple getting to know each other are sequenced together). Lepage inserted a montage sequence into *The Dragon's Trilogy* not long after the stairwell scene just discussed: in his basement, Wong gives Crawford some opium as a thank-you gift for teaching him to play poker, and the two smoke it together. They then execute slow-motion choreography inspired by taï-chi, and are joined by the other main characters, who mime everyday activities in ways that presage upcoming events in the story. This includes the central characters, Jeanne and Françoise, at this point pre-teens, folding sheets and handling dishes before being separated in a whirlwind. The scene ends with Crawford and Wong in the same positions as at the beginning, back in the moment before the former receives the gift of opium from the latter.[2] When the next scene starts and relatively naturalist conventions resume, Jeanne and Françoise are costumed more maturely and smoking cigarettes; the dialogue communicates that they are three years older than before.

On one level this sequence serves the same purpose as a Hollywood montage, moving the time frame forward to the next section, in which Jeanne and Françoise are older, and communicating that new activities have been introduced into the life of the community – drug use and gambling. But it also hints at events yet to happen in the narrative, in particular the two girls being separated when Jeanne's father, Morin, loses her in a card game and she is married off to Wong's son, Lee. The framing of the sequence with Crawford and Wong's opium use provides a context for these complex significations: the audience are invited to consider what's happening as outside the expected workings of time and space – as if the characters, and perhaps viewers as well, are perceiving it through the altered perception of a drug trip. Thus, while spectators are invited to map their presumed existing familiarity with Hollywood montage effects onto their reading of the scene, Lepage also adds levels of complexity to this convention and challenges his audiences to follow along.

In both of these sequences we see Lepage experimenting with what can be accomplished by playing montage techniques live in front of audiences in three dimensions rather than composing them after the fact of filming, in the editing booth: in the stairwell sequence he plays with real-time movement through space and time, while in the opium montage he explores simultaneous action as well as fast-forward effects. The latter sequence is a version of what I have already introduced as spatial montage, which Manovich argues is the paradigm for screen storytelling in the digital era. Spatial montage attempts to push beyond the inherently sequential nature of film (in which images must necessarily appear frame after frame) to offer the impression of multiple time periods overlapping and intersecting in the same field. Relatively unfamiliar in twentieth-century mainstream film and television, spatial montage appears in avant-garde and experimental films in the form of superimpositions, rear-screen projection shots, and deep-focus effects (see Manovich 148–9). It found its way into

popular culture largely through music videos and is present in twenty-first-century pop cultural representations via split-screen techniques.

The three-dimensional nature of the stage is better geared to spatial montage than is the screen, because action does not necessarily have to advance sequentially, but can unfold simultaneously. Lepage exploits this fact via the creation of spatial montage techniques that allow him to place in proximity images and ideas which are not temporally connected and might not initially seem to be logically related, but which the production is presenting as linked. As Lepage articulated in the early 1990s, his use of such techniques is a response to the representational and perspectival limitations of traditional Western theatre:

> The perspective in theatre tends to be so expansive or wide-ranging that I find it hard to create intimate close-ups, blow-ups of small details, and ways to isolate things, to concentrate fully on them. However, the frame *around* the theatrical action allows me to create these filmic effects without a huge budget ... you can position a character downstage, saying such and such, while upstage, behind him, you can position a big icon which is suggesting something altogether different. (qtd in Salter 76, emphasis in original)

The technique he describes here – simultaneously presenting (or, if you will, superimposing) two or more characters, activities, and/or scenic elements on stage and thus suggesting a relationship between them – is what I am calling spatial montage.

Montage, metaphor, metonymy

Having established spatial montage as one of the key formal building blocks of Lepage's theatre, the question becomes the sorts of relationships that might be suggested through this technique. Lepage told Alison McAlpine in 1995 that he understands his theatremaking as metaphoric:

> Metaphorical storytelling is when you've seen a piece of theatre and you say, 'There was this thing going on, but at the same time there was another level that's going on, and then there's this other level and things seem to be connected in a vertical way: things are piled up.' (144)

The understanding of Lepage's stage work as driven by metaphor is widely accepted; Lavender, for example calls it 'a theatre of metaphor or simultaneity' (121). Spatial montage on a basic level functions metaphorically.

An early example is drawn from the first fully staged scene of *Vinci*, called 'Décollage' (in English, 'Take-Off'). The scene ostensibly takes place in a psychiatrist's office, with the central character, Philippe (played by Lepage), talking to the unseen psychiatrist about his problems with self-expression (the doctor is imagined to be in the audience's position, so that the actor addresses us directly) (figure 3.1). As he speaks, Philippe slowly turns on his chair until he is in profile; recorded sounds

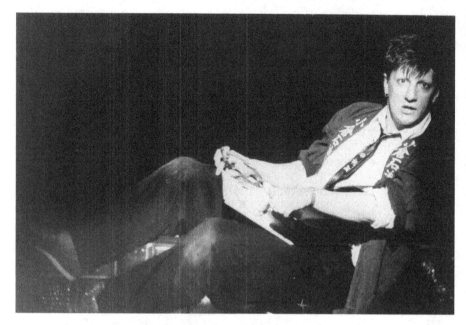

3.1 Robert Lepage in *Vinci*.

of an on-board airline announcement and a plane taking off are heard. He leans back in his seat to simulate the effect of take-off, while continuing his monologue about his personal and artistic difficulties and fear of 'letting myself go' (Lepage, *Vinci* 11). In the final lines of the monologue Philippe reveals that he's found psychoanalysis a waste of time and money and that he's going to Europe instead: 'I have a ticket for London next week' (ibid.). At first glance this could be considered another version of a Hollywood montage, creating an ellipsis in time, but what makes it particular is that it depicts that ellipse by making two subsequent time periods overlap. It is better described as a spatial montage intercutting two related, subsequent pieces of action: the therapy session in which Philippe reveals he is soon to travel to London, and the flight itself – a spatio-temporal overlapping that would not have been possible in a single-screen filmic context. It functions as a metaphor in that it overlaps a depiction of Philippe-as-analysand to Philippe-as-traveller and invites the audience to see them as similar to each other. This metaphoric relationship, likening the search for self-knowledge to physical journeying, extends throughout the production. As I explore in Chapter 2, *Vinci* frames Philippe's struggle to understand and realise himself as an artistic as well as personal one, likening it to Leonardo da Vinci's attempts to capture reality through representation. As these layers of meaning-making accrue, complex sequences and images are presented that can be analysed in the terms of semiotic condensation that I am soon to introduce, but my goal here is to provide this relatively simple example of spatial montage that introduces the production's central metaphor.

Spatial montage begins with comparison – things are placed on stage and a rela-

tionship is suggested between them – but in my view this relationship cannot fully be contained by metaphor. Other discursive figures come into play, specifically metonym and its subset, synecdoche. Before turning to Lepage's particular understanding of metonymy as it relates to his work, it is useful to review the definitions of these terms established by Roman Jakobson and elaborated by David Lodge. Metaphor is 'substitution based on a certain kind of similarity' (Lodge 75) in which, at the same time, there must be 'a feeling of disparity' between the two parts of the metaphor in order for it to function; they 'must belong to different spheres of thought' (ibid.). While metaphor is based on selection of its two parts, metonymy and synecdoche 'belong to the combination axis of language' (76). In metonymy, 'the name of an attribute or adjunct' (Oxford Dictionaries) is substituted for the thing intended, while in synecdoche a part substitutes for the whole. Creating a metonymy involves deleting items in a statement; this becomes a 'rhetorical figure' – choice and creativity are involved – in that the items deleted 'are not those which seem logically the most dispensable' (Lodge 76). Lodge offers the statement 'keels crossed the deep' as an example: keels is a synecdoche (standing in for the larger thing of which it is a part, a ship), while deep is a metonym: it stands in for 'sea' as a quality of the sea, and is not the obvious word choice – 'sea' would have been more straightforward (ibid.). A further crucial point about the difference between metonym and metaphor is that the former is an internal operation within the creative expression itself, while the latter plays out externally: '[s]election (and correspondingly substitution) deals with entities conjoined in the code but not in the given message, whereas, in the case of combination, the entities are conjoined in both or only in the actual message' (Jakobson 61). In the statement 'ships ploughed the sea', ploughed is a metaphorical reference, likening the motion of the ship's keel through the water to a plough moving through a field (see Lodge 75). The connection between ploughs and ships is 'conjoined in the code of English ... but not conjoined in the message', while the connection between keels and ships in the metonymic example 'reflects their actual existential contiguity in the world' (Lodge 77).

As previously established, Lepage describes his work as the vertical stacking of significations on top of each other and suggesting similarities between them, and calls this metaphoric. He contrasts this operation with metonymy, which he describes as 'more a horizontal thing: beginning, middle, and end – things happen in a certain order' (qtd in McAlpine 144). He associates this kind of structure with traditional theatrical dramaturgy, in which things happen in logical sequence: in theatre's 'very metonymic way of telling a story ... we make things very simple' (Lepage and Mroz). The implication here is that traditional metonymic dramaturgy relies on its elements having an essential sequential relationship to each other – of one thing needing to follow on from the next because the elements are necessarily and sequentially related through processes of cause and effect. His mode of working, as he articulates it, is not interested in necessary relationships between elements but, rather, in contingent, suggestive ones that stimulate the audience's imagination about what might connect them. Lepage indicates through these statements that he thinks of metonymy in terms of overall story construction and that he does not see it as an important part of his creative tool kit. It is my assertion that metonymy does appear in his work, in its

constituent units of signification as well as in the way in which these units are put together to form larger narrative structures. Questions of contexture – 'the process by which "any linguistic unit at one and the same time serves as a context for simpler units and/or finds its own context in a more complex linguistic unit"' (Jakobson qtd in Lodge 76) – come into play.

To return to a discussion of Lepage's work with the question of the relationship between metaphor and metonym in mind, I want to highlight a particular quality of his technique of spatial montage: that it works not by suggesting likenesses between discrete items placed near to each other, but by suggesting multiple significations of the same objects and bodies. This action of selection and substitution, ostensibly metaphoric, thus inherently contains combination and (another key term in this discussion) condensation. Jakobson and Lodge follow Freud's understanding of condensation as 'the process by which the latent quality of the dream is highly compressed, so that one item stands for many different dream thoughts' (Lodge 79 ff.). Eisenstein uses condensation to describe 'montage juxtapositions that are metonymic as well as metaphoric' (Lodge 85): this happens when a metaphoric operation of comparison is pursued to its breaking point, so that 'the chain of intervening links falls away, and there is produced instantaneous connection between the figure and our perception of the time to which it corresponds' (Eisenstein 14). While not explicitly linking his discussion to the Freudian or Eisensteinian applications of the term, Reynolds identifies 'semiotic condensation' as a key narrative mechanism in Lepage's work – by which he means Lepage's tendency to imbue objects and bodies with meanings to the point where 'significations appear as a tumult, as their … inter-relation cannot be assimilated quickly' ('Acting' 135). Reynolds offers an example from *The Far Side of the Moon*, in which the image of a puppet in a spacesuit brings together three aspects of the production – 'Philippe's life, the loss of his mother and [a] cosmonaut's spacewalk' (ibid.). The power of the image derives from the convergence of a number of meanings previously assigned to the puppet. Combining my analysis with Reynolds's, semiotic condensation happens when instances of spatial montage are layered to the point where they cease to function individually as metaphors and the spectator is invited (perhaps even compelled) to see them as metonymic – that is, to consider the connections between them as essential rather than circumstantial, an experience of convergence that delivers powerful affect, to the point of being difficult to assimilate. Interestingly, Reynolds references Brecht (via Herbert Blau) in his discussion of the puppet-astronaut sequence in *Far Side*; in Chapter 4 I will pursue the question of the potential Brechtian political efficacy of such moments, along with exploring their affects. Not all such instances of condensation in Lepage's work build to such a peak that their meanings overflow; rather, the relationships suggested by re-signification of the same objects and bodies through spatial montage accumulate and are stored as mounting potential towards such affect-laden moments. The point I am establishing here is that condensation, combining the work of metaphor and metonym, is a building block of Lepage's stagecraft that figures in his productions' broader contexture.

To look at such complex significations in action, I return to the first fully staged scene of *The Dragon's Trilogy*, introduced in Chapter 1 (see figure 1.4). In this scene, 'La Rue St-Joseph', Jeanne and Françoise play a game by creating a model of the main

street of their Québec City neighbourhood, with shoeboxes placed in rows representing shops and houses. One girl knocks on the top of a box and the other girl responds as the shopkeeper or inhabitant, and they banter about the news of the day and the life of the neighbourhood. They move on to the next building when one of the girls gives the order 'OK, en change!' (OK, let's change!). This game is interrupted when Crawford strides into the street and starts knocking on boxes, trying to find a place to sell the shoes he has brought with him from Hong Kong. Eventually, he knocks on Wong's door; Crawford's revelation that he speaks some Chinese prompts a longer conversation between the two men, and their professional and personal relationship is launched. The spatial montage here is the transformation of the girls' game into the street it represents. The miniature version of Rue St-Joseph which they created with shoeboxes seems to become real when Crawford appears in it, through a playful shift of spatial perspective. For a short period of stage time the two versions of the street co-exist simultaneously as Jeanne and Françoise send Crawford from shop to shop ('You can see very well I'm with another client. Go see Plamondon!') before he makes his way to Wong's (Pavlovic 45).[ii] Two related pieces of action – the girls' game-playing and Crawford's arrival – are spliced and played together in a spatio-temporal overlapping that is impossible in a mainstream filmic context. The sequence is based in a metaphoric relationship – the rows of boxes are like a street – which is then explored in a ludic fashion to suggest metonym, leading to condensation. What if the boxes actually were a street instead of just looking like one – and not just any street, but the very street in which the girls are playing the game? Playing out this 'what if?' creates meanings beyond the game itself; these meanings function in complex ways through multiple rhetorical figures.

To expand on the basic metaphor: boxes – more specifically, little girls playing with boxes – are like a street in Québec City in the 1910s in which an Englishman arrives from Hong Kong and encounters a Chinese immigrant. Following Eisenstein's theory of classic montage as described by Woycicki, the two images have a similar 'visual harmonics' (53) that bring the images together 'into a harmonic whole and by so doing gives a degree of aesthetic pleasure to the spectator, but [also] supports a message and an argument that may carry an ideological and political agenda' (55). An ideological reading of this metaphor in the Eisensteinian vein would read the girls' game in relationship to Wong and Crawford's encounter: both are images of Québec society under construction. But that very image contains complexities that cannot be contained within this metaphor. Synecdoche is at play in that the small-scale and immediate – the girls, their imagined street – stands in for the immature and still-developing Québec, 'a closed society full of racial, religious, and other prejudices' (Pavlovic 43).[iii] There is a subversive power relationship communicated through the fact that it is the girls who conjure the adult men: juvenile, feminised Québec is fashioning its future, one in which it will assert agency over the masculine coloniser. As discussed in Chapter 1, the critic Lorraine Camerlain found great emotional power in this scene which derived from the specificity of the girls' colloquial Québécois, their

ii 'Vous voyez ben que j'suis occupée avec une cliente. Allez-vous en donc chez Plamondon!'
iii 'une société fermée pleine de préjugés raciaux, religieux, et autres'.

evocation of an intimate neighbourhood familiar in nature to her, and the fact that history was being told through the perspective of women (86). While this reading is specific to Camerlain, it suggests the complexity and variety of possible reactions to the scene depending on the positionality of the spectator. While the relationship here begins with metaphor – the girls' game is like the Québec street – it tends towards metonym: its quality of playfulness, inventiveness, and cultural/linguistic specificity condenses qualities of Québec at this moment when it was opening up via immigration to new cultural influences. As the production continues, these themes extend: the story of Jeanne and Françoise, as they grow up, interact with Crawford, Wong, and the different cultures they bring with them, and as they and their families move westward across Canada from Toronto to Vancouver, suggests a much broader narrative of Québec's shift from an inward-looking, nationalist culture to one negotiating difference and interacting with the world (again, as explored in Chapter 1). 'La Rue St-Joseph' may not overflow into the kind of peak emotive moment described by Reynolds, nor would it have made much dramaturgical sense for it to do so, given how early in the production the scene falls. Rather, the combined action of metaphor and metonym in the spatial montage loads signification and affective potential into the sequence which is then built on as the production progresses.

Spatial montage and genre: three case studies

In this chapter thus far I have established spatial montage – the simultaneous presentation on stage of two or more bodies, objects, and/or activities – as a key building block in Lepage's dramaturgy, and have argued that this technique allows him to communicate complex relationships between what is presented through figures that often combine metaphor and metonymy. I offered examples of these techniques in *Vinci* and *The Dragon's Trilogy*. In productions created in the late 1980s and 1990s Lepage continued to experiment with the potentials of spatial montage, alongside another key structuring element: genre. As do filmmakers, novelists, and other artists working with genre, Lepage uses generic conventions as a scaffolding on which to build narrative and as a shorthand for spectators as they decode the various signifiers in the overall piece. In Chapter 1, I established Lepage's gravitation towards melodrama; this has become the genre on which he is most reliant, as he acknowledges in the 2007 book *Creating for the Stage*: 'Basically, our stories are melodramas!' (24). Indeed, many of his productions involve a number of melodramatic qualities: an extremity of situation and emotion, the omnipresence of suffering in characters' lives, an emphasis on the relationship of past to present, and a foregrounding of the role of chance and coincidence in determining human fates. Lepage describes the melodramatic aspects of his productions as a means to 'appeal to the intelligence of the audience' by starting with 'stories that are relatively simple, or simple at first glance' and then grow in complexity and towards a 'more universal narrative where the themes reach beyond the scope of the individual's travails' (ibid.). Lepage here points to the broadly meta-

phorical nature of his theatre – the simple story is compared to the 'more universal' story – an account which I am complicating through this discussion of his integration of other rhetorical figures into these metaphorical structures. In what follows I trace Lepage's engagement with the tropes of melodrama as an overall structuring agent for his large-scale productions by looking specifically at *Tectonic Plates*, while also exploring his experimentation with the cinematic genres of thriller and art film in the smaller-scale works *Polygraph* and *Needles and Opium*.

Tectonic Plates: melodramatic drift

Plaques tectoniques/Tectonic Plates, created and toured between 1987 and 1991, was Lepage's next major group-created show following on from the international success of *The Dragon's Trilogy*. It furthered his desire to work with artists from other national backgrounds and to explore themes of travel and the relationships between cultures that were now informed by his own experience. It was an ambitious project and its creative process was fractious, as Lepage and his collaborators struggled with structuring the production and with differing interpretations of its central premise – continental drift and the relationship between Europe and North America (its starting creative resource was a jigsaw-puzzle map of the world).[3] Over the production's four-year development and production period as documented by Jill MacDougall, we can observe Lepage testing the metaphorical or vertical stacking approach (that is, his methodology of presenting a series of suggestive likenesses) by pushing it to its limits. The initial idea behind the show's structure was that it would be made in a number of stand-alone sections which, 'like interlocking pieces of a jigsaw puzzle ... could be presented alone or fit into [the] larger picture' of a marathon show which could run for between six and twelve hours (156). The production was thus envisioned as drifting structurally, without its montage ever being fixed in place. The first presented version, in 1988 in Toronto, involved five disconnected scenes, all of which treated the relationship between Europe and North America, largely through stories of individuals (156–8). In 1989 the production hit a major snag when the collaborators cancelled a long-scheduled appearance at the Festival de Théâtre des Amériques in Montréal because they were unable to work the material into something they felt was performable (139–40) – the first of several high-profile last-minute postponements and cancellations in Lepage's career.[4] When the company regrouped in Québec City for their next workshop, Lepage announced that he wanted the production to focus on one of the characters that had emerged in the first version – Madeleine, a Québec City art history student on a soul-searching visit to 1960s Venice; and that he wanted to 'develop the sexually ambivalent character of Georges Sand' (177). While drifting became a central theme, the production ended up moving more towards a fixed formal structure than Lepage had hoped. It increasingly came to deliver coherent (if temporally fractured) plot and characters, and to rely, as did *The Dragon's Trilogy*, on the tropes of melodrama as structuring agents. The continental drift concept evolved

into a metaphor for human psychology, as Joyce McMillan articulated in her review of the production's Glasgow run:

> Its controlling image is immensely powerful, based on the geological reality of the huge, shifting continental plates which make up the earth's surface. The idea is that beneath the surface of human behaviour, continents (both literal and metaphorical) are moving, separating, colliding, grinding; and that the life in human affairs paradoxically emerges from the destruction that takes place at these points of impact and inundation. ('Chopin')

These 'themes of cultural and sexual fault-lines and convergences' (ibid.) were communicated, in the show's final version, through the stories of characters in extreme, emotive situations; suffering in dysfunctional or hopeless romantic and family relationships; struggling with their pasts and identities; and searching for guidance and enlightenment through numerous means, from drugs to travel to gender transformation to, most centrally, psychotherapy. The final version focused on three Québécois characters: the transgendered Jacques/Jennifer McMann (played by Lepage), a character inspired in part by Georges Sand; Madeleine (played by Marie Gignac); and Antoine (played by Richard Fréchette).[5] The three characters meet in university, where their emotional lives become entangled – Madeleine loves Jacques, who is in love with Antoine, who is deaf-mute. Their stories are thematically linked to nineteenth-century Romanticism and the historical figures of Sand and Frederic Chopin; and to the 1960s–1970s counterculture and the music of Jim Morrison and the Doors. Père Lachaise cemetery in Paris, where Morrison and many other artists are buried, became one of the principal creative 'landmarks' in the production, along with the jigsaw-puzzle map (MacDougall 142). The centrepiece of Michael Levine's design, a shallow onstage pool which initially represented the Atlantic ocean, came to suggest the human psyche.

In the production's final version, which played in Glasgow and London in 1990, the central theme of drifting was communicated on numerous visual and narrative levels and fuelled by metaphoric comparison. A pair of grand pianos served their literal function in the Chopin plotline, were moved around to suggest continents shifting, and were then used as the playing space of a scene set in a garret. Stacks of books suggested a library or bookstore, but with a change of lighting 'their white-striped bindings can represent the Manhattan skyline' (150). Madeleine, lovelorn and rudderless in her post-university years, falls in with artistic drifters on a trip to Venice, wanders into an art auction where Delacroix's portrait of Sand is being sold, and meets a Welsh pianist with a passion for Chopin (figure 3.2). These coincidental and seemingly happenstance events in some cases became meaningful: Madeleine goes on to become an art historian, and in a scene set twenty years after her time in Venice gives a lecture about the Delacroix painting. Opinions were divided among commentators as to whether the production's technique of accumulating metaphors was usefully suggestive or excessively vague. For Mary Brennan, writing in the Glasgow *Herald*, the '[s]hifts and influences. Vibrations and coincidences. Co-incidences, really, with the word taking on the full meaning of impact and collision' did add up: 'as the episodes accumulate across some three or more hours, strands emerge that draw them together'. In the *Times Literary Supplement* James Campbell identified

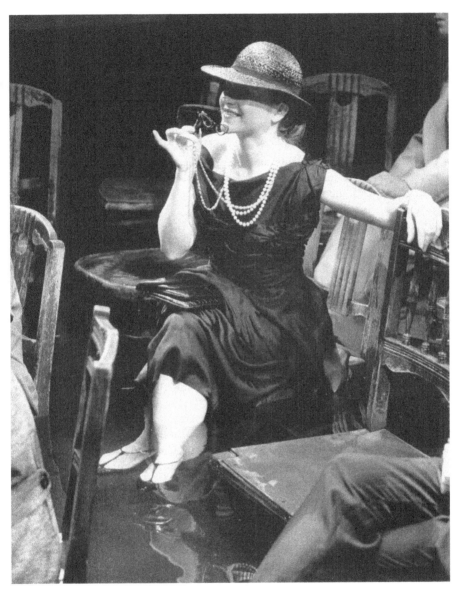

3.2 Lorraine Côté in *Tectonic Plates*.

'music, the human voice, death by water, transsexuality, Celtic myth, and above all, the interaction of art and human drama' as the show's 'central metaphors', brought together through 'Lepage's genius in creating connections that ultimately cohere in the imagination' ('Shifting'). *The Sunday Times*'s John Peter noted a 'touch of playful sadism, both physical and intellectual' in the show's profusion of references and allusions: 'Psychology closely resembles geology: you look for hidden layers. Human life

is a series of broken relationships: people drift apart like broken continents separated by dark waters. To love is to drown' ('Reflecting'). In the *Independent on Sunday* Irving Wardle, by contrast, questioned whether Lepage's methodology of 'interrogating a chosen object on the assumption that it contains hidden links with other objects across space and time' created a production that was sufficiently 'about' something: the likening of continental drift to human relationships was 'too vast to mean anything … how, if life consists of drifting, can there be any purposeful action?' ('Making').

An aspect of the production that was questionable for some of its Scottish participants and commentators was the inclusion of culturally specific content among numerous themes and plot points compared via metaphor. The reference in question – to the figure of Sgàthach, a mythic Celtic warrior woman called Skaddie in the production – was at the centre of a bravura sequence of spatial montage which helped to establish the pool/human psyche metaphor. In the sequence, Lepage as Jacques, wearing a long red wig, sits opposite a female psychiatrist in the pool. In a convention that extends throughout the production, neither seems to notice that their feet and lower calves are submerged in water. The psychiatrist asks Jacques to describe a recent dream, and it springs to life. A female actor 'with long red hair, bare-breasted and wearing a Scottish kilt' (MacDougall 148) has been hanging from a metal radio tower on one side of the stage, clanging two swords together (figure 3.3). She jumps into the pool, offers Jacques a sword, and they duel, ending with her bringing her sword between his legs and him collapsing into the pool as red liquid billows around him (figure 3.4). The 'Scottish amazon', dripping and panting, replaces Jacques in his chair. '"Well, Jacques", says the unflappable psychiatrist, apparently ignoring the radical metamorphosis of her patient. "I can see we have a lot of work to do"' (149).

Here spatial montage allows the integration of a scene understood to have actually happened (the therapy session) with the imagined, symbolic representation of Jacques' gender transition. As MacDougall argues, the sequence establishes the pool as the '[i]ronic device and metaphorical medium in which the actors literally bathe' (ibid.). The pool stands in as shorthand for the transformative nature of the psychotherapeutic encounter, its phenomenological presence (the actors are actually wet; there is audible and visible splashing) adding a layer of theatricality to the filmic spatial montage technique. In further scenes, the pool continues to be the site where characters undergo therapy and recall past traumas, as when the character Stewart remembers his sexual abuse of his daughter Constance.

The metaphor suggested by the spatial montage likens Jacques to Skaddie and presents his experience of psychotherapy as key to his transformation from male to female. The fact that this transformation involved not only gendered but cultural identity became a sticking point for some of the production's Scottish collaborators and commentators, who balked at seeing an aspect of their culture entering into the production's shifting web of comparisons in ways they found stereotypical. The production had gone through two significant development periods in Canada before the cast was expanded to include four Scots and one Welshman (whom the Québécois performers called 'the Celts'; MacDougall 167). The fundamental structure and themes as well as many of the characters that the Celts would play were already set in place when they joined the company; this included the Skaddie figure (see Carson 48–9 and

3.3 Emma Davie as Skaddie in *Tectonic Plates.*

MacDougall). The Québécois devised this figure through improvisation, and when Lepage discovered that she really existed in Celtic mythology it was a 'confirmation' of the effectiveness of his creative process: 'When you confront that kind of coincidence you believe in the alchemy of art,' he said in 1992 (qtd in Fricker 'Interview'). But this ready-made representation of their culture (played by a Québécoise) made some of the Celts uncomfortable. 'In Scotland that kind of grated with us a little bit,' explained the Scottish actor Emma Davie. 'Although we liked it theatrically we didn't know how it expressed our identity' (qtd in Carson 49). Skaddie was singled out by McMillan as the production's significant flaw: 'to a Scottish audience, this Rob Roy imagery looks like a joke' ('Chopin'). Davie and McMillan saw metonym or synecdoche where the Québécois saw metaphor: that is, they understood Skaddie to be intended as an attribute of Scotland standing in for Scotland, but for them this was an obvious, limited, and stereotypical reference point. This demonstrates a larger

3.4 Robert Lepage as Jacques and Emma Davie as Skaddie in the film version of *Tectonic Plates*.

concern which plays out across a number of Lepage's productions: the layering of metaphorical meanings can snag for spectators who perceive culturally specific significations attached to an element in that meaning-making system (I further explore such concerns in the following chapter).

Beyond this specific instance, observers of the *Tectonic Plates* creative process noted more basic differences between the Québécois and Celtic performers' understanding of what constituted culture. The Québécois were surprised that, in an initial group discussion in which Lepage presented the jigsaw map and asked the collaborators for their associations, the Celts continually brought the focus to political and geo-political issues – 'apartheid and genocide, nuclear plants and nuclear warheads, droughts, famine, global pollution, torture, and dictatorship' – whereas the Québécois' associations were more in the realm of 'personal anecdotes' (MacDougall 167). Lepage told the critic Mark Fisher that the Celts' seriousness took the Québécois aback: 'In Canada there are TV shows for that!' ('Celtic'). As MacDougall argues, the Québécois creators tended to pass off such discrepancies as 'cultural differences' (168) rather than delve into the ideological differences that they seemed to belie, and perhaps to use the outcomes of such discussions as material. The Québécois' approach seems driven, on one level, by the desire to preserve the potential for metaphor to drive the production's significations through iterative comparisons, without references doubling back to topical, real-world situations. Nonetheless, in MacDougall's persuasive reading, the production also subtly communicated concerns particular to Québec. The production was created in the context of a Québécois nationalist renaissance, given controversies

over the Canadian constitution and language laws that led to the Meech Lake crisis.[6] While *Tectonic Plates* seemed to steer clear of politics on the surface, MacDougall argues that its eventual focus on 'the narcissistic and pathologically divided self-describe[d] a trajectory leading back to the collective identity problematic' (6); that is, it was possible to read the troubled individuals at its centre synecdochically, as representative of Québec itself. The production, in her view, 'plays with the motors of national anxiety: the fear of losing the language and the concomitant fear of disappearing as a distinct society' (175–6). The three main characters were all Québécois struggling for – but not literally finding – a voice. There was Madeleine, the archetypical Lepagean figure of the Québec artist on a journey of self-discovery, who started out pursuing the 'talking cure' of therapy but instead becomes a painter, 'expressing her voice through the visual medium' (188). Antoine is mute but ends up being the character with the most agency in terms of reuniting the old friends and is associated with several alternative modes of communication – sign language and touching a speaker's throat to feel the vibrations of their speech. After his therapeutic breakthrough in the pool, Jacques becomes Jennifer, moves to New York, and hosts a radio talk show about literature and the arts – thus making a living through her voice.

While this theme of cultural and linguistic identity was focused largely around Québec, it was extended in the brief exchange between Madeleine and the famous pianist she meets in Venice:

> 'Are you an artist?' he questions. 'No, just a student', she replies. He presents himself as William Reese, virtuoso. 'Are you French?' asks the pianist in a very upper-class British accent. 'Non, Québécoise', she mumbles. 'And you, you are English?' questions Madeleine. The pianist hesitates and then says, 'Uh, no, Welsh'. (MacDougall 190)

This moment consistently provoked laughter, MacDougall reports, in a variety of locations where the production played. The humour was located in the way in which the exchange pinpointed a larger problematic – the elusive nature of cultural and personal identity – through well-observed particulars:

> It is in the moment of the shift ... that the subject can be discovered. The laughter indicates both recognition and surprise. The spectators savour the joke of being caught in the jostling of positions along binary gaps: minority/majority, personal/political, self/other. (196)

In this exchange the concept of drift so central to the production seemed to find its desired realisation by both pointing to and undercutting the idea of fixed identities, on a number of levels: Madeleine's question exposes Reese (who initially transmits identity markers of privilege) as minoritised, and this revelation has the effect of levelling power relations between him and the younger, female, not-famous Madeleine. Metaphor and metonym converge: a comparison between the characters is both accurate and incommensurate; they are like each other, but connected also to cultural reference points familiar to the audience on and which the sequence and its humour depends.

In the same period as he was testing the limits of a metaphorical/melodramatic approach to story construction through the ambitious international project that was

Tectonic Plates, Lepage also worked on two smaller-scale projects in which he experimented with the capacity of montage to simulate film genre on stage: *Polygraph* and *Needles and Opium*.

Polygraph: A stage thriller

Polygraphe/Polygraph (1988–91) was Lepage's first significant foray into the detective genre, with which he would further engage in his first film, *Le Confessional*. It is a three-hander he co-wrote and performed in with one of his *Dragon's Trilogy* collaborators, Marie Brassard (figure 3.5).[7]

In discussing this production I will make use of film studies terminology to make the distinction between the story which viewers understand a film to have told, which is called the fabula, and the 'actual arrangement and presentation' of the pieces of the story in the film, which is called the syuzhet (Bordwell 50).[8] As David Bordwell has argued, the 'central formal convention of the detective tale' is the viewer's 'activity of piecing together cause and effect in the crime fabula' (69). It is a genre that relies on particularly active spectator engagement as syuzhet information is strategically disclosed and viewers attempt to fill narrative gaps. Lepage and Brassard, in this spirit, focused on the delivery of information to spectators, but *Polygraph* was a genre piece

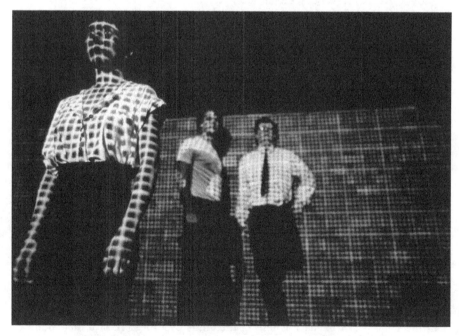

3.5 Marie Brassard, Pierre Phillippe Guay, and Robert Lepage in *Polygraph*.

with a difference, as the production's subtitle – 'a metaphysical detective story' – suggests. While detective films are structured around an investigation of a previously committed crime, in *Polygraph* the investigation is putatively over (if inconclusive). True to the detective genre, the production promotes suspense and surprise as it reveals information to spectators, but the key plot point is not the discovery of who killed Marie-Claude Légaré (indeed this information is never revealed). Rather than the questions and answers that detective stories usually provide, Brassard and Lepage were interested in indeterminacy and the elusiveness of truth. The overriding metaphor was the relationship of representation to reality; this was most clearly articulated in a plot strand about a film being made about the Légaré murder, in which the actress Lucie agrees to perform until she realises that her friend and neighbour François was a suspect in the case, which was never solved.[9] The production queries the ethics of such representations of real-life crimes, and presents numerous situations in which truth and falsehood become blurred. The message is summed up in a scene in which the German criminologist, David, gives a stacking Russian matrushka doll to Lucie, which he says represents generations of people, but 'can stand for many other things, I believe, like Truth. One truth which is hiding within another truth, and another one and another one ...' (Brassard and Lepage 58). The production worked to evoke the slipperiness of representation via a self-conscious engagement in a genre which depicts the forensic pursuit of truth. Michael Sidnell argues that *Polygraph* casts negative judgement on 'filmmaking as voyeuristically detached with respect to what it produces and inartistically involved with its subject in its processes' (46). As regards the play's treatment of the film-within-a-play, this critique certainly applies. But, overall, the play's relationship to film is more engaged and ambiguous than Sidnell allows: Brassard and Lepage plumbed the filmic medium for technical, narrative, and stylistic inspirations and material, even as they query the ethics of a specific film's relationship to its subject. For the *New York Times*'s critic Stephen Holden, what made *Polygraph* 'fascinating' was its creators' attempt to 'make a play that has the form and texture of a film' made up of 'twenty short "sequences" in which theatrical equivalents are found for filmmaking techniques like dissolves, cross-cutting, montage, flashbacks, dream sequences, and slow-motion action'. The most apt comparator for *Polygraph*, Holden argues, 'is not a play but Michelangelo Antonioni's mystery film *Blow Up*'; as in that film, 'the more one learns of what might have taken place, the deeper the mystery becomes' (Holden).

While *Polygraph*'s engagement with the detective film is knowing, the production also draws, seemingly less self-consciously, on melodrama. This is evident in its dependence on coincidences to drive the plot forward: Lucie happens to meet David in the Montréal Metro as they both witness a suicide; David was involved in the investigation of a murder six years earlier in which François was a suspect; and Lucie, in the course of the play, is cast as the victim in a film about the murder. The central role played by romantic/sexual relationships is also a key melodramatic element: the story of Lucie and David's affair after their coincidental first meeting propels the story forward, alongside the question of François's involvement in the murder. The steering of viewers' identification towards the whole situation and the full range of characters rather than a single character (in the detective story, the investigator) is

another melodramatic element, as is the way in which Lepage uses '[a]ll the expressive resources of mise-en-scène ... to convey inner states (Bordwell 70) – in this case live music, scenography, and choreographed sequences communicating relationships and characters' feelings. The surprising plot twist of a sexual encounter between Lucie and François (who is otherwise depicted as gay) provokes the production's most quintessentially melodramatic sequence, when Lucie tells David that the carnal knowledge she now has of François is, for her, proof of his innocence, more than anything else he might say or do. This assertion is a further extension of a sentiment repeated several times throughout the production and embodied by the polygraph machine itself – 'the body never lies' – and communicates a melodramatic understanding of 'the body as the site for the heightened expression of largely unconscious meaning and investment' (Hunting 27–8).[10]

As Greg Giesekam argues, the production's intermedial nature must be taken on board when assessing its commentary on representation. Its exploration of what Lepage portrays 'as the voyeuristic nature of film, with its one-way gaze' is contrasted 'with the interactive gaze of the live performer and spectator' (220) through spatial montage techniques, which are used to both deliver and deconstruct the detective story's generic conventions. On the one hand, the technique is used to provide narrative information in the crime fabula by flashing back and forth between past and present, creating the impression, as per the genre, that forward motion is being made towards revelation of the truth. At the same time these sequences offer comment on the impossibility of discerning truth from fiction and on theatrical and filmic representations as themselves built on pretence. In an early scene in which Lucie auditions for the film, for example, she is asked to imagine herself 'in an absolute state of panic'. She screams, and the action shifts (via changes of lighting and use of projections) to the moment of the Métro suicide; we do not see the incident itself but, rather, Lucie's reaction and David approaching and comforting her. The scene shifts back to the audition, and Lucie asks 'Was that enough?' followed immediately by a blackout (Brassard and Lepage 54). The full implications of this complex piece of staging become apparent as the action unfolds. A first level of signification is offered as the audience perceives that Lucie, in order to fulfil the method acting task given to by her auditioners, is recalling a real-life trauma. Initially her scream comes across as faked panic to prove her acting skills; but then, through the spatial montage, we understand that Lucie is actually panicking in the past moment of the trauma. The scream is both real and faked at the same time, both and neither, thus introducing the theme of the relationship between reality and representation, and the moral complexities that emerge when the lines between them are blurred. This theme is advanced in a scene in which Lucie reveals to David one of the tricks of the acting trade: eye drops that help to simulate crying. She lets him try them, and the scene shifts to David's recollection of a letter he received from the woman he left behind when he emigrated to Canada from Germany. When the action shifts back to Lucie's dressing room, David is crying – but whether he is really moved by the memory (and in what way – by sadness, regret, or guilt?) or reacting to the eye drops is another productive ambiguity enabled by a spatial montage technique (54–6).

The production's most elaborate use of spatial montage happens at the moment

when Lucie realises that François is a suspect in the murder she is involved in fictionalising. The scene, about halfway through the play, takes place in the restaurant where François works as a waiter and where he is serving Lucie and David. François tells the couple about his involvement in the Légaré murder; hearing the name, Lucie makes the mental connection between the film and the real-life crime for the first time. She stands up and turns her back to the audience, revealing that it is covered in blood. She collapses between the two men as they continue to talk, not acknowledging her actions. As the scene progresses, in turn the two men drop out of the restaurant action to enact their past relationship to the corpse (as represented by Lucie): François falls to his knees and replays the moment when he discovered Marie-Claude's body; then David enacts part of the autopsy he performed on the body (providing the most concrete evidence yet that he, too, was implicated in the Légaré case). Finally, Lucie stands up and spread-eagles herself against the wall running horizontally across the stage behind the dining table. As the stage directions describe, 'the two men each put one foot on the wall as they talk, and hold their bodies horizontal, parallel with the floor, as they shake hands over her vertical body, so creating the classic cinematic "top shot" of a corpse' (59). The sequence functions as a montage of peak moments from the detective film that this play might have been – death, discovery of body, investigation of body – speeding audiences through a review of the different roles that each character is playing in the Légaré murder and its after-effects. This series of flashbacks is superimposed into the forward-moving, relatively naturalistic action of the restaurant scene in an extended spatial montage that advances the plot and the reality/representation theme. The audience learns more about the nature of each character: Lucie's dismay in learning that François is implicated in the story behind the film she is making is suggested by her standing in as the murder victim (the news slays her, as it were); François's struggle to keep going in the face of the uncertainty over his role in the murder is further revealed; and doubts are cast as to David's trustworthiness, as the audience are given to wonder whether he knew all along that Lucie and François were variously implicated in the murder (and its fictionalisation) and did not reveal his own role in it. Spatial montage is thus a key tool by which the production advances the metaphors on which it is premised – performing is like life, this play is like a detective film – in a knowing, highly metatheatrical/meta-filmic fashion.

Needles and Opium: Lepage's 'art play'

Les Aiguilles et l'opium/ Needles and Opium, Lepage's second major solo production, premiered in Québec City in 1991 and became his biggest touring success to date.[11] With this production Lepage's use of spatial montage took another leap forward, in that the technique became the entire basis for the production's conception and construction. *Needles and Opium* places the story of a contemporary Québécois artist named Robert, suffering emotionally after a relationship breakup (Lepage acknowledges that this figure is autobiographical, though not an exact stand-in for himself),[12]

alongside those of Miles Davis and Jean Cocteau, who visited each other's cities (New York and Paris) in the same time period, 1948–49. Both Davis and Cocteau had drug habits, and the production's central metaphor is the likening of the three men to each other and of love to addiction. There is little sense of forward-moving plot; rather, the effect is one of visual, aural, and thematic accumulation, as Lepage suggests: '[the production] has layers of stories that are connecting. The action that you see is that connection, and the connection is a vertical one' (qtd in McAlpine 144). The overlapping and overlaying of these comparisons extends throughout the piece and forms its structural basis. The production was Lepage's farthest move yet away from traditional plotting and characterisation; in filmic terms, we can liken it to the work of film directors who came to the fore in the late 1950s and early 1960s and who made what Bordwell terms 'art cinema' (205). Lepage's interest in this era of filmmaking is evident through numerous references in his work: *Le Bord d'extrême*, a piece which he co-directed with Michel Nadeau in 1986, was an adaptation of Bergman's *The Seventh Seal* (Beauchamp 52); his early 1990s productions of *Coriolanus* and *Macbeth* were greeted by critics as stylistic homages to Fellini and Kurosawa, respectively (see Hodgdon 90 and Taylor 'Crowded'), and Resnais's *Hiroshima Mon Amour* was a source of inspiration for *The Seven Streams of the River Ota*, which, in its earliest iteration, included a section set in the milieu of *nouveau vague* filmmakers in 1950s Paris.[13]

Bordwell identifies three main tendencies in art cinema narration: a mingling of depictions of lived existence in all its randomness and banality with subjective, individual perceptions; the foregrounding of the filmmaker's sensibility and signature via self-conscious stylistic gestures; and an emphasis on ambiguity, which addresses the seeming contradiction between art cinema's simultaneous presentation of 'a realistic aesthetic and an expressionistic aesthetic' (212). Art cinema poses a challenge to classic narrative cinema's expressionist definition of reality, which is 'rooted in the popular novel, short story, and well-made drama of the late nineteenth century' (206). In the classic narrative model, viewers understand that the story unfolds through cause and effect, and that characters are motivated by goals that they pursue in the course of the story. Art cinema poses a different and more complex depiction of reality as subjective and perhaps unknowable (in this it follows on from literary modernism). In art films, cause and effect are attenuated, and the syuzhet presents multiple gaps which may never be filled in. Frequently, an art film reflects the subjective experience of an individual in what Bordwell, adopting Horst Ruthrof's terminology from literary criticism, calls 'a boundary situation' – a pivotal moment in which the protagonist recognises that 'she or he faces a crisis of existential significance' (208). In *Needles*, Robert's extreme distress in the face of his recent breakup, compounded by being far from home, represents his boundary situation; and the choppy, non-linear, dreamlike (sometimes nightmarish) quality of the production's dramaturgy is a reflection of this existential crisis. He presents his situation in an initial monologue addressed directly to the audience:

> While in France, I was working on a voice-over for a documentary film about Miles Davis's 1949 Paris visit, when I first felt the symptoms of my anguish. It was as if a hand was strangling me, keeping me from breathing properly, choking off my voice. I had the

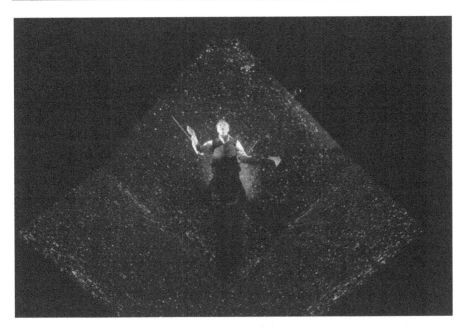

3.6 Marc Labrèche as Jean Cocteau in *Needles and Opium* (revival).

feeling I was in the midst of losing everything, because my voice is also my profession. (Lepage, *Needles* 1)

He goes on to say that he brought on that trip recordings of Davis' music and a copy of Jean Cocteau's 'Lettre aux Américains', which the poet/filmmaker wrote after a visit to New York in 1949. An instance of spatial montage follows on from this monologue. The performer is wearing a harness; hoisted by unseen stagehands he rises in the air and starts speaking as Cocteau, reciting from his famous 'Lettre' – 'Americans, I am writing to you from the plane taking me back to France ...' – while suspended over the stage (Lepage, *Needles* 1–2) (figure 3.6). One spatio-temporal situation intersects with another and the signification of the actor's body shifts from representing Robert to representing Cocteau, suggesting a likeness between them. This introduces one element of the production's extended, layered metaphor: Robert is like Cocteau, and they are in turn like Miles Davis – who in the original version of the production always appeared in silhouette behind a screen, in part in order to mask the fact that neither the performer (Lepage or Labrèche) nor his body double were black. Episodes of Robert talking about and displaying his condition of existential angst are intercut with those of Cocteau continuing to recite from the 'Lettre', including a passage about his opium use, and of Davis playing music, entering into an affair with the actress Juliette Gréco, and preparing and shooting up heroin. The metaphor thus moves between comparison of the three men and comparison of their various addictions and afflictions. The ideal spectator's activity here is not to piece this syuzhet into a coherent, forward-moving, cause-and-effect-driven fabula; rather, it is to appreciate that this is

an experience taking place not in 'Newtonian time' but, rather, in 'psychological time' (Bordwell 209).

It is important to note that coincidence can play a significant role in art film narration. In attempting to move away from forward-moving, cause-and-effect-based storytelling, art filmmakers rely heavily on 'chance encounters' which then prompt the unfolding of the syuzhet (Bordwell 206). This provides another context, alongside melodrama, for the central role that coincidence plays in Lepage's narratives, particularly this one. His discussion of the genesis and development of the production features what has become a mainstay of his discourse about his work: a celebration of the power of intuition and chance as guides to creativity. As established, the instigating incident that launches *Needles and Opium* is Robert's arrival at Charles de Gaulle airport with a Miles Davis recording and the Cocteau letter. The presence of the Davis recording follows from within the fabula, but the association with Cocteau ties back to Lepage's own experience, not directly referenced in the story. As he explains in a 1993 interview with Paul Lefebvre, he became interested in Cocteau when his friend and collaborator Richard Fréchette introduced him to the 'Lettre aux Américains', but did not feel a theatrical impulse around the material until he read a biography of Davis and 'started to make links with Cocteau's text' (18).[iv] He realised that Cocteau's and Davis's paths had broadly crossed (though they never met) at one point in their lives, during which they were both suffering similar addictions. The idea of Davis and Cocteau as opposites – one black, the other white; an American and a European; one whom Lepage associated with the subterranean ('the basements of St-Germain-des-Prés), the other the airborne ('a poet offering ethereal and angelic ideas')[v] – took hold in his imagination (19).[14] *Needles and Opium* includes a clip from Louis Malle's film *Elevator to the Gallows*, for which Davis had improvised music. Malle came to see *Needles and Opium* when it played in London in 1992 and spoke to Lepage afterwards, confirming that 'some details [about Davis]' that Lepage thought he had invented were in fact true. Similarly, at one point during the run of the show, Lepage met an elderly aristocratic Frenchwoman in whose home Cocteau had stayed during the Second World War. She, too, 'confirmed some intuitive discoveries' which Lepage had made about the French poet. For a time before he made *Needles*, Lepage had felt that he needed to rationally examine everything he contributed to a creative process, which 'took a lot of the soul out of my work'. But his experiences of meeting those who could affirm his instincts about Cocteau and Davis prompted Lepage to perform the show more confidently, and taught him that 'I need to be true to my creative intuitions' (ibid.).[vi] This notion of valuing aleatory creative processes because they lead to the discovery of truths becomes a fundamental principle for Lepage, the implications of which I explore in further chapters.

Narration in art films is highly self-conscious, as the '[s]yuzhet and style constantly remind us of an invisible intermediary that structures what we see' (Bordwell 211).

iv 'je me suis mis à faire des liens avec le texte de Cocteau'.
v 'les caves de Saint-Germain-des-Prés'; 'un poète volant qui tient des propos éthérés et angéliques'.
vi 'Il m'a parlé de Miles Davis et a confirmé comme réels des détails que j'avais inventés'; 'm'a confirmé certaines découvertes intuitives'; 'cette attitude a enlevé beaucoup d'âme à ce que je créais'; 'il faut que je me fie à mes intuitions créatrices'.

As Bordwell argues, 'art cinema's mode of production and reception' prompted the 'concept of the *author* as a formal function to emerge in a way it had not previously: 'the author becomes the real-world parallel to the narrational presence "who" communicates (what is the filmmaker *saying?*) and "who" expresses (what is the artist's personal vision?)' (ibid., emphases in original). *Needles and Opium* is an early point where we see Lepage's authorial signature coming into focus – a signature which critics had started to recognise. In his *New York Observer* review of *Needles and Opium* John Heilpern praised Lepage for his capacity to 'expand the frontiers of theatre and produce images of great beauty', and said that the production's 'stage pictures and dreamscapes can blow your mind' ('Needles and Opium' 211). Ian Shuttleworth, in London's *City Limits*, saw *Needles and Opium* as further proof of Lepage's 'phenomenal sensitivity both to the mechanical possibilities and the evocative emotional potential of theatre', which 'continues to leave one awestruck' ('Review'). Eight years into his touring career, Lepage was understood to have a distinctive authorial signature which created expectations around his work and gave it particular value.

In this chapter I launched a discussion of the cinematic nature of Lepage's stagecraft, introducing key concepts and vocabulary and applying them to a number of his early- to mid-career stage productions. The goal was to move beyond the now-familiar observation that Lepage's theatre has filmic qualities, to interrogate how he creates filmic effects on stage and to explore how audiences receive these effects. The central term that I have introduced is spatial montage, which describes the simultaneous layering of numerous significations onto bodies and objects so that actions taking place in different places and times are spliced together live on stage. The effects of this technique are complex, and I have drawn on linguistic and literary terminology – specifically the terms metaphor, metonym, and synecdoche – to work through the relationships suggested between bodies and objects linked through spatial montage. While Lepage privileges the deployment of metaphor to suggest iterative and open-ended associations between elements of his productions (X is like Y is like Z ...), I have argued that his productions frequently also suggest metonymic/synecdochical relationships (X is connected to Y, which is a subset of Z) alongside or as a part of metaphoric ones. Discussion of the early 1990s group production *Tectonic Plates* introduced a key problematic in Lepage's work, on which I expand in the following chapters: the inclusion of culturally specific material which limits some audiences' capacity to see it as just one part of an iterative chain of metaphors, because it relates to identity points (in the case of *Tectonic Plates*, nationality) that are culturally and personally meaningful. Identifying spatial montage as part of Lepage's signature approach and tracing its development through a number of early- and mid-career productions supports my larger argument that there is a method behind his practice, despite his frequent discussions of his work as governed by instinct and self-generating. Another way in which his work can be understood as cinematic is its emulation of film genres, as with *Polygraph*, a stage thriller, and *Needles and Opium*, the construction of which recalls 1950s–1960s auteur cinema. Having now established these cinematic terms of reference, I turn in the following chapter to the ways in which such techniques invite spectator engagement.

Notes

1 My account of this staging owes to Diane Pavlovic's thick description of *The Dragon's Trilogy* in *Jeu* 45: '[c]'est l'étroite cabane du gardien qui figure l'escalier, les deux comédiens y entamant leur descente et, après une interruption de l'éclairage due à l'extinction "accidentelle" de leur chandelle, la terminant en sense inverse avant de réintégrer le plateau' ('Reconstitution' 49).

2 This also owes to Pavlovic's thick description: 's'amorce alors une lente chorégraphie pendant laquelle les autres personnages viendront rejoindre ces deux-ci, esquissant, en des mouvements encore une fois inspirés du taï-chi, des gestes quotidiens autant que des scènes prémonitoires de la suite des événements. Après Bédard, Morin, et les deux soeurs chinoises, Jeanne et Françoise arrivent finalement au centre, manipulant linges et assiettes. Après un tourbillon que separe les deux fillettes ... la scène se termine comme elle avait commencé, les deux protagonistes du début se retrouvait seuls dans leur position initiale' ('Reconstitution' 49).

3 *Tectonic Plates* was produced by the director of the London, United Kingdom-based production company Cultural Industry, Michael Morris, who organised co-funding by the European Economic Community for a 'cross-continental work-in-progress' (MacDougall 139). The initial idea was that this was going to be an international, intercultural collaboration between artists from three cultures – Québec, Scotland, and Catalonia – involving all of their languages. After premiering at the 1988 World Stage Festival in Toronto, it was to play in Glasgow in 1990 and then in Barcelona in 1992. The production ended up being less international in structure, and intercultural in focus, than this ambitious plan initially indicated. For financial and logistical reasons, Catalan actors did not join the process, and the production was never performed in Spain (140). As noted in the Introduction, I saw the production at the National Theatre in London in 1990. In addition to my own recollection and production reviews, I rely centrally here on Jill MacDougall's exploration of the production in the book *Performing Identities on the Stages of Québec*.

4 As discussed in the Introduction (pp. 33–4, note 10), doubtless the most notorious of these was the cancellation of *Elsinore* on the day it was meant to open at the 1996 Edinburgh International Festival. The opening date of *Kà*, which Lepage directed for Cirque du Soleil, was postponed for more than six months in advance of its eventual opening in March 2005. See Fricker 'Le gout'.

5 Jacques/Jennifer's gender is one of the production's most rich and complex aspects; central to MacDougall's account of *Tectonic Plates* is her contention that this character's relationship to her gender is one of ambivalence, and that this can be read as an ironic commentary on Québécois language and identity politics. In the years since the production was created, understanding of and vocabulary about trans identities have expanded and deepened considerably. It is not made clear in the production whether Jacques/Jennifer undergoes a medical gender transition (beyond the imagined operation in the pool that I discuss here). It seems accurate to describe her as transgendered, in that her understanding of her gender does not match her assigned sex.

6 This was the period in the late 1980s in which federal Canadian attempts to repatriate the constitution from Britain met resistance from First Nations and Québécois populations. See Chapter 1, p. 64, note 19.

7 Premiered in French in Québec City in 1988, *Polygraph* toured in French- and English-language versions and enhanced Lepage's growing international reputation in well-received short runs at London's Almeida Theatre (1989) and the Brooklyn Academy of Music (1990). Brassard and Lepage continued to develop the show as it toured; my comments here refer

to the version published in *Canadian Theatre Review* 64, translated by Gyllian Raby. I rely on this published playscript and reviews of the production for my account, as I did not see it performed live.

8 This vocabulary calls on 1920s Russian formalist literary criticism, hence the Russian-language terms.

9 The idea for the play sprang from the fact of the real-life murder of one of Lepage and Brassard's friends, for which Lepage was at one point a suspect; Lepage was invited to audition for a film about the crime while the murder inquiry was still open. See Manguel 39.

10 This passage also hints that François, and perhaps the production itself, suffers from inter-nalised homophobia. André Loiselle explores the problematic depiction of homosexual desire in the play *Polygraph* and Lepage's 1996 film adaptation in *Stagebound: Feature Film Adaptations of Canadian and Québécois Drama*, as does Peter Dickinson in *Screening Gender, Framing Genre: Canadian Literature into Film* and 'Space, Time, and the Queer Male Body: The Film Adaptations of Robert Lepage'.

11 Lepage himself performed in the production for its first three years, when it toured in Australia, Canada, numerous countries in Europe, Japan, and the United States. In an inno-vation which became standard practice for Ex Machina, Lepage was replaced by another actor, Marc Labrèche, who further toured in North America, Europe, and Japan. Ex Machina remounted the production in 2013 and it toured widely for five years. The original produc-tion was relatively low-budget and low-tech, reflecting the limited means available to Lepage at the time. The 2013 remount followed the original script but was more technically and technologically complex than the original, replacing a single revolving screen backdrop with a large cut-out cube which revolved on one of its corners. As noted previously, Labrèche performed in the remount along with Wellesley Robertson III, an acrobat/actor who played Miles Davis. I saw the original production at the Brooklyn Academy of Music in 1992 and the updated production at Canadian Stage (Toronto) in 2013 and 2015. I refer here also to an unpublished script from the Ex Machina archive as well as reviews and scholarly accounts of both versions.

12 'He is myself, and not really myself. There are some parts that are autobiographical, but there are no rules that you should believe everything …' Qtd in Fricker 'Collisions'.

13 This section, titled 'Nouvelle Vague', was part of the story of the Czech photographer Jana Čapek's life that formed the narrative backbone of *River Ota* in its earlier versions. After escaping the concentration camp at Terezin, Jana moves to Paris and works as an usher at an art cinema, which is showing *The Seventh Seal*. She starts a relationship with an aspiring film actress called Simone, who auditions unsuccessfully for Resnais's *Hiroshima Mon Amour*, and eventually commits suicide. I saw this section of the production in a workshop version of *River Ota* in Québec City in April 1994; it was cut before the production had its world premiere in Edinburgh in 1995.

14 These associations invite critique of their essentialist association of ethnic blackness with darkness and the underworld, and whiteness with lightness and the heavenly. This extends what Abdul JanMohamed has termed the 'economy of Manichean allegory' (59) in coloni-alist texts, which transforms 'racial difference into moral and even metaphysical difference', regardless of whether it posits the racial other as of higher or lower moral status than the dominant culture (61).

4

Lepage's affective economy

In the previous chapter I explored the formal techniques that Lepage uses to construct his stage narratives, arguing that his montages innovate the formal languages of film, communicating to audiences on familiar terms made strange again via remediation. I established spatial montage as one of the key building blocks of his stage storytelling, and argued that while his techniques are based in metaphor, they frequently increase in complexity and come to involve metonymy. In this chapter I look more closely at the effects of these formal techniques and, in so doing, engage with broader discussions of the effects of montage on theatre and film audiences. Throughout the twentieth century and into the twenty-first, from Eisenstein's montage of attractions to Brecht's alienation techniques to Lehmann's theorisation of the postdramatic, artists and scholars have explored the ways in which stage and film narratives invite viewers to connect (or not) the various component elements of the piece before them. Leaving gaps between elements, juxtaposing unlike or seemingly contradictory elements, and disrupting conventional expectations of the forward movement of time and the coherent organisation of space are means by which theatre and filmmakers activate spectatorship and prompt viewers to think about what is being represented and their relationship to it in new ways. Questions have long been asked, however, about the political efficacy of montage: whether the intended message of a piece can be guaranteed to land with a viewer; whether absorbing a message through a montage necessarily results in the spectator changing attitudes or behaviour; and about the potential of montage techniques to grow familiar and lose their effectiveness. The question of how and in what ways montage might prompt viewers to new forms of awareness and action has continued to be a focus of critical debate in recent decades, and I draw on those debates in this chapter.

In so doing I approach a particularly contentious aspect of Lepage's work. Many

theatre scholars agree that Lepage's theatre invites spectators to consider the relation-
ship between themselves and the stage and highlight his particular approach to montage
as a key technique in this invitation. Chantal Hébert and Irène Perelli-Contos frame
Lepage, in *Vinci*, as a pedagogue teaching audiences '*how to see*' (*La face cachée* 128
emphasis in original), provoking in spectators reflexive awareness of their habitual
stance in viewing performances, and inviting them to look at art (and the world) in
new ways.[i] For Andy Lavender, Lepage's work represents a 'consistent attempt to turn
spectatorship into a recognised, conscious engagement rather than an unthought mode'
(102–3). James Bunzli calls Lepage's theatre one of 'simultaneity and juxaposition in
which actor, image, "text", and audience are brought into a dialogue, a questioning, and
an active co-constitutive role' ('Geography' 89). Furthering Bunzli's argument, Piotr
Woycicki argues that the 'spectator becomes a co-producer, a co-director, a montageur
of meaning' (72) when viewing Lepage's productions *Elsinore* and *The Andersen Project*.
James Reynolds identifies in Lepage's work a characteristic 'uncanny theatricality' in
which objects and bodies come to hold multiple significations and in which the 'method
of production' ('Hypermobility' 62) of stage illusion is frequently revealed to audiences.
Sometimes explicitly, these scholars present Lepage's intervention into the spectator/
stage relationship as knowingly critical, as when, for example, Woycicki argues that
Elsinore undertakes a 'deconstruction of cinematic aesthetics' which successfully
'prompts … spectatorial "reflexivity" on how cinematic culture influences perceptual
expectations of theatrical works' (43). Invoking Lehmann, Woycicki underlines that
the interpretation of *Elsinore* depends on the spectator's politics of perception – their
'perceptual choices' in how to interpret it – and identifies this as a 'quasi-Brechtian
aesthetic' which 'exposes the process of production' (56). Reynolds, too, argues that
the uncanny nature of Lepage's solo works is 'not that far from the idea of Brechtian
de-familarisation' and, citing Lib Taylor, that such 'theatrical versions of [the] Freudian
making-strange … may well impel political and rational effects' (67).

By contrast, a strain of negative critique of Lepage's productions published in the
1990s and early 2000s by Anglophone scholars grounded in cultural materialism
(including myself), questioned the critical nature of Lepage's engagement with repre-
sentational practices. Considering his work through the lens of postmodern theory, Jen
Harvie argued that the characteristic textual openness of Lepage's productions 'high-
lights and leaves volatile and problematic its representational practices but … does not
explicitly engage in political debate' ('Robert Lepage', 228). Lepage's postmodernity,
for Harvie, 'prioritise[s] pleasure at the expense of achieving critique, deconstructive
or otherwise', and is not 'politically resistant but apolitical' (229). A related line of
argument focused on Lepage's representation of cultures other than his own. Barbara
Hodgdon questioned Lepage's 1992 production of *A Midsummer Night's Dream* at
London's National Theatre for having turned Indonesian culture 'into an abstraction
which can be evoked in the name of transcultural unification and universal harmony'
(83). Harvie argued that while an early production such as *The Dragon's Trilogy* offered
a critical perspective on naïve and racist attitudes in early twentieth-century Québec,
the later and more transnationally ambitious *The Seven Streams of the River Ota* failed

i 'd'apprendre à voir'.

to achieve a 'critique of representational and spectatorial practices and effects' and was, rather, 'decadently hyper-theatrical' ('Transnationalism' 121). Highlighting that production's all-white casting and its 'essentialist' representation of Japanese characters, I argued that *River Ota* 'appropriated catastrophic events from recent world history as a means towards character and audience catharsis … rather than engaging with or exploring their specific circumstances and meanings' ('Tourism' 92).

Clearly, these are complex issues and, given Lepage's lengthy and prolific career, it is important to underline from the outset that a singular statement about the effects of his productions seems not only unlikely but unproductive. My goal here, first of all, is to argue that Lepage's productions engage audience in some characteristic ways while containing the potential for very different effects. I further argue that some of his shows, or parts of them, activate in viewers 'an awareness of the political and ideological factors underlying perception' (Woycicki 4), while others lack critical perspective on representational practices. I do so by bringing the existing scholarship on the effects of his work together with several related contemporary critical strategies. Considering Lepage's work through affect theory and through Jacques Rancière's conceptualisation of the emancipated spectator allows us to move beyond binaries of passive/active spectatorship and of a/political creative production, and to identify a key quality of Lepage's work: the capacity to evoke a sense of wonderment in spectators through effects of transformation communicated via spatial montage. A frequent image in Lepage's work is that of the suspended body: I explore several such images from different productions as representative examples of transformational moments and discuss how these contribute to the overall construction of those productions. Placing such affectually powerful moments alongside the development of plot and theme through representational, dialogue-based scenes invites both shifting identification with characters and themes, and engagement with the workings of theatre itself. The dynamism of this dramaturgy draws spectators' attention to the fact that what they are seeing is representation and adds an inherently critical quality to the work. That being said, two recurrent tendencies have led to critiques of Lepage's work as not sufficiently engaged with or responsible for its representations. One (more commented on in the scholarly literature) is the inclusion of cultural references detached from their contexts and histories; the other is the use of transformational staging moments as attempts to sum up a production's meanings, which can lead to erasure of possible significations and the connection of affective response with semiotic meaning that registers as prescription rather than invitation.

To begin with, I argue that a thorough consideration of Lepage's engagement of the spectator must take on board questions of feeling.

A theatre of meaning

Making people feel things strongly is an articulated goal of Lepage's work: he has constantly underlined in interview that generating affect is more important to him

than semiotic representation or material effects, as in this comment, made in the 1990s about *River Ota*:

> People sometimes say to me about *The Seven Streams*, 'Why do you make us voyeurs of these hard situations?' But that's what theater is there for. It's the ceremony of life and death and of love. People have started abandoning theater because it stopped giving them these sensations ... People go to theater not to feel good ... They go there to feel. (qtd in Winters)

Journalistic accounts consistently note the strong affective charge that Lepage's shows can produce, and argue for this as part of their particular value. The critic Charles Spencer describes *The Far Side of the Moon*, for example, as 'evocative ... comic, poignant and endlessly creative' ('Lepage launches'), while Sarah Hemming compliments the production's 'great poignancy'. To fully appreciate *The Andersen Project*, Hélène Merlin argues, audiences should 'open your eyes, your ears, your hearts and your neurons'.[ii] *La Presse*'s Alexandre Vigneault calls *Lipsynch* a 'moving fresco about human nature' whose final scene will leave audiences 'choked up'.[iii] These reviews (among others) are posted on Ex Machina's website, suggesting that the company too finds value in the emotional power of its work. That scholarly accounts of Lepage's work tend not to consider affect demonstrates how, traditionally, feelings were 'subordinated to other faculties' in theatre studies as well as philosophy, cultural theory, psychology, sociology, and other fields (Ahmed, *Cultural* 4), a significant gap that affect studies has worked to address. By exploring the ways in which affect figures in Lepage's ongoing project and in the value and pleasure that audiences derive from his work, my goal is not to reinforce a thinking/feeling dichotomy. It is, rather, to argue that both thinking and feeling are involved in the engagement that his productions invite from spectators, and that a distinctive aspect of his practice involves the accumulation of significations to a point at which a sense of affective plenitude momentarily arrests intellectual processing. Here, I establish some terms of engagement about affect and Lepage's theatre, drawing on the work Gilles Deleuze and affect theorists in the Deleuzian tradition; and on the culturally turned affect theory of Sara Ahmed.

In an extended series of interviews with the Québec broadcaster Stéphan Bureau published in 2008, Lepage attempted to articulate the big-picture goals of his ongoing creative project:

> ROBERT LEPAGE: [In today's society] there is a problem with meaning. Why did we go to war? Why was my son killed in Iraq? Why? What sense can I make of that? There is a big problem with meaning in our times. I hope that the theatre heads towards a theatre of meaning, towards a theatre which treats these things ... When you meet young people, when you talk to them, it's always about meaning – they're asking about the meaning of their lives ... For me this is a very, very important theme, and one that we're trying to get stuck into more and more.
> STÉPHAN BUREAU: All the more because there is so much nonsense out there in the

ii 'ouvrez grands vos yeux, vos oreilles, vos coeurs et vos neurones'.
iii 'émouvante fresque sur la nature humaine ... gorge nouée'.

world that comes to us through TV, through all the media – you have to ask these questions.

LEPAGE: Yes. That's exactly it.

BUREAU: And you ask this of yourself before you ask it of everyone else.

LEPAGE: Yes, that's it. Exactly. You can't really raise that question if you're not yourself looking for meaning. For me, I am constantly motivated to know why I do what I do, why I'm alive, and so forth. So, it's this very personal quest, searching for meaning, that makes the shows, the pieces of theatre, the films. (41–2)[iv]

It is useful to think about the double valences of the word 'meaning' in this context. Here and elsewhere Lepage makes clear that he is more interested in making work that feels meaningful (that moves and touches audiences) than in the exact semiotic meanings that audiences take away from his significations. His search for meaning did not, by and large, lead Lepage in his early and mid career to make productions that take socio-political realities such as the war in Iraq as their central subject matter.[1] Nor did those productions purport to communicate concrete truths, lessons, or morals. Lepage's 'theatre of meaning' is ultimately less interested in presenting people, objects, experiences, and relationships whose identities are specific and grounded than in evoking the search for meaning itself. He does this by staging signification as a process through the use of techniques by which bodies, objects, and set pieces continually seem to transform from one state of being to another; and by paying particular attention to the transitions between scenes and locations. In his work the identities of bodies and objects are not fixed but, rather, in constant evolution. This commitment to evolution and ever-emergent meaning is also apparent in the ways in which the productions are made, through a process-based mode in which productions are continually in development and in dialogue with their audiences. As Bunzli articulates, Lepage's focus is on '"creation" as a process, an ongoing state-of-being in which writing begins in performance' ('Geography' 84); that is, while most traditional theatremaking begins with a script, Lepage approaches artistic creation through an ongoing, cyclical movement of ideas-generation, improvisation, structuring, performance, and back to ideas-generation. Theatrical productions emerge from this process, and all aspects of creativity – performances, dialogue, sound and music, design, and the overall affect of the performance – contribute to those productions' meanings.

iv LEPAGE: Il y a un problème de sens. Pourquoi on va à la guerre? Pourquoi mon fils a été tué en Irak? Pourquoi? C'est quoi, le sens de ce qu'on fait? Il y a un gros problème de sens en ce moment. Et j'espère que le théâtre s'en va vers un théâtre de sens, vers un théâtre qui traite de ces choses-là … Quand tu vas voir [les jeunes], quand tu parles avec eux, et tout ça, c'est une affaire de sens. Les gens se demandent c'est quoi le sens de leur existence … Pour moi, c'est un thème très, très important, et on commence à se barrer les pieds dedans et plus en plus.
 BUREAU: D'autant qu'il y a tellement de non-sens apparents dans le monde et qui nous sont renvoyés part la télé, par l'ensemble des médias que, nécessairement, on aura à se poser la question.
 LEPAGE: Absolument. Mais c'est ça.
 BUREAU: C'est pour soi qu'on la pose avant de la poser pour l'ensemble.
 LEPAGE: Oui, c'est ça. Exactement. Tu peux pas vraiment soulever cette question-là si t'es pas toi-même en quête de sens. Moi, c'est une motivation constante de savoir pourquoi je fais ce que je fais, pourquoi je vis, etc. Alors, c'est cette quête-là bien personnelle de recherche du sens qui fait les spectacles, qui fait les pièces de théâtre, qui fait les films.

Deleuze's concepts of becoming and immanence help to elucidate Lepage's overriding commitment to process and his understanding of meaning as continually emergent rather than fixed. Deleuze, alone and with Félix Guattari, constantly strove to move beyond approaches to philosophy that affirmed a ground for existence, that strove to identify a Truth and that tried to locate 'an outside to thinking' (Colebrook 74). This was part of his understanding of human experience as not leading to or aspiring for transcendence – for something that exists above or outside experience – but, rather, as committed to continual emergence and becoming, which Deleuze terms *immanence*. Everything that humankind might reach for as foundational, such as 'God, Being, or Truth', are 'inventions rather than givens' (Colebrook 71). Transcendence (God, Truth) is an illusion, which we imagine in an attempt to locate a basis for our existence. What is constant is becoming – different potentials for experience that are continually being taken up. As Elizabeth Grosz articulates it, for Deleuze, '[b]ecoming is the operation of self-differentiation, the elaboration of a difference within a thing', and, as such, 'unbecoming is the very motor of becoming'; what is most important and constant is 'the inevitable force of differentiation and elaboration, which is also another name for becoming' ('Bergson' 4). Given his overall dismantling of concepts of transcendence, for Deleuze the function of art is not to affirm preexisting (transcendent) truths but to 'open us up to whole new possibilities of affect' (Colebrook 24). While art may convey messages, that is not its principal role, as Grosz explains: 'Art is the art of affect more than representation, a system of dynamised and impacting forces rather than a system of unique images that function under the regime of signs' (*Chaos* 3). Artists must always push beyond what is given or assumed to be known 'in order to release the sensibilities from which actual experience is composed' (Colebrook 77).

Considering Lepage's work from this Deleuzian perspective creates a context for his overriding emphasis on emergence and process, which we can understand as a commitment to immanence – to becoming. This comes through first and foremost in Lepage's transformative stagecraft. When, for example, in *Tectonic Plates*, the character of Jacques seems to transform on stage into the mythic figure Skaddie; or in *Polygraph* when the scene shifts from Lucie's audition to her witness of a suicide in the Métro, we might reflect on the literal meanings that these shifts suggest. That is, we might search for the connections that Lepage is suggesting between the different narrative planes of his stories and the ways in which these advance the productions' thematics: in the former, gender fluidity and the relationship between Québécois and Celtic cultures; and in the latter, the emotional and ethical manipulation that may be involved in the craft of acting, as well as characters' overlapping implications in a crime and its fictionalisation. While these themes are relevant to the production's plotting and characterisations, it is also important to consider the fluidity and multiplicity of identifications that these representations produce: as the performers' bodies move between significations, our desire for this to fix on one identity is challenged, and we are presented with transformation as an ongoing process. What is produced is not a larger truth or message but, rather, an affirmation of the centrality of becoming (in Deleuzian terms) to experience. On a broader level, Lepage's affirmation of the importance of becoming over being comes through in the commitment to work in progress, as he and his collaborators revisit their projects as they develop

and tour them, continually dismantling, reassessing, and reassembling the material. And more broadly still, we can see his consistent return to certain themes, tropes, and problems in productions throughout his career – including, importantly, his own self-articulation through the solo productions – as a commitment to difference (in the Deleuzian sense of a constant state of becoming), renewing his ongoing personal/ creative project by bringing in whatever insights, experiences, or impulses he has encountered along the way.

Thinking of art as a means to affirm becoming and generate new possibilities of affect sheds light on Lepage's understanding of the relationship of his work to specta- tors. Early in his career he said in interview that he did not aspire to communicate with audiences. Rather,

> I want all of us to commune, *communier* with the public, and the public with us. You know *communier* in [the Catholic] religion? To partake of the body and blood of Christ? That's what I want to do, but with the public. We give them our body and blood. We become a whole. We share an experience, not an idea. (qtd in Manguel 37)

Twenty-five years later, speaking to Bureau, Lepage reiterated his view that theatre should have a 'spiritual' function and that it should not be a place of communication but, rather, of communion (194).[v] The articulation of Ex Machina's creative ethos on its website also underlines this idea (Ex Machina 'Creation'). In describing this desired relationship of communion with his audience, Lepage uses the language and imagery of the Catholic Church, a dominant force in Québec when he was growing up, but reconfigures the notion of transubstantiation, the moment at which the Communion bread and wine are understood to transform into the body and blood of Christ. In his formulation, the actors' bodies are the Communion offering, and what happens at the moment of transformation is a union between spectator and performer. This is a metaphysical transaction, but one that does not point to a higher power outside the transaction but, rather, identifies the transaction itself, and the bodies involved in it, as the site of transformation; the sacred connection is between human bodies and spirits. The acceptance of the performers' bodies by the spectators creates some- thing new – a collective experience of shared affect between spectators and performers. Ahmed's theorisation of affect as relational is useful here to clarify this point: she urges us to think beyond understandings of feelings as coming from inside the individual, or generated externally and then absorbed by the individual. Rather, feelings happen between and in relation to people and objects; they 'create the very effect of the surfaces and boundaries that allow us to distinguish an inside and an outside in the first place' (*Cultural* 10). That is, it is by having emotions in response to the world around us that our sense of selfhood comes to exist. Emotions are therefore not purely private affairs or 'psychological dispositions', but 'work, in concrete and particular ways, to mediate the relationship between the psychic and the social, and between the individual and the col- lective' ('Affective' 119). Traditional theatre and performance are particularly ripe sites for affectual exchanges because they depend on the live co-presence of spectators and

v 'spiritualité … c'est pas un lieu de communication, c'est un lieu de communion'.

performers. We can identify spaces as being 'intense' with '[s]hared feelings', Ahmed
further argues, without claiming that we know what people are feeling, nor claiming
that everyone is feeling the same thing (*Cultural* 10). This is an important point that
allows us to acknowledge that Lepage's performances generate intense, interpersonal
affects without then asserting that we can know exactly what those feelings are for each
spectator – the fact of the affect-generation can still be recognised and explored.

Lepage and the aesthetic regime

Having established the central role of feeling in Lepage's theatre practice, we can start
to fold questions of semiosis and signification back in, by way of the work of Rancière,
among whose signal contributions to contemporary thought has been the challenge
of binaries such as feeling/thinking and active/passive. In his theorisations of peda-
gogy (*The Ignorant Schoolmaster*) and culture (*The Emancipated Spectator*), Rancière
challenges conceptions of learning and spectating as inherently reception-based and
inactive. Students bring intelligence and experience into their learning and are not
just vessels into which knowledge is poured. Similarly, looking at and listening to art
are active pastimes because the spectator 'observes, selects, compares [and] interprets'
(*Emancipated* 13).[2] Rancière's writings on culture build on those of Kant and Schiller
in identifying engagement with art as a unique realm of experience, referred to as
the aesthetic regime. Introducing his conception of this regime, Schiller describes the
Juno Ludovisi, a Greek statue, as existing 'within itself ... a completely closed creation
... without yielding, without resistance' (Schiller qtd in Geil 57) before which the
spectator is 'at once pulled in and held back, caught up in a condition of utter rest and
extreme movement' (Geil 57). Within this 'free play' – being both drawn into and held
outside of what she is regarding – the spectator experiences a 'paradoxical coexist-
ence of passivity and activity' (ibid.) which, for Rancière, is where her emancipation
begins. Usual understandings and identifications are neutralised and the potential is
opened for *dissensus*, 'a rupture in the relationship between sense and sense, between
what is seen and what is thought, and between what is thought and what is felt. What
comes to pass is a rupture in the specific configuration that allows us to stay in "our"
assigned places in a given state of things' (*Dissensus* 143). This notion of the disruption
of assigned places has implications far beyond the aesthetic realm: it destabilises a
hierarchy dating back to Plato which places thought above action and therefore 'those
who think' above 'those who work' (Geil 60). Because significations are suspended
and open to free interpretation, an equality is established: one doesn't need to be
initiated into the art world and know what things are ordinarily supposed to signify in
order to participate in the aesthetic regime. Rancière's favoured example demonstrat-
ing spectatorship's democratising potential is that of the joiner Gabriel Gauny, who
wrote a diary entry around the time of the French Revolution about briefly stopping
his work to gaze out of the window and enjoy the view 'better than the [owners] of
the neighbouring residences' (qtd in Rancière, *Emancipated* 71). Gauny disrupted

hierarchies of time and space by taking a break from labouring for others and gazing out upon houses owned by the wealthy, briefly redistributing (a key Rancièrian word) existing 'occupations and capacities' (Geil 61). Gauny's action was not political per se, but 'contributes ... to the framing of a new fabric of common experience or a new common sense, upon which new forms of political subjectivisation can be implemented' (Rancière, 'Method' 280). Indeed, for Rancière, the political meaning and efficacy of art is not a question for artists but for those who apprehend the work: 'It is up to the various forms of politics to appropriate, for their own proper use, the modes of presentation or the means of establishing explanatory sequences produced by artistic practices rather than the other way around' (*Politics* 65). A Rancièrian approach to art and spectatorship, then, does not privilege intellect over affect but, rather, identifies the aesthetic realm as one in which 'sense and sense' – thought and feeling – are both present and open to disruption and redistribution. This resonates with the double valence of 'meaning' discussed in the previous section and is relevant to Lepage's approach to spectatorship. As noted in the Introduction, he has said of his work that '[t]here's no moral ... It's just putting people into a bath of sensations and ideas and emotions. And then they come out of it and do what they want with it' (qtd in Bunzli, 'Geography' 97). A possible response to this is that Lepage is being irresponsible: shouldn't an artist have an idea of what he is trying to say with his work? This statement is also quite striking when we consider that Lepage has made a reputation as one of contemporary theatre's most distinctive auteurs, with a particular artistic signature. The approach to authorship articulated here, however, is one that understands the spectator as the key figure in meaning-making, and the experience of one of his productions – the 'bath of sensations and ideas and emotions' – as the key site where this meaning-making happens. If one considers the experience of spectating Lepage's productions as an experience of the aesthetic realm in Kant/Schiller/Rancière's terms, then the potential of his work to offer visions of transformation in the representative regime (that is, the world we inhabit) opens up. Perhaps the experience of viewing objects and bodies as they move between identifications, and of relating sense to sense and meaning to meaning, will allow the spectator to view existing systems, and her place in them, differently – not as fixed and inevitable but as containing the potential for change and evolution. This is, as underlined previously (and to bring Ahmed's ideas back into this discussion), a communal experience in which affect is generated between and in relation to people and objects, and in which transformation is a central activity and value. While the experience of the aesthetic realm that Rancière describes is a singular one, the spectator is nonetheless aware – on sensory and cognitive levels – that she attends theatre among others. The awareness that others are having meaningful experiences viewing theatre in the same space and time, even if it can't be known exactly what they are making of the experience, contains the potential for the acknowledgement of difference and, from that, perhaps, new ways of distributing the sensible (that is, understanding the world). As Rancière writes:

> The collective power shared by spectators does not stem from the fact that they are members of a collective body or from some specific form of interactivity. It is the power

each of them has to translate what she perceives in her own way, to link it to the unique intellectual adventure that makes her similar to all the rest inasmuch as this adventure is not like any other. (*Emancipated* 16–17)

Lepage's affectual economy

While the argument thus far opens up, I hope, some productive pathways for considering spectatorship of Lepage's work, it remains on the level of generalisation (indeed many of these points could be made about the work of other theatre artists). Moving forward to look specifically at Lepage's practices, it is important to reintroduce the line of argument about montage as a key aspect of his theatremaking. The central action of montage is the join or the cut – the place where two or more pieces of content are spliced together – and this is the site where Lepage's signature appears, understanding signature both as a characteristic and identifiable way of doing things, and the place in which spectator engagement is particularly activated. Spatial montage, as I have described it, is Lepage's technique of writing multiple meanings onto the same body or object, relations that combine metaphorically and metonymically. This technique allows him to create moments of transformation in which physical matter on stage (bodies and objects) seems to shift from one identity or state of being to another. Strong feeling results from these moments because spectators are presented with so much visual (and, sometimes, aural) stimulus that the capacity to process it intellectually is momentarily disabled.

My analysis here draws on the particular understanding of affect for those working in the Deleuzian tradition: as Erin Hurley explains, moments of affect are bodily, first-line reactions to experience, which 'make [themselves] known through autonomic reactions like sexual arousal or sweating' (*National* 147). These reactions precede cognitive processing and precede 'emotion, where emotion is understood as an expression of or name for (hence, a conventionalisation of) affective experience' (148). Spectators of Lepage's spatial montages experience a rush of affect as a result of the surprising abundance of information they are taking in, as the situation on stage presents them with bodies and objects at points of transformation in which they seem to inhabit multiple spatio-temporal planes at the same time. A spectrum of (semiotic) meanings may be released after these moments, but not before the arresting rush of affect that makes these moments meaningful (in the affective sense), after which semiosis is re-established. As previously noted, Reynolds names such moments sites of 'semiotic condensation' in which an 'accumulation of meanings reaches saturation point' and 'becomes overwhelming and affective' (*Revolutions* 93). What is seen on stage takes on a 'heightened presence', while an interior flux of meanings engages the spectator simultaneously' ('Acting' 135), giving the spectator 'an impression of wonder' as she experiences 'the apparently sudden perception of the meaning of the play' (141).

Extending Reynolds's argument, I suggest that the characteristic affect generated by Lepage's signature moments of staging is wonderment. Colebrook has written

about how the work of certain artists becomes associated with certain affects: for example, through their combination of words and the ideas, images, and feelings they suggest, some of Emily Dickinson's poems create 'the affect of fear without an object feared, a reason, or a person who is afraid' (22). The plays of Harold Pinter create 'the affect of "boredom"', not by portraying bored characters or by boring the audience, but by 'convey[ing] the boredom of modern bourgeois life' (23). We can adapt this idea to explore the unique affect of Lepage's work. As Dickinson's poems produce the affect of fear and Pinter's plays produce the affect of boredom, so I contend that Lepage's work produces an affect of wonder by evoking the 'time-space compression' that David Harvey argues is a defining characteristic of life under the conditions of postmodern, globalised capitalism (284–307). Lepage creates split-second moments of time-space compression by presenting a human body or object at a crux point at the intersection of different depictions of space and time. These are moments of convergence, in which different layers of narrative come together and a transformation is suggested; this creates moments of intensity that briefly arrest signification and explode with affect. Spectators collectively witness moments in which 'time [seems to be] reorganised in such a way to reduce the constraints of space, and vice-versa' (Waters 65) – which theorists from McLuhan to Robertson to Harvey have identified as a defining experience of the globalisation of culture (Lonergan 36). For a Marxist critic such as David Harvey, the phenomenon of time-space compression has largely negative implications in that it alienates workers and products from their labour and places of origin, rendering capital and value ever more ephemeral (284–307). Certainly, for many, life under the privileged, rapidly changing conditions of late capitalist globalisation can be atomised, depersonalised, and overwhelming. These moments of time-space compression that Lepage's productions offer disrupt such associations by offering a fleeting, generative sense of connectedness. This feeling of connection comes from the perception that elements of the production relate to each other in ways that may just have come into focus, and from the spectator's own work in perceiving those relationships.

Such feelings are part of the defining value of Lepage's productions for many spectators and commentators. Critics and journalists consistently reach for otherworldly or spiritual terms to describe his capacity to evoke transformation – he has been called a 'magician', 'sorcerer', 'wizard', 'alchemist', and 'guru', someone whose 'epic ambition' helps spectators to 'join up the dots in our everyday lives'.[3] This points to what we can call, after Ahmed, the 'affective economy' of Lepage's work. Ahmed uses this concept to describe how certain affective values come to stick to certain social figures and to thus '[create] the very effect of a collective' by powerfully '[binding] subjects together' ('Affective' 119). Affective economies 'align individuals with communities – or bodily space with social space – through the very intensity of their attachments' (ibid.). Lepage's affective economy is built around his capacity to craft productions that generate an affect of wonderment, leading to spectators feeling a sense of connectedness with themselves and the world around them. This feeling-relationship does not depend on a particular geographic location or on grounded socio-political circumstances. As his career has become ever more globalised, with productions touring between different organisations and venues, Lepage has built this affect into

his productions and thus curates the spectator's experience in ways that can remain relatively consistent even as the productions travel. This is not to say, of course, that spectator responses entirely can be predicted or will be consistent; what is notable is the extent to which Lepage takes care to orchestrate spectator experience as part of the overall work of creating the productions. This capacity to create a powerful affective environment imbued with wonder is his particular value proposition within the wider economy of globalised theatre production. As his career has developed, producers, presenters, and audiences have come to expect work that delivers these qualities; the sticky affect associated with his work – and the artist himself – is wonderment.

Scenes of suspension

I now offer some specific examples from Lepage's productions in which he uses spatial montage to create moments of time-space compression that generate wonder. Each of the examples involves the presentation of a human figure in a state of suspension, understood literally as being held in mid-air, and also through the affect theorist Brian Massumi's understanding of the term as an instant of 'pure potential' (103) or 'intensity' (27). In Massumi's argument, moments of suspension demand attention, are filled with generative potential, and lie outside preexisting structures of meaning:

> For structure is the place where nothing ever happens, that explanatory heaven in which all eventual permutations are prefigured in a self-consistent set of invariant generative rules. Nothing is prefigured in the event. It is the collapse of structured distinction into intensity, of rules into paradox. It is the suspension of the invariance that makes happy happy, sad sad, function function and meaning mean. Could it be that it is through the expectant suspension of that suspense that the new emerges? (27)

Suspension thus understood characterises a live body in a state of potentiality: 'The body as an object, not a subject – not being a particular someone but rather becoming something else' (Stelarc qtd in Massumi 99). In *Parables for the Virtual* Massumi devotes a chapter to Stelarc's suspension projects, in which the Australian artist hung his body by its skin on hooks. Massumi sees in Stelarc's creation of 'body-objects' an 'art of sensation ... the direct registering of potential ... a kind of zero-degree of thought-perception, and of the possibility it disengages' (97). These acts of body art suspend 'need and utility' (ibid.) and seem to interrupt the flow of time: 'The body is in a state of invention, pure and not so simple. That inventive limit-state is a pre-past suspended present. The suspension of the present without a past fills each actual conjunction along the way with unpossibilised *futurity*: pure potential' (103, emphasis in original). Suspension has an 'implied ethics' in 'the value attached – without foundation, with desire only – to the multiplication of the powers of existence, to ever-divergent regimes of action and expression' (34). While Lepage's theatre does not push the performer's bodily borders and limitations to the same extreme as Stelarc's,

the trope of the suspended body resonates between the two artists' practice, as Steve Dixon has suggested. Dixon terms 'extratemporal' moments in Lepage's productions which 'temporarily appear to suspend time and space' and observes that these 'occur particularly when gravity is challenged and the *suspension* metaphor becomes visually literal, as Lepage's body appears to defy or struggle against gravity' (505, emphasis in original). Such moments in which bodies seem to float in space indeed appear so frequently in Lepage's productions, particularly his solo works, that they have become a signature trope; as mentioned in the Introduction, it is notable that several books about or by Lepage feature cover photographs of him seemingly flying or hanging in space (see figure 0.1).

I now explore how such images function as moments of suspension by looking closely at the scene in his early solo production *Vinci* in which the performer momentarily seems to become the Mona Lisa, discussed in Chapter 2. To recap, this happens about midway through the production when the central character, the photographer Philippe, is visiting Paris; he is touring Europe trying to move beyond a loss of artistic confidence which he experienced following his friend Marc's suicide. In a Burger King near The Sorbonne, the audience is put in Philippe's position as we encounter a young female artist (also played by the solo performer, Lepage) who, at a certain point in a funny monologue about postmodern art, strikes a pose emulating da Vinci's famous painting (see figure 2.5). I have argued for this as a consummate moment of remediation – of immediacy emerging from hypermediacy – that disrupts the narrative flow; it is as if two strands of time intersect, or that the production's dominant movement of time and evocation of space briefly intersect with an alternative spatio-temporal scheme. Even if the spectator can see it coming (and the whole Burger King scene is a set-up of this image), the moment where da Vinci's painting is recreated on stage interrupts the spectator's perception and, very briefly, displaces semiotic activity with a surprising profusion of visual information. Something that happened in the past in a different place coincides with what is happening in the present on the stage in a way that would be impossible outside this context of representation. Lepage's body as Mona briefly seems suspended somewhere between sixteenth-century Italy (when da Vinci painted the *Mona Lisa*) and then-present-day Paris, where the painting now hangs in the Louvre. The way in which the image collapses and merges different times and spaces creates a moment of Massumian suspension – of 'unpossibilised futurity' and 'pure potential' – before semiosis resumes. The audience member experiences a split second of surprise, a rush of affect. Once the spectator's brain kicks back in, likely responses are laughs or groans of recognition in response to this knowingly kitsch sequence (yet another replication of the over-familiar image of the Mona Lisa …) but its affectual power creates a surplus that makes the sequence do more than advance plot and comment on commodification. Affect is shared between stage and spectators; their co-presence as essential to the workings of the theatrical mechanism is affirmed.

Another such image of a suspended body was discussed in the previous chapter (see figure 3.6): the moment early in *Needles and Opium* when the solo actor surprisingly flies into the air and begins to recite Jean Cocteau's 'Lettre aux Americains', which Dixon classes as perhaps Lepage's 'most powerful and abiding suspension image' (506). Up until this point, the performer had been playing the contemporary

Québécois character Robert, addressing the audience directly about his personal struggles while visiting Paris to record a voice-over for a film about Miles Davis. Having mentioned that he arrived in France carrying a copy of Cocteau's 'Lettre', he then transforms into Cocteau and somewhat shifts his mode of address: while still talking to the audience directly, his accent changes from Québécois to Parisian and his physical style of performance becomes more self-consciously heightened. Two of the production's three key representational planes – Robert's in the play's present day; and Cocteau's in the mid-twentieth century, presented largely in mid-air – converge for the first time, creating a situation of informational, visual, and sonic overload that has the effect of momentarily halting semiosis as the spectator processes it. Dixon understands such moments as Lepage's embrace of a 'quasi-Jungian' understanding of temporality that 'relates back to prehistoric (as well as some modernist) notions of time' (505). This is in contrast to the 'negatively configured "non-time" (the *atemporal*)' of some postmodern thought and artistic practice, and to Levinas's conception of 'a saturated contemporary present enveloping all tenses' (ibid., emphasis in original). While such connections of this performance to alternative conceptions of temporality are possible, my interest remains in the immediate moment of performance and the affect it generates within and between spectators, before intellectual processing resumes and such connections might be made.

A final example is drawn from *The Seven Streams of the River Ota*, a group project developed between 1994 and 1998. The fourth of seven sections in the published playscript, 'Mirrors' is largely a flashback by the artist Jana Čapek of her time in the Terezin concentration camp during the Second World War. At the beginning of the section the actor playing the adult Jana (Ghislaine Vincent) lies down in front of a mirror in 1990s Hiroshima, and perhaps sleeps; as she remembers or dreams of the past, it is enacted on the other side of the mirror, which turns transparent with a lighting change.[4] The action in Terezin is played between this transparent surface and two sets of mirrored walls which 'create a series of images which are intricate and often dazzling' (Frieze 133) (figure 4.1). We watch as twelve-year-old Jana (Marie Brassard) meets and grows close to the opera singer Sarah Weber (Rebecca Blankenship). Sarah hangs herself at the end of the section, overcome, it seems, by the hopelessness of existence in the camp, from which Jana eventually escapes. As the section ends, the adult Jana sits up as Blankenship walks slowly forward behind the glass, singing the title character's final aria from *Madame Butterfly*, in which she says goodbye to her child ('Look closely at the face of your mother, so a trace will remain …') before committing suicide (Bernier et al. 57). A parallel is suggested between Butterfly's relationship to her child and Sarah's relationship to Jana. That Jana is awake and attentive at this point creates a productive ambiguity about the status of Sarah's image; while we know this is a dream or a flashback, it is as if Jana's memories and feelings about Sarah become so strong that she is just about able to bring her back, were it not for the glass between them, behind which Sarah's body seems to float, suspended in time and space. Time-space compression is achieved, in that multiple narrative and thematic planes – Jana's present, her past, and an imagined staging of *Madame Butterfly* – converge in a way that is literally impossible but affectively

4.1 Rebecca Blankenship as Sarah in *The Seven Streams of the River Ota* (original version).

powerful. To be sure, this a moment of high intensity that flirts with melodramatic kitsch, given the emotive quality of the historical context evoked, the music, and the echoes of Sarah's own death by hanging. The association with *Madame Butterfly*, which resonates through this and several other, less direct references in the production, may have blocked some spectators' capacity to connect to the moment affectively, as it is associated with a history of Orientalised representations that render invocations of the character and Puccini's opera potentially problematic. I will continue to explore these associations in the discussion that follows; my purpose here is to identify another example of time-space compression evoked through a suspended body, so as to establish this as a central trope of Lepage's theatremaking.

In these moments that I have identified as a signature aspect of Lepage's dramaturgy, different identifications are suggested for the same body at the same time: Lepage in *Vinci* is at once Philippe and the Mona Lisa, an impossible proposition that the spectator is invited to accommodate. In *Needles and Opium* the performer switches from Robert to Cocteau so quickly and without warning that for split second he potentially appears as both to the spectator. In *River Ota* Blankenship hovers between memory and dream and between the characters of Sarah and Butterfly. Meaning – in the form of affect and of signification – shimmers and oscillates between these possibilities. Meaning, in other words, is momentarily suspended, as is the body suspended in mid-air, and the spectator is caught up in this play of significations. The fact that spectators are all experiencing and processing this effect of time-space compression in the same physical space and time creates a space intense with feeling, and this provides the

sense of connection, of joined-upness, that many commentators have identified as characteristic of Lepage's work, and as having positive value.

It is important to note at this point that the three moments I highlight happen in the flow of the productions' action, and that they do not promote audience identification with one single character. After the Mona Lisa scene, *Vinci*'s action resumes with Philippe travelling to Florence and the actor transforming into a number of other characters, including da Vinci himself. *Needles and Opium* continues with the show's opening credit sequence, and then Robert making a phone call from his Paris hotel room. While the placement of the *Butterfly* sequence directly before an intermission of *River Ota* added to an impression that the moment was being milked for its strong emotive power, it is notable that the next section of the production was set in 1970s Osaka and did not feature Jana or Sarah.[5] In the case of *Vinci* the strong affective charge of the Mona Lisa moment is not pointed in the direction of inviting audience empathy with Philippe's situation. The gesture was not towards the troubled psychology of the central character but is, rather, an expression of the generative capacity of making art. In *Needles* Robert's direct address to the audience and his articulation of a pathos-laden personal situation invite empathy, but this is interrupted by the cuts between his story and those of Cocteau and Davis. While all of the *Butterfly* sequence in *River Ota* is arguably happening in Jana's imagination or memory, it is significant that she spends much of the scene with her back to the audience, and that the action in Terezin as well as Blankenship's performance of the aria are staged behind a transparent surface. These gestures mediate the section's high emotion and limit the potential for engagement in any one character's experience.

Thus these moments are not summative and do not attempt to gather meanings together in a totalising fashion, nor to invite identification with a single character, but, rather, present complex spatio-temporal situations that briefly overflow with affect, working on spectators' bodies and emotions to underline the fundamental fact of the communal presence of audience and performers in the theatre. These points are significant because they go to the larger question of the construction of Lepage's productions – how his montages work more broadly to convey character, plot, theme, and feeling. His approach to dramatic structure and characterisation works differently on spectators than those of productions which follow the traditional codes of mimetic realism, in which spectators are engaged primarily through identification with characters and by a story structure that draws the audience into an intrigue or problem and builds to a climax. The cumulative effect of Lepage's strategies of dramaturgy and characterisation is to create a sense of what Reynolds has classed 'intimacy' with Lepage's productions ('Evaluating' 118), which takes the place of the identification that we associate with mimetic drama. Such identification has been the object of significant critique for the ways in which it can engulf or erase the identity of what is being represented; promoting intimacy while avoiding such erasure lends Lepage's work a particular ethical value which I will go on to explore. First, I will outline some of his recognisable strategies of characterisation and dramaturgy, making reference to Reynolds's analysis as well as Lepage's own account of his practices.

Emotion, character, and audiences

In most cases, the plots of Lepage's original stage works treat a character or characters who have experienced a crisis and struggle to cope with its effects. In *Vinci*, Philippe is trying to deal with Marc's suicide; *Needles*' Robert is suffering after a breakup; we meet *Polygraph*'s characters after the murder of Marie-Claude; and the action of *Lipsynch* is triggered by Lupe's death during its prologue. The triggering crisis in *The Dragon's Trilogy* is Crawford's arrival in Québec City, which stands in metonymically for English colonial contact. Further examples could be offered; the larger point is that the productions tend to treat individuals in a state of distress as they search for bearings after a trauma and tend – particularly the group shows – to be episodic rather than to work towards a single peak point. The productions do not focus directly on the psyche of a character or characters but, rather, build up several thematic layers alongside and echoing that central struggle, one of which tends to be a historical or cultural event, location, process, or conflict, a technique which Melissa Poll, referring to Lepage's stagings of existing plays and operas, calls 'historical-spatial mapping' (*Scenographic* 65). In *Polygraph* the Berlin Wall is used as a framing context for the stories of François, Lucie, and David's personal entanglements and their various relationships to the death of Marie-Claude. *The Far Side of the Moon* sets Philippe's grief and his difficult relationship with his brother against the Soviet–American space race. In *The Blue Dragon* contemporary China's relationship to Western consumerism forms the larger context for Pierre, Xiao Ling, and Claire's love triangle and the questions of parenting and legacy which it raises. This technique, among others, invites a form of engagement that moves between a personal story or stories and a broader context.

In mimetic drama we understand characterisation to mean the presentation of a coherent and complex psychological portrait of an individual whose identity is demonstrated and put to the test by challenges or situations presented in the course of the play. In Lepage's dramaturgy, the development of character is more impressionistic and episodic. In the solo productions, which Lepage always first performs himself, characterisation and performance are deeply interrelated. Reynolds classes Lepage's approach to performance in the solo shows as 'scenographic acting' ('Acting' 134), which derives from the interplay of Lepage's body with puppets and objects on stage. Lepage as an actor 'reconfigure[s] his body as an uncanny object' (133) in order to allow spectators to accept a 'complicated stage-reality' (134) in which significations are constantly shifting and inanimate objects uncannily seem to become animate, and vice versa. Characterisation emerges as 'a "chain" of significations' which are not always inscribed onto the performer's own body; in *Far Side*, for example, we are introduced to various 'facets of Philippe's identity: character; academic; bereaved son; executor; brother; filmmaker; mother; child; exercise fanatic; employee; ex-lover; patient; teenager; socially abandoned; long distance traveller; failure; winner; and finally, weightless' (139). Philippe as a child is played by a puppet, interacting with the performer playing Philippe's mother; and Philippe as a patient is represented by

an ironing board being examined by the performer playing a doctor. The character emerges as a composite effect of all of these snapshots; the overall effect is to create 'a complex perception of character' without Lepage having to engage in the kind of psychological engagement that we associate with representational drama: '[s]tated as an abstract principle, character is perceived without it having to be seen' (140).

Reynolds's analysis of scenographic acting by Lepage in his solo productions can be extended to that of other performers who appear in his works. The group productions tend to feature a number of central characters and the narrative moves between their stories; the spectator pieces together what their problems, desires, and goals are through the montage of scenes. We tend to meet characters at key points in their struggle towards self-realisation, but the montage discourages ongoing identification with any one character or story in favour of a larger engagement with structure, themes, and ideas. Lepage talks about his approach to theatrical creation and acting not in terms of the actor identifying with their character but, rather, as having a form of ownership of it because they contributed to its creation:

> Theatre acting often means pretending to dream up words that are not yours. The more the audience has the impression that the actor himself wrote the words that he is speaking, the more credible his performance. So why not ask actors to write their own speeches, to become playwrights? I am interested in acting only insofar as it is a form of writing. (qtd in Caux and Gilbert 37)

The eventuality that an actor may not achieve credibility even if they have created their own material is not mentioned; but this is perhaps covered, in Lepage's thinking, by the fact that he hand-picks collaborators who he believes have the capacities to contribute well to the work as writer/performers. He seeks out performers with 'intriguing personalities, people who, through their intuition, their intelligence, their culture, their education, and their experience provide interesting input to discussions and improvisations' (ibid.). By curating adventurous, risk-taking companies of performers, Lepage asserts, and by empowering them to create productions together, compelling performances will ensue. This sense of ownership over material does not extend, however, to strong identification with particular characters. As Patrick Caux explains in *Creating for the Stage*, as the companies develop the group shows,

> [c]haracters do not belong to those who created them. They belong instead to the story, to the narrative. The fact that an actor develops a role through improvisation does not mean that he will be performing that role. The characters are like costumes – they are ready to wear. They can be loaned, exchanged, or given away. (39)

Lepage also encourages distance from identification at the level of performance; he does not believe in a Stanislavskian approach in which actors 'interiorise' emotion.

> It is a method that gives excellent results in film – acting that portrays a character's inner world. I am inclined to believe that in theatre, however, that method is full of pitfalls. I realise that there is no automatic relationship between the actor's emotional state and the effect he produces on the audience … the actor's role is not necessarily to be personally moved, but to move the audience … In order to provoke the desired effect, there is no point

in erecting a fourth wall. What is required instead is to convey to the audience the energy of the situation. That means that the emotion must be in the audience, not onstage. (38)

This is a key point about Lepage's approach to performance and affect: the point for him is not the actor feeling things, but the actor finding 'the energy that will produce an emotion in his audience' (qtd in Charest 157).[6] What moves the audience member is a sense of a connection to the actor, a connection brokered by character. Lepage connects this to Brecht's approach to alienation, which he says tends to be 'poorly understood': 'You have to feel the actor not the character' (ibid.). We see here, again, an articulation of acting style and characterisation which makes the performer/spectator relationship its central focus: an audience member might be moved not by observing an actor identifying emotionally with their character but, rather, by feeling like they are being acknowledged and reached out to by the performers.

A politics of identification

All of these techniques are part of an approach to creation and performance which invites audiences to feel intimate with what they are seeing, without necessarily identifying overall with a particular character or performance. Rather, spectators engage by taking in and working to make sense of the productions' numerous elements. They are drawn into the energy of situations, invited to decipher layered, complex storytelling, and rewarded with a strong sense of ownership over meaning. If identification happens, it is mobile and contingent – spectators might see themselves briefly in one character or situation, then another, then perhaps be swept up in the production's aesthetic of transformation and overall affect of wonderment. These strategies of audience engagement thus avoid some of the potential pitfalls around identification which have been the source of concern for centuries of theorists, starting with Plato, who feared that the experience of viewing theatre could destabilise citizens' identities and possibly society itself. Aristotle modified these claims when he described theatre as the art of imitation rather than wholesale identification; spectators understand that what they are watching are 'exemplary characters and emplotments of their suffering' (Diamond 405). Feeling pity and fear as we watch their stories, 'spectators become uplifted through the purgative actions of catharsis' (ibid.). The feminist critic Elin Diamond offers significant critique of the 'mimetic pleasure of identification' (403), questioning how imagining oneself in the place of another might lead to the appropriation and erasure of the other's subjectivity: 'I lose nothing – there is no loss of self – rather I appropriate you, amplifying my "I" into an authoritative "we"' (403–4). Mimetic realism, in Diamond's argument, promotes such 'imperialistic and narcissistic' (403) identification in its production of coherent fictions that affirm the socio-political status quo, even if it is claiming to critique those realities. Diamond returns to Plato's ideas and spins them differently by positing that 'the borders of identity, the wholeness and consistency of identity, are transgressed by every act of identification' (410) – and that this might

have the positive effect of prompting a 'politics of identification ... that dismantles the phenomenological universals of transcendent subjects and objects' (411). This would be accomplished by making spectators aware of their own positionality – historical, cultural, gendered – vis-à-vis the material they are spectating, and using this awareness as a means to reflect on the contingent nature of their position and the possibility for personal and social change.

Diamond's ideas on spectatorship and identification, articulated in a 1992 essay, resonate with those of Rancière, whose *Emancipated Spectator* first appeared in French in 2008. Both theorists explore the potential of spectatorship to disrupt the spectator's understanding of her identifications and her place in the world, and both acknowledge the key role of affect in such disruption. Lepage's productions, at their most effective, promote this kind of active spectatorship. Spectators are drawn into the productions by engaging with different characters, situations, and levels of signification; this generates a profound but shifting affectual engagement while reminding spectators of their own role in the process of meaning-making. The productions are full of moments that invite identification (and its pleasures) and then switch formal and thematic tack, requiring spectators to take account of these shifts. It is in its capacity to promote engaged and reflexive spectatorship that Marvin Carlson and Janelle Reinelt locate a particular value of Lepage's work. Like those of Complicité and Needcompany, Reinelt argues, Lepage's productions 'are constructed ...[so] that you can enter the experience from a variety of different perspectives and places' (190). For Carlson, Lepage's work is so open that it sometimes risks incomprehension: 'he is giving us something that came be read on a number of levels ... no single audience member is likely to understand the variety of cultural references or even the languages [Lepage's characters] use' (189). For Carlson, the extent of the work's openness does positive cultural work, in that it reminds spectators of the limitations of their own viewpoints and that 'positionality determines ... understanding' (190). Such openness represents an advance, Carlson argues, on the work of a previous generation of theatre artists such as Peter Brook, which were based on a 'universalist theory ... that you can somehow tap into something human no matter where you go ... because we are all human we will all experience the same thing at some basic level' (189). Indeed, as I have been arguing, Lepage's discussions of his early- and mid-career work tended not to make the sort of universalist claims that Carlson notes, but, rather, stated an aspiration to create opportunities for affectually powerful viewer experience by staging a search for meaning. Not all spectators are interested in productions that prioritise feeling over direct reference and grounded socio-political argument, but many are. Lepage's early- and mid-career work was geared for them.

River Ota and the global image bank

I now turn to some of the debates around Lepage's approach to meaning-generation, dramaturgy, and characterisation, which allow further exploration of how signification

functions in his work. Carlson hints at these debates in the discussion with Janelle Reinelt referenced above: Lepage, Carlson notes, has been 'accused of a kind of inter-cultural cherry-picking, taking a little Japanese stuff, a little French stuff, and so on' (189). I have engaged with critiques of Lepage's representation of cultures other than his own in the previous chapters, as with the discussion of China and Japan in *The Dragon's Trilogy* in Chapter 1; and in Chapter 3's consideration of the character of Skaddie in *Tectonic Plates*. Questions about rights of representation and appropria-tion became a central aspect of discussion around *Les sept branches de la rivière Ota/ The Seven Streams of the River Ota*, an epic production inspired by and set partly in Japan, which took major events of world history, including the bombing of Hiroshima, as its subject matter and theme. This was a point at which Lepage's characteristic attempts to keep the focus of his works' signification on infiction were stretched to their breaking point, leading commentators to query the ethics of his engagement with his chosen content. Questions that circulated around the production included: what responsibilities, if any, do artists have to cultures and events distant from their own experience? Is any and all material potentially up for grabs? Do those whose culture or experience is represented in an artwork have the right to a say in those representations; and if so, how to involve them? How can artists best communicate sensitivity to cultural difference in and through their work? Are there expectations and should there be limitations around the representation of material associated with historical trauma? Who is the rightful arbiter of such concerns? These are debates in which Lepage and his work have continued to be engaged throughout his career and came to a head again in controversies around the productions *Slàv* and *Kanata* in the summer of 2018 (as I discuss in Chapter 7). Criticism and scholarship around *River Ota* set some of the terms of this dialogue.

Entering into this area of discussion, it is useful to return to the argument begun in the last chapter about metaphoric and metonymic storytelling. As discussed, Lepage considers metaphor the basic building block of his theatre and describes his method as the layering of significations on top of each other. Spatial montage is such a layering technique – meaning is stacked upon meaning to the point that the spectator cannot fully process them all, and affect is generated. Lepage understands traditional theatri-cal dramaturgy as metonymic – stories that move forward in a linear fashion through a series of comparisons – and contrasts his own practice to this. I argue, however, that his productions tend to combine metaphoric and metonymic strategies, not just comparing elements (metaphor) but also working with elements that are inherently related and suggesting connections between elements that may not initially seem to be in relationship – both of which are metonymic techniques. Saying that relation-ships in his work remain metaphorical is one of Lepage's characteristic gestures of elusiveness: if what he is doing is suggesting likenesses and never fixing elements in relationship, then it is hard to hold him accountable for a representation or an argu-ment. And, as suggested in the discussion of Skaddie in *Tectonic Plates*, the perception of references as metaphoric or metonymic can be culturally inflected. What might be an uncontroversial comparison to one spectator could be a problematic reduction to another. Dundjerović argues that 'any cultural content and artistic tradition can become a resource and material for [Lepage's] devising' and characterises this as

a 'typically pragmatic' aspect of Lepage's creativity (44, 45). Many elements which Lepage brings into his montages, however, have histories and meanings that some spectators cannot detach from them. In such cases, meaning-generation does not continue onwards in a series of iterations; rather, the external referents disrupt and expand the meaning-making process and, in a number of cases, enter the productions into dialogues around cultural appropriation.

The complex debates about *River Ota*'s representations illustrate this problematic. Created between 1994 and 1998, it was Lepage's most ambitious undertaking to date, involving a four-year-long creative process and twenty-three co-producing organisations; in its final form it was over seven hours long.[7] Lepage's initial conception was that the show would be structured as seven discrete sections, each exploring a different artistic genre and a different decade in the twentieth century (Ex Machina, 'Seven Streams' 1994). Its socio-historical backdrop eventually came to include some of the most grave and resonant events of modern history: in addition to the bombing of Hiroshima, it also treated the Holocaust and the AIDS crisis of the 1980s and 1990s. Its primary location was Hiroshima, with some scenes taking place in Osaka, Amsterdam, Terezin, and New York. Ric Knowles described the production as a 'kind of interculturalist "six degrees of separation"' which

> brings together disasters and healings that range from Hiroshima to the Holocaust to AIDS and explores, not causal or even analogical relations between them but their interrelated impact on a group of people related through blood, friendship, and history. ('Festival' 91–2)

Many commentators embraced the production's ambitious sweep and humanist vision, and in particular highlighted its affectual power. In *The New Republic*, Robert Brustein called it a 'masterpiece' which 'attempts to show how suffering and sensitivity to suffering are human qualities that somehow manage to unite people' (29), while Jean Beaunoyer in *La Presse* called it 'Lepage's great work, because he succeeded like never before in marrying aesthetics and emotion – the whole gamut of emotions' ('Monumental').[vi] In *American Theatre* Jim O'Quinn praised the piece as a 'masterwork of indirection – a monumental, impressionistic riff on the bombing of Japan, which the play likens to two other of the century's most formidable calamities'. Lepage, O'Quinn argued, 'is not concerned with … documentary questions' but, rather, asks, 'What are the human consequences?' (19). Peter Brook's praise of *River Ota*, originally published in a letter to the Québec newspaper *Le Devoir* and then reprinted in the published playtext, seems clearly informed by the humanist worldview which Carlson mentions above: Brook called it 'a theatre where the terrifying and incomprehensible reality of our time is inseparably linked to the insignificant details of our everyday lives – details that are so important to us, so trivial for others' (qtd in Bernier et al. ii). Lepage and his collaborators' creation of individual fictional stories connected to real-life, large-scale traumatic events was an effective technique,

vi 'la plus grande œuvre de Lepage parce qu'il a réussi comme jamais auparavant à marier l'esthétique et l'émotion. Toute la gamme des émotions.'

4.2 Patrick Goyette as Luke and Anne-Marie Cadieux as Nozomi in *The Seven Streams of the River Ota* (original version).

in Brook's analysis, of giving audiences a purchase on these events and of prompting empathetic responses. This movement back and forth between one's own individual life-world and the broader historical-social-political-economic context, it is implied, is a shared human experience. For Jen Harvie, however, the fact that these 'personal and even domestic' stories were set against the background of what Lepage called 'rather self-importantly and certainly idiosyncratically ... "the three holocausts of this century"' was problematic in that the 'accumulation and mutual contextualisation' of the Holocaust, Hiroshima, and AIDS made 'them seem somewhat iconic, even generic' ('Transnationalism' 119). Sherry Simon, too, questioned the ethics and effectiveness of a referential net cast so wide, arguing that the production's linking of these events as a 'series' is 'a major flaw in the structure of the play' ('Robert Lepage' 224). Through its structure, she argues, the production suggests that these catastrophes are 'in some fundamental way "the same thing"... One would wish for a more nuanced and problematised confrontation of these historical "events"' than the suggestion of their 'commensurability' (ibid.). In other words, these critics objected to the metaphoric principle of likening these major world events to each other: to suggest similarity without a full consideration of these events' specificity is, in their view, a problematic reduction of their significance.

Some might argue that involving people directly affected by the historical events in the creative process, such as a *hibakusha* (a survivor of the Hiroshima or Nagasaki bombings) or a Holocaust survivor, would have added ethical weight to the process

and perhaps led to the addition of material that communicated greater distinctions between these events. The production was inspired in part by Lepage's encounter in Hiroshima with a *hibakusha* (see O'Mahony), but that person was not involved in the production. Lepage and his collaborators may have had direct links to the Holocaust and the AIDS crisis through their own experience or that of relatives and loved ones,[8] and their research process may have involved interviews with people with such direct experience, but this was not foregrounded in their discourse around the production. Discussion of the ethics of representing historical events and phenomena associated with mass trauma, and of rights of representation more broadly, did not feature in the rehearsals of the production that I attended over its multi-year development. Rather, in my observation the collaborators' approach was as Dundjerović suggests: a process of following instincts and interesting creative leads, researching, and gathering material from what might be characterised as a global image bank of ideas, images, and events. The risks of this approach, as evidenced from Harvie's and Simon's responses, is that some spectators may object to the removal of content from its historical and cultural context and its treatment as raw material for creativity and affect-generation.

Michael Billington's *Guardian* review of the production's 1996 London run introduced a related line of critique:

> there is a whiff of cultural colonialism about the idea that the show is about Westerners who come to Hiroshima to find themselves 'confronted by their own devastation and their own enlightenment'. The more we know about Hiroshima the better; but the idea that, having first destroyed it, we should then use it as spiritual salvation sticks in the throat. ('Grand Stage')

While set largely in Japan and featuring some Japanese and Japanese-American characters, the production's actor-creators were all Caucasians and all but one of them were Québécois.[9] It is possible, as Harvie argues, that the cultural and ethnic distance between the creators and the characters they played added to its 'tourist gaze, a gaze expressly looking in, not claiming insider status' ('Transnationalism' 119). Reviewing the Edinburgh world premiere for *The New Statesman and Society*, Angus Calder argued that Lepage 'acquits himself' of potential claims of Orientalism through elements of casting and plotting which underline the distance between the artists and the cultures they are depicting: 'When Sarah sings Butterfly in Theresienstadt, it is with frankly blonde hair pinned up Japanese-style. Jana and her new young lover are outsiders seriously trying to understand Japanese culture' (32).[10] In Harvie's further assessment, however, this tactic of the creators distancing themselves from their depictions was undermined by the production's inconsistent treatment of representation as an overt theme and subject matter, and by its spectacular nature. Were it to have maintained a consistent position of self-awareness about its own status as representation, Harvie argued, this might have provided audiences with an interpretative framework.[11] But for Harvie and other commentators it became difficult to understand the production as intending 'a critique of representational and spectatorial practices and effects' when it, for example, invoked the peak moment

of tragedy from *Madame Butterfly* without acknowledgement of the familiarity of the reference (121). 'Is Butterfly deployed ironically, or merely for her intercultural, hyper-theatrical flavour?', asked James Frieze in *The Journal of Dramatic Theory and Criticism*. 'In practice', he continued, 'the question is somewhat moot, the hyper-theatricality overwhelming the irony. Like many a stadium rock concert, the play is so driven by aesthetic set-pieces ... that it provides an intense but strangely vacuous experience' (137). By not 'turning a critical eye on the dramatic practices and appa-ratus, which produce naturalistic effects and potentially naturalise Orientalist fanta-sies', the production ran the risk of extending those effects and tropes, Harvie further argued (121).

For Sherrill Grace, that Lepage is Québécois, 'constructed as Other' by the Canadian nation-state (138), provides a crucial context for his use of *Butterfly* as a principal structuring agent of *River Ota*. As she points out, in addition to being directly invoked in the 'Mirrors' section, *Butterfly's* narrative informs the production's opening and closing sections, in both of which a Western man makes love to and leaves an Asian woman (figure 9.2). Grace invokes Homi Bhabha's conception (following Derrida) of supplementarity – the repetition that destabilises the very notion of a singular state-ment, which in the context of minority voices or the colonised speaking from within the dominant culture 'can be turned into the discourses of emergent cultural identi-ties, within a non-pluralistic politics of difference' (Bhabha 305). Because Lepage has, Grace argues, effectively been Orientalised himself, this gives him 'the power of vision, of seeing things differently', which he uses in the production to reflect on representa-tion and 'decentre aspects of the dominant Western discourse of identity (national, racial, ethnic, sexual, and linguistic)' (138). In her reading, the production is char-acterised by abundance and a recurrent trope of mirroring, in which one reflection begets another, generating a 'potentially endless exfoliation of continuing, yet related, differences' (147). This and 'its ensemble creation and performance all constitute a form and methodology of supplementarity. No single character dominates the play; no isolate mind contains the action ... the play spills over, exceeds its bounds', and in so doing serves to 'expose and explode the sterile, deadly binary on which the Butterfly narrative rests' (149).

Grace identifies here the mechanism of signification based on metaphor – representation following on representation through the suggestion of similarities, in an endless, non-teleological fashion – which is Lepage's stated aspiration for his work. A snag in her argument, however, is that it rests on Lepage's assertion that he uses Asian cultures as a way to better understand himself and Western culture: Lepage's statement that 'you need a mirror, and one of my first mirrors was the Orient' (inter-view with Rémy Charest qtd in Grace 136) is an epigraph for her chapter.[vii] A Western subject understanding himself in contrast to 'the Orient' (a diverse range of cultures reduced to a single term) is the very definition of Orientalism as articulated by Edward Said in his 1997 volume of the same name. Thus the principle of supplementarity which Grace sees playing out in the production is grounded in the East/West binary which, she argues, it explodes. The reiteration of a reference (such as the *Butterfly*

vii Grace quotes Lepage in French: 'Il nous faut un miroir et pour moi ... c'était l'Orient'.

trope in *River Ota*) does not necessarily negate its problematics; engaging the refer-ence metaphorically does not erase the metonym that is suggested, connecting East to West in a relationship of binary otherness. The assertion that an experience of marginality grants someone the 'power of supplementarity' would seem to substitute ontology for representation and is far away from the kind of post-colonial hybridity that Bhabha espouses, in which colonial subjects adopt, replicate, and adapt tropes and styles by which they have previously been objectified and in so doing illustrate their reductiveness. Grace's attempt to recover Lepage's engagement with *Butterfly* is therefore not fully successful in refuting arguments that his use of it was appropriative and less than fully critical.

The limits of metaphor

The larger point which these debates demonstrate is the complications that ensue when Lepage inserts imagery and ideas into his montages that carry existing cultural meanings with them, particularly meanings that are contentious within the specific circumstances of reception. Recalling Rancière's assertion that it is the responsibility of politics to make use of the possible meanings of art, and not 'the other way around', it could be argued that this is not Lepage's concern, and his comments about his work being there for audiences to do 'what they want with it' suggest that he would agree with such an argument. There are risks involved in such a reception-based practice. As Reynolds underlines, if references do not accumulate into a '[climax] of convergence' (*Revolutions* 94) but, rather, stay at the level of comparison for spectators, what results is, in critic Kate Taylor's words, a 'theatre of coincidences rather than narrative, figures rather than characters and symbols rather than themes' ('Trilogy'). To use Lepage's stacking imagery, in such instances references pile up but do not reach sufficient affective weight to collapse into each other: verticality does not collapse into the horizontal, that is, back into the narrative where the references might suggest meaningful connections between characters, storylines, and themes.

Taylor highlights two scenes from the 2003 revival of *The Dragon's Trilogy* as examples of such attempts of affective signification working and not working. The successful one was the 'Skater's Waltz' sequence (figure 4.3), in which

> soldiers wearing ice skates wantonly march through the multiple pairs of shoes that [Lee] Wong is desperately trying to tidy into families – one for daddy, one for mummy, one for baby – creating an image that summarises both the sweeping destruction of history and the small domestic tragedy taking place in Jeanne's household.

Taylor describes here an effect of the accumulation of meaning to a point of sum-mation in which macrocosm and microcosm connect, creating a moment of liter-ally impossible but affectively powerful convergence, one which resonates with the sequences from *Vinci* (Mona Lisa), *Needles and Opium* (Robert's transformation

4.3 'The Skater's Waltz' sequence in *The Dragon's Trilogy* (original version).

into Cocteau), and *River Ota* (Sarah singing *Butterfly*) discussed above. For Taylor, metaphor and synecdoche worked in harmony in this sequence, as bodies and objects were both compared to each other and stood in as small-scale representations of larger phenomena or entities: the organised movement of skating to music is placed alongside and then transforms into the organised movement of marching (metaphor); the soldiers symbolise war while the shoes symbolise that which is destroyed by war (synecdoche); Jeanne and Lee's family tragedy is likened to 'the sweeping destruction of history' (metaphor) and comes to stand in for that destruction in microcosm (synecdoche). This family story was sufficiently credible and engaging for Taylor to accept it as representative of the destruction of the Second World War.

By contrast, the intended climactic scene between the Québécois character Pierre and the Japanese woman Yukali did not work for Taylor: 'the text collectively written by the original performers sounds painfully simplistic while the Japanese fertility symbol that accompanies their union looks ludicrously overblown'. The attempted convergence of significations in this invented fertility ritual was noted in many accounts as one of the affective high points of the original 1980s production of *The Dragon's Trilogy*; but Taylor, encountering this sequence nearly two decades after the production was first staged, could not accept the relationship suggested, it is implied, because the metaphor and synecdoche did not flow easily into each other. Taylor balked at accepting the characters as stand-ins for West and East and their union as the symbolic convergence of those concepts, so that what was clearly intended to be inspiring and moving came across as heavy handed. Taylor's resistance here is

reflective of evolving sensibilities around rights of representation and appropriation that were also at play in reception of *River Ota*, evidence that Lepage's representations of non-Western cultures have become an increasing sticking point, largely among commentators from Anglophone backgrounds since approximately the year 2000. For these commentators, the concepts *West* and *East* cannot be extracted from debates around colonialism and Orientalism in which they figure, and in which they are widely considered as damagingly reductive. As I explore further in Chapter 7, Lepage and his collaborators centred the concept of artistic liberty in the controversies around his 2018 productions *Slàv* and *Kanata*: 'People must have the right to use others' stories to tell their own', Lepage said in a July 2018 Radio-Canada interview ('Entrevue').[viii] With this he asserts his own creative freedom even as the notion of the spectator's freedom to 'do what they want' with his productions – so central to his early- and mid-career thought and practice – slips from the foreground of his discussion. A long view on his career reveals that the crises of 2018 had been brewing for a long time, presaged in responses to *River Ota* and the revival of *The Dragon's Trilogy*. The broader Lepage's frame of reference grew and the more prevalent post-colonial and intersectional thought became in the wider culture, the more provocative and incommensurate some of his representations became to some spectators. Signification obstructed affectual engagement; metonym blocked metaphor.

Narrative structures and narrative closure

A final area in the consideration of the meaning-generation in Lepage's work has to do with the overall structure of his large-scale productions, and the relationship of such structures to the productions' endings. A number of his shorter productions are open ended, as with *Needles and Opium*, which does not resolve the character Robert's personal struggles but, rather, leaves the metaphoric layers of its narrative (the comparisons between Robert, Cocteau, and Davis) open, suggesting endless potential iteration and significations. The ending of *The Far Side of the Moon* is similarly open ended; I discuss it in Chapter 7. Some of his large-scale group-created productions, by contrast, steer the audience towards conclusive moments of catharsis in which meanings are consolidated rather than left open.

One example is the published version of *River Ota*, which comes to a climax with what collaborators named 'the kimono dance' (145). The context for this is an exchange between the young artist Pierre (Éric Bernier) and the Japanese woman Hanako (Marie Brassard), who is renting him a room in her house in Hiroshima while he visits the city to study butoh dance. In helping him to compose a performance in which he plays an *hibakusha*, Hanako dresses him in a Japanese wedding kimono which has been hanging at the back of the stage throughout most of the show. What ensues is a staging of time-space compression through spatial montage in which

viii 'Il faut que les gens aient le droit d'utiliser les histoires des autres pour parler des leurs.'

various storylines and characters are drawn together. *River Ota* opens with a prologue which states that the production concerns 'people from different parts of the world who came to Hiroshima and found themselves confronted with their own devastation and their own enlightenment' (1), and the kimono dance reminds spectators of several of them – the American Luke, the Czech Jana, and the Québécois Pierre. As Hanako puts the kimono on Pierre, he slowly turns around. After the turn, actors have replaced each other so that older Jana is then seen putting the kimono on Sarah – recalling the 'Mirrors' sequence. Another turn and the spectator sees Nozomi and Luke, the Japanese *hibakusha* and American serviceman who meet in the first section (see figure 9.2); a final turn and Pierre and Hanako reappear (146). The relationship suggested is metaphorical – each couple is like the next – and the sequence functions as a climactic flashback montage in which the audience is reminded of these characters and their stories. The affective and narrative significance of this sequence is enhanced by its positioning at the end of the production: it does the work of tying the stories together, but in so doing generalises and erases differences between them. The problematic usage of Hiroshima/Japan as the site for Western spiritual salvation, as mentioned by Billington, is at its most pronounced here and underlined through the spatial montage technique. Inviting audiences to see Hanako, Sarah, and Pierre as related and/or similar arguably likens the artistic angst of the young Québécois to the direct experience of an atom bomb survivor or someone who died in the Holocaust. This contributes to the production's problematic correlation of three major global catastrophes identified by Harvie and Simon: to add in an individual contemporary artist's personal struggle to this grouping is to flatten and banalise the specificity and gravity of the historical events referenced.

Similar questions can be raised about the final scene of *Lipsynch*.[12] The production's through line is the story of the Nicaraguan woman Lupe (Nuria Garcia): her death in the production's prologue, during an international airplane journey, is the jumping-off point for its networked stories, which include those of the opera singer Ada (Rebecca Blankenship) who adopts Lupe's orphaned baby; and of that child, Jeremy (Rick Miller), in his adult life as he searches for his family story. In the production's final section it is revealed that Lupe had been networked into prostitution in Germany, and was on her way to a better life in North America when she died on the plane. The production ended with a Pietà-like image with Lupe cradled in Jeremy's arms, observed by Ada – a moment which echoes the opening scene, in which Ada holds the baby Lupe on the plane. The scene depicted is impossible in naturalist narrative terms (the son is holding his own infant mother) and thus seems intended as a summing-up of the play's themes and imagery. Its placement at the end of the production, the quotation of the previous image, and the invocation of themes of motherhood and martyrdom all seem geared towards creating an effect of time-space compression through spatial montage, providing a sense of shared emotional purgation as does catharsis in mimetic drama. By not placing the phenomenon of human traffic into any socio-political context, however, and because of an investment in the notions of fate and destiny elsewhere communicated in the show's narratives, the production arguably implies that such horrors as befell Lupe are somehow inevitable and that perhaps women from the developing world are destined to such ends, a socially

conservative and fatalistic message. In Reynolds's assessment, this is an example of Lepage's signature technique of narrative layering becoming overladen:

> neither the character narratives swirling around the central triad of Ada–Lupe–Jeremy, nor the production's multifaceted engagement with voice, could fully converge in this iconic image. It may be that convergence – which relies on density of meaning, packed into an object or character – can be neutralised as an affect by excessive weight of material. (*Revolutions* 132)

The sequence's emotive power was underlined in six of ten reviews of the production when it played at London's Barbican Centre: critics praised it as 'deeply moving' (Spencer 'Lipsynch'), 'devastating' (Marlowe, Murphy), 'magnificent' (Woddis 'Lipsynch'), 'touched by a sorrowful magic' (Szalwinska), and 'uplifting, puzzle-solving' (Benedict). This was an affective moment, however, which limited and steered rather than opened up interpretations of the production's meanings. Such a narrative choice runs against the kinds of staging strategies I have discussed in this chapter which promote and celebrate spectator ownership of meaning and communicate a strong commitment to signification and affective engagement being ongoing, fluid processes.

The prescriptive endings of *River Ota* and *Lipsynch* are, in my observation, a result of larger struggles around the formal organisation of these large-scale group projects. Lepage frequently stated his desire that these productions should have modular structures so that sections could be performed in different orders at different performances. With *Lipsynch*, for example, Lepage suggested that it might 'start at any given story out of the [nine sections]. This would give the form of the piece a circular motion' (Knapton 45). If that were the case, then no final summing-up moment would be possible or necessary, as the production would end differently depending on the order in which it was played. In the course of developing the productions, however, questions arose about if and how the different storylines, themes, and planes of action connect to each other, and around coherence and narrative build; in the case of *Lipsynch* this led to the full-length version ending with the conclusive, cathartic, and conservative final image just discussed. As discussed in Chapter 3 (pp. 105–12), *Tectonic Plates* was another such instance: while Lepage initially envisioned a number of sections which could be presented in various orders, the production experienced a significant crisis in 1989 when the collaborators could not agree on a performable version, and a major festival booking was cancelled. The production as it moved forward settled into an established sequence and did not feature the modularity that Lepage had initially envisioned.

In the case of *River Ota*, Lepage conceived it as being made up of discrete sections which could be performed in different sequences; as the creative process continued, more sections were added and their order shifted around. The Edinburgh premiere, for example, opened with Pierre arriving in Hiroshima, a section that became the fourth of five sections in its 1995 version (see Friedlander), and eventually the final of seven sections. In its shorter versions, as Harvie notes, the production was shaped around Jana's life story as its 'central narrative vehicle', whereas its seven-hour version shared out the role of 'participant in and witness to events' ('Transnationalism' 119)

among many characters – a technique which allowed the sorts of mobile and contingent identifications I discuss earlier in this chapter. It is notable that, while the version presented and published in 1996 was originally intended to represent the end of the creative process, Lepage and his collaborators came to feel that this 'wasn't a completed version' and kept working on the show into 1997 (qtd in Smith). The production that played in Chicago and Montréal in May–June 1997 was 'the absolutely complete version', according to Lepage (ibid.), an account which differs significantly from his initial conception in which completion was not a desired goal. Lepage and his collaborators' approach to the 1997 version was shaped by their work on a spin-off creative product: a short film directed by Francis Leclerc, in which each of the production's seven sections was distilled into seven minutes. In making the film with Leclerc, Lepage says, '[w]e had to make choices and connections that we had not seen' (qtd in Lapointe).[ix] As in Leclerc's film, the 1997 stage version was structured around Hanako. While in previous versions the character had been the wife of the character Jeffrey Yamashita, in this one she became his sister and Nozomi's daughter; the 1997 production began with the child Hanako witnessing the bombing of Hiroshima, which blinded her. The kimono dance was thus given even more power of narrative closure, given the framing of the overall production as Hanako's experience from childhood through adulthood. In a June 1997 press conference five of the production's actor-creators expressed, in the observation of the critic Jean St-Hilaire, 'the feeling of having finally achieved, after three long years of uncertain journeying, creative satisfaction' ('L'urgentologue').[x] This satisfaction seems clearly connected to the creation of a version of the production with a strong narrative backbone connected to a single character's journey – a long way from the vision of the non-linear, modular, ever-shifting entity which Lepage originally envisioned.

In this chapter I have extended the discussion of the cinematic nature of Lepage's theatremaking by talking about the effects of his representations. Drawing on the work of theorists including Hurley, Deleuze, Ahmed, Massumi, and Rancière and building on the previous chapter, I have introduced further concepts and vocabulary with which to explore the dual valence of 'meaning' in Lepage's work – meaning as signification and meaning as affective power. I have suggested the ways in which Deleuze's theorisation of becoming and immanence can usefully be applied to Lepage's conception of theatremaking as process and to his understanding of theatre's relationship to spectators as one of communion. Rancière's conceptualisation of the emancipated spectator is also useful in thinking through the work of the audience in relationship to Lepage's productions. Observing bodies and objects transform on stage, processing what is happening, and connecting this to one's own experience of navigating contemporary globalised life creates for many audiences an affect of wonderment that is characteristic of Lepage's work. One of Lepage's signature staging effects involves bodies apparently suspended in time and space when storylines and themes associated with them converge, creating an overflow of significations which bring a sense of

ix 'Nous avons donc dû faire des choix et des raccords que nous n'avions pas vus.'
x 'le sentiment de toucher enfin, après trois longues années de pérignations incertaines, à l'accomplissment créateur'.

affective plenitude. Following Ahmed, I have argued that such an affect can be shared communally without individual spectators knowing exactly what others are feeling and thinking; such an assertion allows the acknowledgement of the importance of affect to Lepage's practice without crossing into excessive speculation about others' experience. A consistent and significant critique of Lepage's work concerns what some feel is the reductive or insensitive treatment of important events from world history and of cultural/national identities that are not his own. In such instances, I have argued, spectators resist the connections that are being offered between bodies, objects, and ideas, and do not find access to the potential experience of shared wonderment. Lepage distances himself from such situations by underlining the liberty of the spectator to find significance in his work, but, as I further discuss in Chapter 7, such avoidance is becoming increasingly difficult for him to maintain in the mature period of his career. In this chapter I have also discussed some of the challenges that Lepage and his collaborators faced in the structuring of large-scale group productions, which consistently led away from open-form structures to more traditional narrative arcs and endings that bring catharsis and closure. In these instances the context and experience of group creation led to Lepage altering his stated goals for the projects. It is likely that such dynamics are part of what led him to move away from such large-scale collaborations, as I discuss in the next chapters, which consider questions of authorship, signature, and branding as negotiated by Ex Machina since its founding as a company.

Notes

1 There has been a shift in Lepage's approach to direct reference to topical political situations since approximately 2010. The *Playing Cards* series portrayed contemporary soldiers' experience of war (*Piques/Spades*) and an Algerian immigrant to Québec's relationship to conflict in his home country (*Coeur/Hearts*), as Reynolds explores in chapter 8 of his 2019 volume. Similarly, Melissa Poll argues that Lepage's 2011 collaboration with the Huron-Wendat nation on a production of *La Tempête* saw him engaging with questions of Indigenous/settler relations, cultural power, and representation in newly politicised ways. While considerable controversy arose about the circumstances of their creation and presentation, *Slàv* engaged with African-American slave narratives and *Kanata* explored the history of oppression and exploitation of Indigenous people in Canada.

2 In mid-1990s interviews with Rémy Charest, Lepage articulated points of view about pedagogy and theatre that resonate with Rancière's: 'A good teacher is one who succeeds in arousing the student's curiosity so that he can actually want to know the population of Canada or the altitude of Mount Everest. The teacher creates a desire to understand. In the same way, the most interesting kinds of theatre trigger a series of questions in the audience, rather than simply providing answers' (142).

3 'Magician' (Morrow); 'sorcerer' (Rupert Christiansen); 'wizard' (Leung); 'alchemist' (O'Mahony); 'epic ambition ... join up the dots ...' (Coveney 'Ferocious').

4 References are to the cast members who were also co-authors of the production during its original development period and touring life (1994–98). Ex Machina revived the production in 2019 with largely a new cast.

5 The order of sections of *River Ota* changed throughout its development. I am referring to the ordering in the published playtext by Bernier et al.

6 As noted in the Introduction, this approach to acting, emotion, and audiences was central
 to Théâtre Repère, as articulated by the company's co-founder Jacques Lessard.
7 The co-producers were the Edinburgh International Festival; Manchester '94, City of Drama;
 La Maison des Arts de Crétail; Wiener Festwochen; Theatreformen '95, Braunschweig;
 Change Performing Arts, Milan; IMBE Barcelona; Präsidalabteilung Der Stadt Zürich,
 Zuercher Theater Spektakel; Aarhus Festuge; Bunkamura Tokyo; Harbourfront Centre,
 Toronto; Kampnagel, Hamburg; Les Productions d'Albert, Le Centre Culturel de
 Drummondville; Le Centre Culturel de l'Université de Sherbrooke; Les Productions
 Specta; Staatschauspiel Dresden; Københaven '96; Ludwigsburger Schlossfestspiele;
 Stockholm Stadsteater; the Brooklyn Academy of Music, New York; Becks; and
 Cultural Industry, Ltd. Source of this and further lists of co-producers: Lacaserne.net.
 The primary creators of the show along with Lepage were Éric Bernier, Normand
 Bissonnette, Rebecca Blankenship, Marie Brassard, Anne-Marie Cadieux, Normand
 Daneau, Richard Fréchette, Marie Gignac, Patrick Goyette, and Ghislaine Vincent. Macha
 Limonchik joined the production for several of its 1996 engagements and contributed to
 the creation of material during that time. Gérard Bibeau served as dramaturg. I observed
 three week-long stints of the *River Ota* creative process in 1994, 1995, and 1996, all in
 Québec City. I wrote English-language surtitles for the show's June 1996 run at the Wiener
 Festwochen, and co-transcribed several of the Vienna performances towards the publica-
 tion of the English-language playscript, which I edited. In addition to Vienna in 1996, I saw
 the production performed multiple times in Edinburgh (1994), Tokyo (1995), Québec City,
 London, and New York (1996), and Montreal (1997).
8 Co-creator/performer Rebecca Blankenship had, in my observation, particular investment
 in the elements of *River Ota* set in Terezin, bringing many research materials about the
 Holocaust to the process.
9 Lighting designer Sonoyo Nishikawa was the only Japanese person on the core creative
 team.
10 The structure of *River Ota* and the ordering of its sections changed frequently throughout
 its four-year development, as did some of its characterisation. In the Edinburgh premiere,
 the character Jana Čapek owns a house in Hiroshima and hosts the young Québécois artist
 Pierre. Grace, below, refers to the Methuen playtext version, in which it is the Japanese
 character Hanako who owns the house in Hiroshima and welcomes Pierre.
11 Christopher Balme praises *River Ota* as a consummate example of intermedial theatre
 which takes photography – 'the medium of memory in the twentieth century' – as its
 theme, 'connecting the various strands of action as they shift back and forth over fifty years
 and three continents' (11). Notably, Balme leaves discussion of the production's culturally
 specific content and its references to catastrophic world events out of his discussion.
12 I am referring here to *Lipsynch*'s full-length version which played at London's Barbican
 Centre in September 2008.

5

Branding Ex Machina

Lepage's early- and mid-career original productions reveal a preoccupation with the relationship between art and commerce. They feature the recurrent figure of an artist, frequently self-identified, who struggles to maintain integrity and agency while navigating an environment in which buying and selling their work is an inevitability. His fascination with great artists is accompanied by a critical – often comically critical – awareness that such greatness is a historically and culturally determined construct. In *Vinci*, Philippe attempts to comment on the universe's coldness by photographing bathroom fixtures, but that critique is not perceived by the bathtub company that wants to use his images in their advertising. In the same production, Lepage re-imagines the Mona Lisa as a radical performance artist who gives tours of the Louvre to make a living. The first appearance of the self-identified character Pierre Lamontagne, in *The Dragon's Trilogy*, figures him not only as an artist but also as a gallery owner, whose encounter with the 'meditative artwork' of the Japanese artist Yukali 'causes him to reevaluate his commercial relationship to art' (Moy 500). A key location of *Tectonic Plates* is the art auction, and it is the character played by Lepage, Jennifer McMann, who points out that a famous painting of Georges Sand and Frederic Chopin was cut in two to better circulate around the world as individually saleable art objects (see Donnelly 'Tectoniques'). *Elsinore* is less an attempt to deliver *Hamlet* than to riff on the cultural significance and weight attached to the play and character: it is Shakespeare as a game to be played, a set of ideas, words, and clichés to be explored (see Kidnie, Knowles 'From Dream'). In the 2000s, a newer figure appears in Lepage's work, the successful but disillusioned middle-aged artist (*The Andersen Project*'s Frédéric; Philippe in *The Blue Dragon*), as does a darker twist on the art-as-commodity theme: the potential of the loss of creativity under the deadening hand of commercial forces. Art markets are depicted as treacherous, volatile places where

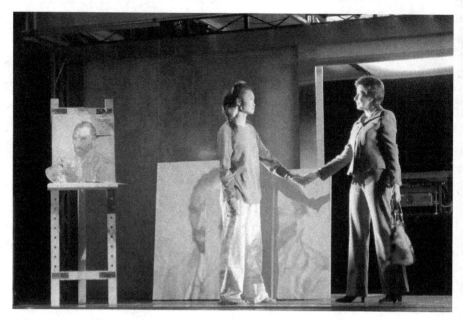

5.1 Tai Wei Foo as Xiao Ling and Marie Michaud as Claire in *The Blue Dragon*.

creativity and idealism cannot easily thrive, as in *Andersen*'s arch portrayal of the commoditisation of the international opera world, and the nightmare image in *The Blue Dragon* of the promising young photographer Xiao Ling exiling herself in the Chinese neighbourhood of Dafen, painting knockoff Van Goghs (figure 5.1).

Lepage's artist characters navigate what Howard S. Becker influentially termed 'art worlds' – 'network[s] of people whose cooperative activity, organised via their joint knowledge of conventional means of doing things, produce[s] the kind of art works that art world is noted for' (x). As Kimmel has argued, Becker's theorisation of the art world ruptures narratives of 'the artist as genius and the beautiful work as an expression and embodiment of genius' (733), rather understanding art as the product of networked labour. Through the depictions mentioned above and others, Lepage too has worked to debunk the lone-genius model of artmaking, and in discussions of his methods frames them as collaborative and featuring a distribution of creative responsibility. He has nonetheless become known for a distinctive and saleable artistic signature and is the only creative constant in work that, since the mid-1990s, has been produced and distributed via the production company Ex Machina, in association with Robert Lepage Incorporated (RLI), a private enterprise; in 2019 the arts centre Le Diamant, a project which Lepage initiated, became part of this small conglomerate of arts organisations with him at their centre. However knowing his depictions of art and artists working within systems of capital, and however much he attempts to distance himself from full artistic ownership of his productions, he has nonetheless been lionised as one of the great auteur theatre artists of his era. In this and the following chapter I focus on the relationship between Lepage's creative practices and the

production and distribution frameworks that support them, exploring the ways in which these practices both benefit from and attempt to resist the neoliberal economic systems in which they circulate.

Lepage articulates his creative views and values in the books *Quelques Zones de Liberté* (in its English version, *Connecting Flights*) and *Chantiers d'écriture scénique* (*Creating for the Stage*). A central value that emerges in both is freedom – the liberty to create on his own terms and timescales; the title of the first volume, a quote from Cocteau, translates somewhat awkwardly as 'Some Spaces of Freedom'. This theme comes through particularly strongly in the second book, as does the recognition that, paradoxically, systems are required to sustain such metaphorical and literal zones of liberty. Indeed, it was out of recognition that 'what was needed was a structure capable of adapting to an organic form of creating new work' that Ex Machina was founded (Lepage qtd in Caux and Gilbert 18). A cornerstone of this approach was the laboratory space of La Caserne Dalhousie, which allowed Ex Machina 'the means of pursuing its approach and complete freedom to explore an endless variety of creative pursuits' (ibid.). Lepage's ongoing efforts to create and sustain a professional context for his creativity on his own terms have been noted and admired by fellow theatre artists: Sarah Garton Stanley, associate artistic director of English theatre at the National Arts Centre of Canada observed in 2017 that Lepage has 'built a structure around himself to enable him to continue to be independent'.

The success of these efforts allows Lepage to celebrate the place he has made for himself 'outside of ... systems of cultural industries' (qtd in Fisher 'Interview'). Because Ex Machina's work is funded by dozens of theatres, festivals, and venues domestically and internationally, he argues, and because it moves between different sites of reception, the company can recover from unfavourable funding decisions or bad press that might hobble other artists or organisations:

> Most people I know have to deal with the audience, the money that's available to produce, the criticism of this country, this province, sometimes of this city ... if you get a bad review or you make a bad choice, you're guilty. But we're outside of all that. We have audiences all over the place ... I make a lot of bad choices; there's a lot of trial and error but I'm relaxed about it. (ibid.)

In fact, the situation that Lepage describes is not outside of systems of cultural industries but imbricated in multiple of them. There is a robust exchange of economic and symbolic capital, for example, between Lepage and Québec: Ex Machina receives government subsidy (national, provincial, and local) for its work that tours around the world and domestically; the company is commissioned to create works for national institutions and events, such as the *Image Mill* sound and light show for the 400th anniversary of Québec City; and in turn Québec benefits from its association with Lepage and Ex Machina's success. The movement of his work between domestic and international markets and between subsidised and for-profit spheres has benefited from – arguably, could not exist without – the privileging within neoliberalism of open markets and of the '"liberty" of individuals to trade as they please' (Harvie, *Fair Play* 63). As Jen Harvie argues, following Justin O'Connor, the fear of the artist being drawn inexorably into the 'Culture Industry' has been 'a key index of cultural

catastrophe at least since the eighteenth century, when an understanding of the artist as radically free creative genius became central to the western art tradition' (ibid.). In *Fair Play: Art, Performance, and Neoliberalism* Harvie explores how this dynamic is playing out in the early twenty-first century. She argues that under the conditions of neoliberalism artists are increasingly called on to function as 'creative entrepreneurs' by displaying the capacity for 'independence and the ability to take initiative, take risks, self-start, think laterally, problem-solve, innovate ideas and practices, be productive, effect impact and realise or at least stimulate financial profits' (62). Lepage and his colleagues display many of these characteristics as they adapt their production systems to respond to evolving circumstances and new opportunities. While there are many aspects of the drive towards entrepreneurialism that are potentially positive and 'expedient, helping artists to survive when even formerly semi-stable source of public support ... erode', Harvie also highlights its potential risks: that 'individual self-interest is emphasised in ways that damage social relations and principles of social equality', that 'it becomes increasingly accepted that destruction is necessary ... to promote growth', and that entrepreneurialism compels artists 'to focus on productivity' above all else (62, 77, 78). Individual self-interest vs. the collective; creative destruction; and the drive towards productivity and profit: all three are areas of active and ongoing contestation for many artists and arts organisations in the early twenty-first century. These two chapters explore the specific ways in which Lepage and Ex Machina are confronting these challenges.

Referring to Lepage as an entrepreneur – 'someone who sets up a business and takes on financial risk in the hopes of profit' (65) – requires some clarification of terms. Lepage's entrepreneurialism involves him and colleagues who work with him and on his behalf, specifically Ex Machina's producer Michel Bernatchez; Lepage's agent and sister Lynda Beaulieu, who is president of Le Diamant; and their teams. The notion of profit also requires articulation: Ex Machina is a not-for-profit company that receives government subsidy and that feeds any surplus from its activities back into the company, while RLI is Lepage's personal business. Financially, the work of the private company feeds the public one: Charest's 1995 book confirmed that RLI is 'a primary investor in Ex Machina' (107), and in 2017 Lepage put $500,000 of his own money into the capital campaign for Le Diamant, the bricks-and-mortar home in Québec City for Ex Machina's repertoire (Everett-Green). The drive for productivity that propels Lepage and his companies does not seem profit-driven in the capitalist sense: the primary goal is not to generate wealth for company executives and shareholders. Rather, I here explore the ways in which the 'neoliberal social and economic order' (Savran 65) intersects with Lepage's particular appetite for and approach to creative labour, and the way in which he and his associates work within and attempt to counter neoliberal imperatives.

As David Savran has argued, the rise of neoliberalism has been paralleled by multinational corporations' attempts to 'emotionalise and personalise their offerings' (66) via the techniques of branding. In this chapter I describe Ex Machina's attempts, in the first decade of its existence, to brand its work in order to assist its circulation in the deterritorialised space of global performance. It did so by associating the company with a set of core values which would help to create a sympathetic context for the

viewing of its work. The list of these values strongly echoes Harvie's taxonomy of entrepreneurial traits required of the neoliberal 'artrepreneur' (*Fair Play* 62): creative independence, freedom from classification, innovation, multidisciplinarity, collaborativity, the commitment to creativity as process, and an intimate, reflexive relationship between creative techniques and methods of production and distribution. At first glance it seems curious that Ex Machina did not foreground Lepage as the face or name of the company and the brand, given that his signature was the only creative constant and most high-profile element of its productions. I believe this can be understood, in part, as evidence of Lepage's characteristic elusiveness and reluctance to be categorised. Reading these choices through studies of branding provides further context: associating Ex Machina's productions with certain values and ideas – rather than an individual name or personality – is a way to mitigate against risk, create a set of expectations around the reception of the work, and fashion the circumstances in which Lepage can function best. His self-definition as maverick – outside of systems – is central to the brand. Through an exploration of the critical response to five of Ex Machina's large-scale productions, I argue that these initial efforts to brand its work were of limited success because they stretched the principles of branding beyond their breaking point. In the chapter that follows I discuss the more straightforward brand identity that Ex Machina has adopted since the end of the first decade of the 2000s, which foregrounds Lepage's capacity for multi-tasking and the company's ability to deliver multiple projects simultaneously.

I now return to the founding days of Ex Machina in order to establish the circumstances in which the company turned to the techniques of branding, before I go on to detail the mixed success of these endeavours.

Ex Machina and the festival circuit

As outlined in earlier chapters, following on from Lepage's first successes with Théâtre Repère, interest in his work blossomed in the rest of Canada, the United States, and Europe. This suited him personally and professionally: 'I've always wanted to travel, to get to know other countries, even before I had my first local success', he says in *Connecting Flights*, 'so my life took shape accordingly' (115). Lepage's appearance on the international scene dovetailed with the rise of the theatre festival circuit, a loose association of arts organisations throughout the developed world for which co-producing and/or presenting touring productions makes up all or part of their programming. In development since the formation of the Edinburgh and Avignon festivals in the late 1940s, the festival circuit reached a point of particular maturation in the 1980s and early 1990s. What had been a mode of distribution of theatrical productions became one of creation as well: festivals and other venues began to offer production funding up-front in exchange for a run of the show.[1] This proved a congenial environment for Lepage, whose preferred mode of working benefits from significant initial investment to enable lengthy creation periods. *Tectonic Plates*, co-produced

by the European Economic Community, the Festival de Théâtre des Amériques, and Canada's National Arts Centre and touring from 1988 to 1991, was an early iteration of this way of working. Lepage and his producers found, however, that they were not equipped to manage such ambitious international projects, leading to 'difficult conditions – agents who were efficient but spread too thin, offices (often consisting of only a telephone and a filing cabinet) on three continents, rehearsal halls rented as availability dictated' (Caux and Gilbert 17).

The creation of Ex Machina was the means whereby Lepage attempted to manage this situation and establish control and agency over his working life. Given that the 'spirit' of Ex Machina was one of flexibility and adaptability (18), a building-based theatre offering seasons of productions did not seem viable at that point, for a number of reasons: it could not easily accommodate the long-term work-in-progress format that is Lepage's favoured mode, and it would require a level of engagement with local audiences that did not make sense for a company focused on international markets. Lepage thus looked to the model established by two of the festival circuit's senior figures, Peter Brook and Ariane Mnouchkine, who have their own 'laboratory' spaces where they work 'free of the constraints of seasonal programming'. Tired of moving around the world to work in others' spaces under conditions outside their control, Lepage and his associates laid down a 'basic rule': whenever possible the creation of projects would take place at La Caserne (ibid.). The internationalism of Lepage's early career had 'expanded the horizons of Québec theatre' (10) and now it was time to reap some rewards: Lepage and his collaborators 'had traveled the world. Now the world would have to travel to their facilities in Québec City' (18). Ex Machina also chose to build La Caserne without a performance space but, rather, made it 'fully dedicated to research and exploration' (ibid.) – this in contrast to Brook's Bouffes du Nord and Mnouchkine's Cartoucherie, which are performance venues as well as creative laboratories. This became controversial, prompting the critique that Lepage was not adequately valuing the contribution of the Québec government, and by extension the Québec taxpayer, by making work 'primarily for export' (Harvie and Hurley 306). As previously argued (see Introduction, pp. 18–21), if there was exploitation going on in the Ex Machina–Québec relationship it surely ran both ways. Québec's and Lepage's international ambitions have run very much in parallel – as the comments above about opening up of horizons indicate – and Québec benefited enormously from the international scope and success of Lepage's work. Harvie and Hurley themselves argue as much when they state that via Lepage (and Cirque du Soleil), 'Québec logs into international commercial and cultural networks and enlarges its ideological parameters to become pluralist, modern, and open to the world' (302). I will return to the question of the reciprocal relationship between Lepage and Québec in this and the following chapter.

The Seven Streams of the River Ota is testament to the high regard for Lepage in his professional milieu. As discussed in the previous chapter (pp. 143–7), it involved nearly two dozen international co-producers, nearly all of which were venues and festivals. While made in Québec in a series of rehearsal/creation periods between 1994 and 1998, *River Ota* was performed in theatres around the world and never came to rest in any home venue. The production's first performances at the Edinburgh

International Festival in August 1994, however, were very rocky: the show was still coming together formally and creatively but was billed as a headline event, creating expectations that it would be a polished work. These performances, which Lepage later acknowledged to be 'terrible' (qtd in Tusa 2005), demonstrated the risks in integrating Lepage's collaborative, process-based methods into the festival circuit. A tension became apparent between a market created to tour high-quality performing arts products and a way of working which prioritised process. In response, Ex Machina turned to the techniques of branding in an attempt to create a context for their mode of production, in so doing participating in the global shift away from product-based marketing and towards the brand economy. It is important here to provide an overview of how branding works and the ways in which some commercial theatre producers have embraced its potentials, before then returning to Ex Machina's particular engagement with branding.

The rise of the brand economy

The late 1980s and early 1990s were the era in which consumption of brands became a central feature of contemporary globalised culture, as young professionals 'cast off the last remains of the progressive heritage of the 1960s and 1970s, to devote themselves to consumption in the pursuit of life-style and self-realisation' (Arvidsson 2). Companies began to move beyond single products or product lines to offering networks of products supporting a 'more or less complete life-style', as with the expansion of Ralph Lauren Polo to include housewares as well as clothing and perfumes (ibid.). Large corporations began to use techniques of branding to promote their values to employees and the public, thus facilitating the global expansion of brands such as Starbucks and Nike. As Scott Lash and Celia Lury argue, this reflects a fundamental shift in capitalist systems from the culture industries theorised by Horkheimer and Adorno to a global culture industry (GCI) in which brands have superseded individual commodities, and culture has become part of society's base and not its superstructure. In the GCI, 'goods become informational, work becomes affective, property becomes intellectual and the economy more generally becomes cultural' (7). The era of the cultural industries was dominated by products, which have a specific identity and circulate in the marketplace with an understood exchange value. In the age of the GCI, the key unit is the brand, which does not circulate materially but, rather, in capital markets, and which 'is constituted in and as relations' (6). Products have value inasmuch as they are recognisable as themselves, whereas '[b]rands only have value in their difference' and seem to have a life of their own, as opposed to static and moribund products (ibid.). Branding is driven by and facilitates globalisation in that brands, being immaterial and conceptual, travel easily through space and time: establishing strong brand loyalty paves the way for consumers to then purchase individual products which allow them the pleasures of participating in the values associated with the brand.

 What are the implications of the rise of globalised brand culture for theatre, which

inherently involves grounded relations in space and time? In his pioneering analysis Patrick Lonergan argues that global branding is relevant to the live performing arts most notably in the work of major producers such as Cameron Mackintosh, Disney Theatricals, and Cirque du Soleil. Because theatre is live and therefore can change from performance to performance, and because its 'reception (and hence [its] financial success) is ... generally dependent on unpredictable factors, such as reviews, performances by actors, and so on', producers 'ensure (as much as possible) against such risks' by techniques of branding (73). They do so by developing productions (and production styles) that become familiar to audiences, and then working to assure that the individual performances of productions adhere to the brand model. This, as John Frow has argued, represents a reversal from previous artistic eras in which an artist's (or, for the sake of this argument, producer's) 'name' used to be a 'certification of originality'; now that name is a 'guarantee of consistency, quality, and market value of an *oeuvre* and a distinctive "style"' (70). Walter Benjamin argued that theatre is radically different from mechanically reproduced art forms such as film because it can claim authenticity: being embedded in its social setting lends live performance a sense of uniqueness and presence, which Benjamin famously named its aura (221). While productions by Mackintosh, Disney, and Cirque du Soleil are not, as strictly defined, mechanically reproduced, their success has demonstrated the ways in which branding, among other techniques, 'removes the site of authenticity and authority – the production's "aura" – from the live performance, and makes it conceptual: the authenticity of a cultural product is now grounded in the recognisability of its cultural sources' (Lonergan 72).

This works in practice in the case of megamusicals such as Mackintosh's *Les Miserables* and Disney's *Lion King* by allowing audiences to familiarise themselves with the material in advance by viewing the source material (such as Disney's *Lion King* film, which preceded the stage show), listening to the cast album, or participating in a licensed school production of the show. Recognisable logos and defining images – the girl in the beret for *Les Mis*, the lion's head for *The Lion King* – also cement brand identity. Attending one of these productions thus tends to be less about encountering something new and rather about consuming something reassuringly familiar, and then being encouraged to purchase merchandise to further integrate the brand into your lifestyle; as Maurya Wickstrom notes, the auditorium of the Broadway production of *The Lion King* empties directly into a Disney Store (293). Cirque du Soleil, for its part, has successfully crafted a brand identity in which the company itself is the defining feature, rather than its individual shows. The Cirque du Soleil brand, as Harvie and Hurley argue, involves the on-stage creation of 'a brightly coloured, fantastical world characterised by the harmonious play of an international cast of circus performers' (312). This formula obscures the identity of its individual performers so that, in the words of a company representative, 'it's the show that's the star' (qtd in Harvie and Hurley 313); what defines Cirque du Soleil, and what audiences come to expect, is its 'unified production aesthetic' (314).

Branding Ex Machina

Branding, then, works to set consumer expectations – to prime consumers to receive products as an expression of a certain set of values associated with the brand. In the commercial globalised performing arts sector, the challenge is to deliver familiar products in the form of megamusical productions that sound and look like their cast recordings and brand imagery, or circus productions adhering to predictable performance codes. Ex Machina faces a different, in some ways opposite challenge: its work is by its nature constantly changing, and so what an audience might see at a particular performance cannot be guaranteed. While any live performance will always be different from another, due to variables including performers' energy levels, timing, the size and demographics of the audience, and so forth, the unpredictability of an Ex Machina production, particularly early on in its touring life, is of a different valence – it is a defining feature of the work. Lepage's approach to creativity as a self-determining discovery process is a central theme of *Connecting Flights*: 'Theatre is an adventure that's bigger than we are; an adventure which we embark on with many questions, but virtually no answers' (25). He opens the book by likening himself and his collaborators to Christopher Columbus, setting off to parts unknown for which there is no map (ibid.), a self-description he has returned to in his career (see Cavendish 'Ten Days'). The notion that processes must be allowed to proceed on their own terms and that 'the play in its final form exists even before we begin to work' comes up repeatedly in *Creating for the Stage* (31; see also 47, 51). I will continue to explore this conception of the work being pre-determined and self-determining in this and the following chapter.

Given all this, Ex Machina attempted to turn process into a brand – to associate the chimeric nature of its work with a set of values that it presented as positive. These values include, as already noted, freedom from constraint, faith in the integrity of creativity, risk-taking, multidisciplinarity, collaboration, innovation, a productive dialectic between the local and the global, and productivity. These values are communicated through publishing projects such as the two volumes already mentioned; through the company's website, which includes pages devoted Ex Machina's approach to creation as well as descriptions and media footage of present and past projects; and in interviews with Lepage, in which he consistently returns to these themes. Encouraging audiences to understand its productions as expressions of a set of values was an attempt, as I read it, to contextualise and recover the fact that what might be seen on a particular night could not be predicted.

I assess here how Ex Machina's branding strategies worked in practice by engaging with the response of journalistic theatre critics to five of its productions created and toured between 1994 and 2013, understanding journalistic critics as writers and broadcasters employed by mainstream media outlets (newspapers, magazines, and radio) to offer expert analysis and evaluation of live theatre.[2] While critics are not necessarily representative of the broader public, they are particularly well positioned to engage with Lepage and Ex Machina's work on its preferred terms: reviewers in

major theatre capitals have the chance to see numerous of Lepage's productions, and sometimes to engage with the same production more than once at different points in its development. Exploring critical response to some of Ex Machina's productions, then, allows us to evaluate the messaging around brand values transmitted by the company, and the ways in which this was received by these privileged theatregoers. I consider productions – *River Ota, Geometry of Miracles, Lipsynch, Zulu Time*, and *The Blue Dragon* – that Lepage created with groups of performers, rather than solo productions created during the same period (*The Far Side of the Moon, The Andersen Project*), largely because the company advanced the work-in-progress narrative more around the group shows than around the solos. This prompts several key initial observations about this narrative: it is expedient and contingent. Because they involve a larger number of creative inputs, are developed over longer time periods, and are of larger scale than the solo productions, the evolution of the group shows tends to be more volatile than that of the solos (as evidenced in discussions of *Tectonic Plates* and *River Ota* in the previous chapters; see pp. 105–12, 141–7 and 149–52). Ex Machina evidently foregrounded the process narrative to account for this volatility when describing and promoting its work. When such context is less necessary, as in the case of the solo productions, the company's discussions and descriptions focus on content and inspiration (for example, in the case of *Far Side*, Lepage's mother's death; and in *Andersen*, the parallels between Hans Christian Andersen's personal story and Lepage's own) rather than process.[3] Ex Machina's engagement of the process narrative, then, is inconsistent, one of the weaknesses in their approach to branding that led it to be only sporadically successful. As they were attempting an already counterintuitive approach to branding in trying to turn unpredictability into a (predictable) virtue, applying this approach selectively added another layer of instability which compromised their brand values.

In considering responses to these five group productions, it becomes clear that presenting process as a defining and inherently positive aspect of the work was not consistently successful. This approach functioned best when critics had the opportunity to see the productions at different points in their development and feel personally drawn into the larger narrative of their creation. It was also most effective when it offered a story that the critics could narrate as coming to a positive conclusion, in the form of a production they deemed to be a creative success. In such cases, critics became part of the branding strategy, in that they reiterated the message about the show being in constant evolution in their coverage, further disseminating the company's ethos. Overall, as we shall see, most critics appeared to lose interest in the process narrative once they became familiar with it, and subsequently responded to Ex Machina's productions without taking note of their ongoing creative development. The company's narrative of process and participation proved of limited interest to privileged spectators embedded in a cultural economy the basis of which is unique, stand-alone productions. It is also notable in critics' responses that the process narrative competed with and could never fully override Lepage's status as the star figure behind the productions.

The Seven Streams of the River Ota

As already established, this production had a rocky start at the 1994 Edinburgh International Festival (EIF). Negative critical comments focused on the production's slow pace, long and disorganised scene changes, and what Martin Hoyle in the *Financial Times* called 'slender substance monumentally swamped by style'.[4] The *Independent*'s Paul Taylor critiqued the production's themes to be 'all-embracing to the point of vacuousness', while the *Mail on Sunday*'s Louise Doughty found it overly serious and preachy, 'the theatrical equivalent of eating your greens'. Critics who knew about the process-based nature of the work, however, tended to be more positively disposed. Ex Machina's producers spread the word on press night that Lepage and his collaborators had been working on the show until the last minute, and that it had a long development period ahead of it.[5] In his *Guardian* review, Michael Billington referenced this knowledge, writing that 'Lepage – right until the opening – was still cutting it down to a mere three-and-a-half hours' and that he 'emerged feeling that something remarkable may be taking shape but that it isn't there yet'. Being made privy to the company's process gave Billington a context to understand the production's unfinished nature and encouraged him to invest in the idea of its future development. At a hastily assembled press conference the day after the opening, Lepage acknowledged that the show was not finished, but pointed out that Ex Machina's agreement with the EIF was to deliver a work in progress and that they had made good on this commitment, even if critics' and audiences' expectations had not been set to anticipate unfinished work. The question of the production's work-in-progress nature became one of the major talking points of that year's EIF, to the extent that the Glasgow *Herald*'s John Linklater devoted a feature article to the issues raised, and offered praise to the EIF for 'being prepared to risk presenting work at so early a stage of development'.

The story of the Edinburgh premiere became a determining, and largely positive, context for the production's ongoing reception, in that the premiere became a negative point of comparison for a show that was considered by many critics to be evolving into a great work. 'Many of us had glum faces in Edinburgh when this first opened, wondering if our hero had lost his way', wrote Jane Edwardes in *Time Out* when *River Ota* played at London's Riverside Studios in October 1994: '[t]here is still much work to be done, but the journey now looks like one that is well worth making'. Even those critics who had not reviewed the show in Edinburgh tended to mention its difficult opening there, and to frame their consideration of the version they were seeing in the context of the work-in-progress format. Lyn Gardner, for example, commented in her *Guardian* review that 'what makes [the show] truly thrilling is the sense that this is a genuinely organic piece of work that will keep evolving and growing until its planned completion in 1996'. The *Times*' Kate Bassett similarly found it fascinating that 'the creative process is ... going on under the public's gaze'.

Following another period of creative development, the production played in Toronto in November 1995, and Ex Machina succeeded in sending a clear message

to critics there about the nature of its creative approach and where this iteration fitted in the show's overall trajectory. Six major reviews noted that the show had been evolving constantly since its Edinburgh premiere, and that it would continue to grow as it toured further.[6] Several reviewers offered direct commentary on aspects of the production which they felt needed improvement. The *Globe and Mail*'s Kate Taylor, *Variety*'s Mira Friedlander, and the Montréal *Gazette*'s Pat Donnelly, for example, all noted that the show's farcical ending was not satisfying (if they saw the production's 1996 version in which the farcical section had been moved to become the fifth of seven segments, they were rewarded with the knowledge that their advice had been heeded). Among the major reviews of the 1996 version at the National Theatre in London, seven of eight mention the work-in-progress context and/or the disastrous Edinburgh performances;[7] Billington goes so far as to recast the Edinburgh premiere as a 'workshop version' in his review, an act of revisionist history effacing the high stakes of those first performances. For the *Telegraph*'s Charles Spencer, the excellence of this iteration of *River Ota* was sufficient to '[lay] … doubts to rest' about Lepage, following on from the show's 'incoherent and indulgent' Edinburgh premiere as well as the cancellation of *Elsinore* at that year's EIF. Spencer's response demonstrates the larger principle: critics prove most open to the work-in-progress narrative if they can turn it into a success story. Lepage's approach is most assimilable if critics perceive that it has led to a production that they deem of quality and value.

Geometry of Miracles

Following on from *River Ota*, the next major Ex Machina group production was *Geometry of Miracles*, which premiered at the 1998 Du Maurier World Stage Festival in Toronto.[8] A situation similar to the Edinburgh premiere of *River Ota* unfolded: *Geometry*'s opening performances featured dialogue that came across as under-rehearsed or improvised, a slow pace, and, in the words of the *New York Times*'s Peter Marks, 'a shapeless narrative that flirts with incoherence'. Many critics agreed that while the subject matter of the production – the related lives and practices of the American architect Frank Lloyd Wright and the Russian guru Georgi Gurdjieff – had promise, the connections between the two men and their work were not clear. While Gurdjieff appeared as a major character played throughout by the same performer (Rodrigue Proteau), it was a conceit of the production at that point that Wright was represented by several props and costume pieces (a trenchcoat, walking stick, and grey wig) worn at various points by different members of the cast. While the World Stage Festival's marketing and promotion presented *Geometry* as a complete work and the cost for tickets was on a par with its other headline productions, Lepage framed the production in a pre-show feature article as still in evolution, and praised Toronto audiences for being 'indulgent' and 'supportive' of his approach (qtd in Wagner 'Miracles'). Certainly, the extent to which critics writing about the Toronto premiere of *Geometry* absorbed the company's ethos is striking: despite it not being

marketed as such, every review treated the show as a work in progress – though not always with the level of indulgence that Ex Machina was hoping for. *Globe and Mail* critic Kate Taylor expressed exasperation at a 'grand philosophy' that can 'sometimes leave the busy director appearing at major international events with work that simply isn't ready for a critical audience'. John Coulbourn in the *Toronto Sun* took a relatively neutral stance, noting that 'All the elements are there. They simply haven't been refined.' The *Ottawa Citizen*'s Janice Kennedy, after criticising the production's 'embarassingly mundane' dialogue, the performers' 'indistinct uttering', and some scenes as an 'almost autoerotic orgy of overkill', argues that it is a 'signature mark of [Lepage's] genius that his creations are in a continual state of evolution' – evidence that she has absorbed the association of process with creative virtue that Ex Machina's branding promotes.

As in Edinburgh, the World Stage Festival called a press conference the day after the *Geometry* opening to allow Lepage to explain the production's unfinished state.[9] He argued that if there was a problem, it was not what the company had delivered but had to do with those receiving the production:

> People shouldn't expect a finished and rigid show ... We've been working this way for ten years: we work, and then one day, audiences and critics arrive in the writing process. People have always said that's a bit dangerous, and we've always accepted this state of affairs. We like to work in chaos because that's the only way to renew ourselves. (qtd in Baillergeon)[i]

Lepage also introduced the line of argument about his practice existing outside of systems of production and reception that he has extended in the years since:

> This will surely sound pretentious, but my shows sell out three months in advance, wherever I go, anywhere in the world. So to have a good or a bad review doesn't affect my economic circumstances ... I don't do marketing and I don't have to. (qtd in Baillergeon)[ii]

Such arguments send mixed messages about the value of individual spectators to Ex Machina's work. On the one hand, audiences are framed as a necessary part of the creative process, the mirrors that help Ex Machina understand what it is doing. On the other, Lepage makes clear that in economic terms the success or failure of a single run is inconsequential to the company – that whole tranches of spectators and responses are essentially disposable. Lepage went on in the press conference to suggest that to really appreciate his work, the spectator should see it multiple times. As *La Presse*'s Stéphanie Bérubé points out, 'the problem' with this argument is that 'mere mortals can't see the show if it's presented on the other side of the world, and don't want to pay to see the same show four or six times, however in love with Lepage's work one

i 'Les gens ne doivent pas s'attendre à un spectacle fini, rigide ... On fonctionne comme ça depuis dix ans: on travaille, et puis un jour, le public et la critique arrivent dans le processus d'écriture. Les gens ont toujours pensé qu'on était un peu casse-gueule, et on a toujours accepté cet état de fait. On aime travailler dans le chaos parce que c'est la seule façon de se renouveler.'

ii 'ça va paraître bien prétentieux ... je vends mon tickets trois mois d'avance, partout où je vais, partout dans le monde. Alors, avoir un bon ou un mauvais papier, ça ne change rien à mes conditions économiques ... Je ne fais pas de marketing et je n'en ai pas besoin.'

might be'.[iii] Lepage's public statements were starting to expose the contradictions and privilege inherent in his conception of his ideal spectator.

United Kingdom critics, a year later, similarly treated *Geometry* at Glasgow's SEC Centre and the National Theatre in London as a work in progress, despite it not being explicitly identified as such. The consensus, as articulated by the *Scotsman*'s Joyce McMillan, was that the production was 'not vintage Lepage', but, despite describing the production as at turns superficial, breathtaking, self-indugent, and banal, McMillan still praised Lepage's capacity to 'invade my mind, and change the way I look at the very stuff of life'. In the *Telegraph* Bassett extended the argument, established in her response to *River Ota*, that being brought into the creative process is 'thrilling ... almost like looking at an artist's drawings prior to a great canvas'. The *Observer*'s Susannah Clapp, similarly, deemed the show an 'unfinished work' of 'a massively gifted man, whose drafts are more alive with ideas and visual fire than much of what passes for polished drama', and Gardner declared in the *Guardian* that there is 'something missing in the equation' of the show but that 'it will surely grow and bloom'. Other critics, however, were starting to tire of Ex Machina's approach. The process-based ethos is 'noble and fine', said Catherine Lockerbie in the *Independent on Sunday*, 'but what falls by the wayside is substance, a solid core, a clear guiding path through all the wonderwork'. Benedict Nightingale, having seen the production a year earlier at the Salzburg Festival, was disappointed that it had changed but not improved, 'at least if you value narrative clarity, intellectual incisiveness and dramatic momentum'. Most damningly, John Peter in the *Sunday Times* railed on the show as 'formless and intellectually vacuous' and negated the company's approach:

> I'm told that that this is 'work in progress'. There is a word for this in the theatre: it is called rehearsal. So if you want to pay to see a famous director, financed by twenty-four arts organisations on three continents, trying to sort out his ideas in public, you can do so at the National Theatre next week. You've been warned.

The production continued to tour for fourteen months after its United Kingdom performances. An interview with Lepage published in Montréal's *Le Devoir* in March 2000 declared the version premiered there as its 'definitive form' (S. Lévesque 'Un théâtre').[iv] The *Gazette*'s Donnelly, who had assessed *Geometry* to be 'very rough' in its Toronto premiere ('Lepage Work'), argued that this new Montréal version had improved greatly thanks to the casting of English actor Tony Guilfoyle as Wright: the production now had an 'epicentre', and relations between Gurdjieff, Wright, Wright's wife Olgivanna, and other characters 'now [seem] more integral to the work' ('Lepage's *Geometry*'). The *Chicago Tribune*'s Richard Christiansen too, reviewing an April 2000 run in that city, viewed Wright as the 'subject' of the piece and praised it for the ways in which its attention to 'shape and form' echoed Wright's investment in these qualities. The onward touring of this version to Bogotá and North Adams,

iii 'Le hic, c'est que le commun des mortels ne peut pas voir le spectacle lorsqu'il est présenté à l'autre bout du monde et ne veut pas payer pour revoir une même pièce à cinq ou sept reprises. Aussi amoureux soit-on du travail de Lepage.'

iv 'forme définitive'.

Massachusetts was, when compared to past productions, limited, and thus relatively few audiences had the opportunity to engage with the production in what these critics agree was its most realised form.

This example further indicates Ex Machina's success in turning its process-based approach into a brand value, but prompts questions about the possible ambiguous or negative effects of this. Many critics eagerly adopted the work-in-progress narrative, which helped Ex Machina by producing generous reviews that disseminated the company's values. Toronto audiences, however, had received no indication from the World Stage Festival that what they were going to see was unfinished, were charged high prices for their tickets, and were dismissed by Lepage as unimportant. However engaged and generous reviews became in the production's post-1997 runs, it is also likely that the initial negative critical response limited the production's further touring, another compromising effect of the company's approach. The response of critics such as Lockerbie, Nightingale, and Peter further indicate that the work-in-progress narrative had the potential to wear thin; and the fact that the definitive version of the show was seen by relatively few spectators prompts further questions about the value proposition that the production offered to many of its audiences. Is being involved in a process worth the price of a top-dollar ticket?

Zulu Time

Subtitled 'A Cabaret for Airports', *Zulu Time* was Lepage's boldest attempt to date to create a performance that reflected and expressed contemporary global culture, and also reflected his desire to 'move out of the theatre realm', which he defines as 'a homogeneous group of people doing the same craft' (qtd in Shewey 'Bold').[10] With this he upholds Ex Machina's commitment to multidisciplinary projects bringing together live performance and technology; the project also saw Ex Machina attempting to innovate its brand identity to accommodate Lepage's desire to experiment. The production's rocky and financially damaging trajectory reflects a number of factors: its chance intersection with world-changing events, the resistance of producers and critics to a production by Lepage that did not fulfil their expectations of Ex Machina's work (responses that raise questions about the effectiveness of the process-as-brand approach), and a lack of collective understanding and shared discourse among Québec's communities about appropriate terms of representation of cultural difference.[11] The idea behind the production grew out of Lepage's considerable international mobility: 'I am the privileged witness of a certain reality, which is to spend two thirds of my life in a plane or an airport,' he told *Le Soleil*'s Marie-Christine Blais. 'So I wanted to talk about our relationship to time and space in an airport'.[v] The show began its life in 1998 under

v 'Je suis le témoin privilégié dune certaine réalité, qui est de passer les deux tiers de ma vie dans
 un avion ou un aéroport ... J'ai donc voulu parler de notre rapport au temps et à l'espace dans un
 aéroport.'

5.2 *Zulu Time.*

the working title *Cabaret Technologique*, when Lepage invited international artists and technicians, including the Austrian video artists Granular Synthesis and the French videographers Philippe Sorin and Lydie Jean-dit-Pannel, to present their work to him at La Caserne. As Kurt Henschläger of Granular Synthesis later commented, the idea behind the production was that it was to be free flowing and without structure:

> The initial concept, as Robert told it to us, you would walk into the space and a cabaret would be going on for hours, endlessly. It would have a series of numbers, a stream of events, but it wouldn't matter when you'd walk in or leave. The concept changed later and became more theatrical again. (qtd in Shewey 'Bold')

The production was eventually set on a massive steel scaffolding that was made to represent several locations in the trajectory of air travel: X-ray queues, raised walkways, and an airport café; the interior of a plane; bedrooms and cocktail lounges in chain hotels; and a golf course underneath a flight path (figure 5.2). It was organised as a series of vignettes named for the alphabetic time-zone codes in the system that governs air traffic worldwide, which in military and aeronautical fields is called Zulu Time: A for Alpha, B for Bravo, C for Charlie, through to Z for Zulu. This alphabet and the airport setting were Lepage's metaphorical means of communicating his observation that 'despite our cultural, economic, and other differences, we are all moving towards a universality of the concepts of space and time' (qtd in Blais).[vi]

vi 'malgré nos différences culturelles, économiques et autres, nous allons tous vers une universalité des
 concepts de l'espace et du temps'.

Zulu Time was poorly received in its first two runs at the Zürcher Theater Spektakel in August 1999 and the Maison des Arts in Créteil in October 1999. A reviewer in the Swiss newspaper *Neue Luzerner Zeitung* referred to production in the Zurich as a 'black hole of presence'[vii] and the *Globe and Mail*'s Philip Anson found its attempt at a plot about drug smugglers dying in a plane crash frustrating because it lacked a moral, and its use of strobe lights, videos, gymnastics, and robots 'embarrassingly amateurish'.[12] Reviews were somewhat less negative in Créteil, but critics continued to have problems with the production's dependence on poorly executed technological effects and on the weakness and misleading quality of its attempts at narrative (see Rioux, Schmitt). According to producer Bernatchez, the feedback that the company received at this stage from presenters and venue managers familiar with Lepage's work was that 'the show wasn't theatrical enough – it wasn't text-based, and what's more, in its first version it wasn't relying on actors' performances. So most presenters in our traditional network didn't like it.' Bernatchez describes Lepage and his collaborators' subsequent work on the production as 'trying to get the human back in that huge machine' ('Interview'). These responses indicate that in the eyes of critics and performing arts professionals, Ex Machina productions had a clear brand identity based around narrative, character, and humanism – not around process and change, as the company was attempting to communicate.

Characteristically, Ex Machina continued to develop the show in response to feedback, and it was the next version of the production, presented at Québec City's Carrefour festival in 2000, which received the strongest reviews. While commenting that the production was 'excessive' and 'grandiose', David Cantin in *Le Devoir* admired that Lepage offered his 'impressions of the current epoch ... more than judging or responding' and remarked that the production was 'coherent',[viii] and the *Globe and Mail*'s Kate Taylor wrote that it was Lepage's most interesting show since *River Ota*, which 'represents the natural progression of Lepage's work away from a conventional script – never his strong point – toward performance art'. And yet, despite this positive response, Lepage later criticised the Québec version, along with earlier incarnations, as having 'more machines than people' in it (qtd in Perusse). Lepage was clearly conflicted about the production, initially pursuing the idea of a free-form technological spectacle, and then speaking out self-critically against that impulse.

The show was then to have appeared, after more development, as the performance centrepiece of 'Québec/New York', a major festival of Québec arts in New York City in September 2001, but the terrorist attacks on the World Trade Centre and the Pentagon forced the cancellation of the festival and all its component elements. This cancellation was very costly for Ex Machina and contributed to *Zulu Time* becoming the most expensive production at that point in the company's history. It found a new performance context as part of the Montréal International Jazz Festival in June 2002, but further performance dates that Ex Machina desired for the production never materialised, perhaps because of its mixed reception in Montréal; and perhaps

vii '... boîte noire de la présence'.
viii 'impressions sur l'époque actuelle ... plutôt que de juger ou répondre ... cohérente'.

5.3 Marco Poulin as the Zulu in *Zulu Time*.

because of the production's large size and expensive running costs.[13] The vignettes in the Montréal version of *Zulu Time* offered a series of impressions about contemporary life and travel, within which were mingled several depictions of people of non-white ethnic origin which prompted very different responses among commentators, in particular the show's only representation of a black man (figure 5.3).

The figure in question was a non-black actor (Marco Poulin) covered in all-over black body paint with his torso exposed, wearing a headdress and carrying a spear and shield.[14] This costuming echoes that of the natives in the 1964 British film *Zulu*, which played as an in-flight movie in one of the show's early scenes of air travel. Ludovic Fouquet, who observed rehearsals of *Zulu Time*, argues that Lepage considered the Zulu one of a number of 'archetypes' conjured by the show ('Notes' 168);[ix] it is possible that Lepage's inclusion of such a stock representation was intended to be ironic and knowing. The figure of the Zulu prompted strongly negative reactions from several commentators of Anglophone and immigrant backgrounds. For Rahul Varma, the figure of the Zulu was part of 'a collection of constructed images of the Other' which revealed 'more about Lepage's expanded beliefs and fantasies than the actual cultures and people he depicts' (5). The *Globe and Mail*'s Alan Conter argued that the production 'dabbles in cultural pastiche – most of it embarrassing, some of it painful', and wondered '[w]hat was [Lepage] thinking?'

Even more troubling to Varma and other commentators were the connections that the production seemed to be making between the Zulu and monkeys. Kate Bligh

ix 'archétypes'.

argued that the staging encouraged audiences to create connections between the Zulu and a monkey played by the contortionist Jinny Jessica Jacinto: 'The monkey and the Zulu shared stage position and gesture. There was a pattern, a pattern of associations that were not clarified or contextualised and whose interpretation is still troubling to me' (72). The 'pattern of associations' which Bligh refers to is that of the racial slur likening monkeys to black people, historically associated with nineteenth-century attempts, via early anthropology, to argue for the superiority of certain population groups and the inferiority of others by differentiating between their appearances and likening some groups to animals. For Varma, the images of the Zulu struggling with contemporary technology, the woman dressed as a monkey, and a video of the musician Peter Gabriel teaching a monkey to play the keyboards 'demonstrate a colonial mindset, one that hasn't yet freed the white man from a paternalistic desire to civilise others – the animal, the woman, and the natives' (5). Few Francophone commentators made mention of the production's depiction of non-white characters, nor of animals, and those that did read them as mildly ironic and/or reflective of the production's overall presentation of contemporary cultural mixing (in French, *métissage*). For Jean St-Hilaire in *Le Soleil*, the production presented the airport as a space where 'nature and culture, animality and humanity, primitive and modern technology – not to mention weapons – collide and sometimes hybridise'.[x] *Le Devoir*'s Hervé Guay, on the other hand, singled out the vignette called 'Kilo' as not a celebration of cultural mixing but an ironic commentary on it: 'Not without irony ... Lepage stages an Occidental woman covered with a burka to smuggle cocaine while a Muslim man wears a pilot's uniform and suitcase in order to blow up his own airplane'.[xi] Guay thus seems to read the vignette as a comment on the rise in fundamentalism and racial profiling following 9/11, pointing out that appearances are deceiving.

Overall, the divergent responses to the production's Montréal run are an indication of how far Québec's communities are from a shared understanding of issues of difference, power, and representation – a divergence underlying the controversies around the productions *Slàv* and *Kanata* in 2018, as I discuss in Chapter 7. *Zulu Time* was also notable in that it did not deliver what critics and producers had come to expect from Lepage and Ex Machina in terms of original work: collaboratively created shows – some made and performed by a group, some solo – which develop and change as they tour, and which deliver character-driven stories through transformative, cinematic stagecraft and performances by human actors often interacting with objects. While experimenting with form by staging a technological cabaret was in keeping with Ex Machina's core values of multidisciplinarity and innovation, this was received as off-brand and did not appeal to producers and critics. Lepage and Ex Machina nonetheless persevered with technology-led shows; the success in particular of the sound and light spectacular *The Image Mill*, which played in Québec City during the summertime from 2008 to 2013, helped to shift Ex Machina's brand image towards that of being

x 'nature et culture, animalité et humanité et techniques – pour ne pas dire armes – primitives et technologies modernes se choquent en s'hybridant parfois'.

xi 'Non sans ironie ... Lepage montre une Occidentale qui se couvre d'une burka afin de passer en douce de la cocaïne alors qu'un musmulan porte l'uniforme et la valise d'un pilote de ligne dans le but de faire sauter l'avion dans lequel il prend place.'

purveyors of a variety of live entertainments, most foregrounding human performers but some offering technological environments within which spectators respond (another example of this is the virtual reality exhibition *The Library at Night*).[15]

Lipsynch

This production, which treated themes of voice, speech, and language, was produced by Ex Machina and Théâtre Sans Frontières, a small company based in Hexham in the north of England, in association with Northern Stage, a major institutional theatre in Newcastle-upon-Tyne.[16]

The marketing, publicity, and ticket prices for the show's first public run, at Northern Stage in February 2007, reveal a new awareness on Ex Machina and its co-producers' part of the need to highlight the particular qualities of its early performances, and an emphasis on the active solicitation of audience feedback. Northern Stage promoted the show as 'one of the most exciting theatre productions Newcastle has ever seen', in part because of audiences' capacity to affect its ongoing creative trajectory ('International Arrivals'). The press release made clear that the five performances of this first version of the show would be 'seen only in the UK' and that 'Newcastle audiences will play a unique role in shaping the future development of this new production'. Response cards asking spectators to 'Please tell us what you think' were distributed to all audience members; the cards also invited feedback to a special section of Northern Stage's website. Tickets were priced at £28, £22, and £18 ('International Arrivals') – less than what admission to a production in its season would usually cost. The press was not invited to these performances, but several United Kingdom critics nonetheless wrote articles for Canadian outlets that included review content. In *La Presse* Mark Fisher argued that while the show in its current state was 'riddled with unexplained details, hesitant dialogue and scenes of uncertain purpose' it was 'captivating'.[xii] Writing for the *Toronto Star*, Mark Brown offered praise for the show's opening scene in which soprano Rebecca Blankenship sang a section of 'Henryk Gorecki's almost impossibly moving *Third Symphony*'. The focus of Brown's feature article was the work-in-progress approach: while 'much of the show … had only been fifteen days in the making', Northern Stage's chief executive, Erica Whyman, felt that the company had been successful in conveying this to its audiences. 'People have really grasped that they are seeing something being born,' Whyman told Brown.

When the production played in June 2007 at the Festival TransAmériques in Montréal, it was billed in the show programme and on the festival website as a North American premiere and not as a work in progress. Nonetheless, the message disseminated by the media was that this was a five-hour version of a show that in its 'defini-

xii 'criblé de details inexpliqués, de dialogues hésitants et de scènes dont la raison d'être demeure
 incertaine … captivant'.

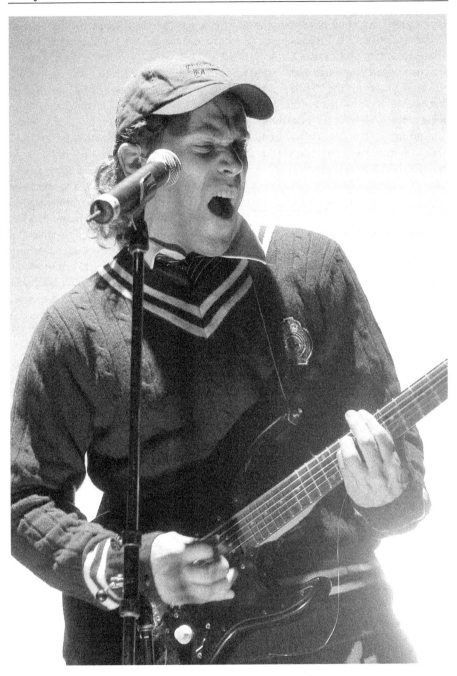

5.4 Rick Miller as Jeremy in *Lipsynch*.

tive version' would be nine hours long (St-Jacques 'Premiers fragments').[xiii] Several Montréal critics took this messaging on board and framed the production and their responses to it as provisional. *La Presse* titled Sylvie St-Jacques' review 'First fragments of a large fresco' (Premiers fragments d'une grande fresque); while praising each of the nine performers for the 'depth and complexity' of their characters, St-Jacques argued that 'we will have to wait for the "long" version of *Lipsynch*' to understand 'how these beings create, without necessarily knowing or meeting each other, a little planetary community'.[xiv] The *Gazette*'s Matt Radz did not review the production but, rather, wrote a feature including interview material from performer/creator Rick Miller, who said the show was at that point 'halfway' finished. *Le Devoir*'s Guay used his review to reflect on how Ex Machina was using its process-based approach to shape spectator response. Lepage's stardom and the great anticipation around his productions, argued Guay, deflect attention away from 'some very basic questions. Among them: in what state has his new show reached its public?' Referring to the Newcastle premiere as 'secret' and its critics as 'hand-picked', Guay noted that developing productions over a series of years in different places 'invariably makes the public eager to know what's coming next'. This, Guay argues, is skilful sleight of hand, another of the 'magician's gifts' that 'so many of my colleagues attribute to this creator'. In his mixed review, Guay deems the production 'fairly lightweight ... there remains ... much work to be done to explore the interiority of certain characters and to deepen questions about voice and speech that are still in their infancy'.[xv]

Just a year after Guay argued that Ex Machina was instrumentalising the work-in-progress narrative to steer critical and audience responses, the London reviews of the full-length version of *Lipsynch* revealed the limitations of these tactics. Despite a programme note by Mark Fisher focusing on the company's developmental approach – 'What kind of world premiere takes place 18 months and two continents after its first performance? ... a Robert Lepage world premiere, that's what' ('Truly Original' 8) – seven of eleven major reviews did not mention the production's development but, rather, reviewed it as a stand-alone work. Three reviews (by Paul Taylor in the *Independent*, Clapp in the *Observer*, and Sam Marlowe in the *Times*) were highly positive, while the rest were mixed to negative.[17] Most critics focused their comments on the production's long running time (nine hours, including intermissions) rather than on the creative methodology behind it, and several agreed with *Variety*'s David Benedict that Lepage, despite his seemingly 'endless resources ... lacks an editor'. Among the factors leading to the show's over-length, in Benedict's view, may have been its production structures: 'There's a nagging sense that the form has been

xiii 'version définitive'.
xiv 'Premiers fragments dune grande fresque'. '[P]rofondeur et complexité ... Reste à savoir comment tous ces êtres forment, sans forcément se connaître ni se rencontrer, une petite communauté planétaire. Pour cela, il faudra attendre la version "longue" de *Lipsynch*.'
xv 'les questions les plus fondamentales. Parmi elles, dans quel état sa nouvelle création parvient-elle au public? ... confidentiel ... triés sur le volet ... rendant immanquablement le public impatient de connaître la suite ... Les dons de magicien que tant de mes collègues prêtent à ce créateur ... passablement léger ... Il reste, on le sent, beaucoup de travail avant que ne soit creusée l'intériorité de certains personnages et que ne soit approfondi le questionnement sur la voix et la parole qui est encore à ses balbutiements.'

dictated by notions beyond the material. Why have a wholly tangential comic plot set in Spain? Because that's where some of the funding is from.' Why was the work-in-progress angle, so important for many of these critics in interpreting Lepage's past shows, barely a consideration here? It could be that this creative methodology was now so well known as to be taken for granted; or that these critics, not having been invited to view the show in its developmental state in Newcastle, felt distanced from this aspect of the production. That this was largely assessed to not be among Lepage's best works was also likely a contributing factor: the developmental story seems most enticing as an argumentative frame when it leads to a triumphant outcome.

The Blue Dragon

As with *Lipsynch*, Ex Machina launched its next group production not in a theatrical capital but in an institutional theatre in a smaller city, with the evident goal of avoiding mainstream media as the show came into creative and technical focus. While this was largely successful, it had the knock-on effect of removing the work-in-progress element from narratives around it, and indeed after its first year of touring critics did not mention process when reviewing the piece. *Le Dragon Bleu/The Blue Dragon* was 'born of the desire to return to an exploration of the universe of *The Dragon's Trilogy*' and was principally a collaboration between Lepage and Marie Michaud, who had played Jeanne in the 1980s epic (Caux and Gilbert 60). *Creating for the Stage* contains an account of a workshop of the production at La Caserne, which provides useful insight into the creative process. A central goal for Lepage was to update the vision of China that he and his collaborators had presented in *The Dragon's Trilogy*: when they first created that show, none of them had ever visited China, but in the intervening years Ex Machina's work had toured extensively in East Asia, especially Hong Kong, and Lepage had travelled frequently in the region. As research, Lepage and Michaud visited Shanghai in January 2007, and by June 2007, when the documented workshop took place, they had settled on a number of key ideas and thematics: a focus on Pierre Lamontagne, who in this production is fifty years old and an art gallery owner in Shanghai; an engagement with the aesthetic and themes of the Hergé comic book *The Blue Lotus*, which was the 'first contact with China' for many of the show's creative team; an exploration of the Chinese art market, particularly its large trade in forged paintings by Old Masters; and the work of tattoo artists (Caux and Gilbert 60). In the production, Michaud's character, Claire Laforest – a successful businesswoman and Pierre's ex-wife – struggles and eventually fails to adopt a Chinese baby, a plot line informed by Michaud's research into Chinese government restrictions on international adoption, which had recently been tightened (Caux and Gilbert 62). It was during this workshop that Lepage and Michaud realised that they wanted to add a third central character to the show, in addition to Pierre and Claire (ibid.); this led to the dancer/actor Tai Wei Foo joining the cast as the young Chinese artist (and Pierre's lover) Xiao Ling.

The show was first performed in April 2008 at La Comète in Châlons-en-Champagne, one of France's network of national theatres (see Radio-Canada 'Un Dragon Bleu').[18] The Châlons performances were billed as *avant-premières* (previews; see Fouquet, 'L'envol' 25) and generated little press attention, as did subsequent short runs in the French cities of Mulhouse and Grenoble. The show then had a two-day run at the Festival Internacional de las Artes de Castilla y León in Salamanca, Spain. In interviews with the Spanish press, Lepage said that the show was in 'process' and that nightly changes were creating 'a nightmare for the person handling the surtitles' (qtd in Torres).[xvi] A new theme emerged in his statements to the press about his work: a dismissal of the 'sickly communion' (ibid.) between critics and theatre artists in favour of a celebration of a newly revived relationship between theatre and its spectators.[xvii] The status of the production when it played in Los Angeles in November 2008 was unclear: while the *Los Angeles Times* reviewer Charlotte Stoudt understood the UCLA Live presentation as a work in progress, *Variety*'s Bob Verini referred to it as a world premiere, while noting that it was 'still finding its footing, with sliding panels hitting furniture, and projected subtitles out of sync with spoken Chinese' (it was the first time the show had been performed in English).

These first five runs functioned, effectively, as *The Blue Dragon*'s work-in-progress phase; for the remainder of its touring life (2009–13) the process narrative all but disappeared from discussions of the show. In its place critics tended to use the show's continuation of the *Dragon's Trilogy* story as the framework for their discussions, particularly in markets where Lepage's work was familiar (including Québec, Montréal, London, and Paris). Leading off her 2009 review for the Montréal *Gazette*, for example, Donnelly wrote: 'The fourth dragon has arrived, at last. One thing about auteur/director Robert Lepage, he is faithful to his metaphors.' While such discussions tended to represent Lepage's oeuvre overall as in continual evolution, critics treated *The Blue Dragon* as a discrete, complete aesthetic entity. Reviews focused on the production's treatment of themes of globalisation and commodification in contemporary China, and on the love triangle between Pierre, Claire, and Xiao Ling.[19] Overall, response was mixed. Robert Hurwitt gave the show an out-and-out-rave in the *San Francisco Chronicle*, arguing that its 'impressive stagecraft is in service of an evocative, affecting and refreshingly adult story'; similarly the *Guardian*'s Billington praised it as offering 'an ideal marriage of form and content'. By contrast, a number of critics across markets (Patrick Langston in the *Ottawa Citizen*, J. Kelly Nestruck in the *Globe and Mail*, Brigitte Salino in *Le Monde*, and *Variety*'s Verini) responded positively to the production's ideas and stagecraft but did not find it one of Lepage's outstanding works. Several others commented on its conventionality and lack of subtlety: in the *San Jose Mercury News*, Karen D'Souza called it a 'surprisingly old-fashioned love story', while Lyn Gardner in the *Guardian* argued that its 'theatrical cultural commentary … seldom rises above stating the obvious'. The *Irish Times*'s Peter Crawley admired the show's 'striking imagery and great technical accomplishment' but found its representations full of 'glib stereotypes'.

xvi 'en proceso de creación … Una pesadilla para el que hace los sobretítulos'.
xvii 'comunión enfermiza del creador con el crítico'.

In contrast to Gardner and Crawley's perspectives, several theatre scholars responded positively to *The Blue Dragon*'s depiction of contemporary China: Chris Hudson and Denise Varney argue that the production's central love story is best considered as metaphor, 'a compelling vision of the new China and the West's relation to it' (134), and that Pierre and Claire's restless inability to feel at home either in Shanghai or in Québec reflects the indeterminate, 'liquid' quality of human life under globalised late capitalism as theorised by Zygmunt Bauman (134–5). Part of what destabilises them is encounters with the 'hip young artist' Xiao Ling, who is 'assertive, self-possessed, and an embodiment of the new China' (141). Unlike nineteenth-/ early twentieth-century Orientalism, which 'allowed the Western subject to remake and consume the Orient', Pierre is confused and immobilised by his long immersion in Chinese culture and 'left with no clear identity' (145). Hudson and Varney read the production's multiple endings (which I discuss further in the next chapter; see pp. 184–5) as another gesture towards liquid rather than determinate meanings (ibid). As do Hudson and Varney, Melissa Poll highlights the 'constant scenographic motion' that characterises *The Blue Dragon*'s physical and spatial dramaturgy (165), which uses projections, mobile screens, simulated bicycle rides through the Shanghai streets, and scenes set in train stations and airports to visually and aurally underline themes of mobility and uncertainty. For Poll, '*The Blue Dragon*'s twenty-first-century China is a place that confounds imperialist notions of an East/West binary and challenges cultural essentialism' (160).

While underlining *The Blue Dragon* as part of a trajectory of ongoing 'auto-adaptation' (151–84) in Lepage's work (which came to include a graphic novel version of the story, designed by Québéc visual artist Fred Jourdain), Poll does not treat the production itself as a work in progress. She mentions the collaborative creation process behind it only briefly (162), critiquing the fact that Tai Wei Foo was not named as one of its authors, despite her significant contribution to characterisation and choreography (a critique to which I will return in the following chapter's discussion of authorship; see pp. 186–92). Hudson and Varney do not consider the creative process behind *The Blue Dragon* but, rather, treat the iteration of the production they viewed (in Melbourne in 2010) as a stand-alone entity. These scholarly discussions, along with journalistic critical response, serve as evidence that with *The Blue Dragon* Ex Machina's attempts to turn process into a brand fully ran out of steam. The enthusiasm with which many critics greeted this strategy when Ex Machina first introduced it – to the point of describing productions as being in progress even when they were not advertised as such – reveals its appeal in principle. Presenting artistic work as alive and changeable is a powerful selling point, a reminder of the qualities of uniqueness and presence that Benjamin identified as auratic in non-mechanically reproduced works of art. Ex Machina pushed its engagement with the liveness of its productions beyond a breaking point, however, in that they attempted to extract process from the art object itself and brand it as their work's defining feature. As noted above, Lonergan argues that successful theatrical branding locates a production's authenticity in the extent to which it is recognisable vis-à-vis its sources. With its foray into branding, Ex Machina tried to innovate this model by locating the authenticity of its productions in the recognisability of their propensity to change. This approach proved unsustainable,

I believe, in part because Ex Machina applied it inconsistently, turning to the process narrative to frame their group works but not their solo productions. A more fundamental concern is that Ex Machina was attempting to alter terms of engagement within entrenched systems that would have needed to shift more profoundly in order for the company's methods to work in the long term. At the festivals and other venues in which Ex Machina's productions played, there were expectations that works should be innovative and polished, especially from artists with existing reputations for excellence such as Lepage. A forthright and consistent approach would have been required to challenge these expectations: productions that were still in development needed to be presented as such before the fact and priced accordingly. If receiving feedback from audiences was a goal, then the creation of an effective system (such as was used during the Northern Stage run of *Lipsynch*) was necessary. Sensitive media relations would also have been required: the traditional theatre review, combining description, analysis, and judgement of the artwork, is arguably not the most appropriate form of response to work in early stages of development; it may have been more productive to propose other forms of writing that explore how the work is made without issuing a critical judgement about its quality.[20] There is potential for such a strategy to backfire: part of the function of traditional newspaper criticism is reporting and, since his early career, Lepage's productions have been news. Attempting to shape the nature of critics' response could have been taken for interference – getting between the writer and the story. We see evidence of this in Guay's response to *Lipsynch*: the fact that the production had not been conventionally reviewed in previous runs led him to be suspicious that Ex Machina was avoiding critical scrutiny. This was in fact true; the company's attempts to protect the work from judgement at an early stage in its development were perceived by Guay as inappropriately disrupting the established conventions of the critic/artist relationship. A further, somewhat paradoxical, consequence of keeping critics away from productions such as *Lipsynch* and *The Blue Dragon* in their early stages was that it made the process narrative less legible. Because there was little critical record of those productions' development, critics of their later runs tended to treat them as discrete, finite entities. It is for all these reasons – inconsistent application, sometimes reactive rather than proactive methods, and the distance between their way of working and existing systems and conventions of production and reception – that Ex Machina's attempts to brand their process-based approach eventually were not successful within the terms in which they were made.

If there is a consistent feature in an Ex Machina production, of course, it is Lepage's hand in it; but the company initially resisted placing him and his signature at the centre of their branding strategies, apparently at least in part in response to his desire to frame himself as a collaborator, not as an auteur. If we look beyond the collaboration and process narratives that Ex Machina foregrounds, however, Lepage's place as the company's defining feature is hard to ignore. In the previous chapters (see pp. 8–10, 12–13, 17–18, 25–32, 62–3 (note 9), 105–19, 138–53) I have argued that questions of authorial responsibility are among the most contentious in discussions of Lepage's work. In the next chapter I continue to explore such questions and where they fit in Lepage and Ex Machina's continuing evolution of their working practices within the context of globalised economic neoliberalism.

Notes

1 For more on the development of the festival circuit and its implications, see Fricker 'Tourism'; Knowles *Reading*, especially chapter 7; and Maurin.

2 The definition, functions, and boundaries of theatre criticism are the subject of ongoing and lively debate, as explored by Mark Fisher in the 2015 manual *How to Write About Theatre*. He notes the traditional dichotomy between a reviewer ('someone who writes with immediacy, often over night [sic], painting a picture of what has taken place and offering thumbs-up/thumbs-down consumer advice') and a critic ('a deeper thinker, someone who presents reflections that set the production in a broader context, less concerned with its strengths and weaknesses than what it means in the greater scheme of things') (7). Fisher further acknowledges that, in the contemporary context, most critical practices lie between 'the extremes of snap judgement and analytical essay' and defines criticism, for the purposes of his book, as 'anyone who steps beyond the purely experiential ("I liked it") to the quizzical ("why did I like it?")' (7–8). In the present discussion, I use the words reviewer and critic interchangeably, and understand that the task such writers undertake in their assessment of a production by Lepage (or anyone else) is to describe, analyse, and judge the production on the basis of a single viewing, writing or broadcasting on a quick deadline to a prescribed and relatively brief word count. Such writing may also place the production reviewed in the broader context of Lepage's work and, as such, can play a role in disseminating information about Lepage's creative approach and the trajectory of his career. My definition of criticism here does not involve online writing about theatre in blogs and other digital publications, not out of disregard for such platforms, but because they began to play an important role in critical response to theatre after the time period I treat in this chapter. As Haydon (2013) argues, the rise of theatre blogging in the London (United Kingdom) market was a 'quiet revolution' happening between 2007 and 2012, whereas my discusssion here involves productions created between 1994 and 2008.

3 *Creating for the Stage* includes material about *The Andersen Project* which foregrounds how process figured in its creation, describing how, during an early run of the show, Lepage cut a significant amount of material, 'completely revised' the scene order, and added two new scenes which he improvised during a performance. This was 'perilous' but is presented in a positive light, as evidence of the company's commitment to innovation and risk-taking (56). When interviewed by journalists about *Andersen* while the production was still touring, Lepage did not mention these major changes.

4 For ease of reading, in this and following sections of this chapter, references to the year of publication are not included after brief citations but, rather, assumed by the context. For example in this paragraph about *River Ota* in Edinburgh, all reviews are understood to be by their authors in 1994.

5 I was personal witness to these activities in Edinburgh on the night of 15 August 1994 and was present at the press conference on 16 August 1994.

6 See Bemrose, Coulbourn, Donnelly, Friedlander, Taylor, and Wagner, all 1995.

7 Billington, Butler, Coveney, Nightingale, Shuttleworth, Spencer, and Stratton (all 1996) mention the production's past, while Gore-Langton does not.

8 Co-producers were Salzburger Festspiele, Salzburg; Pilar de Yzaguirre – Ysarca, Madrid; Créteil, Maison des Arts; Festival d'Automne à Paris; Royal National Theatre, London; Tramway – Culture and Leisure Services, Glasgow City Council; EXPO '98, Lisboa; Change Performing Arts, Milano; Harbourfont Centre, Toronto; Hancher Auditorium, Iowa City; Brooklyn Academy of Music, New York; Sydney Festival; Walker Arts Center, Minneapolis; Northrop Auditorium, Minneapolis; Le Manège, Scène National de Maubeuge; La Maison

de la culture de Gatineau; Le centre culturel de Drummondville; Les Productions d'Albert, Sainte-Foy; Le Centre culturel de l'Université de Sherbrooke; Le Palace, Granby; Wexner Center for the Arts, Columbus. I saw the production during its Toronto premiere run and at London's National Theatre in April 1999.

9 In my experience reviewing theatre in four major markets (New York, Dublin, London, and Toronto) over twenty-five years, such post-opening press conferences are a practice unique to Lepage and Ex Machina and were used only in the context of *River Ota* and *Geometry*.

10 *Zulu Time* was an Ex Machina/Real World production, co-produced by Maison des arts de Créteil; Zürcher Theater Spektakel, Zurich; and Festival d'automne, Paris. I saw the production twice during its run at the Festival de Jazz de Montréal in June 2002.

11 Material in this section is adapted in part from Fricker 'À l'Heure zéro'.

12 The German-language review in *Neue Luzerner Zeitung* was cited in French in an article in *Le Soleil* about poor reponse to the show in Zurich. No author is cited for the *Neue Luzerner Zeitung* review; the *Soleil* article is also not attributed to a specific writer. See *Le Soleil* 1999.

13 The production was able to go forward after the cancelled New York run's major financial losses only because Ex Machina had uncharacteristically formed a private company for the production's finances. Nonetheless, Ex Machina was left with a nearly $500,000 deficit following the show's 2002 run and had to apply to a special Québec fund for a partial bailout (see Reynolds, *Revolutions* 76–80). According to Bernatchez, the production's total costs up to and including the Montréal run were $1.6 million Canadian ('Interview').

14 Poulin is Métis and played Caliban in Lepage's 2011 production of *La Tempête*, which figured Prospero as a settler and Caliban as Indigenous (see Poll *Scenographic*, chapter 5). His national background was not mentioned in the programme and other materials around *Zulu Time*.

15 Based on Alberto Manguel's book of the same name, *The Library at Night* offers a 360-degree tour through ten real or imagined libraries. It was created for the tenth anniversary celebrations of the Grand Bibliothèque de Montréal in 2016 and has toured to Québec City and internationally. See Ex Machina 'Library'.

16 *Lipsynch* was produced in association with Northern Stage and Cultural Industry; and co-produced by Barbicanbite08; Cabilto Insular de Tenerife; Festival TransAmériques, Montréal; Festival de Otaño Madrid; La Comète (Scène Nationale de Châlons-en-Champagne); Arts 276/Automne en Normandie; Le Volcan – Scène nationale du Havre; Luminato, Toronto Festival of Arts & Creativity; Chekhov International Theatre Festival, Moscow; and the Brooklyn Academy of Music. I saw the production in Newcastle in February 2007, in Montréal in June 2007, and in London in September 2008.

17 The remaining reviews were by Bassett, Benedict, Hemming, Murphy, Maxwell, Spencer, Wolf, and Woddis, all 2008.

18 Co-producers were La Comète (Scène Nationale de Châlons-en-Champagne); La Filature, Scène Nationale de Mulhouse; MC2: Maison de la Culture de Grenoble; Le Théâtre du Nouveau Monde, Montréal; Festival Internacional de las Artes de Castilla y León, Salamanca 2008; Théâtre du Trident, Québec; Simon Fraser University, Vancouver; UCLA Live; Canada's National Arts Centre, Ottawa; Cal Performances, University of California, Berkeley; Barbicanbite10, London; BITEF Belgrade International Theatre Festival; Le Volcan, Scène nationale du Havre; TNT – Théâtre national de Toulouse Midi-Pyrénées; Ulster Bank Dublin Theatre Festival; Festival de Otoño de la Comunidad de Madrid; Théâtre National de Chaillot, Paris; Tokyo Metropolitan Theatre; Melbourne International Arts Festival; Mirvish Productions, Toronto; Napoli Teatro Festival Italia. I saw the production in Salamanca in June 2008, in Dublin in October 2009, and in London in February 2011.

19 Lepage played Pierre from the production's creation through its run in Berkeley in June
 2009; Henri Chassé then took over the role, with Lepage returning intermittently for runs
 in other cities.
20 An example of such a form of writing is embedded criticism, which has grown in popular-
 ity and profile since the advent of the theatre blogosphere in approximately 2007. Also
 referred to as behind-the-scenes reporting, it involves 'observing productions in rehearsal
 and writing about this experience, usually on a personal or group blog site' (Fricker, 'Going
 Inside' 45). My engagement in this form of writing about theatre, as a pedagogue as well as
 critical practitioner, is fuelled by a retrospective awareness that it would have been a useful
 tool to chart my involvement in the *River Ota* creative process. The serial nature of embed-
 ded writing allows for the relatively immediate recording of rehearsal-room observations,
 something particularly useful when productions are developed over a series of years.
 Rather than holding onto (and perhaps second-guessing) observations, the embedded critic
 releases them into the public sphere, where they are available to the artists themselves as
 well as interested readers.

6

Neoliberalism, authorship, legacy: Lepage and Ex Machina's futures

I began the previous chapter by identifying an ongoing theme in Lepage's work: the relationship between art and commerce. Since approximately 2007 this theme has been joined by a related one – legacy. In *The Blue Dragon* Pierre Lamontagne becomes a father, and the play's three endings, played in sequence, present different outcomes of how the baby might be parented: by Pierre and the child's birth mother, Xiao Ling; by adoptive mother Claire; or by Claire and Xiao Ling together, with Pierre left behind, alone, in China. While this was played lightly, the production revealed that questions of responsibility, the balance between artistic and family life, and what we leave behind were active ones for Lepage and Marie Michaud in their creation of the show. The central trope of *887* is memory: in it Lepage, playing himself, recalls his early years in Québec City and considers the struggles of his taciturn taxi-driver father to support the family and reconcile his own federalist leanings with the nationalist tide of the Quiet Revolution. In it Lepage also represents himself, with dark humour, as obsessed with his pre-recorded Radio-Canada obituary, which he obtains and listens to on headphones, so that the audience cannot hear to what Lepage is (unhappily) reacting (see figure 2.4). It is a powerful representation of the desire to control how one is remembered, and also reflects the recognition that some of this is out of our hands. Some – but not all: in this mature phase of his career Lepage and Ex Machina are channelling energies into the sustainability of their creative and business interests. As they do so, they have shifted tack from the strategy described in the previous chapter of branding their work as being defined by creative evolution and progress. Ex Machina now foregrounds its capacity to deliver excellent and creatively daring performances across a number of genres and in multiple international locations with high levels of professionalism and efficiency. With the Diamant project Lepage

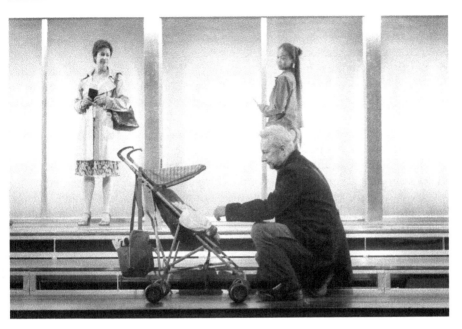

6.1 Marie Michaud, Tai Wei Foo, and Robert Lepage in *The Blue Dragon*.

and Ex Machina are also working to cement their position as leaders in Québec's cultural economies by creating a permanent site for the creation of new projects and the performance of existing repertoire.

This more straightforward brand image and the addition of Le Diamant reveal Lepage and Ex Machina's drive to not just maintain but expand their operations, and to further gird themselves against the instability of the touring market. There are moves which express commitment to the companies' longevity and to the broader artistic ecosystems in which they function. At the same time, it remains the case that these enterprises are defined and driven by the creativity and narratives of a single individual, working within existing systems to maximise that person's productivity. A portrait emerges of a networked artistic enterprise driven by the neoliberal values of individualism, entrepreneurialism, and resistance to external regulation (see Harvie, *Fair Play* 2–3). In responding to its circumstances and altering its approach within them, Ex Machina displays the pragmatism and reflexivity that Wendy Brown argues characterise an embrace of neoliberalism: '[t]he model neoliberal citizen is one who strategises for her- or himself among various social, political, and economic options, not one who strives with others to alter or organise these options' (43). It bears pointing out, however, that Ex Machina puts pressure on performing arts organisations that it produces with to evolve their ways of working: major entities including the Metropolitan Opera and Canada's Stratford Festival have altered their rehearsal and production systems in order to co-produce with Ex Machina on Lepage's terms. As Reynolds argues, such interaction 'with the mainstream' is 'an impetus towards gradual change' within arts industries (*Revolutions* 6). Through its work Ex Machina

expands the modes of collaboration possible in the international performing arts milieu and adds to the variety of productions on offer.[1] Making these systems of production and distribution dependent on a single creative source is a risky business model that hews to the neoliberal valorisation of the individual. The emphasis since the early 2000s on building an Ex Machina repertoire is legible as the company's acknowledgement of this fact, and an attempt to gird itself against the inevitable eventual loss of its creative motor.

Given these multi-faceted realities, I find it most useful to characterise Lepage and Ex Machina's relationship to neoliberal systems as one of active and ongoing contestation. I find support for this approach in Jen Harvie's volume *Fair Play*, in which she argues that there are many aspects of the drive towards artistic entrepreneurialism that are potentially 'expedient, helping artists to survive and sometimes thrive even when formerly semi-stable sources of public support for arts practices erode' (62). At the same time, as noted in the previous chapter (pp. 155–9), Harvie highlights the potential risks of such entrepreneurialism: the prioritisation of individual self-interest over the collective; creative destruction; and the necessity of non-stop productivity (77–8). In this chapter I explore these three areas of risk in Lepage and Ex Machina's practices and identify ongoing, evolving struggles within them.

Individualism, collaboration, authorship

A principal risk of the drive towards entrepreneurialism in contemporary art and performance, as Harvie argues, is the valorisation of the individual at the expense of 'social relations and principles of social equality' (77). This tension – between the individual and the collective – has been at the centre of Lepage's working practices from the beginning of his career and has become only more acute since the founding of Ex Machina. These tensions exist on multiple, interrelated levels: creative processes; distribution of and compensation for labour; and systems of production and dissemination of work. While his enterprises exist to serve Lepage's vision, it is difficult to chalk this up wholly to individual self-interest in that many artists, technicians, and producers have input into and gain livelihood from his work – Ex Machina has up to thirty permanent employees and annually hires several hundred more on part-time contracts (see Reynolds, *Revolutions* 157). Further, it has always been difficult, on a societal level, to extract 'self-interested individualism' from the 'collective good' when it comes to Lepage, inasmuch as his career and success have always been linked to the interests and vibrancy of his national culture (Harvie, *Fair Play* 78). The imagination and ambitions that propelled him to see the world and create work about those voyages were consistently framed as reflective of and participating in Québec's own process of maturation and internationalisation. The national service he performs – to borrow a conceptualisation from Erin Hurley (*National*) – is thus another challenge to the extraction of personal from collective interests around Lepage's work. The following sections focus on Lepage and Ex Machina's working relationships with other

artists and the relationship of his enterprises to Québec; here I explore the relationship between individualism and collaboration in Lepage's approach.

Lepage functions best in group settings, and a principal driver of his various enterprises is the establishment and maintenance of conducive contexts for him to create on his terms, always with others. It was its 'collaborative nature' that 'drew me to theatre' initially, Lepage says. 'Being shy and timid, I found in theatre a way to undertake artistic work with other people' (qtd in Charest 110). But, as he further explains, he quickly became well known for his particular approach, so that his name 'made or unmade' a project. 'Everything became personal and my shows were no longer seen as being the shows of companies with which I was involved.' Such attention often misinterpreted the level of his input, he says. '[T]he credit I received was often out of proportion with my real contribution', which he found 'dizzying' (ibid.). Charest notes that, in the interviews that led to *Collecting Flights*, Lepage 'tended to describe the creative process in the first-person plural ... putting a strong emphasis on the collective aspect of his creative work', even when speaking of his solo shows. Thinking in terms of 'we' is a 'collective refuge' for this 'very singular creator', Charest concludes (66). Becoming artistic director of French theatre at the National Arts Centre in 1989 was the first time that Lepage 'took on the [leadership] role that was being attributed to me anyways' (111), but he did not feel ready for the responsibilities of that position: when he stepped down after one term in 1992, he said it was 'too early for me to say what the role of a national theatre is' (Curtis). He and producer Michel Bernatchez set up Ex Machina as a place where Lepage's personal creativity could blossom. What interested Lepage 'most of all' in his work was 'gathering artists together, combining different styles and disciplines' (Charest 26), and thus Ex Machina was conceived as a 'meeting place for architecture, music, dance, literature, acrobatics, play and so on' (ibid.). Collaboration is definitional of the company: in the English-language foreword to *Creating for the Stage* Lepage goes so far as to say that Ex Machina is a 'collective creative process' (7).[i] At the same time, this is collectivity with a singular leader, as signalled in the story of its naming that appears on its website: 'In 1994, when Robert Lepage asked his collaborators to help find a name for his new company, he had one condition: the word theatre could not be part of the name' ('Ex Machina'). As this statement makes clear, Lepage is in charge: while he asks for input into this important decision, he is the one who sets the parameters and, presumably, makes the final choice. The collective has a voice, but outcomes are shaped and finalised by Lepage. In Harvie and Hurley's analysis, there is a more significant missing word in Ex Machina's name: Lepage is its 'most likely "deus"' (299). Leaving out the reference to God or the god-figure that arrives to resolve a challenging situation is a recognisable move on Lepage's part, Harvie and Hurley imply, to deflect questions about his central, determining role in his creative processes and the systems around them.

Discussions of Lepage as a collaborator broaden into questions of authorship, signature, and the embrace of impulse and the aleatory as a central guiding principle of his creativity. These topics are contentious in scholarly treatment of Lepage's work: while

i In the French, he says that the company uses collaborative creation without equating one with the other: 'Le travail de création collective d'Ex Machina est basé principalement sur l'intuition' (7).

some commentators describe his working methods as practical, ingenious means of generating and shaping material, others question his use of fellow artists as generative sources when the credit and authorship accrue largely to him. While exploring these debates, it is important to note, as discussed in the Introduction (see pp. 25–7), that questions about the role of a director or another leader in collaborative creation processes are not unique to Lepage. Central to the 'rhetoric' in the early 1960s–1970s heyday of theatrical devising were equality – the notion of 'all members of the group contributing equally' (Heddon and Milling 4) – and freedom. This reflects the political and social climate out of which devising processes grew, in which all kinds of hierarchies and authority structures were being questioned in favour of expressions of cooperation, 'de-commodification', and 'social change' (5). While from the 1990s forward '"devising" has less radical implications, placing greater emphasis on skill sharing, specialisation, [and] specific roles', including that of a director (Oddey 9), the association of collaborative creation with ideologies of equality and liberation remains. Over the decades, many well-known theatre companies that work through collaborative creation have been led by directors, leading Heddon and Milling to ask whether 'a director, who ultimately has the last word, who accepts final responsibility, complicate[s] the notion of non-hierarchal work or democratic participation?' (5).

This question is germane to Lepage's work with Théâtre Repère and Ex Machina. His emergence in the 1980s was representative of a shift in Québécois theatre away from text-based work and towards *écriture scénique* (scenic writing), a visually-led approach to creation (see Hébert 'The Theater'). Such work complicated traditional understandings of theatrical production, in which a writer's existing text is staged by a director: Lepage was celebrated for the ways in which he composed his work through a combination of devising, staging, and scenography. Questions about the exact nature of his practice and where his contribution began and ended have thus been circulating since the earliest days of his career, a situation of ambiguity which is for him both familiar and productive. Freedom, lack of structure, and group work are central values for Lepage, and clearly part of the appeal to him of collaborative creation is the capacity to work within environments that have such qualities. Such circumstances and choices have evidently contributed to Lepage's resistance to being understood as the author of his work, calling himself 'just the spokesperson' and 'the face you put on the work and on the signature' (qtd in Shevtsova and Innes 137).

A number of scholars who have observed Lepage's working practices agree that they prompt reconsideration of authorship and of the role of the director. Ludovic Fouquet argues that Lepage 'has gotten rid of the author, but then more than a dozen authors are found' (*Visual* 218). For Fouquet, Lepage's capacity to inspire creativity within a group and distil the resulting material into a piece that bears his signature is one of his defining gifts. Inspiring creativity involves the performers generating content from their own impulses and experiences. Aleksandar Dundjerović describes Lepage's work as involving 'a plurality of performers' personal references ... resulting in a multi-layered theatricality' (31). The onus is on the performers to find their way through this process of content-generation, as Lepage's frequent collaborator Marie Gignac notes: 'When creating the piece, he gives [actors] very few directions. It is up to the actors to come up with ideas, images, and components that will allow the play

to move forward' (Qtd in Caux and Gilbert 37). This is a position of responsibility to which not all actors are suited, and it is risky, inasmuch as Lepage cannot necessarily tell when he selects an actor whether or not they can handle the pressure of this way of working (see Bureau 30). In Fouquet's observation, part of Lepage's great skill as a leader of collaborative processes is creating a conducive atmosphere in which creativity can flow. He here describes his impressions of the making of *Geometry of Miracles*:

> Lepage is the great unifier in this process. He starts from nothing, combining questions and instincts, without knowing exactly where he is going or exactly what the show will look like. That is why so much effort goes into making the actors feel comfortable: they aren't used to be working so out in the open and following the trail of coincidences, and they generally hate uncertainty. For Lepage, preparing the actors means getting them to see that he too is letting himself be guided. (*Visual* 224)

In Fouquet's observation, Lepage's approach to scenography is more authoritative than his approach to content; and the fact that he '[knew] exactly how the set [had] to be' while still remaining unclear about aspects of plot and character was disconcerting to the *Geometry* ensemble (ibid.). Keeping these anxieties in balance required a subtle hand: Lepage's

> strength lies in the ability to orient the creation from the work done at the table without appearing to do so, to connect with, through conversations and experiments, the instincts that initially drove the work and to arrive at a collaboratively created show, while pursuing his own intuitions. (225)

In a similar vein to Fouquet, Dundjerović understands 'the dynamism and tensions between the collective and individual performer's creativity and the role of director' as 'important generators of creative energy in Lepage's theatricality' (37). While particularly characteristic of group projects, Lepage's reliance on other artists to help him generate and shape material is also true of his solo shows: as described in *Creating for the Stage*, working on the solos involves an understudy or stand-in – whom Lepage calls the 'shadow' – who steps in as Lepage directs so that he can 'visualise the performance space and understand the obstacles and possibilities of the set design gradually taking shape' (43). The role of dramaturg on the solo shows is also 'invaluable … providing resources and approaches that nourish the process, and that also offer Lepage certain acting choices' (ibid.).

In Lepage's account, it is the project itself, beyond generative interactions with other artists, that has a determining role in how the work proceeds. The notion that the 'play in its final form exists even before we begin to work' and that the job of the company is to 'invent a way of getting to our destination' (Caux and Gilbert 31) is central to Lepage's understanding of his creativity. This does not mean, Lepage explains, that 'everything is prearranged' but, rather, that stories must be allowed to 'evolve slowly, advancing along with our research, our discoveries and the accidents that occur along the way' (ibid.). Hence his repeated references to his way of working as a discovery process (see, for example, *Connecting Flights* 25, 27, 30–1, 70–1, 99, 129, 159, 178): what they may discover is already out there, but finding it is not a foregone conclusion. 'Intuition as

a structuring element' is a remarkably common feature of collective creation, Heddon and Milling note (9), while also pointing out that it is possible to be sceptical about the 'function of this mechanism as an inexplicable element of the practice' (10). As Foucault has argued, 'every sentiment … has a history' (153), and groups of devisers, as they work together, generate a 'shared set of patterns and experience' that might lead them to recognise something discovered in improvisation as a shared 'performance solution', not because the work self-identifies as such but because it fits into the group's shared assumptions (Heddon and Milling 10). One of the most interesting and complicated aspects of the *River Ota* process, as I observed it, was how decisions were made about what material to include and how to structure the production. Post-rehearsal discussions among the collaborators frequently went on late into the night, during which any number of possible avenues for further work or resolutions to narrative and structural challenges were mooted. Though to me nothing seemed to have been resolved in these conversations, it was often the case that the next day a common way forward was understood. It is possible that there were side conversations in the meantime, but it is also possible that the company had developed a shared understanding about how to process such open-ended conversation – that they possessed the 'shared set of patterns and experience' that Heddon and Milling describe. I found Lepage's hand in this aspect of the creativity to be light: he facilitated discussions but did not suggest that his ideas might have more merit or weight than those of others.

Given this, that eleven actors and a dramaturg along with Lepage are listed in *River Ota*'s playscript and programmes as its authors strikes me as just – they all generated content, though some were more generative than others. On the other hand, Lepage's further credit as director feels inadequate to the authority he held in this project. This included posing the initial premises and conditions for the work in terms of subject matter, personnel, theme, and design; editing and shaping content; physically blocking many of the scenes; and serving as the production's principal spokesperson through most of its four-year touring life. While Dundjerović argues that Lepage's directorial hand becomes definitive only towards the end of creative processes as he 'facilitates the final composition of the piece' (33), in fact Lepage's creativity dominates every stage of such processes, starting with casting. He does not hold auditions, as Ex Machina explains, 'preferring to proceed by invitation. Artists are often chosen following chance encounters' (Caux and Gilbert 37). Being involved in one of Lepage's productions, then, requires having already entered his sphere of reference: his life-world determines participation. Lepage's determining role from the outset of his processes is also evident in his choice of the resources that spark Ex Machina's group productions. While 'every performer in the group establishes his or her own reference point with the starting resource' (Dundjerović 32), the identification of the resource itself is Lepage's domain. He launched *River Ota* by 'sharing his ideas with [his collaborators]: seven boxes, seven streams, seven sliding Japanese doors, a house, and a garden' (Fouquet, *Visual* 217). *Geometry of Miracles* grew out of Lepage's interest in Frank Lloyd Wright's 'organic' approach to architecture, and the subsequent discovery that Lloyd Wright and Georgi Gurdjieff had known and influenced each other (Hood 129–30). The starting resource for *Lipsynch* was 'a rough sketch' that Lepage had made 'of an aeroplane interior; a screaming baby

sits at the back of the plane, while an adult with a cultured voice sits to the front in club class' (Reynolds, 'Authorial Process' 181).

Given the complexities and ambiguities of these processes, it is not surprising that questions have been raised about the power structures underlying them. 'Although is it certainly possible to see Lepage as insistent on a democratic dispersal of authorial power in his productions,' Harvie argues, 'it is nevertheless also possible to see him as monopolising much of the authority – and certainly much of the credit – for the productions' ('Robert Lepage' 229). In 1993 Christie Carson wondered how the *Tectonic Plates* process could be a 'truly collaborative dialogue' when 'Lepage retain[s] the role of director and therefore ultimate creative control' (46). James Reynolds contributed to this vein of scholarship in a 2012 chapter in which he worried that, by not acknowledging Lepage's role as the '"big" author' in his processes – given his decisive role in choosing resources (including human ones), determining the mode of creative work, leading that work, and editing through his signature mode of montage – Ex Machina 'risks the appropriation of subjectivity' ('Authorial Process' 184, 185). Reynolds further critiqued Lepage's description of his work as 'self-producing' as an 'abdication of authorship' (185). Having observed a number of Lepage's creative processes in the years since, Reynolds significantly revised his point of view in his 2019 volume, arguing that Lepage's 'authorial role' within his work 'is problematic only if he denies it – and he doesn't', while also allowing that Lepage's 'discourse around his practice can be vague' (*Revolutions* 65). Performers in Lepage-led productions are contracted and compensated by Ex Machina as authors and are thus aware from the start that their role will involve the generation of material as well as appearing on stage (64–5). Lepage functions, in Reynolds's reading, 'with the authority of a director-within-devising' (64), and he argues that a misplaced understanding of Lepage's creative relationship to the RSVP Cycles plays a significant role in misconceptions of his authorship.[2] While group identification of concrete, physical resources is a central tenet of RSVP-based work, Lepage has long made clear that he has adapted the Cycles considerably and does not adhere strictly to them. Identifying the resources himself – resources which can sometimes be conceptual and sometimes concrete – is an acknowledged aspect of Lepage's approach (63–4). Reynolds's accounts of the creative process of several Ex Machina productions and co-productions – in particular that of *Playing Cards: Hearts* (2013) – includes nuanced observation of Lepage's collaborative style, which involves leaving creative choices and discussion open early on his processes, but 'chang[ing] gear' as public showings of the work approach: 'there is a very different energy in his directing; he speaks faster; uses demonstration more often; makes a greater number of suggestions, and is more prescriptive' (173). This dovetails with my observation of *River Ota*: the open-ended and exploratory nature of rehearsals in Québec City shifted significantly in the week before the company was due to perform in the 1996 Vienna Festival. Creative work could not start until Lepage arrived a few days after the company assembled, and, following on from group discussion of several significant concerns around plot, characterisation, and structure, Lepage made decisions swiftly and authoritatively on which the company then acted.

Such decisions affect, of course, not only the performers but everyone involved in the production. Reynolds relates an anecdote from *River Ota*'s lighting designer Sonoyo

Nishikawa: before a run of the production in 1995, also in Vienna, Lepage called for major changes which involved Nishikawa and her assistant reprogramming the whole five-hour show (*Revolutions* 66–7). These are part of the risks and responsibilities that come with working for Ex Machina; in the company's ethos the work of designers, technicians, and producers is valued and foregrounded, countering the 'hierarchical division of theatrical labour' that is the norm in Western theatre traditions, in which the artistic director and director are at the 'top of a pyramid' and designers and technicians at the bottom (Caux and Gilbert 50). In *Creating for the Stage*, behind-the-scenes work, usually understood as organisational, technical, and artisanal, is framed as creative: the team of producers, production managers, and production directors led by Bernatchez are acknowledged as playing an 'artistic role' within the company (51), and the fact that stagehands and technicians are 'obliged sooner or later to develop creative solutions to practical problems' also allows them to influence 'the artistic content of the play' (50). Ex Machina integrates acknowledgement of the collective labour that goes into its productions by (in a stylistic nod to cinematic convention) projecting credits onto a screen or stage wall, including the names of artistic and production personnel, and by having the stage crew take a bow with the actors after every performance. Ex Machina's description of the integration of technicians' ideas into productions sounds somewhat conscriptive, and the environment in which this work happens highly pressured: it is described as an 'advancing locomotive' and a 'creative machine' that moves forward 'at a frenetic pace' (51). One imagines that, as with performers, there are those who will not respond well to the pressure to participate and generate ideas under these circumstances. This valorisation of what Lepage calls the 'flip side' of creation (50) nonetheless resists the neoliberal drive towards 'dissociated labour' (Sennett 36) 'which alienates and isolates workers' (Harvie, *Fair Play* 96). Blurring the line between artisanal and artistic work and acknowledging behind-the-scenes contributions as integral to the creative processes invites designers and technicians to feel ownership over their labour and its outcomes, and to feel part of a larger team.

The relationship between collective work and individual contribution, then, is a central, complex element of Ex Machina's practices. While Lepage's signature identifies the work, it is also widely acknowledged that the productions result from shared creative labour. Reynolds's most recent arguments go some way towards countering claims that this shared labour is exploitative, but, given the power differential between Lepage and everyone else he works with, one can still imagine a scenario in which a performer/ author, designer, or technician has concerns about a representation or idea but refrains from voicing this or is overridden if they do so. This may be the cost of doing creative business with Lepage.

Countering creative destruction

A central aspect of Ex Machina's activities in the mature phase of Lepage's career is facilitating the distribution of his energies among numerous projects simultaneously,

allowing him to work across disciplines, experiment with new forms, and engage with other artists and companies while keeping his businesses afloat. Centralising Ex Machina's activities and requiring that creative work on co-productions should happen whenever possible in Québec was a necessary step in the maturation of the company's systems, explains Bernatchez: whenever Lepage left to work on a project elsewhere, the company was 'not generating income' (qtd in Reynolds, *Revolutions* 115). An additional concern was that Ex Machina sometimes found it difficult to sell its own productions to international festivals and venues when there were Lepage-directed productions for other companies also in circulation (33). Bernatchez now insists that Lepage and Ex Machina are a package deal, as with this negotiation with Cirque du Soleil on the Lepage-directed *Totem*: 'I said – "We need to be front and centre in one way or another. His absence is costing us money, and we're not involved in the production". So a significant royalty was negotiated for Robert, and we get two thirds of that royalty' (115). Centralisation is thus a key element to the company's productivity and sustainability, understanding sustainable to mean 'capable of being maintained at a certain growth or level' (Oxford Dictionaries). Insisting on Ex Machina's participation in all of Lepage's creative activities, and that these activities happen in Québec, are part of the ways in which Ex Machina contends with creative destruction – another of the risks which Harvie associates with artistic entrepreneurialism. Creative destruction, she explains, 'describes how capitalist economic creativity, innovation, or development rarely seems simply to add on to existing economic activity which remains undisturbed' (*Fair Play* 88). The drive towards forward progress 'seems necessarily to destroy the existing economic context – or at least significant parts of it – making it obsolescent' (ibid.). Examples of this phenomenon within creative economies are the ways in which recording media such as the eight-track tape and the cassette rapidly become outmoded as new media are developed, and how '[e]volving technologies and modes of acting' made 'the melodramatic silent-film actor redundant' (89). Cutting out 'dead wood' in the form of 'practices, organisations, companies, technologies, and workers which are outmoded, inefficient, and stagnant' is part of the economic logic of neoliberalism, and can lead to 'prosperity, progress, efficiency and – capitalism's holy grail – greater profit'. But bringing prosperity to one place often means bringing economic destruction to another, as when a multinational corporation moves from one location to the next to outsource cheaper labour and materials: increasingly, 'mobile capital' can contribute to profound 'instability' (ibid.).

Lepage's practices involve a characteristic push and pull between a drive towards the creatively new and the desire to retain and repurpose existing practices, material, media, and human resources in the form of collaborators. His techniques of remediation – adapting filmic techniques of storytelling into live staging techniques, as discussed in Chapters 3 and 4 – are ways in which he repurposes existing artistic modes. His way of working could, on the one hand, be described as creatively wasteful: it involves 'generating the greatest quantity of material possible in terms of both form and content' (Caux and Gilbert 52), and this often means that 'many good ideas' will be 'cast aside' (ibid.). Over the years, though, Ex Machina has become 'more serene' about this, knowing that some discarded material 'resurfaces in another project' (ibid.). Worries about creative excess, then, are assuaged by the understanding that

productions mutually inform and build off each other; old material becomes new material to the extent that the distinction between them blurs. An example is the evolution of the character of Pierre Lamontagne through a number of productions, from *The Dragon's Trilogy* to *River Ota* (where he was renamed Pierre Maltais) to *The Blue Dragon*; he is also a central character in *Le Confessional*. Pierre's reappearance in the film and these productions – each more technically and technologically sophisticated than the last – links them together and creates an anchoring meta-narrative, a return to and renovation of the familiar that weaves together with the embrace of the new. The 2013 revival of *Needles and Opium* worked in a similar fashion: Lepage refashioned existing material using up-to-date technology and the sophisticated design and production capacities that had become available to him in the twenty-one years since he first created the show. Such 'upgrades', Lepage says, are 'not recycling with the goal of doing the same thing again – [but] recycling with the goal of pushing the idea further, now that we have the means to push it further' (qtd in Reynolds, *Revolutions* 75). Lepage and Ex Machina have similarly upgraded *The Dragon's Trilogy*, the opera *Faust*, *The Far Side of the Moon*, and other productions, and introduced the scenic element of a rotating cube, first experimented with in the 1994 *A Dream Play*, into *Needles and Opium* (2013) and *Hamlet Collage* (2014), which is an upgrade of *Elsinore* (see Reynolds, *Revolutions* 4).

Such updating of material and scenographic elements through remounted productions forms part of Ex Machina's contribution to the local creative economy. As previously noted (see pp. 18–19), Lepage and his associates were criticised at the time of Ex Machina's founding for prioritising international touring over performing their work for local audiences, priorities exemplified by not building a performance space at La Caserne (see Harvie and Hurley). This is in its way a critique of the company's perceived embrace of the neoliberal imperative of productivity; the implication is of a sort of reverse outsourcing – that Ex Machina was exploiting Québécois resources and labour without sufficiently giving back to Québec in the form of performances that the local public might attend. It can also be argued, however, that Lepage and his associates work on numerous levels to bring benefits, economic and otherwise, to Québec, and to make these sustainable. By making it a condition of Lepage's projects that whenever possible labour is undertaken locally rather than in foreign venues, his companies are creating employment opportunities and driving investment into Québec. This has caused complications, most notoriously in the case of the staging of Wagner's *Ring Cycle*, produced by New York's Metropolitan Opera (the Met) in association with Ex Machina, which ran between 2010 and 2012. The production's elaborate set, designed by Carl Fillion and dubbed 'the Machine' – two towers supporting a sixty-foot central shaft around which were attached twenty-four moveable planks – was built at Scène Éthique, a scenic design and construction company in Varennes, outside of Montréal. This led to disputes between the Met's unionised stagehands and the non-union Québec companies around the distribution of labour (see Wakin 2009), and further complications when the set 'turned out to be so heavy [fifty-four tonnes] that the Met had to reinforce its stage with steel beams', adding 'to the considerable cost' of the *Cycle*, estimated at approximately $21 million (Wakin 2010).[3] The fact that the set was being built elsewhere than its site of use and that com-

munications were happening across languages and different theatrical systems likely contributed to these problems, which contributed to considerable negative media commentary around the production.[4] Creating opportunities for labour to happen in Québec and for capital to flow into the province in this instance led to considerable funds being spent on this project that could have been supporting other ventures, and caused some damage to Lepage's reputation.

At the same time, Ex Machina's insistence on making its work in Québec has brought significant financial benefits to the city and province. Of Ex Machina's annual budget of $10 million dollars (as of 2007), more than 80 per cent of its independent revenue 'is generated in foreign currency (mainly in euros), while more than eighty per cent of [its] expenditures are made in Québec in Canadian dollars' (Caux and Gilbert 53). Ex Machina has become a major employer of local creative workers, hiring many artists and artisans for its stage productions and other projects. This benefits the company and contributes to its productivity, while helping to create ongoing opportunities for employment in a small market and in creative fields where work is contract based and precarious. La Caserne not only housed Ex Machina and Robert Lepage Incorporated but rented out offices to designers and other 'small companies that work with Ex Machina as partners' (Fouquet, *Visual* 212). The company also serves as a meeting point for artists who go on to establish their own creative enterprises, as with Félix Dagenais and Louis-Xavier Gagnon-Lebrun, who formed the urban installation company ATOMIC3, having worked together on several Ex Machina projects (Dagenais as stage manager and assistant director; Gagnon-Lebrun as lighting designer). Dagenais confirms that having worked for Ex Machina 'greatly contributed to the credibility of our approach' when he and Gagnon-Lebrun set up ATOMIC3, helping them to attract clients and generate further work.[ii] Ex Machina's influence thus ripples out more widely into Québec's creative ecosystems and economies.

Another aspect of Ex Machina's activity that contributes to local economies and to its legacy is publication: in 2005 the company began 'systematically publishing its play scripts' (Caux and Gilbert 56), a practice in which it had engaged sporadically in previous years.[5] This reflects a change in thinking around the nature of the company's work from Lepage's early- and mid-career, in which the emphasis was on ongoing creativity without productions necessarily taking a final or definitive form. The vision now, as articulated by Caux and Gilbert, is that the playscripts are 'the final step in the evolution of the company's projects'. They point out that publishing can 'give new life' to one of Ex Machina's shows by allowing other companies to produce it, and that it allows 'researchers and fans ... access to the Ex Machina universe' (56). Other publishing projects include large-format versions of *The Blue Dragon* and *887* – the former as a graphic novel with illustrations by Fred Jourdain, the latter as an enhanced version of the playtext with illustrations by Steve Blanchet. These, along with the *Chantiers d'Écriture Scènique/Creating for the Stage* volumes by Caux and Gilbert, constitute a de facto publishing arm of Ex Machina, in collaboration with a number of small publishers, nearly all Québec based.[6] Publication serves multiple purposes: revenue generation (in that royalties from the books and productions flow back into

ii 'a grandement contribué à donner de la crédibilité à notre demarche'.

the company), documentation, and engagement with the broader artistic community. All of these outcomes contribute to Ex Machina's legacy in that they contribute to the financial viability of the company, create a historical record of otherwise evanescent artworks, and invite other artists to use their work as the source material for further creativity.

A final element in this consideration of the relationship of existing resources to new ones in Ex Machina's practices are Lepage's collaborators. In the 1980s and 1990s he worked consistently (though not exclusively) with a group of colleagues and friends whom he has known since the Repère years, and in some cases from his theatre school days, including Normand Bissonnette, Marie Brassard, Richard Fréchette, and Marie Gignac.[7] River Ota was the last time that this core group of artists participated in a collective piece together, joined by members of a younger generation of Québécois performers (Éric Bernier, Anne-Marie Cadieux, Normand Daneau, Patrick Goyette) who had worked on previous recent projects with Lepage, notably the late 1990s Shakespeare Trilogy. After River Ota these Québécois artists were sometimes involved individually in Ex Machina projects,[8] alongside artists from a broader sphere of creative disciplines and from a variety of cultural and national backgrounds. Such diversification was a key objective for the company: 'our dream for Ex Machina is that it will become the type of multidisciplinary and experimental company that Repère wasn't able to be', Lepage says in Connecting Flights (144). Working with artists from different national and cultural backgrounds and different disciplines is central to this vision. The Geometry of Miracles ensemble, for example, included among others the Croatian actor/director Tea Alagić, the English actor Anthony Howell, the United States-born actor Kevin McCoy (who is Lepage's domestic partner), the American actor/dancer Thaddeus Phillips, and the Québécois dancers Daniel Bélanger, Denis Gaudreault, Rodrigue Proteau, and Catherine Tardif, along with Brassard as a core creator/performer. The Vienna-based American operatic soprano Rebecca Blankenship became an important collaborator on Ex Machina's projects from River Ota forwards, collaborating in Geometry of Miracles and Lipsynch and a number of opera projects. The Lipsynch ensemble was Lepage's most multinational to date, featuring performer/authors from the Canary Islands, Canada, England, Germany, Québec, Scotland, and Spain. The casts of Playing Cards were also multinational and multi-ethnic, featuring, in the case of Hearts, the Algerian-Québécois actor Reda Guerinik playing the Algerian immigrant Chaffik, as well as the veteran United Kingdom-based theatre artists Kathryn Hunter and Marcello Magni.

This more adventurous and expansive approach to casting, while in keeping with Lepage's stated goals for Ex Machina, has not necessarily resulted in creative success. River Ota was the last multi-character, large-scale production that was hailed, in its most developed form, as a major achievement; as noted in the previous chapter, Geometry of Miracles and Lipsynch were met with equivocal critical response. The more modestly scaled The Blue Dragon toured to a number of major venues, including the Brooklyn Academy of Music and the Barbican Centre in London, but also received mixed reviews. Lepage's solo shows created during the same time period, The Far Side of the Moon, The Andersen Project, and 887, all toured more extensively than the group works: while this in part doubtless has to do with the fact that they

are less expensive and unwieldy to tour, it is also notable that they were well received critically.[9] It is to the solos that audiences and critics can continue to look for the moments of spatial montage and 'feeling global' affects that made Lepage's reputation and characterised his early- to mid-career work. The ambitious *Playing Cards* project, conceived as four full-length shows each themed around a suit in the deck of cards and staged in the round, was only half realised.[10] The group-creation approach appears to have run its course in Lepage's early- and mid-career period, and the decline in its effectiveness may also be connected to the broadening of Lepage's sphere of actor/performer collaborators. Group collaborations including *The Dragon's Trilogy*, *Geometry of Miracles*, and *River Ota* benefited from the shared set of patterns and experience among their collaborators noted above; the expansion of Lepage's ensembles appears to have compromised this mode of work. This is not to argue that group collaboration is an inherently Québécois form, but, rather, that its success in this case seemed to stem from personal intimacy and a sense of complicity that comes from shared experience, points of reference, and cultural and artistic background. The particular internal dynamics of this kind of creativity could not be as effectively replicated in the newer, multidisciplinary, and multinational collaborations that Lepage had so long desired. Since 2007 work in a variety of genres, including circus, dance, opera, and installation/multimedia, and upgrades of existing works have come to the fore of Lepage's work, taking the central place previously occupied by group creations.

In this mature period of his career, relationships with designers and other behind-the-scenes figures have become a more consistent aspect of Lepage's collaborations, as opposed to relationships with performer/creators. He tends to work with designers over a number of projects, such as set designer Fillion, composer and sound designer Jean-Sébastien Côté, props designer Patricia Ruel, and puppeteer/designer Michael Curry.[11] Assistant directors such as Adèle Saint-Amand (*Coriolanus*, *Quills*, *887*) and Dagenais (*Eonnagata*, *Spades*, *The Blue Dragon*, *Lipsynch*, *Andersen*) also provide continuity across projects. Two key roles providing continuity and sustainability are those of creative director and dramaturg. The former role resembles the job of director of creation in Cirque du Soleil's producing structures – an assistant director during the creative process who is responsible for the artistic integrity of the show once it begins to tour. Ex Machina modelled this sort of working relationship with Neilson Vignola, who assisted Lepage on several opera projects, including the Ring Cycle, and on the Cirque du Soleil production *Kà*. Steve Blanchet, who first worked with the company as co-creator and image designer of *The Image Mill*, became part of the Ex Machina staff in 2013 with the job title 'Creative Direction'. His role involves preparatory research on productions once they have been conceptualised by Lepage: as Lepage describes it, Blanchet 'sets the table … mak[ing] sure that the integrity of the artistic idea – wherever it goes – is nourished by references, expressed with mood boards, and all that' (qtd in Reynolds, *Revolutions* 120). Because Lepage and Blanchet think the same way, this has 'accelerated Ex Machina's creative process', which, Lepage specifies, doesn't mean working faster: '[w]e attain results earlier. That's the difference,' he says (133). While Lepage has worked with other dramaturgs including Marie Gignac, it is Peder Bjurman who works most consistently with him in this capacity, on projects including *A Dream Play*, *La Celestine*, *Andersen*, *Far Side*, *Playing Cards/Hearts* and

Spades, and *887*. Bjurman's participation can be generative: he pitched the idea of *Far Side* and convinced Lepage to perform in the show (Reynolds, *Revolutions* 75). He works with Lepage before creative processes begin, researching and generating ideas, and keeps a focus on narrative during the creation periods on group shows (162–74). Reynolds describes the working relationship between Lepage, Bjurman, and Blanchet as a central aspect of Ex Machina's approach to creativity in this mature period of Lepage's career: their work on *887* 'effectively triangulat[ed] the material as it developed, and allow[ed] its depth to emerge in the final performance' (120). Having these close creative partners is part of what allows Lepage to work on multiple projects at once: Bjurman and Blanchet continue research and development while Lepage is deployed elsewhere, and enable him to pick up work without backtracking.

A centre for productivity: Le Diamant

The final risk of artistic entrepreneurialism identified by Harvie is that of 'relentle[ss]' productivity becoming the primary driver and dominant value of creative enterprises (*Fair Play* 63). Very high productivity seems to be an inevitable part of Ex Machina's working structures, given Lepage's extraordinary work ethic: Bernatchez 'identifies over-productivity as a major feature of Lepage's creative psychology' (Reynolds, *Revolutions* 133); '[h]e is happiest when juggling several projects at once' (Connolly). A narrative spanning the decades of Lepage's career is the continual development and redevelopment of producing structures that attempt to meet his pace and style of working by creating capacity to develop different projects simultaneously. Le Diamant is the latest and most ambitious element of these structures and will add further capacity to a networked artistic enterprise already notable for its efficiency and high levels of output. The genesis of Le Diamant lies in Lepage's desire, after three decades of 'travelling the world' to 'put down [his] suitcases'[iii] in Québec (Le Diamant 'Mot de Robert Lepage').[12] When first conceived, it was envisioned as an 'extension of the artistic incubator that is the Caserne', allowing for the establishment of a 'permanent troupe performing [Ex Machina's] repertoire' and a site for ongoing work on newer productions 'while the company is on hiatus from its touring obligations' (Caux and Gilbert 57). The project was a response to former Québec City mayor Jean-Paul L'Allier's call for cultural projects to revitalise an abandoned highway tunnel in the Old Port area near La Caserne; its eventual location became a renovated YMCA building in the Place d'Youville (figure 6.2), where the government district meets the walls of the old city. The $54 million project was slowed by a particularly tempestuous period of Québec provincial politics, as shifts between Liberal and Parti Québécois governments led to major tranches of funding being alternatively promised and withdrawn. The commitment of $30 million by the provincial Liberals in April 2015,

iii 'Depuis maintenant trente ans que je parcours la planète, il m'apparait nécessaire de poser mes valises et de créer Le Diamant'.

6.2 Le Diamant.

followed by $10 million from the federal government in June 2016, locked in the project, which opened in the autumn of 2019 (see Government of Canada; Martin; Richer; Boivin).

Le Diamant represents, at the time of writing, the most fully articulated and ambitious physical evidence of Lepage and his colleagues' 'culturepreneur'-ship (see Levin, 'Performing Toronto' 161): its budget dwarfs the $7.5 million costs of renovating and building La Caserne (Harvie and Hurley 309), and the values and promises attached to it are in keeping with neoliberal discourses around creative cities in which the arts are 'valued because they contribute to urban development, city branding and tourism' (Levin, 'Performing Toronto' 161). The presence of artists and their 'innovative ideas' in a creative city, according to this line of thinking, 'attract[s] corporate investment and thus help[s] to boost a city's global competitiveness and economic success' (ibid.). Indeed Mélanie Joly, then Canada's Heritage Minister, framed the government's contribution to the Diamant project not as charitable giving but as an investment in a highly productive sector of the country's economy, worth more than fisheries, agriculture, and forestry combined (see Government of Canada). Le Diamant is represented by the government and its own literature as an enterprise that will bring expansive economic and social improvements to its local and broader community via world-class artistic production. The broad spectrum of values and benefits associated with the Diamant project, as listed on its website, include 'cultural innovation', 'collective space', 'economic effervescence', 'international tourism', and

'heritage architecture' ('À propos du Diamant').[iv] From the beginning, Le Diamant has been planned as an arts centre which will host shows from other Québec City companies as well as touring work, thus serving the broader populace and helping to raise the bar for the performing arts in the city. The private fundraising campaign was led by Lepage, and its presidents were the leaders of BMO Groupe financier (Québec) and the Mouvement Desjardins, the largest cooperative financial group in Canada ('Partenaires'). Both of these organisations are financial partners of the project along with a number of other companies and individuals, including the City of Québec and Lepage himself: as noted, he has committed half a million dollars of his own money to the Diamant project (Everett-Green).

A perhaps unlikely $1 million investor is the Japanese businessman Takeya Kaburaki, whose company imports Québec maple syrup to Japan. Lepage told the *Globe and Mail* that he embraces Kaburaki's creative input as well as his financial contribution: he is 'helping us rethink the presence of Japanese culture in theatre and music' (qtd in Everett-Green), a comment alluding to Lepage's longstanding fascination with Japan and past Japan-themed projects. This multi-layered engagement with Kaburaki is exemplary of the neoliberal thinking behind cultural cities, blurring the lines between financial and creative activity and drawing international revenue and international players into the local economy. Tourism makes a 'significant economic contribution' to the Québec City region (8 per cent of jobs and 3 percent of regional GDP; Québec International 18), and Le Diamant is represented as a significant potential driver of tourism activity. According to its own literature it will 'help make Québec a top-class tourist destination' with a 'rich and diversified cultural offer' ('À propos du Diamant'),[v] while the *Globe and Mail*'s Robert Everett-Green sees in it the potential for 'the start of a new era for a city better known for stone fortifications and horse-drawn carriages than for the performing arts', but which at the time of the project's launch was experiencing a 'renaissance'. Overall, according to Joly, Le Diamant and institutions like it will 'play a key role in the development of dynamic communities ... better meet the needs of Canadians, strengthen the economy, and build Canada's place in the twenty-first century' (Government of Canada). As such, the project was positioned as representative of the Liberal government's 'investments in cultural infrastructure as part of our investment in social infrastructure' (Liberal Party of Canada) under the leadership of then-Prime Minister Justin Trudeau.

This latest turn in Lepage's ongoing, dialectic engagement with the local and global thus finds him instrumentalising his global image, reputation, and existing enterprises in the service of boosting the local and provincial economy through creative production, creative leadership, and tourism. It is very likely the case that the establishment of Le Diamant will enable Lepage and his collaborators to work towards their desired goals, in sync with official discourses. By participating in neoliberal systems and ideologies which link creative cities to economic vibrancy, Lepage and his collaborators also address some of the problems that come with artistic entrepre-

iv 'Innovation culturelle', 'lieu collectif', 'effervescence économique', 'tourisme internationale', 'architecture patrimoniale'.
v 'contribuera à faire de Québec une destination touristique de premier ordre ... une offre culturelle riche et diversifiée'.

neurialism. The threat of creative destruction will be lessened by the creation and maintenance of repertoire, by publishing projects, and by the employment of creative artists and artisans. The venue will welcome Québécois and international productions, starting with Ex Machina's work but also including 'circus, puppetry, British Christmas panto ("done in an Ex Machina way"), virtual reality and even wrestling' (Everett-Green). Lepage has made assurances to the local arts organisations that the goal is 'collaboration, not competition' and that the intent is not to 'steal their audience' (ibid.). A partner in Le Diamant is the annual Carrefour international theatre festival, the artistic director of which since 1997 has been Lepage's long-time collaborator Marie Gignac. Moving Ex Machina's base of activity to Le Diamant will create space for the young people's theatre company Les Gros Becs to take over La Caserne (Everett-Green), thus promoting not destruction but expansion of the arts infrastructure in the city.

A complex set of creative and production enterprises have become required to allow Lepage to engage with those things that keep him productive: exploration, working through process, collaborating with existing and new artistic and artisanal partners, keeping multiple projects on the go simultaneously. With Le Diamant, a missing piece in those enterprises – a site for dissemination not tied to touring – has been met. If successful, the project will contribute to the sustainability of the performing arts scene in Québec through collaborations with other organisations, expansion of local creative infrastructures, increased tourism, and the growth of local and international audiences. What remains unclear is whether this innovation will allow Lepage to achieve his long-articulated goal of slowing down and travelling less. At the time of writing in late 2019 he has recently performed *887* in Canada and South Korea; *The Library at Night* had recently toured to Sélestat in France and was heading to Rio de Janeiro in 2020; and a new production of *River Ota* had been performed as the opening production of Le Diamant in August 2019. Lepage generated all of these projects, which draws attention to the reality that he remains the only creative motor of all of Ex Machina's activities; he has not identified protégés to whom he might pass on his philosophy, nor does he teach his approach. A next organisational step for his companies will need to be an articulated plan for how they will continue to function once he is no longer generating new work. The creative director role, which appeared around the same time as the Diamant project was greenlighted, is the closest Lepage has come to identifying a position of sustained artistic responsibility to his work other than himself, but this is a position of creative support, not initiatory leadership. An Ex Machina repertory will outlive Lepage but is not sustainable far into the future. The prospect looms that, without the hyper-productive engine at its centre, Ex Machina and Le Diamant may indeed become victims of the destructive potential of individualism. Typically and troublingly, the question of the creative futures of Lepage's companies remains hovering and indeterminate.

Notes

1　The company's output includes productions and co-productions of classics; dance and music pieces; original ensemble and solo works, including remounts or 'upgrades' of

their existing repertoire; and technology-driven presentations such as installations. See Reynolds, *Revolutions* 3–4.

2 See pp. 29–31, especially note 20 for an introduction to the RSVP Cycles.

3 This and all other mentions of dollar amounts in this chapter are in Canadian dollars.

4 The *Ring Cycle*'s set became notorious for being 'glitch-prone'. It creaked and clanged audibly during performances; at the climax of the opening night of the first opera in the cycle, *Das Rheingold*, a malfunction meant that 'the machine did not form the bridge for the entry of the gods into Valhalla'; and in 2011 another problem meant a forty-five-minute delay in a performance of *Die Walküre* that was being streamed live in high-definition video around the world (Barron 2013). The *New Yorker*'s music critic Alex Ross called the Met/ Ex Machina *Ring* 'the most witless and wasteful production in modern operatic history' (2012). The Met's general manager, Peter Gelb, defended Lepage's vision, saying that his integration of technology into scenography and live performance made him perhaps 'the first director to execute what Wagner actually wanted to see on stage' (qtd in Tommasini 2012). See Poll *Scenographic*, ch. 4.

5 *River Ota* was published in 1996 and *Polygraph* in 1997, both in English by Methuen (now Bloomsbury Methuen). A previous version of *Polygraph* was published in *Canadian Theatre Review* 64 (1990), and *Elsinore* was published in *Canadian Theatre Review* 111 (2002).

6 These publishers include L'instant scène (playtexts, co-publication of *Chantiers d'Écriture Scènique*), Québec Amérique (*887*), Les Éditions Alto (*Le Dragon Bleu/The Blue Dragon*), Septentrion (co-publication of *Chantiers d'Écriture Scènique*), and Talonbooks (*Creating for the Stage*). All but Vancouver-based Talonbooks are located in Québec City and Montréal.

7 Brassard, Gignac, and Marie Michaud, for example, were co-creators of *The Dragon's Trilogy*; Brassard co-created *Polygraph*; and Fréchette and Gignac co-created *Tectonic Plates*.

8 Goyette starred in the film *Le Confessional*. Marie Gignac worked as a script collaborator on *The Andersen Project* and first as an actor, then as an author and dramaturgy consultant on *Lipsynch*. Bissonnette was Lepage's assistant director for the 2013 revival of *Needles and Opium* and performed in the 2011 production of *La Tempête*. Marie Michaud co-created *The Blue Dragon* in 2007, having not collaborated with Lepage since *The Dragon's Trilogy*.

9 *The Far Side of the Moon*'s extraordinary touring success includes, at time of writing, seventy-seven runs over eighteen years (February 2001–November 2019). *Andersen* had forty-four runs over nine years, and at the time of writing *887* had played forty runs over four years (February 2015–June 2019). By contrast, *Lipsynch* had seventeen runs over five years and *The Blue Dragon* had twenty-four runs over five years.

10 *Spades* played fifteen runs between 2012 and 2015 and *Hearts* seven runs between 2013 and 2015, and at the time of writing there were no articulated plans to continue with the project.

11 Fillion designed the sets for *Elsinore* and *River Ota* and other theatrical projects through to *Needles and Opium* in 2013; and designed the sets for opera projects including the *Ring Cycle* and *The Nightingale and other Short Fables* (Carlfillion.com). Côté worked on nearly all of Lepage's theatre productions from 1999 to 2017, including *Far Side*, *Andersen*, *Needles and Opium*, *887*, and several opera and dance projects (Jscote.com). Patricia Ruel worked on the Cirque du Soleil project *Kà* and on two operas (*1984* and *The Rake's Progress*) (Patriciaruel.com). Curry designed the puppetry for *The Nightingale and Other Short Fables* and the sets, costumes, and props for the opera *L'Amour du Loin* (michaelcurrydesign. com).

12 It should be noted that, twenty-five years before the opening of Le Diamant, Lepage cited the need to slow down and put down roots (and his suitcases) as the reason for creating La

Caserne Dalhousie. In an interview published in 1994 with the scholar Christine Borello, he said that La Caserne was 'an important project' because 'we have to take root here, come back here with all our luggage, all that we went to do elsewhere, everything we've taken from elsewhere, and try to structure, to do work that is less scattered, much deeper' (86) ('Maintenant j'ai l'impression, et c'est pourquoi La Caserne devient un projet si important, qu'il faut s'enraciner ici, revenir avec toute cette somme de bagages, tout ce qu'on est allé faire ailleurs, tout ce qu'on est allé prendre ailleurs, et essayer de structurer, de faire un travail beaucoup mois éparpillé, beaucoup plus fouillé').

7

Coda: Lepage exposed

I began this book by suggesting that elusiveness and resistance to categorisation are central strategies for Robert Lepage. His career is marked by ongoing attempts to fashion contexts and circumstances that allow him to work on terms that suit him. This means a delicate combination of freedom and structure: he resists serving others' agendas and answering to timetables that are not his own, but because his work inherently involves other people and has become increasingly elaborate in terms of design and technology, organisations and systems are required to make it happen. On the one hand, he is still viewed as something of a free agent (as per Sarah Garton Stanley's observation [see p. 157] that Lepage has created systems to allow himself to be independent); on the other hand, he is in charge of a network of organisations that at time of writing had just grown further, with the opening of a major physical cultural hub in Québec City. While he does not generate the core idea for every project he is involved in, he works only on things that personally hook and engage him. His belief that creativity is a continuous and iterative process led his companies, first Théâtre Repère and now Ex Machina, to create production systems that allow his shows to develop as they tour. As argued in Chapter 5, these systems were not wholly successful, because a process-based approach clashes with the product-oriented nature of the theatre festival circuit, and because the initial critical and audience success of his group-created productions did not sustain through his mid-career. As I have explored, a distinctive aspect of his productions is their layered construction, in which a number of references – bodies, objects, storylines, themes – are offered up together and the audience is invited to make connections between them. This offer, while acknowledging the role of the spectator in the creation of a production's significations, is also characteristically elusive, a means for Lepage to place responsibility for meaning-making elsewhere than himself. A signature associated with his work

is the moment when a number of these references come together for audiences – when connections between the references become apparent – and there is a satisfying impression of convergence. I call this spatial montage and identify it as an effect that happens particularly and distinctively in live-stage contexts, one that gives privileged spectators the impression of time and space converging, echoing the effects of living under the conditions of globalisation.

There is a connection, I believe, between the continued critical and touring success of Lepage's solo productions, the decline of success in his original group creations, and the way that global culture has evolved over the decades of his career. The references in his productions gravitate towards two poles: the personal and the global. On the one hand, there is material that derives directly from Lepage's own experience; and on the other he treats experiences to which many people living under privileged conditions of globalised late modernity can relate: feeling lost in the world, feeling estranged from family and friends, wondering what we'll leave behind, experiencing moments of plenitude and satisfaction when connections are made despite distance and hardship. Lepage's solo productions are grounded in the interplay between these poles: all treat a central artist character identified with Lepage but masked by a pseudonym (*887* breaks somewhat from this masking pattern, as I discuss in what follows). This artist character is suffering from a crisis brought on by loss and/or artistic blockage; he goes on a journey in which he interacts with figures including great artists and artistic creations and comes to a new level of understanding of his relationship to his work and his broader environment.[1] There is a middle ground of reference, grounded in history and in national, gendered, and ethnic identities, which became increasingly challenging for Lepage to navigate over the course of his career; these challenges figured particularly in the group creations. *The Dragon's Trilogy* found Lepage and his collaborators on firm representational ground with an exploration of Québec national identity. Youth culture and identity quest created reference points for the *Tectonic Plates* collaborators and many avenues for possible connection with audiences. As references grew more ambitious and far away from the collaborators' own experience in *The Seven Streams of the River Ota*, *Zulu Time*, and *Lipsynch*, so did questions accumulate about cultural ownership, responsibility, and power, largely posed by Anglophone scholars working with post-colonial and cultural materialist theory. The middle term became a barrier to connection for a sufficient number of privileged spectators (critics, co-producers, and programmers) to contribute to the attenuation of the touring life of a number of Lepage's original group creations. The creative mode for these projects – bringing together a group of collaborators to create a show from scratch based on a resource identified by Lepage – has not been attempted by Ex Machina (at the time of writing) since the *Playing Cards* project came only to half-fruition in 2012–15. The company continues its high productivity with many other kinds of projects, including touring solo shows; co-productions of classical plays; dance, opera, technological and musical productions and co-productions; and remounts/upgrades of existing works.

What it means to represent the experience of others, and whether there can be any rules or shared understanding around the creation of such representations, are complex questions that go well beyond Lepage's practice. The increased centrality of

such concerns in mainstream culture became evident in the significant controversy over two Lepage-directed productions in the summer of 2018. *Slàv*, a music-theatre piece created with Betty Bonifassi, was cancelled by the Montréal Jazz Festival in July 2018 following protests about its use of slave songs as material, given that neither Lepage nor Bonifassi are of African descent (see CBC News, Dunlevy). After Lepage initially stated that he 'will always demand the right for theatre to talk about anything and anyone' ('Position'), Ex Machina went forward in early 2019 with a Québec tour of *Slàv*, 'reworked and rewritten', in Lepage's words, to address 'dramaturgical problems [which] corresponded exactly to the ethical problems the show was criticised for' (*Slàv*). In August 2018 Indigenous artists and leaders in Québec raised questions about the lack of Indigenous collaborators involved in *Kanata*, a theatre piece Lepage was creating with Ariane Mnouchkine's Paris-based Théâtre du Soleil ensemble, which takes settler/Indigenous relations in Canada as its subject matter (Aubin-Dubois et al.). The significant international media attention to these protests led to some North American co-producers withdrawing their support from *Kanata*, and Ex Machina cancelling the project ('Annulation'). After consideration, Théâtre du Soleil went forward with the production, renamed *Kanata – Épisode 1 – La Controverse* (Kanata – Episode 1 – The Controversy), without Ex Machina as a co-producer and with Lepage working as director and co-creator without financial remuneration. At its Paris premiere in December 2018 several critics understood one of the production's plot lines, about a French artist who is opposed by Indigenous groups when she paints portraits of Indigenous women killed by the real-life serial killer Robert Pickton, as making metatheatrical reference to Lepage's own struggles around the show (see Cappelle, Maga).

These productions and the controversies around them played out as I completed the manuscript for this book, and will likely prompt critical and scholarly engagement in the years to come. It was striking to observe Lepage, who has worked so long and so skilfully to avoid being caught in any definition or discourse, entangled in situations in which his approach was held up to sustained and divisive public scrutiny. The sorts of questions about his methods and representations which had been asked for many years in Anglophone scholarly contexts were asked in the public sphere about *Slàv* and *Kanata*, evidence that the thinking behind post-colonial, intercultural, feminist, and critical race theories had by 2018 entered mainstream discourse. It would be too simplistic to argue that disagreements around these productions rested wholly on the difference in traditions of thought, culture, and representation between Francophone and Anglophone populations: many of the leaders of Québec-based protests against *Slàv* and *Kanata* were Francophones of African descent and Indigenous Francophones, respectively (see Webster, Aubin-Dubois et al.). It is nonetheless the case that the polarised nature of these controversies – with Francophone journalists, arts leaders, and even politicians referring to the criticism against Lepage, Ex Machina, and their collaborators as censorious attacks on artistic freedom (see Haentjens, Lapierre), while Anglophone commentators couched the debate in terms of cultural appropriation, uneven power relations, and histories of oppression (see Nestruck 'Too Bad', Salutin) – further exposed a lack of shared understanding around the representation of difference that had previously been on display in divergent responses to the 2002

presentation of *Zulu Time*, as discussed in Chapter 5. While centred in Québec, the rupture in understanding and discourse around *Kanata* extended to its coverage in France, with *Libération* journalist Ève Beauvallet arguing that the 'righteous and emancipatory' nature of *Kanata* had been misunderstood by its critics, and that the concept of cultural appropriation is both a 'conceptual tool' and 'militant weapon born in the wake of postcolonial studies in the 1980s'.[i]

 In Anglophone theatre and performance studies these debates are familiar, recalling Rustom Bharucha's claims in 1988 that Peter Brook's celebrated production of the Hindu epic *Mahabharata* was a 'blatant (and accomplished) appropriations [sic] of Indian culture' and that Brook had 'decontextualised' the epic 'from its history in order to sell it to audiences in the west' (1642). Claims that a text such as *Mahabharata* is 'universal' were undercut by Brook's representations, which 'exclude[d] and trivialise[d] Indian culture', Bharucha argued. 'The *Mahabharata* ... is universal *because* it is Indian. One cannot separate the culture from the text' (1643, emphasis in original). Questions asked by Mnouchkine in defence of the creators of *Kanata* – in an interview titled 'Cultures Are No One's Property' – hearken back to the terms of the *Mahabharata* debate:

> Are we racists and colonialists, for ever and ever over the centuries, or are we bearers of universality, just like Blacks, Jews, Arabs, Khmer, Indians, Afghans, [and] Indigenous people whose stories we sometimes want to tell, and who just like us and before their cultural particularities carry within them this universal humanism?[ii]

The fact that such questions, couched in very similar terms, were asked about productions staged three decades apart could be taken to suggest that not much understanding had been forged in the meantime. Such an argument, however, would overlook the significant canon of post-colonial and intercultural theory that emerged in the late twentieth and early twenty-first centuries, not to mention progressive intercultural theatre and performance practices by artists and companies in many national and international contexts in which sensitivity to the origins, contingencies, and multiple potential significations of culturally specific material are foregrounded.[2] Rather, the *Slàv* and *Kanata* controversies were points when such questions found their way to the mainstream, exposing persistent disparities in thought between Anglophone and Francophone populations on these issues, and raising awareness of the complexities of cultural globalisation – that is, of the challenges that may arise when artists, their work, and the assumptions and beliefs behind it come into contact with people outside their sphere of reference who may have different views and experience. Lepage found himself at the centre of these debates, a position that is uncongenial to him and one that found him struggling to understand their terms: in a Facebook message posted by

i 'justicière et émancipatrice ... outil conceptuel autant qu'arme militante né dans le sillage des *post-colonial studies* dans les années 80'.
ii 'sommes-nous, pour toujours, dans les siècles des siècles, des racistes et des colonialistes ou sommes-nous des êtres humains, porteurs d'universalité, tout comme les Noirs, les Juifs, les Arabes, les Khmers, les Indiens, les Afghans, les autochtones, dont nous voulons parfois raconter les épopées et qui, comme nous, bien avant leurs particularités culturelles, portent en eux cet universel humain?'

Ex Machina in July 2018 about the *Slàv* controversy, he wrote that cultural appropria-
tion is 'an extremely complicated problem and I don't pretend to know how to solve
it' ('Position'). In December of that year he wrote on Facebook that his 'opinion has
evolved' on *Slàv* but that still, 'my position is far from being clear' ('*Slàv*'). Working
things out publicly remains a strategy for Lepage, but this is an ethical, thinking
process rather than a creative one, and thus a new form of openness and vulnerability.

What to reveal about himself and what to keep hidden: these are concerns that
Lepage has negotiated throughout his career. Questions of Lepage's self-exposure,
his fragile body, and his central role in professional structures that revolve around
him extend throughout this book; and I close it with snapshots from three of his
solo productions – moments when Lepage has briefly appeared from behind layers
of discourse, allowing himself, his strengths, and his weaknesses to be seen. Such
moments of self-revelation may not be intentional or in his control. As he explained
to the *Times*'s Dominic Maxwell in 2008:

> The alopecia, the other personal stuff, I let it emerge into my work. I'll use some other
> starting point – like Hans Christian Andersen in *The Andersen Project* – and then find
> out after twenty or thirty shows, oh no, it's really all about me! And you think, well, the
> work dragged it out of me – because I don't understand these things, because I don't know
> exactly how they affect me, or how my struggle, how my example can help others. I don't
> think about that. It wouldn't help.

In considering these moments I return again to the centrality of spectatorship in
Lepage's work, and in particular to the ways in which his solo pieces invite the viewer
into a relationship with the figures on stage. I ended my discussion of *Vinci* in Chapter
2 by arguing that its otherwise brilliantly inventive engagement with Renaissance
perspective is kept from being thoroughly critical by the place of Lepage himself in its
attempted circuit of gazes. The personal exploration and disclosure that *Vinci* (if we
follow his above formulation) dragged out of him required the audience member's
participation: the spectator is called on to be the mirror that the character Philippe's
late friend Marc once was for him, a position that is flattering but also potentially
coercive. *Vinci* is also, in my reading, a queer narrative that ends uncertainly, as
Philippe attempts too late and abortively to express his passion for Marc, and subli-
mates that desire into making art.

In asking, about *Vinci*, what it might mean for Lepage to see and be seen, to use
his productions as a means to give over to the other's gaze, I called on Laura Levin's
reading of the ending of *The Far Side of the Moon* – a production which in her persua-
sive argument finds Lepage again grappling with questions of exposure, relationship,
and spectatorship.[3] Central to the production in the fractious relationship between
the brothers André and Philippe, the former a confident gay man who is 'routinely
exasperated by his [straight] sibling's visible weakness' and offers Philippe 'coaching
in self-mastery' by telling him how to organise his wallet and how to self-present in
public without feeling foolish (*Performing* 179). In many of his solos, Lepage appears
in drag; in *Vinci* his appearance as the Mona Lisa queered his own body and the paint-
ing itself, underlining how that famous image, by dint of its replication and familiarity,

is always already camp. In her discussion of Lepage's appearance as Philippe and André's mother in *Far Side*, Levin calls on José Esteban Muñoz's definition of camp 'as reanimating ... a lost country or moment that is relished and loved' (128). The play is a story of grieving, prompted by Lepage's loss of his mother, and part of Philippe's passage through grief is embodying his mother in an impossible, imagined scene in which she gives birth to him by pulling a puppet astronaut through the central scenic element of a circular washing machine door. The returned look that Lepage receives in the production – 'a sensuous and mournful yielding of perceiver to the perceived' (Levin, *Performing* 181) – is not from audience to performer but between Lepage and a surrogate representation of his child self, something to which the audience bear witness but in which they are not necessarily conscripted.

The final scene of *Far Side* is one of Lepage's most admired moments of staging. In it, Philippe is sitting in an airport, waiting for a flight home after a trip to Russia during which he has finally accepted that his long-laboured-over PhD project has failed and which has seen him starting to build bridges with André. Also on this trip, he has acknowledged that his grief for his mother's death may be blocking his capacity to see new possibilities in his life, and found out that he has won a contest to send a video into outer space, which suggests that making art might replace his abortive academic career. As Beethoven's *Moonlight Sonata* plays, the performer slips to the floor and starts to slowly roll and twist around; when spectators look in a tilted mirror over the stage, he appears to be floating in mid-air. In Chapter 4 (see pp. 149–53) I noted the ways in which some of Lepage's productions end with moments of staging that tie up meanings in prescriptive and conservative ways. The success of the ending of *Far Side* rests in part in its evocative but indeterminate nature: many of the production's reviews mention the ending's affective power while underlining its openness to interpretation.[4] A number of reviewers state that this final image suggests an astronaut on a spacewalk. Several read it as a moment of personal, emotional liberation for Philippe: for Jennifer Parker-Starbuck, the character 'breaks free of his own gravitational pull' (154), while John Coulbourn says he 'slip[s] off the confines of emotional gravity' ('Lepage's Giant Leap') and Luc Boulanger says he is '[f]ree, alone, and finally, perhaps, at peace with himself' ('*La face cachée*').[iii] Sarah Hemming reads the moment as pulling together a number of the production's recurring images: 'This solitary figure, spinning weightlessly, reminds us of the tumbling clothes in the first scene, of a baby in the womb, of a cosmonaut in space, and so seems to speak of the existential loneliness of modern man' ('Journey').[5] This layering of meanings resulted in a signature moment of spatial montage, the affective power of which is heightened by its semiotic openness. Paul Rae's negative assessment of this scene – that it forecloses possible meanings and betrays the production's promise of a cosmopolitan worldview by communicating, above all else, Philippe's desire to return to the womb – stands out among these accounts in how definitively Rae reads the 'foetal symbolism' of the floating body (16).

In his study of Lepage's films Peter Dickinson finds particular hope in the last scene of *The Far Side of the Moon*, which, like the stage version, has Philippe floating in

iii 'Libre, seul, et, peut-être, enfin en paix avec lui-même.'

space above the Moscow airport. Consistent with his Deleuzian approach, Dickinson reads this as a crystal-image moment which 'splits time in two, launching Lepage's queer male body into a future as yet undiscernible but fundamentally free, at least in my estimation, from the weight of its hitherto overdetermined nationalist inscriptions' ('Space' 153). As discussed in the Introduction, Dickinson's treatment of Lepage's films includes a sustained critique of their lack of queer characters or, if such characters are present, their depiction as 'so overlain with the symbolic weight of internalised guilt and dysfunction as to be borderline homophobic' (134) – a concern which he connects to the 'mutuality of the sexual symbolic and the national symbolic in much Québécois cinema' (135). *Far Side* breaks free from such significations, in Dickinson's reading, because Lepage himself performs in it; the 'alienation' that Lepage has acknowledged he feels from his own body supersedes the national narrative and 'would seem to authorise a reevaluation of all of [Lepage's] screen images of the male body' (153). A scene set in a bathhouse in which Philippe encounters his brother's boyfriend Carl (played by Marco Poulin) reverses the voyeuristic, policing gaze that Dickinson finds so troublingly characteristic of Lepage's cinema, in that it is gay Carl with his 'tauter, tanned, tattooed and pierced queer' body who is checking out 'Philippe's overweight, out-of-shape, and pale straight' one (ibid.).[6] Dickinson reads the final scene of weightlessness as a highly personal expression of Lepage's desire for liberation from his particular embodiment – as a gesture towards a future that is not determined by national narratives nor by narratives that objectify him because of the condition that renders his body visibly other to societal norms.

Levin's reading of the stage version of the much-interpreted final scene of *The Far Side of the Moon* complements Dickinson's. She sees it as evidence that Philippe has discovered 'that his own being is tied to being-for-others' and, as a result, he drops his defences and gives himself over to the other's gaze (*Performing* 184). In so doing the production 'illuminates the intrinsic redundancy of the solo show: that the performer is alone onstage but never really alone. It is the audience's gaze that situates the performer in space' (183). Crucially, Lepage's staging gives the audience a choice – to look at the actor in the suspended mirror so as to see 'the … self set adrift in phenomenal and international space', or to look at him on the floor: 'the self anchored to a finite map' (184). As does Dickinson, Levin sees Philippe's future split into possible vectors and underlines the audience's agency in reading them, underlining that '[m]ost likely, our gaze falls somewhere in between the two' (ibid.). Both vectors are possible; it all depends on how you look at it, and the choice is yours. What is at stake here, as has always been at stake in Lepage's self-performances, is the place of the artist himself and his fragile, queer body in the line of the audience's gaze. The gesture of the end of *Far Side* is not neediness but generosity, inviting compassion: engaging with this self-identified character's journey offers the spectator opportunities for interpretation and affective reward – a relationship of mutual need and responsibility is affirmed.

Another moment of notable and complex self-exposure takes place in *The Andersen Project* and involves the character Frédéric on a 'memorable multimedia-projected train journey from Copenhagen to Cologne' (Dixon 206).[7] One of the production's central scenic devices is a concave screen which is used several times for projec-

tion effects that appear to immerse the performer in an environment, as when the
opera producer Arnaud walks up the (projected) interior steps of the Garnier Opera
House. As the train journey scene begins, the actor changes costume from that of
Hans Christian Andersen to the contemporary character Frédéric. Sound and video
projection effects suggest the shift from the steam train of Andersen's era to the TGV
of Frédéric's. For Izabella Pluta, this is a characteristic moment of staging in which
Lepage 'call[s] attention to the progress of the montage' out of a 'desire to show the
mechanics of things to the audience' (195). I am interested in the subsequent part of
the scene and the way it uses spatial montage to create a moment of suspension that
carries a powerful affective charge. As the journey continues, Frédéric, reeling from a
bad meeting in Copenhagen, frustrated by travel delays, anxious about drug dealers
menacing the apartment he is subletting in Paris, and worrying about how his late
arrival home will affect the dog he's looking after, takes one of the dog's Ritalin pills
(see Lepage, *Andersen* 43–55). The projections of passing landscapes grow more psy-
chedelic, reflecting his drug-altered state (the scene is called 'speed' even in its French-
language version, a reference to the drug and its effects as well as Andersen/Frédéric's
literal journey through time and space). A dance remix of Sarah McLachlan's *Sweet
Surrender* plays as Frédéric writes in a notebook, and then starts to sing along to the
lyrics: 'The life I've left behind me is a cold one / I've crossed the last line... And sweet,
sweet surrender / is all that I can give' (44–5). Then, as the stage directions describe,
'In time with the music, Frédéric jumps down from the set, crosses the stage frame,
and dances to the jerky light of a strobe. Blackout' (45) (figure 7.1).[iv]
 Read on one level, this is a moment of time-space compression following on from
the shift from Andersen in the past to Frédéric in the present: the action then leaps
forward in Frédéric's experience (fuelled by drugs) to later that night in a Cologne
nightclub. Another way of reading this moment has to do with the character's
psychological state and relationship to his body. Frédéric is albino, which Lepage
has acknowledged is a reference to his own physical condition; the character talks
about being bullied as a child because of this (53), something that Lepage has also
acknowledged about his own experience. Frédéric is established in the production as
unconfident and somewhat tortured, not fully recovered from a broken relationship
and out of his element in Paris. In the scene where he dances, the character seems
briefly to have left his painful self-consciousness behind, and the spectator observes
him moving with liberation – as the lyrics suggest, with surrender. It is significant
that this dance happens not against the screen, which has been established as the
production's main site for suspension effects; it is also significant that the performer
moves towards the audience over rails on the stage that convey various props and
set pieces. The performer presents his body to the audience's gaze, the body which
has been the source of torment and alienation in the past. Through a strobe-lighting
effect – a notably simple one, in the context of this complex and sophisticated staging
– a moment of suspension is created in which the character is briefly distanced from
his oppressive experience of embodiment, seemingly weightless rather than heavy

iv 'sur un accent musical, Frédéric saute en bas du dispositif, traverse le cadre de scène et danse à la
 lumière saccadée d'un stroboscope. Noir.'

7.1 Robert Lepage in *The Andersen Project*.

with physical challenges and sadness. The liberation is fleeting, which is part of what lends it an affective charge. For those aware of Lepage's close identification with aspects of Frédéric's story that charge is potentially stronger: this usually reserved artist is allowing himself to be seen in a state of abandon and exposure, dancing as if no one were watching, while knowing full well we are. The time-space compression in this sequence works on multiple levels: the forward movement from Andersen's time to Frédéric's; the simultaneous movement across space from Copenhagen to Cologne and then on to the dance floor; and the movement back and forth between the fictional and autobiographical significations of the performer's body. This shifting embodiment lends the production's representations a queerness, albeit a limited and strained one: Lepage plays the straight composer Frédéric, who has been dumped and betrayed by his girlfriend; the producer Arnaud, who is a porn addict and, it is fleetingly implied, a closeted homosexual; the Algerian immigrant Rachid, whose face is never seen by the audience and who never speaks; and the Dryad, a doomed figure from an Andersen story whom Lepage performs in drag with his back to the audience. The combination of Frédéric and Andersen's difficult experience of embodiment and sexuality, the association of homosexuality with denial and deviance through the character of Arnaud, and the constrained employment of cross-dressing offer a vantage onto tortured psychosexual terrain from which the scene of dancing offers intense but brief respite.

The final snapshot is taken from Lepage's most avowedly autobiographical solo piece, *887*, in which the guise of a stand-in or pseudonym such as a Pierre, Philippe, or Frédéric has dropped: the premise of the show is that the person performing is actually Robert Lepage.[8] This is of course still a persona, but Lepage's investment in presenting himself to the audience seemingly without filter is notable, and introduced in the production's first scene, which offers a theatrical version of the televisual/filmic 'cold open' in which the action begins 'before the title sequence or opening credits are shown' (Macmillan Dictionary). After the house lights dim but have not yet gone to black, a man enters and walks to centre stage. Each time I saw the show there was a collective jolt in the audience when the realisation hit that this was Robert Lepage himself – a moment of pure affect sometimes followed by applause (at which point those in the audience who did not know that it was him would likely begin to work it out). Lepage welcomes the spectators, takes his smartphone out of his pocket, and offers a wry version of the now-predictable pre-show request to turn off your phone. He goes on to talk about the place that such devices hold in his and many other twenty-first-century lives, holding all sorts of information that we used to store in our memories. His own memory now sometimes fails him, Lepage says, as when he struggled to memorise the long poem 'Speak White' after accepting an invitation to recite it at a commemoration of the forty-year anniversary of La Nuit de la Poésie, an important cultural event during the early days of the Quiet Revolution. A phone number appears on the screen behind him – his own phone number, he explains, when he was growing up in his family apartment at 887 Rue Murray in Québec City, and one that he is surprised to still remember. A scale model of that apartment building appears, and the production is underway, its themes – identity, memory, and Lepage's experience of late 1960s Québec – established through this smooth segue from the actual

space of the theatre to the imaginative space of performance. Part of the production's gambit is to keep the audience believing that there is very little distance between these spaces – between Lepage's actual life experience and the mediated self he presents on stage. His success in doing so is in evidence in one review of the 2015 Toronto world premiere, in which the critic questions Lepage's claim in the show that he had trouble remembering 'Speak White' when he is 'obviously capable of memorising the text for a solo play that is two hours long' (Hoile), as if this incapacity to remember was not a theatrical fabrication.

The Lepage that Lepage performs in *887* is one that rewards investments in his trustworthiness and veracity. The soft open invites such investment, easing spectators into the show's potential fictions through Lepage's self-effacing undertaking of labour (the cellphone speech) usually left to disembodied voice-overs. While performing humility, he's dressed as success: this is the most elegant Lepage has ever presented on stage, more tailored than *Andersen*'s leather-jacketed Frédéric or the postgrad-schlumpy Philippe of *Far Side*, and more conservatively dressed than the arty-chic public persona he adopts off stage. Of the first version of *Needles and Opium*, Ann Wilson wrote admiringly that it 'disrupts the notion of a coherent self which can be told in a story', presenting instead a 'subjectivity … fractured on several axes' (37). In *887* there is a move away from a theatrical identity based on ambivalence – on not allowing himself to be defined, categorised, or definitively embodied on stage – to a performance of visibility, respectability, and maturity. Within this, a struggle between arrogance and humility emerge as key themes. The Lepage of *887* reveals himself in possession of a significant, tender ego and capable of ungenerous behaviour towards people close to him. In the course of the show he enlists an old friend who is struggling personally and professionally to help him memorise 'Speak White', and proceeds to casually belittle him. Here the production's theme of class struggle, which Lepage believes underlay Québec's battle for independence in under-acknowledged ways (see Trueman), extends to contemporary self-critique: Lepage presents himself as a tone-deaf snob. At the same time the show underlines Lepage's working-class background. While in *Far Side* he played his mother, here he embodies his taciturn, taxi-driver father and, in a gesture that pushes paradox to the point of contradiction, declares that 'only a man who is as humble as his father has the right to' deliver 'Speak White', and proceeds to perform the poem with startling intensity.

This is one of several points in the show in which Lepage expresses, in a manner unprecedented in his solo career, passionate anger: at the shallowness of his pre-recorded obituary, at the economic and social barriers that are keeping working-class young people out of the Québec theatre conservatory from which he graduated, and then during this performance of 'Speak White'. This contributes to the production's complex, uneasy presentation of gender and sexuality. Lepage acknowledges his homosexuality in the show by rehearsing the misogynist and homophobic cliché that spending a lot of time with women at a young age makes you gay,[9] and, unusually for his solo shows, never appears dressed as a woman. In *887* Lepage performs what Jack Halberstam calls 'male masculinity', reflecting Halberstam's argument that in contemporary Western culture it is 'the equation of maleness plus masculinity that adds up to social legitimacy' (16). His self-portrait as a contemporary Québécois of

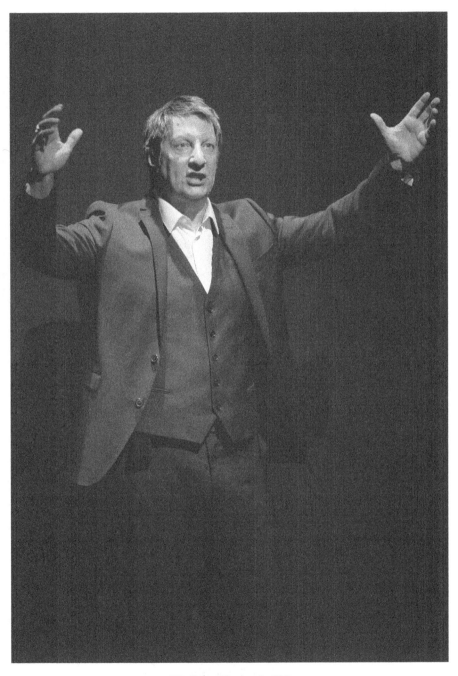

7.2 Robert Lepage in *887*.

stature involves the capacity to express emotions – something that his father never did – but these are strong negative feelings directed at systems and institutions by a person whose adult life is represented as solitary and asexual.

Worrying about these aspects of Lepage's self-presentation in *887* potentially opens me up to a critique of excessive credulity such as I have here made of others. In doing so I am investing in his assertion to Dominic Maxwell, cited earlier in this coda chapter, that his work brings unpredictable things out of him, and I am accepting Lepage's offer, via his art works, of critical engagement. The aspects of Lepage's identity and experiences discussed here are deeply intimate, and put forward by him for the public to engage with: they ask to be seen and to be debated. Unless Ex Machina's systems change, whatever future productions and enterprises it undertakes will all issue from the single source of his imagination. As his solo productions are consistent successes, it seems fair to expect more revelation and self-exploration in the years to come, informed by the bruising exposure of the 2018 controversies, by the experience of opening and running Le Diamant, by questions of legacy, and by the ongoing challenge of navigating simultaneous creative projects around the globe. The questions this book poses remain open.

Notes

1 See Chapter 1, note 3 for caveats around *Elsinore*.
2 Such companies include Back to Back Theatre in Australia; Hong Kong Exile, Neworld Theatre, Theatre Replacement, and Why Not Theatre in Canada; Soho Rep and Theatre for a New Audience in New York City; Arena Stage in Washington, DC; the Oregon Shakespeare Festival; the FuseBox Festival in Austin, Texas; the Bush, Royal Court, and Young Vic theatres in London, United Kingdom; and the Gorki Theatre in Berlin.
3 *The Far Side of the Moon* premiered in February 2000 at Le Théâtre du Trident in Québec City and is Ex Machina's most frequently toured project. It was co-produced by Aarhus Festuge; Bergen Internasjionale Festival; Berliner Festspiele; BITE:03 Barbican; Bonlieu Scène Nationale, Annecy; Cal Performances, University of California at Berkeley; Change Performing Arts, Milan; Cultural Industry Ltd.; Deutsches Schauspielhaus, Hamburg; Dublin Theatre Festival; Espace Malraux Scène Nationale Chambéry-Savoie; Festival de Otoño, Madrid; FIDENA, Bochum; Göteborg Dans & Theater Festival; Harbourfront Centre, Toronto; La Comète Scène Nationale de Châlons-en-Champagne; La Coursive, La Rochelle; Le Manège Scène Nationale, Maubeuge; Le Théâtre du Trident, Québec; Le Volcan Maison de la Culture, Le Havre; Les Cultures du Travail – Forbach 2000; Le Maillon – Théâtre de Strasbourg; Les Célestins, Théâtre de Lyon; Maison des Arts, Créteil; Northern Stage at Newcastle Playhouse; Onassis Cultural Center, Athens; Pilar de Yzaguirre – Ysarca, Madrid; Schauspielhaus Zurich; Setagaya Public Theater, Tokyo; SFU Woodward's Cultural Programs, Vancouver; Steirischer Herbst, Graz; Théâtre de Namur; Teatro Nacionao São João, Porto; Théâtre d'Angoulême, Scène Nationale, Angoulême; Théâtre de Sartrouville & des Yvelines; The Henson International Festival of Puppet Theater, New York; The Irvine Barclay Operating Company, Irvine; The Royal National Theatre, London; The Sydney Festival; TNT – Théâtre National de Toulouse; Tramway Dark Lights, Glasgow; UC Davis Presents, Davis. I saw the production in Glasgow (April 2001), London (July 2001), Montréal (May 2003), and Dublin (October 2003). Lepage originally performed in both *The Far Side of the Moon* and *The Andersen Project* and was replaced by the actor Yves Jacques as the

productions' touring lives continued. My readings here of the productions' autobiographical nature refer to Lepage as their performer.

4 The scene's elusiveness extends to its resistance to photographic capture. Despite efforts, I was unable to find a satisfactory image of it among the available production photography of *The Far Side of the Moon*.

5 Other reviews consulted are Billington 'Far Side'; Cavendish 'Genius'; Coveney 'Mystery'; Crew; Cushman; de Jongh; Gardner 'Far Side'; Karch; Nightingale 'Out of'; Spencer 'Lepage Launches'; Sumi; Taylor 'The View'.

6 The scene appears in the film but not in the stage version of *Far Side*.

7 *The Andersen Project* premiered in February 2001 in Québec City and was a co-production of the Auckland Festival; Bite:06 Barbican; Bonlieu Scène Nationale, Annecy; Festival de Otoño de la Comunidad de Madrid; Cal Performances, Berkeley; Canadian Stage, Toronto; Carolina Performing Art; Célestins, Théâtre de Lyon; Change Performing Arts, Milan; Emerson College, Boston; La Comète, Scène Nationale de Châlons-en-Champagne; La Coursive, La Rochelle; Le Festival d'automne à Paris; Le Grand Théâtre de Québec; Le Théâtre du Nouveau Monde, Montréal; Le Théâtre du Trident, Québec; Le Théâtre français du Centre national des Arts d'Ottawa; Le Théâtre National de Bordeaux Aquitaine; Le Théâtre National de Chaillot; Le Théâtre National de Toulouse Midi-Pyrénées; Le Volcan – Scène nationale du Havre; LG Arts Center, Seoul; Maison des Arts, Créteil; MC2: Maison de la Culture de Grenoble; National Chiang Kai-Shek Cultural Centre, Taipei; Pilar de Yzaguirre – Ysarca Art Promotions, Madrid; Setagaya Public Theatre, Tokyo; Spielzeiteuropa, Berliner Festspiele; Teatre Lliure, Barcelona; the Hans Christian Andersen 2005 Foundation; the Sydney Festival; Théâtre de Caen; and Wiener Festwochen, Vienna. I saw the production in Paris (November 2005), London (January 2006), Montréal (May 2006), and Berlin (December 2006).

8 *887* had preview performances in Nantes and Châlons-en-Champagne, France in February and March 2015 and its world premiere in Toronto in July 2015. It was commissioned by the Arts and Culture Program of the Toronto 2015 Pan Am and Parapan Am Games in co-production with le lieu unique, Nantes; La Comète – Scène nationale de Châlons-en-Champagne; Edinburgh International Festival; Århus Festuge; Théâtre de la Ville-Paris, Festival d'Automne à Paris; Romaeuropa Festival 2015; Bonlieu Scène nationale Annecy; Ysarca Art Promotions – Pilar de Yzaguirre; Célestins, Théâtre de Lyon; Le Théâtre français du Centre national des Arts d'Ottawa; Le Théâtre du Nouveau Monde, Montréal; SFU Woodward's Cultural Programs, on the occasion of Simon Fraser University's 50th Anniversary, Vancouver; Tokyo Metropolitan Theatre; Théâtre du Trident, Québec; La Coursive – Scène nationale La Rochelle; Canadian Stage, Toronto; Le Volcan – scène nationale du Havre; the Brooklyn Academy of Music, New York; the Bergen International Festival; the Barbican, London; Holland Festival, Amsterdam; Chekhov International Theatre Festival, Moscow; Les Théâtres de la Ville de Luxembourg; La Comédie de Clermont-Ferrand, Scène nationale; Onassis Cultural Centre – Athens; Théâtre de Liège; Walker Art Center, Minneapolis; Cal Performances, Berkeley; Performas Produções, São Paulo; and the National Performing Arts Center, Kaohsi. I saw the production in Toronto in July 2015, April 2017, and May 2019.

9 Explaining that he shared a bedroom with his two sisters for the first eight years of his life, he quips 'and that probably explains a lot of things' ('ce qui explique probablement beaucoup de choses') (Lepage, *887* 48).

APPENDIX

Chronology of Robert Lepage's creative work as a director, including original theatre, productions of existing plays and operas, films, rock shows, multimedia shows, and installations.

	Pieces created and/or adapted by Lepage	Pieces co-created and/or co-adapted by Lepage	Pieces directed by Lepage
1979		**Theatre** *L'attaque quotidienne* Collective work by Richard Fréchette and Robert Lepage. Produced by Théâtre Hummm… Premiered at Le Bar Zinc, Québec City. *La ferme des animaux* Collective work by Robert Lepage and others. Based on *Animal Farm* by George Orwell. Produced by Théâtre Hummm… Premiered at Centre François-Charron, Québec City.	**Theatre** *Arlequin serviteur de deux maîtres* By Carlo Goldoni. Produced by/premiered at Collège Lévis-Lauzon, Lévis.
1980		**Theatre** *Saturday Night Taxi* Collective work by Robert Lepage, Richard Fréchette, and Francine Lafontaine. Produced by Théâtre Hummm… Premiered at Le Hobbit, Québec City.	**Theatre** *L'École, c'est secondaire* Collective work by Michel Nadeau, Denis Bernard, and Camil Bergeron. Produced by Théâtre Repère. Premiered at Collège Lévis-Lauzon, Lévis. Toured high schools in the greater Québec City area.

Pieces created and/or adapted by Lepage	Pieces co-created and/or co-adapted by Lepage	Pieces directed by Lepage
1980		**Theatre** **Puppet theatre** *Ooomeraghi Oh* By Jan Truss. Translation and adaptation by Josée Campanale. Produced by Les Marionnettes du Grand Théâtre de Québec. Premiered at Le Grand Théâtre de Québec, Québec City.
1981		**Theatre** *Dix petits nègres* Adapted from *Ten Little Indians* by Agatha Christie. Produced/premiered at Collège Lévis-Lauzon, Lévis. *Le coq* Based on the cartoon *La zizanie* by Albert Uderzo and René Goscinny. Produced by/premiered at Théâtre Méchatigan, Sainte-Marie-de-Beauce. **Puppet theatre** *Jour de pluie, rêves de nuit* By Gérard Bibeau. Produced by Les Marionnettes du Grand Théâtre de Québec. Premiered at Le Grand Théâtre de Québec, Québec City.
1982	**Theatre** *En attendant* Collective work by Richard Fréchette, Jacques Lessard, and Robert Lepage. Produced by Théâtre Repère. Premiered at Le Hobbit, Québec City. *Les rois mangent* Collective work by Théâtre d'Bon Humeur. Produced by Théâtre d'Bon Humeur. Premiered at Centre François-Charron, Québec City. *À demi-lune* Collective work by Johanne Bolduc, Estelle Dutil, and Robert Lepage. Produced by Théâtre Repère. Premiered at L'Anglicane, Lévis.	**Theatre** *Pas d'chicane dans ma cabane* Collective work by Michel Bernatchez, Odile Pelletier, and Marco Poulin. Produced by Théâtre d'Bon Humeur. Premiered at Centre François-Charron, Québec City. **Puppet theatre** Scene in *Claudico, bric-à-brac* By Luc Simard. Produced by Les Marionnettes du Grand Théâtre de Québec. Premiered at Le Grand Théâtre de Québec, Québec City.

Pieces created and/or adapted by Lepage	Pieces co-created and/or co-adapted by Lepage	Pieces directed by Lepage
1983		**Theatre** *Carmen* Based on *Carmen* by Georges Bizet. Produced by Théâtre d'Bon Humeur. Premiered at Théâtre de la Bordée, Québec City. *Coriolan et le monstre aux milles têtes* Based on *Coriolanus* by William Shakespeare. Produced by Théâtre Repère. Premiered at Théâtre de la Bordée, Québec City. *Dieu et l'amour complexe* Collage of writing by Woody Allen. Produced by/premiered at the Conservatoire d'art dramatique de Québec, Québec City.
1984 **Other** *Ligue nationale d'improvistation* Produced by Radio-Canada. (Improvisational comedy).	**Theatre** *Le bal des bals* Collective work by Robert Lepage and others. Produced by Parcs Canada. Premiered at Parc de l'Artillerie de Québec, Québec City. *Circulations* Collective work by Robert Lepage and others. Produced by Théâtre Repère. Premiered at Théâtre de la Bordée, Québec City. Toured throughout Canada.	**Theatre** *Solange passe* By Jocelyne Corbeil and Lucie Godbout. Produced by/premiered at Théâtre de la Bordée, Québec City. *Stand-by 5 minutes* Collective work by Jean-Jacques Boutet, Ginette Guay, Louis-Georges Girard, Martine Ouellet, and Marie St-Cyr. Produced by Théâtre de la Bordée in collaboration with Théâtre de l'Équinoxe. Premiered at Théâtre de la Bordée, Québec City. *Partir en peur* By Hélène Blanchard and Judith Savard. Produced by/premiered at Le Théâtre des Confettis, Québec City.
1985 **Solo theatre** *Comment regarder le point de fuite* By Robert Lepage. Produced by Théâtre Repère. Premiered at Implanthéâtre, Québec City.	**Theatre** *La trilogie des dragons* (*The Dragon's Trilogy*) Collective work by Robert Lepage and others. Produced by Théâtre Repère. Premiered at Implanthéâtre. Toured internationally.	**Theatre** *À propos de la demoiselle qui pleurait* By André Jean. Produced by Théâtre Repère. Premiered at Centre International de Séjour de Québec, Québec City. *Coup de poudre* Collective work by Josée Deschênes, Marin Dion, Simon Fortin, Benoît Gouin, Hélène Leclerc. Produced by Théâtre Artéfact and Parcs Canada. Premiered at Parc de l'Artillerie de Québec, Québec City.

	Pieces created and/or adapted by Lepage	*Pieces co-created and/or co-adapted by Lepage*	*Pieces directed by Lepage*
1985		Theatre	**Theatre** *California Suite* (*Suite californienne*) By Neil Simon. Produced by Théâtre du Bois de Coulonge. Premiered at Théâtre du Vieux Port de Québec, Québec City. **Puppet theatre** *Histoires sorties du tiroir* By Gérard Bibeau. Produced by Les Marionnettes du Grand Théâtre de Québec. Premiered at Le Grand Théâtre de Québec, Québec City.
1986	**Solo theatre** *Vinci* By Robert Lepage. Co-produced by Théâtre de Quat'Sous and Théâtre Repère. Premiered at Théâtre Quat'Sous, Montréal. Toured internationally.		**Theatre** *Comment devenir parfait en trois jours* By Gilles Gauthier. Adapted from *Be a Perfect Person in Just Three Days* by Stephen Manes. Produced by Théâtre des Confettis. Premiered at Implanthéâtre, Québec City. *Le bord d'extrême* Adapted from *The Seventh Seal* by Ingmar Bergman. Co-directed with Michel Nadeau. Produced by Théâtre Repère. Premiered at Implanthéâtre, Québec City.
1987		**Theatre** *Pour en finir une fois pour toute avec Carmen* Adapted from *Carmen* by Georges Bizet by Robert Lepage, Daniel Toussaint, and Sylvie Tremblay. Produced by/premiered at Théâtre de Quat'sous, Montréal. *En pleine nuit une sirene* By Jacques Girard and Robert Lepage. Produced by/premiered at Théâtre de la Bordée, Québec City. *Polygraphe* (*Polygraph*) By Robert Lepage and Marie Brassard Produced by Théâtre Repère in collaboration with Cultural Industry and the Almeida Theatre (London). Premiered at Implanthéâtre, Québec City. Toured internationally.	

Pieces created and/or adapted by Lepage	*Pieces co-created and/or co-adapted by Lepage*	*Pieces directed by Lepage*
1988	**Theatre** *Plaques tectoniques* (*Tectonic Plates*) Collective work by Robert Lepage and others. Produced by Théâtre Repère and Cultural Industry (London), with others. Premiered at Du Maurier World Stage Festival, Toronto. Toured internationally.	**Theatre** *Le songe d'une nuit d'été* (*A Midsummer Night's Dream*) By William Shakespeare. French translation by Michelle Allen. Produced by/premiered at Théâtre du Nouveau Monde, Montréal.
1989		**Theatre** *C'est ce soir qu'on saoûle Sophie Saucier* By Sylvie Provost. Produced by Les Productions Ma Chère Pauline. Premiered at the Maison-Théâtre, Montréal. *Mère courage et ses enfants* (*Mother Courage and Her Children*) By Bertolt Brecht. Produced by/premiered at the Conservatoire d'art dramatique de Québec. *Écho* (*Echo*) Adapted from *A Nun's Diary* by Ann Diamond. Produced by Théâtre 1774 and Théâtre Pass Maureille. Premiered at the Saidye Bronfman Centre, Montréal. *La vie de Galilée* (*Life of Galileo*) By Bertolt Brecht. French translation by Gilbert Turp. Produced by/premiered at Théâtre du Nouveau Monde, Montréal. *Roméo et Juliette* (*Romeo and Juliet*) By William Shakespeare. French translation by Jean-Marc Dalpé. Co-directed with Gordon McCall. Produced by Théâtre Repère and Nightcap Productions. Premiered at Shakespeare on the Saskatchewan Theatre Festival, Saskatoon.
1990		**Theatre** *La visite de la vieille dame* (*Der Besuch der alten Dame*) By Friedrich Dürrenmatt.

Pieces created and/or adapted by Lepage	Pieces co-created and/or co-adapted by Lepage	Pieces directed by Lepage
		French translation by Jean-Pierre Porret. Produced by the National Arts Centre and des Productions d'Albert. Premiered at the National Arts Centre, Ottawa.
1991 **Solo theatre** *Les aiguilles et l'opium (Needles and Opium)* By Robert Lepage. Produced by Productions d'Albert, The National Arts Centre, and Productions AJP. Premiered at Palais Montcalm, Québec City. Toured internationally.		**Theatre** *Los Cincos Soles* By the students of the National Theatre School. Produced by the National Theatre School of Canada. Premiered at the National Arts Centre, Ottawa.
1992	**Theatre** *Alanienouidet* By Marianne Ackerman and Robert Lepage. Produced by/premiered at the National Arts Centre, Ottawa. Remounted at the Carrefour International de Théâtre, Québec City.	**Theatre** *Macbeth* By William Shakespeare. Produced by the University of Toronto Theatre Department. Premiered at Hart House Theatre, Toronto. *La Tempête (The Tempest)* By William Shakespeare. French translation by Michel Garneau. Produced by Atelier de recherche théâtrale de l'Outaouais. Premiered at the National Arts Centre Atelier. *A Midsummer Night's Dream* By William Shakespeare. Produced by/premiered at the Royal National Theatre, London. *Le Cycle Shakespeare: Macbeth, Coriolan, La Tempête (The Shakespeare Cycle: Macbeth, Coriolanus, The Tempest)* By William Shakespeare. French translations by Michel Garneau. Produced by Théâtre Repère and others. Premiered at Le Manège, Maubeuge. Toured internationally.

Pieces created and/or adapted by Lepage	Pieces co-created and/or co-adapted by Lepage	Pieces directed by Lepage
1992		**Opera** *Bluebeard's Castle* (*Le Château de Barbe-Bleue*) By Béla Bartók. Libretto by Béla Balázs. Based on a story by Charles Perrault. Produced by the Canadian Opera Company and Brooklyn Academy of Music. Premiered at the Four Seasons Centre, Toronto. Toured internationally. *Erwartung* By Arnold Schoenberg. Libretto by Marie Pappenheim. Produced by the Canadian Opera Company and Brooklyn Academy of Music. Premiered at the Four Seasons Centre, Toronto. Toured internationally.
1993		**Theatre** *National, Capitale Nationale* By Vivienne Laxdal and Jean-Marc Dalpé (English and French versions). Produced by the National Arts Centre and Théâtre de la Vielle 17. Premiered at the National Arts Centre Studio, Ottawa. *Macbeth* and *The Tempest* By William Shakespeare. Japanese translation of *Macbeth* by Ogai Mori. Japanese translation of *The Tempest* by Takahashi Yasunari. Produced by/premiered at Tokyo Globe Theatre, Tokyo. *Shakespeare's Rapid Eye Movement* Collection of dream texts by William Shakespeare. German translations by August Wilhelm von Schlegel. Produced by/premiered at Bayerisches Staatsschauspielhaus, Munich. **Rock show** *Secret World Tour* By Peter Gabriel. Produced by Real World Tours, London. Toured internationally.

Pieces created and/or adapted by Lepage	Pieces co-created and/or co-adapted by Lepage	Pieces directed by Lepage
1994	**Theatre** *The Seven Streams of the River Ota* (*Les sept branches de la rivière Ota*) Collective work by Robert Lepage and others. Produced by Ex Machina and Cultural Industry (London), with others. Premiered at the Edinburgh International Festival, Edinburgh. Toured internationally.	**Theatre** *Ett Drömspel* (*A Dream Play*) By August Strindberg. Produced by/premiered at Kungliga Dramatiska Teatern, Stockholm. *Noises, Sounds, and Sweet Airs* By Michael Nyman. Based on *The Tempest* by William Shakespeare. Produced by Tokyo Globe Theatre and Shin-Kobe Oriental Theatre. Premiered at Tokyo Globe Theatre, Tokyo.
1995 **Solo theatre** *Elseneur* (*Elsinore*) By Robert Lepage. Based on *Hamlet* by William Shakespeare. Produced by Ex Machina and others. Premiered at Monument-National, Montréal. Toured internationally. **Film** *Le confessional* (*The Confessional*) By Robert Lepage. Produced by Channel 4 Films (London), Cinémaginaire (Montréal), Enigma Films (London), Ciné SA (Paris), and Téléfilm Canada (Montréal).		**Theatre** *Le songe d'une nuit d'été* (*A Midsummer Night's Dream*) By William Shakespeare. French translation by Normand Chaurette. Produced by Ex Machina and Théâtre du Trident. Premiered at Le Grand Théâtre de Québec, Québec City.
1996 **Film** *Le polygraphe* (*Polygraph*) By Robert Lepage. Produced by In Extremis Images (Montréal), Road Movies Dritte Produktionen (Berlin), and Cinéa SA (Paris).		

Pieces created and/or adapted by Lepage	Pieces co-created and/or co-adapted by Lepage	Pieces directed by Lepage
1997 **Film** *Nô* By Robert Lepage. Produced by Alliance Communications Corporation (Toronto) and In Extremis Images (Montréal).		
1998	**Theatre** *La géométrie des miracles (Geometry of Miracles)* Collective work by Robert Lepage and others. Produced by Ex Machina and the Salzburger Festspiele, in collaboration with others. Premiered at the Du Maurier World Stage Festival, Toronto. Toured internationally.	**Theatre** *La Celestina (La Celestine)* By Fernando de Rojas. Swedish translation by Einar Heckscher. Produced by Ex Machina and Kungliga Dramatiska Teatern. Premiered at Elverket, Stockholm. *Kindertotenlieder (The Song Cycle)* By Gustav Mahler. Translation by Blake Morrison. Produced by Ex Machina and Cultural Industry. Premiered at Lyric Theatre Hammersmith, London. Toured internationally. *La tempête (The Tempest)* By William Shakespeare. French translation by Normand Chaurette. Produced by Ex Machina in collaboration with Le Grand Théâtre de Québec, Théâtre du Trident, and the National Arts Centre. Premiered at Le Grand Théâtre de Québec.
1999	**Theatre** *Zulu Time* Collective work by Robert Lepage and others. Produced by Ex Machina in collaboration with Real World Studios and others. Premiered at the Theatre Spektakel, Zurich. Toured internationally.	**Theatre** *Jean-Sans-Nom* By Robert Charlebois. Based on the novel *Famille-Sans-Nom (Family without a Name)* by Jules Verne. Produced by Ex Machina, Gestion Son Image, and CDC. Premiered at CDC, Nantes. **Opera** *La damnation de Faust (The Damnation of Faust)* By Hector Berlioz Libretto by Hector Berlioz, Almire Grandonnière, and Gérard de Nerval. Based on the poem by Johann Wolfgang von Goethe.

Pieces created and/or adapted by Lepage	*Pieces co-created and/or co-adapted by Lepage*	*Pieces directed by Lepage*
1999		Produced by Ex Machina in collaboration with the Metropolitan Opera, Saito Kinen Festival, and Opera nationale de Paris. Premiered at the Saito Kinen Festival, Matsumoto.
2000 **Solo theatre** *La face cachée de la lune (The Far Side of the Moon)* By Robert Lepage. Produced by Ex Machina, with others. Premiered at Théâtre du Trident, Québec City. Toured internationally. **Other** *Métissages* By Robert Lepage. Produced by/ premiered at the Musée de la civilization, Québec City. (Temporary exhibition).		**Film** *Possible Worlds.* Based on the play *Possible Worlds* by John Mighton. Produced by In Extremis Images (Montréal) and The East Side Company (Toronto).
2001		**Theatre** *La Casa Azul* (formerly titled *Apasionada*) By Sophie Faucher. Inspired by the writings of Frids Kahlo. Co-produced by Ex Machina and others. Premiered at Théâtre Quat'Sous, Montréal. Toured internationally.
2002		**Opera** *Die Dreigroschenoper Songspiel (The Threepenny Opera)* By Kurt Weill and Bertolt Brecht. Produced by Ex Machina. Premiered at La Caserne as part of the Carrefour international de théâtre, Québec City. **Rock shows** *Growing Up Tour* By Peter Gabriel. Produced by Real World Tours, London. Toured internationally.

Pieces created and/or adapted by Lepage	*Pieces co-created and/or co-adapted by Lepage*	*Pieces directed by Lepage*
2003 **Film** La face cachée de la lune (*The Far Side of the Moon*) By Robert Lepage. Produced by La face cachée de la lune inc. (Montréal).	**Theatre** La trilogie des dragons (*The Dragon's Trilogy*) [revival] Collective work by Robert Lepage and others. Produced by Ex Machina. Toured internationally.	
2004 **Circus** Kà By Robert Lepage. Produced by Cirque du Soleil. Premiered at the MGM Grand, Las Vegas.		**Theatre** The Busker's Opera Based on the *Beggar's Opera* by John Gay. Produced by Ex Machina and Le Festival Montréal en lumière. Premiered at the Spectrum de Montréal, Montréal. Toured internationally.
2005 **Solo theatre** Le projet Andersen (*The Andersen Project*) By Robert Lepage. Produced by Ex Machina in collaboration with Le Grand Théâtre de Québec, Hans Christian Andersen 2005, and Le 'Théâtre du Trident. Premiered at Le 'Théâtre du Trident, Québec City. Toured internationally.		**Opera** 1984 By Loren Maazel. Libretto by J.D. McClatchy and Thomas Meehan. Based on the novel *1984* by George Orwell. Produced by Big Brother Productions in collaboration with the Royal Opera House, and Ex Machina. Premiered at the Royal Opera House, London. Toured internationally.
2007	**Theatre** Lipsynch Collective work by Robert Lepage and others. Produced by Ex Machina and Theatre Sans Frontières, with others. Premiered at the Barbican, London. Toured internationally.	**Opera** The Rake's Progress By Igor Stravinsky. Libretto by W.H. Auden and Chester Kallman. Produced by Ex Machina, with others. Premiered at Théâtre Royal de la Monnaie, Brussels.

	Pieces created and/or adapted by Lepage	Pieces co-created and/or co-adapted by Lepage	Pieces directed by Lepage
2008		**Theatre** *Le Dragon bleu (The Blue Dragon)* By Robert Lepage and Marie Michaud. English translation by Michael Mackenzie. Produced by Ex Machina in collaboration with others. Premiered at La Comète at Scène Nationale, Châlons-en-Champagne. Toured internationally. **Other** *The Image Mill* Collective work by Robert Lepage and Steve Blanchet. Based on work by Norman McLaren. Produced by Ex Machina in collaboration with the City of Québec, Bunge of Canada, and the Port of Québec. Projected onto the Bunge grain silos in the Old Port, Québec City (Installation).	
2009	**Other** *Aurora Borealis* By Robert Lepage. Produced by Ex Machina in collaboration with the City of Québec, G3, and the Port of Québec. Projected onto the Bunge grain silos in the Old Port, Québec City. (Installation)	**Theatre** *Eonnagata* Collective work by Robert Lepage, Sylvie Guillem, and Russell Maliphant. Ex Machina in collaboration with Sadler's Wells Theatre and Sylvie Guillem. Premiered at Sadler's Wells Theatre, London. Toured internationally.	**Opera** *The Nightingale and Other Short Fables* Music by Igor Stravinsky. Libretto after Hans Christian Andersen *(Nightingale)* and Stravinsky *(Fox)*. Produced by Ex Machina in collaboration with the Canadian Opera Company and others. Premiered at the Canadian Opera Company, Toronto. Toured internationally.
2010	**Circus** *Totem* By Robert Lepage. Produced by Cirque du Soleil. Premiered at Le Grand Chapiteau, Montréal. Toured internationally.		**Opera** *Der Ring des Niebelungen* By Richard Wagner. Ex Machina in collaboration with the Metropolitan Opera. Premiered at the Metropolitan Opera, New York City. (Complete *Ring Cycle* opened in 2012).

Pieces created and/or adapted by Lepage	Pieces co-created and/or co-adapted by Lepage	Pieces directed by Lepage
2010 **Other** *Les grands débordements* Produced by MU in collaboration with One Drop Foundation. Premiered at La Caserne, Québec City. (Installation).		
2011		**Theatre** *La tempête (The Tempest)* By William Shakespeare. French adaptation by Michel Garneau. Produced by Ex Machina in collaboration with the Huron-Wendat Nation. Premiered at an outdoor amphitheatre in Wendake, a Huron reserve near Québec City.
2012	**Theatre** *Playing Cards: Spades* Collective work by Robert Lepage and others. Commissioned by the 360° Network and the Luminato Festival. Produced by Ex Machina in collaboration with others. Premiered at Teatro Circo Price, Madrid. Toured internationally.	**Opera** *The Tempest* By Thomas Adès. Libretto by Meredith Oakes. Based on *The Tempest* by William Shakespeare. Produced by Ex Machina in collaboration with Le festival d'opéra de Québec, the Metropolitan Opera, and the Wiener Staatsoper. Premiered at Le Grand Théâtre de Québec, Québec City. Toured internationally.
2013 **Film** *Triptych* By Robert Lepage, co-directed by Pedro Pires. Adapted from the play *Lipsynch* by Robert Lepage and others. Produced by Les Productions du 8e Art Inc., Québec City.	**Theatre** *Playing Cards: Hearts* Collective work by Robert Lepage and others. Commissioned by the 360° Network. Produced by Ex Machina in collaboration with others. Premiered at the Salzlager, Essen. Toured internationally. *Les aiguilles et l'opium (Needles and Opium)* [revised, revival version] By Robert Lepage. Produced by Ex Machina. Toured internationally.	**Solo theatre** *Hamlet Collage* Based on *Hamlet* by William Shakespeare. Russian translation by Boris Pasternak and Mikhail Lozinsky. Produced by/premiered at Theatre of Nations, Moscow. Toured internationally.

Pieces created and/or adapted by Lepage	Pieces co-created and/or co-adapted by Lepage	Pieces directed by Lepage
2014	**Film** *Michelle, Marie*, and *Thomas* Adaptations of segments of the play *Lipsynch* by Robert Lepage. Co-directed with Pedro Pires. Co-produced by Les Productions du 8e Art and The National Film Board of Canada. (Short films).	
2015	**Solo theatre** *887* By Robert Lepage. English translation by Louisa Blair. Commissioned by Panamania. Co-produced by Ex Machina and others. Premiered at the Bluma Appel Theatre, Toronto.	**Opera** *L'Amour de Loin* By Daija Saariaho. Libretto by Amin Maalouf. Produced by Ex Machina in collaboration with Festival d'opéra de Québec and The Metropolitan Opera. Premiered at Le Grand Théâtre de Québec, Québec City. **Other** *The Library at Night* Based on an original idea by Bibliothèque et Archives nationales du Québec. Produced by Ex Machina, with others. Premiered at Grande Bibliothèque, Montréal. (Exhibition)
2016		**Theatre** *Quills* By Doug Wright. French translation by Jean-Pierre Cloutier. Co-directed with Jean-Pierre Cloutier. Produced by Ex Machina in collaboration with Théâtre du Trident. Premiered at Théâtre du Trident, Québec City. Toured internationally.

Pieces created and/or adapted by Lepage	Pieces co-created and/or co-adapted by Lepage	Pieces directed by Lepage
2018	**Theatre**	**Theatre**
	Kanata – Épisode 1 – La Controverse By Théâtre du Soleil. Produced by Théâtre du Soleil in collaboration with Festival d'Automne à Paris and others. Premiered at Théâtre du Soleil, Paris.	*Coriolanus* (*Coriolan*) By William Shakespeare. Produced by The Stratford Festival in collaboration with Ex Machina. Premiered at The Stratford Festival, Stratford, Canada. Toured internationally.
	Other	**Opera**
	Frame by Frame By Robert Lepage and Guillaume Côté. Based on the life and work of Norman McLaren. Produced by Ex Machina, The National Ballet of Canada, and the National Film Board of Canada. (Ballet).	*The Magic Flute* By Wolfgang Amadeus Mozart. Libretto by Emanuel Schikaneder. Produced by Ex Machina in collaboration with Festival d'opéra de Québec. Premiered at Le Grand Théâtre de Québec, Québec City.
	Slàv Collective work by Robert Lepage and Betty Bonifassi. Based on a collection of slave songs. Produced by Ex Machina in collaboration with others. Premiered at the Montréal International Jazz Festival, Montréal. (Music theatre).	
2019	**Theatre**	
	The Seven Streams of the River Ota (*Les sept branches de la rivière Ota*) [revival] Collective work by Robert Lepage and others. Produced by Ex Machina. Premiered at the Chekhov International Theatre Festival, Moscow. Toured internationally.	

REFERENCES

Adams, Parveen, ed. *Art: Sublimation or Symptom*. Karnac Books, 2003.

Ahmed, Sara. 'Affective Economies.' *Social Text*, vol. 22, no. 2, 2004, pp. 117–39.

___. *The Cultural Politics of Emotion*. Edinburgh University Press, 2004.

Albacan, Aristita I. *Intermediality and Spectatorship in the Theatre Work of Robert Lepage: The Solo Shows*. Cambridge Scholars Publishing, 2016.

Anson, Philip. 'Lepage's latest show a technological flop.' Review of *Zulu Time. Globe and Mail* [Toronto], 24 August 1999.

Arvidsson, Adam. *Brands: Meaning and Value in Media Culture*. Routledge, 2006.

Aubin-Dubois, Kateri and 30 co-signators. Letter. 'Encore une fois, l'aventure se passera sans nous, les Autochtones?' *Le Devoir*, 14 July 2018, www.ledevoir.com/opinion/libre-opinion/532406/encore-une-fois-l-aventure-se-passera-sans-nous-les-autochtones.

Baillergeon, Stéphane. 'Asymétrie du miracle.' Reportage on Toronto opening of *Geometry of Miracles. Le Devoir* [Montréal], 19 April 1998.

Balme, Christopher. 'Intermediality: Rethinking the Relationship between Theatre and Media.' Open Access LMU, 2004, https://epub.ub.uni-muenchen.de/13098/1/Balme_13098.pdf.

Barbe, Jean. '*La Trilogie des Dragons*. Le feu au cour.' *Voir* [Montréal], 8–14 September 1988.

Barron, James. 'Leaving the Met, but not for Valhalla.' *New York Times*, 17 May 2013.

Bassett, Kate. 'Brilliance with Blemishes.' Review of *The Seven Streams of the River Ota. The Times* [London], October 1994.

___. 'First Draft of a Grand Design.' Review of *Geometry of Miracles. Telegraph* [London], 5 April 1999.

___. '*Now or Later*, Royal Court Downstairs, London, *Kicking a Dead Horse*, Almeida, London, *Lipsynch*, Barbican, London.' *Independent on Sunday* [London], 14 September 2008.

Batson, Charles R., and Denis M. Provencher. 'Feeling, Doing, Acting, Seeing, Being Queer in Québec: Michel-Marc Bouchard, Rodrigue Jean, and the Queer Québec Colloquium.' *Québec Studies*, vol. 60, 2016, pp. 3–22.

Beauchamp, Hélène. 'Appartenance et Territoires: Repères chronologiques.' *L'Annuaire théâtral*, no. 8, 1990, pp. 41–72.

Beauchamp, Hélène, et al., eds. 'Dix Ans de Repère.' *L'Annuaire théâtral*, no. 8, 1990.

Beaunoyer, Jean. 'Le plus beau monument du théâtre québécois.' Review of *The Dragon's Trilogy. La Presse* [Montréal], 15 September 1988.

___. 'Monumental … et pourtant si simple.' Review of *The Seven Streams of the River Ota. La Presse* [Montréal], 25 May 1996.

___. 'Les mots ne suffisent plus: C'est du Lepage au maximum!' Review of *Elsinore*. *La Presse* [Montréal], 11 November 1995.

Beauvallet, Ève. '"Kanata", ou le dialogue des sourds des cultures.' *Libération* [Paris], 20 December 2018, https://next.liberation.fr/theatre/2018/12/20/kanata-ou-le-dialogue-de-sourds-des-cultures_1699015.

Becker, Howard S. *Art Worlds*. University of California Press, 1982.

Belzil, Patricia. '*C'est ce soir qu'on saoule Sophie Saucier.*' Review. *Cahiers de théâtre Jeu*, vol. 54, 1990, p. 195.

Bemrose, John. 'A River of Surprises.' Review of *The Seven Streams of the River Ota*. *Macleans*, 20 November 1995.

Benedict, David. 'Review: *Lipsynch*.' *Variety*, 29 September 2008, http://variety.com/2008/legit/reviews/lipsynch-1200470806.

Benjamin, Walter. *Illuminations*. Translated by Harry Zohn, Shocken Books, 1968.

Bernatchez, Michel. Interview with the author. Montréal, 13 July 2002.

___. Phone interview with the author, 10 June 2004.

Bernatchez, Raymond. 'Un pas de plus vers le théâtre global.' *La Presse* [Montréal], 6 March 1986.

Bernier, Éric, et al., eds. *The Seven Streams of the River Ota*. Methuen, 1996.

Bérubé, Stéphanie. '*La Géométrie des miracles*: chercher le sens.' *La Presse* [Montréal], 18 April 1998.

Bhabha, Homi K. 'Dissemination: Time, Narrative, and the Margins of the Modern Nation.' *Nation and Narration*, edited by Homi K. Bhabha, Routledge, 1990, pp. 291–322.

Bharucha, Rustom. 'Peter Brook's *Mahabharata*: A View from India.' *Economic and Political Weekly* [Mumbai], vol. 23, no. 32, 1988, pp. 1642–7.

Billington, Michael. '*Blue Dragon.*' *Guardian* [London], 19 February 2011.

___. '*The Far Side of the Moon.*' *Guardian* [London], 14 April 2001.

___. 'Grand Stage Lepage.' Review of *The Seven Streams of the River Ota*. *Guardian* [London], 24 September 1996.

___. '*Lipsynch.*' *Guardian* [London], 9 September 2008.

___. 'Megaton Symbol.' Review of *The Seven Streams of the River Ota*. *Guardian* [London], 17 August 1994.

___. 'The Show Must Float On.' *Guardian* [London], 23 October 2003.

Blais, Marie-Christine. 'Dernier appel pour les passagers de *Zulu Time.*' *Le Soleil* [Québec City], 30 May 2002.

Bleeker, Maaike. *Visuality in the Theatre. The Locus of Looking*. Palgrave Macmillan, 2008.

Bligh, Kate. '*Zulu Time.*' *Canadian Theatre Review*, no. 112, 2002, pp. 70–3.

Boenisch, Peter. 'Aesthetic Art to Aisthetic Act: Theatre, Media, Intermedial Performance.' *Intermediality in Theatre and Performance*, edited by Frieda Chapple et al., Rodopi, 2006, pp. 103–16.

Boivin, Simon. 'Feu vert au Theatre le Diamant.' *Le Soleil* [Québec City], 9 April 2015.

Bolter, Jay David, and Richard Grusin. *Remediation: Understanding New Media*. MIT Press, 1999.

Bordwell, David. *Narration in the Fiction Film*. Methuen, 1985.

Borello, Christine. 'Mettre en scène, c'est écrire.' *Théâtre/Public*, vol. 117, 1994, pp. 82–5.

Boulanger, Luc. '*La face cachée de la lune*: Objectif coeur.' *Voir Montréal*, 14–20 June 2001.

___. 'Sophie Faucher: Descente En Kahlo.' *Voir.ca*, 12 March 2003, voir.ca/scene/2003/03/12/sophie-faucher-descente-en-kahlo/.

Bovet, Jeanne. 'Identity and Universality: Multilingualism in Robert Lepage's Theatre.' *Theater sans frontières: Essays on the Dramatic Universe of Robert Lepage*, edited by Joseph I. Donohoe, Jr. and Jane M. Koustas, Michigan State University Press, 2000, pp. 3–19.

Bradfer, Fabienne. 'Au plus profound de nous avec *La trilogie des dragons.*' *Le Soir* [Brussels], 17 March 1989.

Brassard, Marie and Robert Lepage. 'Polygraph.' Translated by Gyllian Raby, *Canadian Theatre Review*, vol. 64, 1990, pp. 50–65.

Brassard, Marie, et al. *La Trilogie des Dragons*. L'instant scène, 2005.

Bratton, Jacky. 'Melodrama.' *The Oxford Companion to Theatre and Performance*, edited by Dennis Kennedy, Oxford University Press, 2010, pp. 383–5.

Brennan, Clare. '*887* Review – Touching, Intimate, Powerful.' *Observer*, 23 August 2015, www.theguardian.com/stage/2015/aug/23/887-ex-machina-robert-lepage-edinburgh-observer-review.

Brennan, Mary. 'Tectonic Plates.' *Glasgow Herald*, 27 November 1990.

Brisset, Annie, et al. 'The Search for a Native Language: Translation and Cultural Identity.' *The Translation Studies Reader*, edited by Lawrence Venuti, Routledge, 2012, pp. 343–75.

Brook, Peter. 'Un travail mal compris …' Letter to *Le Devour*. Reprinted in *The Seven Streams of the River Ota*, edited by Bernier et al., Methuen, 1996, p. ii.

Brown, Mark. 'Lepage has hours to go.' Review of *Lipsynch*. *Toronto Star*, 23 February 2007.

Brown, Wendy. *Edgework: Critical Essays in Knowledge and Politics.* Princeton University Press, 2005.

Bruckner, D.J.R. 'Stage: *Dragon's Trilogy*, a Canadian Panorama.' *New York Times*, 10 July 1987.

Brustein, Robert. 'The Journey of Robert Lepage.' *The New Republic*, 10 February 1997, pp. 29–31.

Bunzli, James. 'Autobiography in the House of Mirrors: The Paradox of Identity Reflected in the Solo Shows of Robert Lepage.' *Theater sans frontières: Essays on the Dramatic Universe of Robert Lepage*, edited by Joseph I. Donohoe, Jr. and Jane M. Koustas, Michigan State University Press, 2000, pp. 21–41.

___. 'The Geography of Creation: Décalage as Impulse, Process, and Outcome in the Theatre of Robert Lepage.' *TDR (The Drama Review)*, vol. 43, no. 1, 1999, pp. 79–101.

Bureau, Stéphan. *Stéphan Bureau Rencontre Robert Lepage.* Amerik Media, 2008.

Burke, Sean. *The Ethics of Writing: Authorship and Legacy in Plato and Nietzsche.* University of Edinburgh Press, 2008.

Butler, Robert. 'The Seven Streams of the River Ota.' *Independent on Sunday* [London], 29 September 1996.

Calder, Angus. 'The Quiet Canadian.' Review of *The Seven Streams of the River Ota. The New Statesman and Society*, 19 August 1994, pp. 31–2.

Cambron, Micheline. 'Autour de *Le Singe d'un unit d'état*: Les escaliers de la mémoire.' *Cahiers de théâtre Jeu*, vol. 48, 1988, pp. 45–8.

Camerlain, Lorraine. 'O.k. on change!' *Cahiers de théâtre Jeu*, vol. 45, 1987, pp. 83–97.

Campbell, James. 'Robert Lepage. *The Dragon's Trilogy*.' *Times Literary Supplement* [London], 15 November 1991.

___. 'Shifting not Drifting.' Review of *Tectonic Plates. Times Literary Supplement*, 14–20 December 1990.

Canning, Charlotte. 'Directing History: Women, Performance, and Scholarship.' *Theatre Research International*, vol. 30, no. 1, 2005, pp. 49–59.

Cantin, David. 'Envergure et démesure.' Review of *Zulu Time. Le Devoir* [Montréal], 18 May 2000.

Cappelle, Laura. 'In Robert Lepage's *Kanata*, the Director, Too, Plays the Victim.' 17 December 2018, www.nytimes.com/2018/12/17/theater/robert-lepage-kanata-review.html.

Carlson, Marvin. 'Brook and Mnouchkine. Passages to India?' *The Intercultural Performance Reader*, edited by Patrice Pavis, Routledge, 1996, pp. 79–92.

Carlson, Marvin, and Janelle Reinelt. 'The Local Meets the Global in Performance: A Discussion.' *The Local Meets the Global in Performance*, edited by Pirkko Koski and Melissa Sihra, Cambridge Scholars Publishing, 2010, pp. 177–94.

Carney, Sean. *Brecht and Critical Theory: Dialectics and Contemporary Aesthetics.* Routledge, 2006.

Carson, Christie. 'Celebrity by Association. *Tectonic Plates* in Glasgow.' *Canadian Theatre Review*, vol. 74, 1992, pp. 46–50.

Caruth, Cathy. *Trauma: Explorations in Memory.* Johns Hopkins University Press, 1995.

___. *Unclaimed Experience. Trauma, Narrative, and History.* Johns Hopkins University Press, 2010.

Caux, Patrick, and Bernard Gilbert. *Ex Machina: Creating for the Stage.* Translated by Neil Kroetsch, Talonbooks, 2010.

Cavendish, Dominic. 'Genius Among the Stars.' Review of *The Far Side of the Moon. Daily Telegraph* [London], 18 October 2003.

___. 'Ten Days to Go – And No Script. It's Absolutely Petrifying!' *Daily Telegraph* [London], 4 August 2015.

CBC Arts. 'Robert Lepage Working with Cirque du Soleil Again.' *CBC.ca*, 11 October 2008.

CBC News. 'Jazz Fest Cancels, Apologises to Those "hurt" by *Slàv* after widespread criticism.' 4 July 2018, www.cbc.ca/news/canada/montreal/slav-cancelled-jazz-fest-controversy-1.4733240.

Chamberland, Roger. 'La métaphore du spectacle: Entrevue avec Robert Lepage.' *Québec français*, no. 69, March 1988, pp. 62–5.

Charest, Rémy. *Robert Lepage Connecting Flights.* Translated by Wanda Romer Taylor, L'instant même, 1995.

Christiansen, Richard. 'Frank Lloyd Playwright. Like the architect, Lepage is a master.' Review of *Geometry of Miracles. Chicago Tribune*, 28 April 2000.

Christiansen, Rupert. 'Theatre's Most Dazzling Sorcerer.' *Daily Telegraph* [London], 23 April 2005.

___. 'Trilogy a breathtaking, memorable presentation.' *Chicago Tribune*, 10 June 1990.

Clapp, Susannah. 'Frank's big country.' Review of *Geometry of Miracles. Observer* [London], 4 April 1999.

___. 'Stage Breaks the Sound Barrier.' Review of *Lipsynch. Observer* [London], 14 September 2008.

Colebrook, Claire. *Gilles Deleuze.* Routledge, 2002.

Conlogue, Ray. '*Dragon's Trilogy* from Québec Exciting, Innovative Theatre.' *Globe and Mail* [Toronto], 3 June 1986.

Connolly, Kate. 'Director Robert Lepage: Risking it all.' *Guardian* [London], 8 October 2012.

Conroy, Colette. *Theatre & the Body*. Palgrave Macmilllan, 2009.

Conter, Alan. 'Beating the African drum ever so tangentially.' Review of *Zulu Time*. *Globe and Mail*, 27 June 2002.

Costa, Maddy. 'The Critic as Insider: Shifting UK critical practice towards "Embedded" Relationships and the routes this opens up towards dialogue and dramaturgy.' *Theatre Criticism: Changing Landscapes*, edited by Duska Radosavljević, Bloomsbury Methuen, 2016, pp. 201–16.

Coulbourn, John. 'Geometry's askew.' *Toronto Sun*, 17 April 1998.

___. 'Lepage's Giant Leap of Genius.' Review of *The Far Side of the Moon*. *Toronto Sun*, 20 April 2000.

___. '*Seven Streams* Floods Senses.' Review of *The Seven Streams of the River Ota*. *Sunday Sun* [Toronto], 5 November 1995.

Coveney, Michael. 'It's a Ferocious Fandango of Sparring and Sex during a Long Day's Journey into Day.' Review of multiple productions including *The Seven Streams of the River Ota*. *Observer* [London], 29 September 1996.

___. 'A Masterpiece from Montréal – The Brilliance of Robert Lepage.' Review of *The Dragon's Trilogy*. *Observer* [London], 17 November 1991.

___. 'Mystery and Gravity on this Magical Journey into Space.' Review of *The Far Side of the Moon*. *Daily Mail* [London], 11 July 2001.

Crawley, Peter. 'The Blue Dragon. O'Reilly Theatre.' *Irish Times* [Dublin], 9 October 2009.

Crew, Robert. 'Too Little Too Late from Lepage.' Review of *The Far Side of the Moon*. *Toronto Star*, 20 April 2000.

Csipak, James, and Lise Héroux. 'NAFTA, Québecers, and Fear (?) of Americanization: Some Empirical Evidence.' *Québec Studies*, vol. 29, 2000, pp. 25–42.

Cultural Industry. www.culturalindustry.co.uk/pages/then.html.

Curtis, Nick. 'Wunderkind with a Seven-Year Itch.' *Evening Standard* [London], 20 October 1994.

Cushman, Robert. 'Lepage Returns to Dazzling Form.' Review of *The Far Side of the Moon*. *National Post* [Toronto], 21 April 2000.

Dagenais, Félix. 'Re: Question – votre travail chez Ex Machina.' E-mail, 5 February 2018.

Dassonville, Valérie. '*La Trilogie des Dragons*: Entre Chine et Québec.' *Le Quotidien de Paris*, 26 April 1989.

David, Gilbert. 'Shakespeare au Québec: théâtrographie des productions francophones (1945–1998).' *L'Annuaire théâtral*, no. 24, 1998, pp. 117–38.

De Jongh, Nicholas. 'Family Feuds Lost in Space.' Review of *The Far Side of the Moon*. *Evening Standard* [London], 17 October 2003.

De Kesel, Marc. *Eros and Ethics. Reading Lacan's Seminar VII*. Translated by Sigi Jottkandt, SUNY Press, 2009.

Deleuze, Gilles. *Cinema 2: The Time-Image*. Translated by Hugh Tomlinson and Robert Galeta, University of Minnesota Press, 1989.

Delgado, Maria M., and Dan Rebellato. 'Introduction.' *Contemporary European Theatre Directors*, edited by Delgado and Rebellato, Routledge, 2010, pp. 1–27.

Diamant, Le. 'À propos de notre mission', 2019, www.lediamant.ca/a-propos.

___. 'À propos du Diamant.' *Lediamant.net*, 2016 (page no longer active).

___. 'Mot de Robert Lepage.' *Lediamant.net*, 2016 (page no longer active).

___. 'Partenaires.' *Lediamant.net*, 2019, www.lediamant.ca/partenaires.

Diamond, Elin. 'The Violence of "We": Politicizing Identification.' *Critical Theory and Performance*, edited by Janelle R. Reinelt and Joseph R. Roach. Revised and enlarged edition, University of Michigan Press, 2007, pp. 403–12.

Dickinson, John, and Brian Young. *A Short History of Québec*. 3rd ed., McGill-Queen's University Press, 2003.

Dickinson, Peter. *Here is Queer: Nationalisms, Sexualities, and the Literatures of Canada*. University of Toronto Press, 1999.

___. *Screening Gender, Framing Genre: Canadian Literature into Film*. University of Toronto Press, 2007.

___. 'Space, Time, Auteur-ity and the Queer Male Body: The Film Adaptations of Robert Lepage.' *Screen*, vol. 46, no. 2, 2005, pp. 133–53.

Dixon, Steve. 'Space, Metamorphosis, and Extratemporality in the Theatre of Robert Lepage.' *Contemporary Theatre Review*, vol. 17, no. 4, 2007, pp. 499–515.

Donnelly, Pat. 'Lepage has a lot on his plate in *Tectoniques*.' Review of *Tectonic Plates*. *The Gazette* [Montréal], 22 March 1990.

___. 'Lepage Marathon is a Winner – Even if It Does Hit the Wall.' Review of *The Seven Streams of the River Ota*. *Gazette* [Montréal], 6 November 1995.

___. 'Lepage Work Is All Over the Map.' Review of *Geometry of Miracles*. *Gazette* [Montréal], 19 April 1998.

___. 'Review: Lepage's *Dragon Bleu*.' *Gazette* [Montréal], 23 April 2009.

___. 'Lepage's *Geometry* refines Wright angles.' *Gazette* [Montréal], 18 March 2000.

Doughty, Louise. 'Six of the Fest.' Review of *The Seven Streams of the River Ota*. *Mail on Sunday* [London], 21 August 1994.

Drake, Sylvie. 'Epic Dramas of Chinese Life in Canada.' Review of *The Dragon's Trilogy*. *Los Angeles Times*, 17 September 1990.

Drobnick, Jim. 'Robert Lepage, Ex Machina.' Review of *The Seven Streams of the River Ota*. *Parachute*, July–August–September 1997, pp. 56–7.

D'Souza, Karen. 'Review: *The Blue Dragon* at Cal Performances.' *San Jose Mercury News*, 10 June 2009.

Duguay, Sylvain. 'Self-adaptation: Queer Theatricality in Brad Fraser's *Leaving Metropolis* and Robert Lepage's *La face cachée de la lune*.' *Stages of Reality. Theatricality in Cinema*, edited by André Loiselle and Jeremy Maron, University of Toronto Press, 2012, pp. 13–29.

Dundjerović, Aleksandar Saša. *The Theatricality of Robert Lepage*. McGill-Queen's University Press, 2007.

Dunlevy, T'cha. 'Dunlevy: Jazz Fest Cancels *Slàv*, but Questions Remain.' *Gazette* [Montréal], 4 July 2018, https://montrealgazette.com/entertainment/music/jazz-fest-cancels-remaining-slav-performances.

Edwardes, Jane. '*The Seven Streams of the River Ota*.' *Time Out* [London], 2–9 November 1994.

___. '*The Far Side of the Moon*.' *Time Out* [London], 22–29 October 2003.

___. '*Vinci*.' *Time Out* [London], 29 September 1987.

Eisenstein, Sergei. *The Film Sense*. Translated by Jay Leyda, Meridian Books, 1957.

Elsaesser, Thomas. 'Tales of Sound and Fury: Observations on Family Melodrama.' *Home Is Where the Heart Is: Studies in Melodrama and the Women's Film*, edited by Christine Gledhill, British Film Institute, 1987, pp. 43–69.

Erwin, Edward. *The Freud Encyclopedia. Theory, Therapy, and Culture*. Routledge, 2002.

Everett-Green, Robert. 'Stages of Change.' *Toronto Globe and Mail*, 26 January 2018, www.theglobeandmail.com/arts/theatre-and-performance/robert-lepages-new-Québec-city-venue-may-mark-a-game-change-for-performing-arts-acrosscanada/article37709479/.

Ex Machina. 'Annulation du projet *Kanata* / Cancellation of the *Kanata* Project.' Facebook post, 26 July 2018, www.facebook.com/notes/ex-machina/annulation-du-projet-kanata-cancellation-of-the-kanata-project/1922938524424273/.

___. 'The Blue Dragon.' *Lacaserne.net*, 2015, http://lacaserne.net/index2.php/theatre/the_blue_dragon/.

___. 'Creation.' *Lacaserne.net*, 2015, http://lacaserne.net/index2.php/creation/.

___. 'Ex Machina.' *Lacaserne.net*, 2015, http://lacaserne.net/index2.php/exmachina/.

___. 'The Library at Night.' *Lacaserne.net*, 2016, http://lacaserne.net/index2.php/other_projects/la_biblio-theque_la_nuit/.

___. 'The Seven Streams of the River Ota project overview.' Unpublished document, 1994.

Féral, Josette. 'Robert Lepage.' *Mise en Scène et Jeu de l'acteur. Entretiens*. Vol. 2, Éditions Jeu/Éditions Landesman, 1998, pp. 134–56.

Filewod, Alan. 'Collective Creation.' *The Canadian Encyclopedia*, 4 March 2015, Historica Canada, www.thecanadianencyclopedia.ca/en/article/collective-creation.

___. *Collective Encounters: Documentary Theatre in English Canada*. University of Toronto Press, 1987.

Finlan, Michael. 'Théâtre Repère in Galway.' Review of *The Dragon's Trilogy*. *Irish Times* [Dublin], 13 August 1987.

Fisher, Mark. 'Celtic Soil Brother.' *The List* [Edinburgh], 23 November–6 December 1990.

___. *How to Write about Theatre: A Manual for Critics, Students, and Bloggers*. Bloomsbury Methuen, 2015.

___. Interview with Robert Lepage (unpublished). July 2015.

___. 'Un Robert Lepage aussi captivant que long.' Review of *Lipsynch*. *La Presse* [Montréal], 2 March 2007.

___. 'A Truly Original Artist.' *Lipsynch* [programme], the Barbican [London], September 2008.

Florida, Richard. *The Rise of the Creative Class – Revisited*. Basic Books, 2014.

Forsyth, Craig J., and Heath Copes. *Encyclopedia of Social Deviance 1*. Sage, 2014.

Foucault, Michel. *Language, Counter-Memory, Practice: Selected Essays and Interviews*. Translated by Donald F. Bouchard and Sherry Simon, Cornell University Press, 1977.

Fouquet, Ludovic. 'L'envol du *Dragon*.' *Cahiers de théâtre Jeu*, no. 128, 2008, pp. 25–8.

___. 'Notes de répétitions de *Zulu Time*.' *Cahiers de théâtre Jeu*, no. 107, 2003, pp. 163–8.

Fouquet, Ludovic. *The Visual Laboratory of Robert Lepage*. Translated by Rhonda Mullins, Talonbooks, 2014.

Fraser, Matthew. 'Performance art redefines theatre.' Review of *Vinci*. *Globe and Mail* [Toronto], 11 March 1986.

Fréchette, Carole. 'L'arte è un veicolo. Entretien avec Robert Lepage.' *Cahiers de théâtre Jeu*, no. 42, 1987, pp. 109–26.

Freedman, Barbara. *Staging the Gaze: Postmodernism, Psychoanalysis, and Shakespearian Comedy.* Cornell University Press, 1991.

Fricker, Karen. 'Collisions.' *The Village Voice*, 2–8 December 1992.

___. 'Cultural Relativism and Grounded Politics in Robert Lepage's *The Andersen Project.*' *Contemporary Theatre Review*, vol. 17, no 2, 2007, pp. 119–41.

___. 'Going Inside: The new-old practice of embedded criticism.' *Canadian Theatre Review*, vol. 168, 2016, pp. 45–53.

___. Interview with Robert Lepage. Québec City, 26 August 1992.

___. 'Robert Lepage: PRODUCT of Québec.' *Staging Nationalism: Essays on Theatre and National Identity*, edited by Kiki Gounaridou, McFarland, 2005, pp. 167–85.

___. 'Robert Lepage's Show *887* Is All about Memory and Legacy: Fricker.' *Toronto Star*, 5 April 2017.

___. 'Tourism, The Festival Marketplace, and Robert Lepage's *The Seven Streams of the River Ota.*' *Contemporary Theatre Review*, vol. 13, no. 4, 2003, pp. 79–93.

Fricker, Karen. 'À l'Heure zéro de la culture (dés)unie. Problèmes de représentation dans *Zulu Time* de Robert Lepage et Ex Machina.' Translated by Rémy Charest, *Globe. Revue internationale d'études québécoises, vol.* 11, no. 2, 2008, pp. 81–116.

Fricker, Karen. 'Le goût du risque: *Kà* de Robert Lepage et du Cirque du Soleil.' Translated by Isabelle Savoie, *L'Annuaire théâtral*, vol. 45, 2010, pp. 45–68.

Friedlander, Mira. '*The Seven Streams of the River Ota.*' *Variety*, 19 November 2005.

Frieze, James. 'Channelling Rubble: *Seven Streams of the River Ota* and *After Sorrow.*' *Journal of Dramatic Theory and Criticism*, vol. 133, 1997, pp. 133–42.

Frow, John. 'Signature and Brand.' *High-Pop. Making Culture into Popular Entertainment*, edited by Jim Collins, Blackwell, 2002, pp. 56–74.

Gagnon, Alain-G., and Raffaele Iacovino. 'Interculturalism: Expanding the Boundaries of Citizenship.' *Québec: State and Society*, edited by Alain-G. Gagnon. 3rd ed., University of Toronto Press, 2008, pp. 369–88.

Gardner, Lyn. '*The Blue Dragon.*' *Guardian* [London], 8 October 2009.

___. 'Epic's Progress.' Review of *The Seven Streams of the River Ota. Guardian* [London], 29 October 1994.

___. '*The Far Side of the Moon.*' *Guardian* [London], 12 July 2001.

___. 'Robert Lepage's Magic Muddle.' Review of *Geometry of Miracles. Guardian* [London], 3 April 1999.

Garner, Stanton. *Bodied Spaces: Phenomenology and Performance in Contemporary Drama.* Cornell University Press, 1994.

Geil, Abraham. 'The Spectator without Qualities.' *Rancière and Film*, edited by Paul Bowman, Edinburgh University Press, 2013, pp. 53–82.

Gerould, Daniel. 'Melodrama and Revolution.' *Melodrama. Stage, Picture, Screen*, edited by Jacky Bratton, et al., British Film Institute, 1994, pp. 185–98.

Giddens, Anthony. *The Consequences of Modernity.* Stanford University Press, 1990.

Giesekam, Greg. *Staging the Screen: The Use of Film and Video in Theatre.* Palgrave Macmillan, 2007.

Gittings, Christopher. *Canadian National Cinema: Ideology, Difference and Representation.* Psychology Press, 2002.

Glaister, Dan. 'Fated, Not Fêted.' *Guardian* [London], 15 August 1996.

Gledhill, Christine. *Home Is Where the Heart Is: Studies in Melodrama and the Woman's Film.* British Film Institute, 1987.

Godard, Barbara. 'Between Performative and Performance: Translation and Theatre in the Canadian/ Québec Context.' *Modern Drama*, vol. 43, no. 3, 2000, pp. 327–58.

Gore-Langton, Robert. '*The Seven Streams of the River Ota.*' *Daily Express* [London], 28 September 1996.

Government of Canada. 'Government of Canada Invests $10M in the Construction of Le Diamant, an International-Scale Performing Arts Centre in Québec City.' *Canada.ca*, 10 June 2016, www.canada.ca/en/office-infrastructure/news/2016/06/government-of-canada-invests-10m-in-the-construction-of-le-diamant-an-international-scale-performing-arts-centre-in-quebec-city.html.

Grace, Sherrill. 'Playing Butterfly with David Henry Hwang and Robert Lepage.' *A Vision of the Orient. Texts, Intertexts, and Contexts of Madame Butterfly*, edited by Jonathan Wisenthal, et al., University of Toronto Press, 2006, pp. 136–51.

Gross, John. 'Hope Springs Simplistic.' Review of *The Dragon's Trilogy. The Sunday Telegraph* [London], 17 November 1991.

Grosz, Elizabeth. 'Bergson, Deleuze and the Becoming of Unbecoming.' *Parallax*, vol. 11, no. 2, 2005, pp. 4–13.

___. *Chaos, Territory, Art. Deleuze and the Framing of the Earth.* Columbia University Press, 2008.

Guay, Hervé. 'Festival TransAmériques – L'événement *Lipsynch?*' *Le Devoir* [Montréal], 4 June 2007.

___. 'Pantomime en l'air.' Review of *Zulu Time*. *Le Devoir* [Montréal], 27 June 2002.

Haentjens, Brigitte. 'Nous devons nous battre pour préserver la liberté dans la creation artistique.' *Le Devoir* [Montréal], 4 August 2018, www.ledevoir.com/opinion/idees/533830/nous-devons-nous-battre-pour-preserver-la-liberte-dans-la-creation-artistique.

Halberstam, Jack. *Female Masculinity*. Duke University Press, 1998.

Halpern, Richard. *Shakespeare's Perfume: Sodomy and Sublimity in the Sonnets, Wilde, Freud, and Lacan*. University of Pennsylvania Press, 2002.

Handler, Richard. *Nationalism and the Politics of Culture in Québec*. University of Wisconsin Press, 1988.

Hannan, Martin, and Robert McNeil. 'Festival Gloom as Theatre Showpiece Cancelled.' *Scotsman* [Edinburgh], 14 August 1996.

Hare, John. 'Magnificent Cast explores play's atmosphere, feelings.' Review of *The Dragon's Trilogy*. *Ottawa Citizen*, 5 March 1987.

Harel, Simon. 'Une littérature des communautés culturelles made in Québec?' *Globe. Revue international d'études québécoises*, vol. 5, no. 2, 2002, pp. 57–77.

Harvey, David. *The Condition of Postmodernity. An Inquiry into the Origins of Cultural Change*. Blackwell, 1990.

Harvie, Jen. *Fair Play: Art, Performance, and Neoliberalism*. Palgrave Macmillan, 2013.

___. 'Introduction – Contemporary Theatre in the Making.' *Making Contemporary Theatre. International Rehearsal Processes*, edited by Jen Harvie and Andy Lavender, Manchester University Press, 2010, pp. 1–16.

___. 'Robert Lepage.' *Postmodernism: The Key Figures*, edited by Hans Bertens and Joseph Natoli, Blackwell, 2002, pp. 224–30.

___. 'Transnationalism, Orientalism, and Cultural Tourism: *La Trilogie des Dragons* and *The Seven Streams of the River Ota*.' *Theater sans frontières: Essays on the Dramatic Universe of Robert Lepage*, edited by Joseph I. Donohoe Jr. and Jane M. Koustas, Michigan State University Press, 2000, pp. 109–25.

Harvie, Jen, and Erin Hurley. 'States of Play: Locating Québec in the Performances of Robert Lepage, Ex Machina, and the Cirque du Soleil.' *Theatre Journal*, vol. 51, no. 3, 1999, pp. 299–315.

Haydon, Andrew. 'Crisis, What Crisis?' Nachtkritik.de, 24 October 2013, www.nachtkritik.de/index.php?view=article&id=8662:a-debate-on-theatre-criticism-and-its-crisis-in-the-uk&option=com_content&Itemid=60.

Hays, Matthew. 'Apocalypse When? Robert Lepage's *Zulu Time* Featured Terrorists and Exploding Airplanes – and Was Set for a New York Opening on September 21. A Report from the Premiere that Never Happened.' *The Advocate*, 25 December 2001.

Hébert, Chantal. 'L'écriture scénique actuel. L'exemple de *Vinci*.' *Nuit Blanche*, vol. 55, March–May 1994, pp. 54–8.

___. '"O.K. on change?" ou *la Trilogie des dragons*, un univers en puissance. Entretien avec Marie Gignac.' *Cahiers de théâtre Jeu*, vol. 106, 2003, pp. 125–32.

___. 'The Theater: Sounding Board for the Appeals and Dreams of the Québécois Collectivity.' *Essays on Modern Québec Theatre*, edited by Joseph I. Donohoe, Jr. and Jonathan M. Weiss, Michigan State University Press, 1995, pp. 27–46.

Hébert, Chantal, and Irène Perelli-Contos. *La face cachée du théâtre de l'image*. Presses de l'Université Laval, 2001.

Hébert, Michel. 'Un theatre et des boutique dans la "caverne" Dufferin.' *Réseau Canoë*, 29 January 2007, http://fr.canoe.ca/cgi-bin/imprimer.cgi?id=276180.

Heddon, Deirdre, and Jane Milling. *Devising Performance: A Critical History*. Palgrave Macmillan, 2005.

Heilpern, John. 'Needles and Opium'. *How Good is David Mamet, Anyway?: Writings on Theatre – and Why It Matters*. Routledge, 2000, pp. 211–13.

Held, David and Anthony McGrew. 'The Great Globalisation Debate: An Introduction.' *The Global Transformations Reader*, edited by David Held and Anthony McGrew, Polity, 2003, pp. 1–50.

Hemming, Sarah. 'A Journey into Loneliness.' Review of *The Far Side of the Moon*. *Financial Times* [London], 13 July 2001.

___. 'Synching Feeling.' Review of *Lipsynch*. *Financial Times* [London], 23 August 2008.

Hicks, Colin. 'Imagination Import: Reception and Perception of the Theatre of Québec in the United Kingdom.' *Performing National Identities. International Perspectives on Contemporary Canadian Theatre*, edited by Sherrill Grace and Albert-Reiner Glaap, Talonbooks, 2003, pp. 145–59.

Hodgdon, Barbara. 'Looking for Mr. Shakespeare after "The Revolution": Robert Lepage's Intercultural Dream Machine.' *Shakespeare, Theory, and Performance*, edited by James C. Bulman, Routledge, 1995, pp. 71–91.

Hoile, Christopher. '887.' Stage-door.com, 15 July 2015, www.stage-door.com/Theatre/2015/Entries/2015 /7/15_887.html.

Holden, Stephen. 'Review/Theatre; Metaphysics and Crime.' Review of Polygraph. New York Times, 27 October 1990.

Homer, Sean. Jacques Lacan. Routledge, 2005.

Hood, Michael J. 'The Geometry of Miracles: Witnessing Chaos.' Theater sans frontières: Essays on the Dramatic Universe of Robert Lepage, edited by Joseph I. Donohoe, Jr. and Jane M. Koustas, Michigan State University Press, 2000, pp. 127–53.

Hoyle, Martin. 'The Seven Streams of the River Ota.' Financial Times, 17 August 1994.

Hudson, Chris, and Denise Varney. 'Transience and Connection in Robert Lepage's The Blue Dragon: China in the Space of Flows.' Theatre Research International, vol. 37, no. 2, 2012, pp. 134–47.

Hunt, Nigel. 'The Global Voyage of Robert Lepage.' The Drama Review, vol. 33, no. 2, 1989, pp. 104–18.

Hunting, John. Affect, Melodrama, and Cinema: An Essay on Embodied Passivity. 2006., McGill University, PhD dissertation.

Hurley, Erin. National Performance. Representing Québec from Expo 67 to Céline Dion. University of Toronto Press, 2011.

___. Theatre & Feeling. Palgrave Macmillan, 2010.

Hurwitt, Robert. 'Theatre review: Robert Lepage's Blue Dragon.' San Francisco Chronicle, 11 June 2009.

Ireland, Susan, and Patrice J. Proulx. 'Introduction.' Textualizing the Immigrant Experience in Contemporary Québec, edited by Susan Ireland and Patrice J. Proulx, Praeger, 2004, pp. 1–7.

Jacobson, Aileen. 'A Richly Textured Trilingual Tale.' Review of The Dragon's Trilogy. Newsday [New York], 10 July 1987.

Jakobson, Roman. 'Two Aspects of Language and Two Types of Aphasic Disturbances.' Fundamentals of Language, edited by Jakobson and Morris Halle, Mouton & Co., 1956, pp. 55–82.

JanMohamed, Abdul. 'The Economy of Manichean Allegory: The Function of Racial Difference in Colonialist Literature.' Critical Inquiry, vol. 12, no. 1, 1985, pp. 59–87.

Johnson, Brian D. 'The Visionary.' Maclean's, 11 September 1995, pp. 56–62.

Johnson, Lise Ann. 'Shakespeare Rapid Eye Movement. Bayerisches Staatsschauspiel.' The Production Notebooks, Volume 2: Theatre in Process, edited by Mark Bly, Theatre Communications Group, 2001, pp. 73–139.

Jones, Amelia. Self/Image. Technology, Representation, and the Contemporary Subject. Routledge, 2006.

Karch, Pierre. 'The Far Side of the Moon.' L'Aventure du Cosmos.' L'Express de Toronto, 8 May 2000.

Kay, Sarah. Žižek: A Critical Introduction. Polity, 2003.

Keating, Michael. Nations Against the State: The New Politics of Nationalism in Québec, Catalonia, and Scotland. 2nd ed., Palgrave Macmillan, 2001.

Kelly, Brendan. 'Into the Mouth of the Dragon.' Los Angeles Times, 9 September 1990.

Kemp, Martin. Leonardo da Vinci: The Marvellous Works of Nature and Man. Oxford University Press, 2006.

Kennedy, Janice. 'Greatness buried under weight of theatrics.' Review of Geometry of Miracles. The Ottawa Citizen, 18 April 1998.

Kidnie, M.J. 'Dancing with Art: Robert Lepage's Elsinore.' World-wide Shakespeares: Local Appropriations in Film and Performance, edited by Sonia Massai, Routledge, 2005, pp. 133–40.

Kimmel, Michael S. 'Review of Art Worlds.' American Journal of Sociology, vol. 89, no. 3, 1983, pp. 733–5.

Knapton, Benjamin. Activating Simultaneity in Performance: Exploring Robert Lepage's Working Principles in the Making of Gaijin. 2008. Queensland University of Technology, MA dissertation.

Knowles, Ric. 'Festival de Théâtre des Amériques.' Canadian Theatre Review, no. 92, 1997, pp. 90-5.

___. 'From Dream to Machine: Peter Brook, Robert Lepage, and the Contemporary Shakespearean Director as [Post]Modernist.' Theatre Journal, vol. 50, 1998, pp. 189–206.

___. 'Reading Elsinore: The Ghost and the Machine.' Canadian Theatre Review, no. 111, 2002, pp. 87–8.

___. Reading the Material Theatre. Cambridge University Press, 2004.

Kooijman, Jaap. 'Cruising the Channels: The Queerness of Zapping.' Queer TV: Theories, Histories, Practices, edited by Glyn Davis and Gary Needham, Routledge, 1999, pp. 159–71.

Koustas, Jane. Robert Lepage on the Toronto Stage: Identity, Language, Nation. McGill-Queen's University Press, 2016.

___. 'Zulu Time – Theatre Beyond Translation.' Theatre Research in Canada/Recherches Théâtrales au Canada, vol. 24, nos. 1–2, 2003, pp 1–20, https://journals.lib.unb.ca/index.php/TRIC/article/view/7063.

Krips, Henry. 'The Politics of the Gaze: Foucault, Lacan, and Žižek.' Culture Unbound, vol. 2, 2010, pp. 91–102.

Lacan, Jacques. *The Four Fundamental Concepts of Psychoanalysis. The Seminar of Jacques Lacan Book XI.* Translated by Alan Sheridan. Edited by Jacques-Alain Miller, Norton, 1998.

Langston, Patrick. 'Play a thoughtful, gratifying experience.' Review of *The Blue Dragon. The Ottawa Citizen*, 29 March 2009.

Lapierre, Matthew. 'Parti Québécois Backs Robert Lepage over Cancelled *Slàv* at Jazz Fest.' *The Gazette* [Montréal], 6 July 2018, https://montrealgazette.com/news/local-news/robert-lepage-breaks-his-silence-on-jazz-fest-decision-to-muzzle-slav.

Lapointe, Josée. 'Une version finale des *Sept Branches de la Rivière Ota*.' *Le Soleil* [Québec City], 14 May 1997.

Lash, Scott, and Celia Lury. *Global Culture Industry: The Mediation of Things*. Polity, 2007.

Latouche, Daniel. 'Les personnages qui s'imposent aussi bien à Londres qu'à Montréal.' *Le Devoir* [Montréal], 5 September 1987.

___. 'RE: Query – Robert Lepage's *La Trilogie des Dragons*'. E-mail, 24 August 2014.

Lavender, Andy. *Hamlet in Pieces. Shakespeare Reworked: Peter Brook, Robert Lepage, Robert Wilson.* Nick Hern Books, 2001.

Lavoie, Pierre. 'Points de repère: entretiens avec les créateurs.' *Cahiers de théâtre Jeu*, vol. 45, 1987, pp. 177–208.

Lefebvre, Paul. 'Les coïncidences et l'intuition. Entretien avec Robert Lepage.' *Les Cahiers de la NCT* [Nouvelle Compagnie Théâtrale], no. 6, 1993, 17–19.

___. 'Robert Lepage: New Filters for Creation.' *Canadian Theatre Review*, no. 52, 1987, pp. 30–5.

Lehmann, Hans-Thies. *Postdramatic Theatre*. Translated by Karen Jürs-Mumby, Routledge, 2006.

Léonardini, Jean-Pierre. 'Beautes de l'imprevisible.' Review of *The Dragon's Trilogy. L'Humanité* [Paris], 3 May 1989.

Lepage, Robert. 'Curriculum vitae.' 2019, http://lacaserne.net/cv/CV-ang.pdf.

___. *Needles and Opium*. Unpublished playscript, 1994.

___. 'Position de Robert Lepage concernant *Slàv* / Robert Lepage position on *Slàv*.' Facebook post, 6 July 2018, www.facebook.com/notes/ex-machina/position-de-robert-lepage-concernant-slàv-robert-lepage-position-on-slàv/1891596674225125/.

___. *Le projet Andersen*. L'instant scène, 2007.

___. '*Slàv*, une année de bruit et de la silence; A Year of Noise and Silence.' Facebook post, 28 December 2018, www.facebook.com/notes/ex-machina/slàv-une-année-de-bruit-et-de-silence-a-year-of-noise-and-silence/2137285846322872/.

Lepage, Robert. *887*. Illustrations by Steve Blanchet, Québec Amérique, 2016.

Lepage, Robert. *Vinci*. Unpublished playtext, translated by Linda Gaboriau, Productions Téléferic Inc., 1987.

Lepage, Robert and Marie Michaud. *Le Dragon bleu*. Illustrations by Fred Jourdain, Les Éditions Alto and Ex Machina, 2011.

Lepage, Robert, and Daniel Mroz. 'Conférence de presse avec Robert Lepage.' Théâtre Français, National Arts Centre of Canada, 27 March 2007. *La Création du Projet Andersen* [DVD], Ex Machina, 2007.

'Les quarante ans de la LNI "New York: réalité et illusion".' LaFabriqueCulturelle.tv, Télé-Québec, 20 October 2014, www.lafabriqueculturelle.tv/capsules/10209/sorti-des-voutes-les-quarante-ans-de-la-lni-new-york-realite-et-illusion.

Le Soleil. 'Le dernier Robert Lepage reçu sévèrement à Zurich.' 26 August 1999.

Le Théâtre des Confettis. 'Théâtrographie.' *Le Théâtre des Confettis*, theatredesconfettis.ca/la-compagnie/theatrographie/.

Lessard, Jacques. 'Préface.' *Le Théâtre Repère: Du ludique au poétique dans le théâtre de recherche*, written by Irène Roy. Nuit Blanche Éditeur, 1993, pp. 7–9.

Létourneau, Jocelyn. *A History for the Future: Rewriting Memory and Identity in Québec*. Translated by Phylis Aronoff, McGill-Queen's University Press, 2004.

Leung, Wayne. 'Review: 887 (Ex Machina/Panamania).' *Mooney on Theatre* [Toronto], 15 July 2015, www.mooneyontheatre.com/2015/07/15/review-887-ex-machinapanamania.

Lévesque, Robert. 'Un archange sur la scène du monde.' *Le Devoir* [Montréal], 20 July 1992, p. 9.

___. 'Du dome au crane, l'écho de la vie.' Review of *Vinci. Le Devoir* [Montréal], 6 March 1986.

___. *La liberté de blâmer. Carnets et dialogues sur le théâtre*. Boréal, 1997.

___. 'Québec theatre takes on the world.' *Forces*, no. 84, 1989, pp. 55–6.

___. 'Trucs pour jouer *Hamlet* seul.' Review of *Elsinore. Le Devoir* [Montréal], 13 November 1995.

___. 'Un grand prix va à Robert Lepage.' *Le Devoir* [Montréal], 8 June 1987.

Lévesque, Solange. 'Elseneur.' *Cahiers de théâtre Jeu*, vol. 79, 1996, pp. 133–5.

___. 'Harmonie et Contrepoint.' *Jeu*, vol. 42, 1987, 100–8.

___. 'Un théâtre du dépaysement. Après deux années de metamorphoses, *Géométrie des Miracles* débarque à Montréal.' *Le Devoir* [Montréal], 13 March 2000.

___. 'La visite de la vielle dame.' *Cahiers de théâtre Jeu*, vol. 57, 1998, pp. 179–83.

Levin, Laura. *Performing Ground: Space, Camouflage, and the Art of Fitting In.* Palgrave Macmillan, 2014.

___. 'Performing Toronto: Enacting Creative Labour in the Neoliberal City.' *Performing Cities*, edited by Nicholas Whybrow. Palgrave Macmillan, 2014, pp. 159–78.

Levine, Stephen Z. *Lacan Reframed.* I.B. Tauris, 2008.

Levy, Deborah. 'The Weirdness of our Time.' Review of *The Dragon's Trilogy. New Stateman and Society*, vol. 4, no. 15, 15 November 1991.

Liberal Party of Canada. 'Cultural and Creative Industries.' *Liberal.ca*, 2018, www.liberal.ca/realchange/cultural-and-creative-industries/.

LinkedIn. 'Neilson Vignola – Directeur de creation chez Cirque du Soleil.' March 2018, https://ca.linkedin.com/in/neilson-vignola-b0674b34.

Linklater, John. 'Still a few streams short of a river.' Review of *The Seven Streams of the River Ota. The Herald* [Glasgow], 17 August 1994.

Lockerbie, Catherine. 'So Long, Frank Lloyd Wright' Review of *Geometry of Miracles. Independent on Sunday* [London], 4 April 1999.

Lodge, David. *The Modes of Modern Writing. Metaphor, Metonymy, and the Typology of Modern Literature.* Edward Arnold, 1977.

Loiselle, André. *Stage Bound: Feature Film Adaptations of Canadian and Québécois Drama.* McGill-Queen's University Press, 2003.

Lonergan, Patrick. *Theatre and Globalisation: Irish Drama in the Celtic Tiger Era.* Palgrave Macmillan, 2010.

Macaulay, Alistair. 'The Dragon's Trilogy – Riverside Studios.' *Financial Times* [London], 12 November 1991.

MacDougall, Jill R. *Performing Identities on the Stages of Québec.* Peter Lang, 1997.

Maclure, Jocelyn. *Québec Identity. The Challenge of Pluralism.* Translated by Peter Feldstein, McGill-Queen's University Press, 2003.

Maga, Carly. 'Robert Lepage's Controversial *Kanata* Misses the Mark in Paris.' *Toronto Star*, 18 December 2018, www.thestar.com/entertainment/stage/opinion/2018/12/18/robert-lepages-kanata-pisode-1-la-controverse-misses-the-mark.html.

Manguel, Alberto. 'Theatre of the Miraculous.' *Saturday Night*, January 1989, pp. 33–42.

Manovich, Lev. *The Language of New Media.* MIT Press, 2002.

Marks, Peter. 'The Muse and Architect as one, propagating Immortal Forms.' Review of *Geometry of Miracles. New York Times*, 21 April 1998.

Marlowe, Sam. 'Lipsynch at the Barbican Theatre, London (review).' *The Times* [London], 9 September 2008.

Marshall, Bill. *Québec National Cinema.* McGill-Queens University Press, 2001.

Martin, Stephanie. '10 M$ du federal pour le Diamant de Robert Lepage.' *Journal de Québec*, 10 June 2016.

Massumi, Brian. *Parables for the Virtual. Movement, Affect, Sensation.* Duke University Press, 2002.

Maurin, Frédéric. 'Still and Again: Whither Festivals?' *Contemporary Theatre Review*, vol. 13, no. 4, 2003, pp. 5–11.

Maxwell, Dominic. 'Robert Lepage Wants to Tell You a Story' *The Times* [London], 18 August 2008, www.thetimes.co.uk/article/robert-lepage-wants-to-tell-you-a-story-tc92j00cmrf.

McAlpine, Alison. 'Robert Lepage.' *In Contact with the Gods? Directors Talk Theatre*, edited by Maria M. Delgado and Paul Heritage. Manchester University Press, 1996, pp. 129–57.

McAuley, Gay. *Not Magic but Work: An Ethnographic Account of a Rehearsal Process.* Manchester University Press, 2012.

___. 'The Emerging Field of Rehearsal Studies.' *About Performance*, no. 6, 2006, pp. 7–13.

McLuhan, Marshall. *Understanding Media: The Extensions of Man.* MIT Press, 1994.

McMillan, Joyce. 'From a Tired Old Two-Step to the Stuff of Dreams.' Review of *Geometry of Miracles, The Scotsman* [Edinburgh], 5 April 1999.

___. 'Chopin and Changing.' Review of *Tectonic Plates. Guardian* [Northern edition], 27 November 1990.

Merlin, Hélène. 'Comment est-ce possible?' Review of *The Andersen Project. Les Trois Coups*, 18 December 2007.

Mermikides, Alex. 'Forced Entertainment – *The Travels* (2002) – The Anti-Theatrical Director.' *Making Contemporary Theatre. International Rehearsal Processes*, edited by Jen Harvie and Andy Lavender. Manchester University Press, 2010, pp. 101–20.

Mermikides, Alex, and Jackie Smart, eds. *Devising in Process.* Palgrave Macmillan, 2010.

Meyer, Moe. *The Politics and Poetics of Camp*. Routledge, 1994.

Ministère de Culture et Communications [Québec]. 'Culture Québec, A Culture that Travels the World.' 2001, www.mcc.gouv.qc.ca/publications/culture_Québec_eng.

Ministère des relations internationales et de la francophonie [Québec]. 'Offices Abroad.' 22 July 2019, www.mrifce.gouv.qc.ca/en/ministere/representation-etranger.

Mnouchkine, Ariane. 'Les cultures ne sont les propriétés de personne.' *Le Théâtre du Soleil*, 2018, www.the-atre-du-soleil.fr/fr/a-lire/ariane-mnouchkine-les-cultures-ne-sont-les-proprietes-de-personne-4263.

Morrill, Cynthia. 'Revamping the Gay Sensibility. Queer Camp and *dyke noir*.' *The Politics and Poetics of Camp*, edited by Moe Meyer, 1994, pp. 94–110.

Morrow, Martin. 'Lepage's *Blue Dragon* Breathes Fire Onstage.' *Globe and Mail* [Toronto], 12 January 2012.

Moy, James S. 'Theatre Review: *The Dragon's Trilogy*.' *Theatre Journal*, vol. 42, no. 4, 1990, pp. 499–501.

Mueller, Roswitha. 'Montage in Brecht.' *Theatre Journal*, vol. 39, no. 4, 1987, pp. 473–86.

Muñoz, José Esteban. *Disidentifications: Queers of Color and the Performance of Politics*. University of Minnesota Press, 1999.

Murphy, Siobhan. 'A Long Haul with Lepage in *Lipsynch*.' *Metro.co.uk*, 9 September 2008, http://metro.co.uk/2008/09/08/a-long-haul-with-lepage-in-lipsynch-467495.

Neathery-Castro, Jody, and Mark Rousseau. 'Québec and La Francophonie: The Province as Global Player.' *Québec Questions: Québec Studies for the 21st Century*, edited by Stéphan Gervais, Christopher Kirkey, and Jarrett Rudy, 2nd ed., Oxford University Press, 2016, pp. 462–78.

Nestruck, J. Kelly. 'Lepage taps our anxieties again.' Review of *The Blue Dragon*. *Globe and Mail* [Toronto], 29 March 2009.

___. 'Too Bad It Took Street Protests to Open Robert Lepage's Ears.' *Globe and Mail* [Toronto], 6 July 2018, www.theglobeandmail.com/opinion/article-too-bad-it-took-street-protests-to-open-robert-lepages-ears/.

Nightingale, Benedict. 'Misadventures in Space.' Review of *Geometry of Miracles*. *The Times* [London], 5 April 1999.

___. 'Out of This World.' Review of *The Far Side of the Moon*. *The Times* [London], 11 July 2001.

___. 'Threads from a Strong Yarn.' Review of *The Dragon's Trilogy*. *The Times* [London], 12 November 1991.

___. 'Visual Treats Enliven the Long Journey.' Review of *The Seven Streams of the River Ota*. *The Times* [London], 23 September 1996.

Northern Stage. 'Robert Lepage: *Lipsynch*.' Promotional flyer, 2007.

___. 'Please tell us what you think.' *Lipsynch* programme insert, 2007.

___. 'International Arrivals.' Press release, February 2007.

Oddey, Allison, *Devising Theatre. A Practical and Theoretical Handbook*. Routledge, 1994.

O'Mahony, John. 'Aerial Views.' *Guardian* [London], 23 June 2001, pp. 5–6.

O'Quinn, Jim. 'Calamities through the Camera's Eye.' *American Theatre*, vol. 12, no. 9, 1995, pp. 19, 82.

Owens, Craig. 'Posing.' *Beyond Recognition: Representation, Power, and Culture*. Craig Owens, edited by Scott Bryson, et al., University of California Press, 1994, pp. 201–17.

Paquin, Stéphane. *La revanche des petites nations. Le Québec, L'Ecosse, et la Catalogne face à la mondialisation*. VLB Éditeur, 2001.

Parker-Starbuck, Jennifer. '*The Far Side of the Moon*.' *Theatre Journal*, vol. 53, no. 1, 2001, pp. 151–4.

Pavis, Patrice. 'Introduction: Towards a Theory of Interculturalism in Theatre?' *The Intercultural Performance Reader*, edited by Pavis, Routledge, 1996, pp. 1–21.

Pavis, Patrice. 'Afterword: Contemporary Dramatic Writings and the New Technologies.' Translated by Joel Anderson, *Trans-Global Readings: Crossing Theatrical Boundaries*, edited by Caridad Svitch, Manchester University Press, 2003, pp. 187–202.

___. 'The Director's New Tasks.' Translated by Joel Anderson, *Contemporary European Theatre Directors*, edited by Maria M. Delgado and Dan Rebellato, Routledge, 2010, pp. 395–411.

Pavlovic, Diane. 'Du décollage à l'envol.' *Cahiers de théâtre Jeu*, vol. 42, 1987, pp. 86–99.

___. 'Reconstitution de *La Trilogie*.' *Cahiers de théâtre Jeu*, vol. 45, 1987, pp. 40–82.

Perelli-Contos, Irène, and Chantal Hébert. 'La tempête Robert Lepage.' *Nuit Blanche*, vol. 55, March–May 1994, pp. 63–6.

Perusse, Bernard. '*Zulu Time* cabaret broadens festival.' *The Gazette* [Montréal], 30 May 2002.

Peter, John. '*Geometry of Miracles*.' *Sunday Times* [London], 11 April 1999.

___. 'Reflecting our Split Lives.' Review of *Tectonic Plates*. *Sunday Times* [London], 2 December 1990.

Phelps, Anthony. 'Variations sur deux mots. Ecritures/migrantes, migration/exil.' *D'autres rêves. Les écritures migrantes au Québec*, edited by Anne de Vaucher Gravili, Supernova, 2000, pp. 83–96.

Pluta, Izabela. 'Instance: Robert Lepage and Ex Machina, *The Andersen Project* (2005).' *Mapping Intermediality in Performance*, edited by Sarah Bay-Cheng et al., Amsterdam University Press, 2010, pp. 191–7.

Poll, Melissa. 'Adapting "Le Grand Will" in Wendake: Ex Machina and the Huron-Wendat Nation's *La Tempête.*' *Theatre Research in Canada/ Recherches Théâtrales au Canada*, vol. 35, no. 3, 2014, pp. 330–51.

___. *Robert Lepage's Scenographic Dramaturgy: The Aesthetic Signature at Work.* Palgrave Macmillan, 2018.

Prokosh, Kevin. 'Bigotry Blamed for Play's Reception.' *Winnipeg Free Press*, 23 May 1990.

Québec International. 'Economic Report and Outlooks. Québec City CMA 2016–17.' *Québecinternational. ca*, April 2017, www.Québecinternational.ca/media/3220698/economis_report_and_outlooks_2016–2017-web-final.pdf.

Quirot, Odile. 'Sous le sable, l'étoile.' Review of *The Dragon's Trilogy. Le Monde* [Paris], 22 April 1989.

Radio-Canada. 'Un *Dragon Bleu* Ovationné.' *Arts et Spectacles*, 23 April 2008, https://ici.radio-canada.ca/arts-spectacles/PlusArts/2008/04/23/001-dragon_bleu.asp.

___. 'Entrevue exclusive: Robert Lepage revient sur les tollés suscités par *Slàv* et par *Kanata.*' *Ici première*, 21 July 2018, https://ici.radio-canada.ca/premiere/emissions/les-grands-entretiens/segments/entre-vue/80636/slav-kanata-censure-liberte-de-creation-robert-lepage-stephane-bureau-theatre-debat-excl usif.

Radosavljević, Duska, ed. *The Contemporary Ensemble: Interviews with Theatre-Makers.* Routledge, 2013.

___. *Theatre-Making. Interplay between Text and Performance in the 21st Century.* Palgrave Macmillan, 2013.

Radz, Matt. 'Lepage's *Lipsynch* Is Huge on Every Level.' *The Gazette* [Montréal], 2 June 2007.

Rae, Paul. 'Where is the Cosmopolitan Stage?' *Contemporary Theatre Review*, vol. 16, no. 1, 2006, pp. 8–22.

Rancière, Jacques. 'The Method of Equality: An Answer to Some Questions.' *Jacques Rancière: History, Politics, Aesthetics*, edited by Gabriel Rockhill and Philip Watts, Duke University Press, 2009, pp. 273–88.

___. *Dissensus: On Politics and Aesthetics.* Translated and edited by Steven Corcoran, Continuum, 2010.

___. *The Emancipated Spectator.* Translated by Gregory Elliott, Verso, 2011.

___. *The Politics of Aesthetics.* Translated by Gabriel Rockhill, Bloomsbury, 2006.

Ratcliffe, Michael. 'The Magical Sandpit.' Review of *The Dragon's Trilogy. Observer* [London], 2 August 1987.

Rea, Kenneth. 'Symbols in a Zen Garden.' Review of *The Dragon's Trilogy. Guardian* [London], 29 July 1987.

Rees, Jasper. 'The *Rake's Progress*: The TV Vision of the World's Greatest Director.' *Daily Telegraph* [London], 5 July 2008, www.telegraph.co.uk/culture/theatre/3555851/The-Rakes-Progress-the-TV-vision-of-the-worlds-greatest-director.html.

Reinelt, Janelle. 'The Los Angeles Summer Festival. Summer 1990.' *Theatre Journal*, vol. 43, no. 1, 1991, pp. 107–14.

Reynolds, James. 'Acting with Puppets and Objects: Representation and Perception in Robert Lepage's *The Far Side of the Moon.*' *Performance Research*, vol. 12, no. 4, 2007, pp. 132–42.

___. *Evaluating Performance/Re-Evaluating Process: An Investigation into and Re-Assessment of Robert Lepage's Devised Theatre Practice.* 2010. Queen Mary University of London, PhD dissertation.

___. 'Hypermobility and Uncanny Praxis in Robert Lepage and Ex Machina's Devised Solo Work.' *Journal of Contemporary Drama in English*, vol. 5, no. 1, 2017, pp. 55–69.

___. 'James Reynolds: Robert Lepage and Authorial Process.' *Direction. Readings in Theatre Practice*, edited by Simon Shepard, Palgrave Macmillan, 2012, pp. 177–85.

___. *Robert Lepage/Ex Machina. Revolutions in Theatrical Space.* Bloomsbury Methuen, 2019.

Richer, Jocelyne. 'Le Diamant de Robert Lepage: Québec annule sa subvention de 30 millions $.' *L'actualité* [Montréal], 2 December 2014.

Ridout, Nicholas. *Stage Fright, Animals, and Other Theatrical Problems.* Cambridge University Press, 2006.

Ridout, Nicholas, and Rebecca Schneider. 'Precarity and Performance: An Introduction.' *TDR/The Drama Review*, vol. 56, no. 4, 2012, pp. 5–9.

Rioux, Christian. 'La dernière création de Robert Lepage à Paris: une quincaillerie technologique.' Review of *Zulu Time. Le Soleil* [Québec City], 21 October 1999.

Ross, Alex. 'Diminuendo.' *New Yorker*, 12 March 2012, www.newyorker.com/magazine/2012/03/12/diminuendo-2.

Roy, Irène. *Le Théâtre Repère: Du ludique au poétique dans le théâtre de recherche.* Nuit Blanche Éditeur, 1993.

Said, Edward. *Culture and Imperialism.* Knopf, 1994.

___. *Orientalism.* New York: Vintage, 1979.

Salter, Denis. 'Borderlines: An Interview with Robert Lepage and Le Théâtre Repère.' *Theater*, vol. 24, no. 3, 1993, pp. 71–9.

Saltz, David Z. 'Infiction and Outfiction: The Role of Fiction in Theatrical Performance.' *Staging Philosophy: Intersections of Theater, Performance, and Philosophy*, edited by David Krasner and David Z. Saltz, University of Michigan Press, 2006, pp. 203–20.

Salutin, Rick. 'Cultural Appropriation Sees Two Robert Lepage Productions Cancelled.' *Rabble.ca*, 17 August 2018, www.rabble.ca/columnists/2018/08/cultural-appropriation-sees-two-robert-lepage-productions-cancelled.

Sasayama, Takashi, et al., eds. *Shakespeare and the Japanese Stage*. Cambridge University Press, 2009.

Savran, David. 'Branding the Revolution: *Hair* Redux.' *Neoliberalism and Global Theatres*, edited by Lara Nielsen and Patricia Ybarra, Palgrave Macmillan, 2012, pp. 65–80.

Scène Éthique. '*The Ring Cycle*.' Metropolitan Opera.' Informational/promotional page on company website, http://sefabrication.com/wp-content/uploads/2016/07/The_Ring_Cycle_Met.pdf.

Schmitt, Olivier. 'Le premier cabaret technologique du Québécois Robert Lepage.' Review of *Zulu Time*. *Le Monde* [Paris], 25 October 1999.

Schneider, Rebecca. 'Introduction to Part 4.' *Re: Direction: A Theoretical and Practical Guide*, edited by Rebecca Schneider and Gabrielle Cody, Routledge, 2002, pp. 293–5.

Schryburt, Sylvain. 'Québec Theatre: New Dynamics between the Local and the International.' *Québec Questions: Québec Studies for the 21st Century*, edited by Stéphan Gervais, et al., 2nd ed., Oxford University Press, 2016, pp. 514–27.

Schwartzwald, Robert. '"Chus T'un Homme": Trois (Re)mises en scène d'*Hosanna* de Michel Tremblay.' *Globe. Revue Internationale d'études québécoises*, vol. 11, no. 2, 2008, pp. 43–60.

___. 'Fear of Federasty: Québec's Inverted Fictions.' *Comparative American Identities. Race, Sex, and Nationality in the Modern Text*, edited by Hortense Spillers, Routledge, 1991, pp. 175–95.

___. '"Symbolic Homosexuality", "False Feminine", and the Problematics of Identity in Québec.' *Fear of a Queer Planet. Queer Politics and Social Theory*, edited by Michael Warner, University of Minnesota Press, 1993, pp. 264–99.

Sedgwick, Eve Kosofsky. *Tendencies*. Duke University Press, 1993.

Sennett, Richard. *The Craftsman*. Yale University Press, 2008.

Sheridan, Michael. '*Dragon Trilogy* [sic] "jewel in crown".' *Irish Independent* [Dublin], 13 August 1987.

Shevtsova, Maria, and Christopher Innes. *Directors/Directing. Conversations on Theatre*. Cambridge University Press, 2009.

Shewey, Don. 'Set Your Watch to Now: Robert Lepage's *Zulu Time*.' *American Theatre*, vol. 9, no. 17, 2002, pp. 26–7.

___. 'A Bold Québécois Who Blends Art and Technology.' *New York Times*, 16 September 2001.

Shuttleworth, Ian. 'Review of *Needles and Opium*.' *City Limits*, 30 April 1992, www.cix.co.uk/~shutters/reviews/92047.htm.

___. 'Streams that Lead to Zen.' Review of *The Seven Streams of the River Ota*. *Financial Times* [London], 24 September 1996.

Sidnell, Michael. '*Polygraph*: Somatic Truth and the Art of Presence.' *Canadian Theatre Review*, no. 64, 1990, pp. 45–8.

Simard, François, and Louis-Pascal Rousseau. 'La ceinture fléchée au carrefour des convoitises des communautés canadiennes-françaises, amérindiennes et métisses du Canada.' *Material Culture Review*, no. 59, 2004, https://journals.lib.unb.ca/index.php/MCR/article/view/17973/21974.

Simon, Sherry. *Le trafic des langues: traduction et culture dans la littérature québécoise*. Boréal, 1994.

___. 'Robert Lepage and the Languages of Spectacle.' *Theater sans frontières: Essays on the Dramatic Universe of Robert Lepage*, edited by Joseph I. Donohoe, Jr. and Jane M. Koustas, Michigan State University Press, 2000, pp. 215–30.

Simon, Sherry, and David Leahy. 'La recherche au Québec portant sur l'écriture ethnique.' *Ethnicity and Culture in Canada: The Research Landscape*, edited by J.W. Berry and J.A. Laponce, University of Toronto Press, 1994, pp. 387–409.

Singer, Ben. *Melodrama and Modernity. Early Sensational Cinema and its Contexts*. Columbia University Press, 2001.

Singleton, Brian. 'Introduction: The Pursuit of Otherness for the Investigation of Self.' *Theatre Research International*, vol. 22, no. 2, 1997, pp. 93–7.

Smith, Sid. '*The Seven Streams* a Marathon.' Review of *The Seven Streams of the River Ota*. *Chicago Tribune*, 16 May 1997.

Soldevila, Philippe. 'De l'architecture au théâtre: Entretien avec Jacques Lessard.' *Cahiers de théâtre Jeu*, no. 52, 1989, pp. 31–8.

Sontag, Susan. *Against Interpretation and Other Essays*. Picador, 2001.

Spencer, Charles. 'Lepage Launches a Glorious Lunar Odyssey – Down at the Launderette.' Review of *The Far Side of the Moon*. *Daily Telegraph* [London], 11 July 2001.

___. 'Lepage Proves He Can Still Work Magic.' Review of *The Seven Streams of the River Ota*. *Daily Telegraph* [London], 23 September 1996.

___. '*Lipsynch*: Nine-Hour Flight of Fantasy Too Far.' *Daily Telegraph* [London], 9 September 2008.

___. 'Weird Soap that Aspires to High Art.' Review of *The Dragon's Trilogy*. *Daily Telegraph* [London], 12 November 1991.

Stanley, Sarah Garton. 'What Is the Role of the Independent Artist in Today's Cultural Landscape?' Discussion at the Luminato Festival, Toronto, 24 June 2017.

Stannard, David E. *Shrinking History: On Freud and the Failure of Psychohistory*. Oxford University Press, 1980.

Stevens, Lara. *Anti-War Theatre After Brecht: Dialectical Aesthetics in the Twenty-First Century*. Palgrave Macmillan, 2016.

St-Hilare, Jean. 'L'intégrale de *La Trilogie des Dragons*. L'envoûtement et le triomphe!' *Le Soleil* [Québec City], 8 June 1987.

___. 'L'urgentologue Lepage.' *Le Soleil* [Québec City], 6 June 1997.

___. '*Zulu Time*: La planète des solitudes.' *Le Soleil* [Québec City], 28 June 2002.

St-Jacques, Sylvie. 'Une fresque de Robert Lepage au nouveau FTA.' *La Presse* [Montréal], 23 January 2007.

___. 'Premiers fragments dune grande fresque.' Review of *Lipsynch*. *La Presse* [Montréal], 3 June 2007.

Stoudt, Charlotte. 'Theater Review: *The Blue Dragon* at LA Live.' *Culturemonster, LA Times blogs*, 13 November 2008, http://latimesblogs.latimes.com/culturemonster/2008/11/the-blue-dragon.html.

Stratton, Kate. '*The Seven Streams of the River Ota*.' *Time Out* [London], 25 September–2 October 1996.

Sumi, Glenn. 'Spaced-Out Lepage.' Review of *The Far Side of the Moon*. *NOW Toronto*, 27 April–3 May 2000.

Szalwinska, Maxie. 'Lepage's *Lipsynch* Isn't the Real Thing.' *Guardian* [London], 8 September 2008, www.theguardian.com/stage/theatreblog/2008/sep/08/lepageslipsynchisntthereal.

Tattelman, Ira. 'Speaking to the Gay Bathhouse: Communicating in Sexually Charged Spaces.' *Public Sex/Gay Space*, edited by William Leap, Columbia University Press, 1999, pp. 71–94.

Taylor, Kate. 'At Last, Another Great Show from Robert Lepage.' Review of *Zulu Time*. *Globe and Mail* [Toronto], 20 May 2000.

___. 'Cold *Geometry* a Rickety Structure of Abstract Ideas.' *Globe and Mail* [Toronto], 18 April 1998.

___. 'Lepage Plumbs New Depths in *River Ota*.' *Globe and Mail* [Toronto], 6 November 1995.

___. '*Trilogy* Revives Brilliant Ideas.' *Globe and Mail* [Toronto], 5 June 2003.

Taylor, Paul. 'Art, Youth and Leonardo.' Review of *Vinci*. *Independent* [London], 29 August 1987.

___. 'Crowded Out: Paul Taylor Reviews Lepage's *Coriolan* at the Nottingham Playhouse.' *Independent* [London], 26 November 1993.

___. '*Lipsynch*, Barbican, London.' *Independent* [London], 8 September 2008.

___. 'Now You See It, Now You Don't.' Review of *The Seven Streams of the River Ota*. *Independent* [London], 17 August 1994.

___. 'Paradox of Destruction.' Review of *The Seven Streams of the River Ota*. *Independent* [London], 23 September 1996.

___. 'The View from Planet Lepage.' Review of *The Far Side of the Moon*. *Independent* [London], 12 July 2001.

Théâtre Quat'sous. *Vinci*. Production programme, Montréal, 1986.

Théâtre Repère. *La Trilogie des Dragons*. Production programme, Québec City, 1985.

___. 'Lepage, Repère, and Shakespeare.' Production programme, Québec City, 1992.

Théâtres associés. 'La Tempête.' *Portail du théâtre Québécois*, 28 April 1998, rappels.ca/en/node/1465.

Tomlinson, John. *Globalization and Culture*. Polity, 1999.

___. 'Globalisation and Cultural Identity.' *The Global Transformations Reader*, edited by David Held and Anthony McGrew, 2nd ed., Polity, 2003, pp. 269–77.

Tommasini, Anthony. 'The Met, the "Ring" and the Rage against the Machine.' *New York Times*, 3 April 2012.

Trueman, Matt. 'People Are Interested in What I'm Doing Again: Robert Lepage Interviewed.' *The Spectator*, 22 August 2015, www.spectator.co.uk/2015/08/people-are-interested-in-what-im-doing-again-robert-lepage-interviewed/.

Truth and Reconciliation Commission of Canada. *Honouring the Truth, Reconciling for the Future. Summary of the Final Report of the Truth and Reconciliation Commission of Canada*, 2015.

___. *Truth and Reconciliation of Canada: Calls to Action*, 2015.

Turgeon, Luc. 'Interpreting Québec's Historical Trajectories: *Between La Société Globale* and the Regional Space.' *Québec: State and Society*, edited by Alain-G. Gagnon, 3rd ed., University of Toronto Press, 2008, pp. 51–67.

Tusa, John. *Robert Lepage*. Interview, 1 May 2005, www.bbc.co.uk/programmes/p00ncz5l.

Ubersfield, Ann. 'The Pleasure of the Spectator.' *Modern Drama*, vol. 25, no. 1, 1982, pp. 127–39.

Vacanti, Jeffrey. 'Liberal Nationalism and the Challenge of Masculinity Studies in Québec.' *Left History*, vol. 11, no. 2, 2006, pp. 96–117.

___. 'Writing the History of Sexuality and 'National' History in Québec.' *Journal of Canadian Studies*, vol. 39, no. 2, 2005, pp. 31–55.

Varma, Rahul. 'Robert Lepage's *Zulu Time*: A Dehumanising Show.' *alt.theatre*, vol. 2, no. 4, 2003, pp. 4–5, 15.

Verdussen, Monique. 'Le Retour aux Sources de *La Trilogie des Dragons*.' *La Libre Belgique* [Brussels], 16 March 1989.

Verini, Bob. 'Review: *The Blue Dragon*.' *Variety*, 13 November 2008, http://variety.com/2008/legit/markets-festivals/the-blue-dragon-2-1200472231.

Vigneault, Alexandre. '*Lipsynch*, l'émouvante fresque de Robert Lepage.' *La Presse* [Montréal], 1 March 2010.

Wagner, Vit. 'Lepage's *Seven Streams*. A Flood of Breathtaking Imagery and Imagination.' *Toronto Star*, 5 November 1995.

___. 'Miracles Worker.' *Toronto Star*, 11 April 1998.

Wakin, Daniel J. 'Dispute over sets for the Met's coming "Ring"'. *New York Times*, 5 October 2009.

___. 'The Valhalla Machine.' *New York Times*, 15 September 2010.

Wardle, Irving. 'Magic Space.' Review of *The Dragon's Trilogy*. *The Times* [London], 29 July 1987.

___. 'Making the Earth Move.' Review of *Tectonic Plates*. *Independent on Sunday* [London], 2 December 1990.

___. 'Masterpiece of Revivalism.' Review of *The Dragon's Trilogy*. *The Times* [London], 18 June 1986.

Waters, Malcolm. *Globalisation*. 2nd ed., Routledge, 2001.

Waugh, Thomas. *The Romance of Transgression in Canada. Queering Sexualities, Nations, Cinemas*. McGill-Queen's University Press, 2006.

Webster LS. 'Le problème avec *Slàv*.' Facebook post, 28 June 2018, www.facebook.com/Webster.LStarz/posts/le-problème-avec-slav-quand-ex-machina-ma-approché-à-lété-2017-afin-de-discuter-/21333107 10238477/.

Weiss, Hedy. 'Canada's Magic *Trilogy* Re-invents the Universe.' *Chicago Sun-Times*, 12 June 1990.

Wickstrom, Maurya. 'Commodities, Mimesis, and *The Lion King*: Retail Theatre for the 1990s.' *Theatre Journal*, vol. 51, no. 3, 1999, pp. 285–98.

Wilson, Ann. 'Bored to Distraction: Auto-Performance and the Perniciousness of Presence.' *Canadian Theatre Review*, no. 79/80, 1994, pp. 33–7.

Winters, Laura. 'The World Is His Canvas, and His Inspiration.' *New York Times*, 1 December 1996.

Woddis, Carole. '*Lipsynch*, Barbican Theatre, London (review).' *Herald* [Glasgow], 9 September 2008.

___. '*The Dragon's Trilogy*.' *City Limits* [London], 30 July–6 August 1987.

Wolf, Matt. '*Lipsynch* Decidedly Runs out of Steam.' *International Herald Tribune* [Paris], 9 September 2008.

Woycicki, Piotr. *Post-cinematic Theatre and Performance*. Palgrave Macmillan, 2014.

Ybarra, Patricia. 'Fighting for a Future in a Free Trade World.' *Neoliberalism and Global Theatres. Performance Permutations*, edited by Lara D. Nielsen and Patricia Ybarra, Palgrave Macmillan, 2012, pp. 113–27.

Žižek, Slavoj. *Looking Awry: An Introduction to Jacques Lacan through Popular Culture*. MIT Press, 1991.

___. *The Sublime Object of Ideology*. Verso, 1989.

INDEX

Note: page numbers in *italic* refer to illustrations; 'n.' after a page reference indicates the number of a note on that page; artworks, plays, films, and literary works can be found under authors' names.

Printed in the USA
CPSIA information can be obtained
at www.ICGtesting.com
JSHW011746190424
61522JS00004B/38